DOCTORAL WRITING IN THE CREATIVE AND PERFORMING ARTS

DOCTORAL WRITING IN THE
CREATIVE AND PERFORMING ARTS

First published in 2014 by Libri Publishing

Copyright © Libri Publishing

ISBN 978-1-909818-47-7

A CIP catalogue record for this book is available from The British Library

Design by Carnegie Publishing

Cover image Melissa Laird 2009, NARRATIVE: Death, collage, paper and acetate, private collection, Sydney

Printed by TJ International Limited

Libri Publishing
Brunel House
Volunteer Way
Faringdon
Oxfordshire
SN7 7YR

Tel: +44 (0)845 873 3837

www.libripublishing.co.uk

CONTENTS

Part II

From Within: Student Perspectives and Experiences

Part III
Reflecting: The Nature of the Doctoral Thesis – Researching,
Writing, Thinking

CONTRIBUTORS

Baker, Su

Professor Su Baker holds a Doctorate of Creative Arts and has worked in higher arts education for over 25 years, including senior management roles at Sydney College of the Arts and Victorian College of the Arts, University of Melbourne. In 2010 she was appointed as Director of the Victorian College of the Arts, Faculty of the VCA and MCM, University of Melbourne. She is a leading artist and academic, who has written on the shifting needs of twenty-first-century higher arts education. She was recently elected the President of the new Australian Council of Deans and Directors of Creative Arts.

Barrett, Estelle

Estelle Barrett is Adjunct Research Professor at Charles Sturt University and Professor, Research and HDR Coordinator (0.4) at the Institute of Koorie Education, Deakin University. Barrett's research interests include body–mind relations, affect and embodiment in aesthetic experience, new materialism and creative practice as research. Together with Barbara Bolt, she co-edited the book *Practice as Research: Approaches to Creative Arts Enquiry* (London: I.B.Tauris, 2007; reprinted 2010) on the pedagogy and practice of artistic research and the follow-up volume *Material Inventions: Applying Creative Research*, which will be published in 2014. Also co-edited with Barbara Bolt is the volume *Carnal Knowledge: Towards a 'New Materialism' through the Arts* (London: I.B.Tauris, 2012). In May 2013, Barrett was keynote speaker at the Fourth New Materialism Conference in Turku, Finland and presented a paper at the Spring 2013 Lecture Series, Doing Gender at the University of Utrecht.

Beattie, Annalea

Annalea Beattie is an artist who thinks about the social challenges facing sustainable human life in an extra-terrestrial setting. She is concerned with the nature of space exploration and the kind of future societies that will be perpetuated. Annalea often works with non- artists around different spheres of practice to investigate themes that bridge art and space science. She designs projects that focus on the immediacy and intimacy of collaborative art making in restricted physical environments, exploring how art can influence notions of freedom and constraint. She is particularly interested in the role of imaginative thinking as a survival skill in deep space travel. Annalea is an Executive Director of the Mars Society Australia and a member of the British Interplanetary Society and the International Dark Sky Association. She teaches doctoral writing for the Study and Learning Centre at RMIT University, Melbourne.

Biggs, Iain

Dr Iain Biggs is a Visiting Research Fellow at UWE, Bristol, UK, where he was formerly Director of PLaCE, an interdisciplinary research centre and international network, for which he continues to act as a coordinator. As a teacher–artist–researcher, he has fifteen years' experience supervising arts practice-led doctorates. He undertakes 'deep mappings' that interweave arts practices with humanities and social science methods and publishes on art in interdisciplinary contexts. He recently worked on the ESRC-funded research project Gray and Pleasant Land? and is currently involved in a major AHRC-funded project on 'hydro-citizenship' and on collaboratively developing 'artful ecosophies' in rural contexts.

Bolt, Barbara

Barbara Bolt is a practising artist and art theorist at the Victorian College of Arts, University of Melbourne. She has two monographs *Art Beyond Representation: The Performative Power of the Image* (I.B.Tauris, 2004) and *Heidegger Reframed: Interpreting Key Thinkers for the Arts* (I.B.Tauris, 2011) and three co-edited publications: *Carnal Knowledges: Towards a 'New Materialism' through the Arts* (I.B.Tauris, 2013); *Practice as Research: Approaches to Creative Arts Enquiry* (I.B.Tauris, 2007); and

Sensorium: Aesthetics, Art, Life (2007). She exhibits with the Catherine Asquith Gallery. http://www.barbbolt.com/

Brejzek, Thea

Dr Thea Brejzek is Professor for Spatial Theory at the University of Technology Sydney and 2013 Visiting Professor at the Bartlett School of Architecture as well as teaching in the Theatre Studies Department at the University of Vienna. Thea Brejzek's research focus is on transdisciplinary practices and the politics of space in performative environments.

Brien, Donna Lee

Donna Lee Brien is Professor of Creative Industries, Central Queensland University, Special Issues Editor of *TEXT: Journal of Writing and Writing Courses* and Past President of the Australasian Association of Writing Programs. Donna was a chief investigator on three nationally funded learning and teaching projects: *Australian Postgraduate Writing Network* and *Examination of Doctoral Degrees in Creative Arts: Process, Practice and Standards*, both under the leadership of Professor Jen Webb, University of Canberra; and *Create.Ed*, which networked Australian universities' creative-arts teaching and learning leaders. Donna is currently a CI on a national project developing a creativity skills MOOC for coursework master's students.

Buckley, Brad

Brad Buckley is an artist, activist, urbanist and Professor of Contemporary Art and Culture at Sydney College of the Arts, the University of Sydney. He was educated at St Martin's School of Art, London, and the Rhode Island School of Design. His work, which operates at the intersection of installation, theatre and performance, investigates questions of cultural control, democracy, freedom and social responsibility. His work has been exhibited internationally for over two decades. He is also the editor, with John Conomos, of *Republics of Ideas* (Pluto Press, 2001) and *Rethinking the Contemporary Art School: The Artist, the PhD, and the Academy* (The Press of Nova Scotia College of Art and Design, 2009).

Burr, Sandra

Sandra Burr, BA (LaTrobe), Grad Dip Prof Comm (UC), PhD (UC), is an Adjunct Professional Associate at the University of Canberra where she also teaches creative writing and cultural research. Sandra is on the editorial board of the journal *Axon: Creative Explorations* and was the Project Officer for the ALTC-funded grant *Examination of Doctoral Degrees in Creative Arts: Process, Practice and Standards.* She is a member of the new Donald Horne Institute: Centre for Creative and Cultural Research. Sandra's research focuses on human–animal relationships including a project examining representations of animals and the city.

Catsi, George

George Catsi is a creative writer, performer, producer and teacher with extensive leadership and communication experience that overlaps film, theatre, film business, health and education. His teaching experience is diverse and encompasses university and broader creative areas including communication, performance and comedy writing. He was Australian winner of the Kit Denton Fellowship 2010 for courage and excellence in performance writing for his satirical evangelical comedy *I Want to Be Slim.* George has presented on topics covering: creativity; perceptions of evil and human wickedness; satire; and national identity (maybe they are all the same thing).

Durré, Caroline

Dr Caroline Durré is an artist who has held numerous solo shows in painting, drawing, printmaking and wall painting. Her works are held in national, state, regional, corporate and private collections. Her research centres on the representation of deceptive, paradoxical and fictive space, with an emphasis on the seventeenth century and a particular focus on the architecture of fortifications. As a lecturer in the Department of Fine Arts, Faculty of Art, Design & Architecture, Monash University, she concentrates on the supervision of graduate students in MFA and PhD degrees. Her website is http://carolinedurre.com.

Ednie-Brown, Pia

Pia Ednie-Brown is the Higher Degrees by Research Director in the School of Architecture and Design at RMIT University, Melbourne. She has a speculative creative research practice, *onomatopoeia* (www.onomatopoeia.com.au). Her edited publication *Plastic Green: Designing for Environmental Transformation* (RMIT Press, 2009) was developed through a collaborative research project she directed, involving multiple disciplines across the arts and science. She co-guest-edited an issue of *Architectural Design* (*AD*): *The Innovation Imperative: Architectures of Vitality* (Wiley, 2013). Her academic writing has been published internationally in scholarly journals and books.

Elkins, James

James Elkins is E.C. Chadbourne Professor in the Department of Art History, Theory, and Criticism, School of the Art Institute of Chicago. His most recent book is *What Photography Is* (Routledge, 2011). He writes on art and non-art images; his publications include *Chinese Landscape Painting as Western Art History* (Hong Kong University Press, 2010) and *Art Critiques: A Guide* (New Academia, 2009). Currently he is editing a book series called the Stone Art Theory Institutes (Penn State Press). In 2011 he stopped writing monographs in order to concentrate on an experimental writing project that is not related to art. Email: jameselkins@fastmail.fm

Forbes, Anne-Marie

Dr Anne-Marie Forbes is Senior Lecturer in Musicology at the University of Tasmania Conservatorium of Music, part of the Tasmanian College of the Arts. She has published numerous journal articles and book chapters on British and Australian music of the early twentieth century and has published three major editions of compositions of Fritz Hart. Her current research projects include performativity in Mahler's lieder and a book co-edited with Dr Paul Watt (Monash University) on British composer, Joseph Holbrooke. She has been the Graduate Research Co-ordinator for Music at the University of Tasmania for over a decade.

Friedman, Ken

Ken Friedman is University Distinguished Professor at Swinburne University of Technology in Melbourne, Australia, and Guest Professor at Tongji University in Shanghai. Friedman is also a practising artist and designer, active in the international laboratory known as Fluxus. He had his first solo exhibition in New York in 1966. His work is represented in major museums around the world, including the Museum of Modern Art, the Guggenheim Museum, the Tate Modern and Stadtsgalerie Stuttgart. In 2007, Loughborough University honoured Friedman with the degree of Doctor of Science, honoris causa, for outstanding contributions to design research.

Hamilton, Jillian

Associate Professor Jillian Hamilton teaches and researches in the field of interactive and visual design in the Creative Industries Faculty, Queensland University of Technology. Her teaching spans visual communication theory and practice, digital media theory and professional practice for designers. Her research spans art, digital media and design and she has published in the fields of practice-led research in art and design, interaction design, visual art, embodied media and media arts. She is currently conducting practice-led research on the convergence of mobile technologies, geo-positioning and 3D mapping to support located online social collaboration.

Laird, Melissa

Melissa Laird (PhD) is Academic Director at Whitehouse Institute of Design, Australia. She is a material culture scholar who originally trained as a practitioner of fashion and graphic design. Her recent research frames ephemeral, transient and fragmentary artefacts as significant models for historical study and object-based artwork. Laird exhibited at the UNESCO World Heritage listed Hyde Park Barracks Museum Sydney (2009), won the Groundswell Project People's Choice Award in 'Hidden: A Sculpture Walk' at Rookwood Necropolis and the Cessnock Regional Art Gallery Sculpture Award (2011). In 2012, Laird won the Artist in Residency Award for her work 'Breath' through Scultpure in the Vineyards.

Lowry, Sean

Dr Sean Lowry is a Sydney-based visual artist, writer and musician, and is currently Convenor of Honours in Creative and Performing Arts at the University of Newcastle, Australia. Lowry has performed, exhibited and presented extensively both nationally and internationally. His published writing has appeared in numerous journals and edited volumes. Lowry's most recent initiative is the development of a new global peer-reviewed exhibition model in which the role of curator is replaced with the type of peer-review model typically endorsed by a refereed journal. Emphasising art situated outside conventional exhibition contexts, *Project Anywhere* is dedicated to the dissemination of practice-based artistic research at the outermost limits of location-specificity.

MacNeill, Kate

Kate MacNeill is the program head of graduate studies in arts and cultural management in the School of Culture and Communication at the University of Melbourne. Her teaching and research interests relate to legal aspects of artistic production and circulation and the nature of co-leadership in arts organisations. She has published in *Third Text*, the *International Journal of Cultural Policy*, the *Media and Arts Law Review* and the *Journal of Leadership Studies* and is managing editor of the *Asia Pacific Journal of Arts and Cultural Management*.

Paltridge, Brian

Brian Paltridge is Professor of TESOL at the University of Sydney. His most recent publications are the second edition of his book *Discourse Analysis* (Bloomsbury, 2012) and the *Handbook of English for Specific Purposes* edited with Sue Starfield (Wiley-Blackwell, 2013). He is an editor emeritus for the journal *English for Specific Purposes* and a current editor (with Ahmar Mahboob) of *TESOL Quarterly*.

Phillips, Maggi

Associate Professor Maggi Phillips is the coordinator of Research and Creative Practice at the Western Australian Academy of Performing

Arts, a position that enables daily access to the integration of artistic innovation and research. Her life path has crossed many disciplines and worldviews, from dancer to a world literature doctorate, circus ring to university boardroom. Together with Cheryl Stock and Kim Vincs, Maggi has published *Guidelines for Best Practice in Australian Doctoral and Masters Examination, Encompassing the Two Primary Modes of Investigation, Written and Multi-modal Theses*, the culminating document of an Australian Learning and Teaching Council grant.

Ravelli, Louise

Louise Ravelli is Associate Professor of Communication in the School of the Arts and Media at the University of New South Wales. Her research interest is communication in professional contexts, using social semiotic approaches, including systemic functional linguistics and multi-modal discourse analysis, to enhance communication outcomes. Key areas of application include museum communication and academic literacy. Her books include *Museum Texts: Communication Frameworks* (2006) and *Analysing Academic Writing* (2004, with Robert A. Ellis).

Starfield, Sue

Sue Starfield is Director of the Learning Centre and Associate Professor in the School of Education at the University of New South Wales. She is co-author of *Thesis and Dissertation Writing in a Second Language: A Handbook for Supervisors* (2007) and co-editor with Brian Paltridge of the *Handbook of English for Specific Purposes* (2013), as well as co-editor of the journal *English for Specific Purposes*. Her main research interests are doctoral writing, academic literacy and writer identity.

Stock, Cheryl

Associate Professor Cheryl Stock, PhD, coordinates the Doctorate of Creative Industries at Queensland University of Technology, where she has also held the positions of Director of Postgraduate Studies and Head of Dance. Cheryl publishes in the fields of contemporary Australian and Asian dance, interdisciplinary collaboration, intercultural and site-specific performance, and research methodologies, with recent

publications centred around doctoral approaches in the creative industries. Founding Artistic Director of Dance North, Cheryl has created over 50 dance and theatre works and is a recipient of the Australian Dance Awards' Lifetime Achievement Award. In 2009 she was appointed World Dance Alliance Secretary General.

Thornley, Jeni

Dr Jeni Thornley is a documentary filmmaker, writer, film valuer and lecturer. She lectures in Issues in Documentary at University of Technology, Sydney focusing on the history of documentary, changing forms and ethics. Her distinctive poetic essay films, *Maidens, For Love or Money, To the Other Shore* and *Island Home Country* have screened widely both in Australia and internationally. She regularly writes about documentary film, contributing to *The Conversation, Metro Magazine, Realtime* and her own blog *Documentary.* She is currently developing an archival project, *Memory=Film,* based on her Super 8 collection and documentary films. Thornley's films are available online at beamafilm (http://www.beamafilm.com/).

Vincs, Robert

Rob Vincs currently teaches music improvisation at the Victorian College of the Arts. He is also the Research by Higher Degree Coordinator for the School of Contemporary Music at the VCA and the Chair of the Human Ethics Advisory Committee. Rob balances his research and academic work with his active life as a musician and composer with performances in the US, Europe and Asia. Rob's research and practice is grounded within the practice and theorisation of musical improvisation where he is currently establishing a research centre called the Network for Improvisation, Community and Applied Arts Practice.

Wallen, Lawrence

Dr Lawrence Wallen is Professor and Head of School of Design at the University of Technology, Sydney. A trained visual artist and architect, Lawrence Wallen's research and practice is concerned with the mapping of urban space in such a way that the complexity and shifting nature of such entitites is made visible.

Webb, Jen

Jen Webb is Professor of Creative Practice and Director of the Centre for Creative and Cultural Research at the University of Canberra. Jen has published widely in poetry, short fiction and scholarly works: her most recent book is *Understanding Foucault: A Critical Introduction* (Sage, 2012), and she is currently completing books on embodiment, art and human rights, and research for creative writers. Jen is co-editor of the Sage book series, Understanding Contemporary Culture, the journal *Axon: Creative Explorations* (www.axon.com.au) and the new AAWP literary journal, *Meniscus*. She is lead investigator on an ARC-funded project into poetry and creativity.

Wilson, Jenny

Jenny Wilson has worked as a senior administration manager in the Australian and UK university sector for over 20 years and is currently Major Commercial and Competitive Bid Developer in the Creative Industries Faculty, Queensland University of Technology. Prompted by observations of the challenges for artistic researchers posed by national and institutional research policies, she is currently completing a PhD on artists in the university research management environment through the Victorian College of the Arts and Centre for the Study of Higher Education at the University of Melbourne.

Wood Conroy, Diana

Diana Wood Conroy, BA (Hons) in Archaeology, University of Sydney; Doctor of Creative Arts (DCA), University of Wollongong. A tapestry weaver since the 1970s, her research combines archaeology (University of Sydney Paphos Theatre Excavation) and contemporary visual cultures in publications and exhibitions. The Distinguished Research Award from the Australian Council of University Art and Design Schools in 2005 marked her contribution across art and archaeology. Between 2010 and 2012 she co-ordinated the Senior Artists Research Forum for fast-track doctorates through seminars and fieldwork. She is Emeritus Professor of Visual Arts at the Faculty of Law Humanities and Arts, University of Wollongong, New South Wales, Australia.

INTRODUCTION

Louise Ravelli, Brian Paltridge, Sue Starfield

The doctoral thesis in the creative and performing arts poses significant challenges to universities, both for the institutions themselves which need to supervise and examine these theses, and for students who need to find a way to blend their creative practice with more conventional notions of research. This edited volume showcases collective experience across a range of sub-disciplines within these fields, providing a multi-faceted perspective on the core issues. It highlights an area of particular concern for twenty-first-century universities, as notions of 'research' broaden and evolve.

This volume sits exactly at the researcher–practitioner interface: these are creative artists who are engaging with academia, and must in some way meet its pre-set standards, while continuing to be true to their own. This in turn challenges the institutions themselves to adapt to and accommodate these new academic forms.

As explained in several chapters in this volume, the interest in these kinds of doctorates is the outcome of a number of years of institutional

change. In the UK, Australia and Canada, the doctoral thesis in the creative and performing arts began to appear in the late 1980s, as a consequence of system-wide structural change to the higher-education sector. As the doctoral thesis in these fields typically combines a creative work with a written component (often conventionally referred to as the 'exegesis'), it is very different in kind from theses in more established disciplines, which have a written component only. The combination of these two components raises many questions about the nature of research in these fields, posing many challenges for institutions in terms of preparing, supervising and examining doctoral students in these fields, and for students themselves in terms of integrating their creative practice with written research, raising further questions of both identity and capacity.

However, the doctoral thesis in these fields is no longer entirely new, and certain forms of 'stabilisation' can be seen, in institutions and in disciplines. One of the main aims of the volume is to ensure that current knowledge in the field is widely disseminated, so that all may move forward from a shared base. We thus see this volume as an opportunity to highlight the success of these fields, to share findings within and across disciplines, and to look forward optimistically to ways in which current knowledge and experience can be built upon.

Most importantly, this volume addresses the challenges of these doctoral theses from diverse perspectives. It combines the perspectives of students, examiners, supervisors and institutions to represent a range of responses to the issues. It addresses the challenges facing a range of disciplines, including the visual arts, design, music, film, scenography, dance, and theatre and performance studies, facilitating a shared understanding of challenges and approaches across disciplinary boundaries. In addition, it provides chapters which examine the doctoral theses in these fields as texts in themselves, providing unique insights into their forms and functions, as well as facilitating greater understanding of the nature of research in these disciplines.

The volume is divided into three parts. Part I, 'From the Outside: Institutional and Disciplinary Perspectives', addresses some of the ways in which these theses have been accommodated within the academy, and the challenges in terms of building research capacity in these fields. The volume

opens with a chapter by James Elkins, surveying the current state of doctoral degrees around the world. This sets the stage for the remaining chapters. Su Baker asks "what is the problem [with these kinds of theses]?", making us reflect that the issue is not so much a problem as an area both of interest and of potential, and ends on a strong call to arms for international dialogue, self-scrutiny (such as we are conducting here), and models of doctoral study appropriate to these disciplines. Baker's challenge is taken up by numerous subsequent chapters, firstly by Estelle Barrett, who argues for the subjectivity of artistic research to be a key *strength* of the field, rather than a problem, whereby aesthetic experience contributes in unique ways to praxical knowledge. In Buckley's chapter, we see a complement to Elkin's opening survey, whereby the complex position of the art school in relation to the academy is examined, across a range of international contexts. Bolt, MacNeill and Ednie-Brown provide a specific focus on ethics in relation to artistic research, drawing attention to the typical lack of fit between creative and regulatory practices. They note the significant ethical questions which may be posed by artistic research, and propose a solution based on positive elements within the field itself, that is, on emergent methodologies *as* a methodology for resolving ethical conundra. Questions of research training, already highlighted in preceding chapters, are addressed in further depth by Brien, Burr and Webb, who provide specific insights into the nature of the assessment of doctoral theses in the creative and performing arts. Together, these chapters add flesh to Elkin's opening survey, and begin to provide the answers to Baker's call to arms.

Part II, 'From Within: Student Perspectives and Experiences', gives voice to the student experience. We hear from students themselves – either in progress or with recently completed doctoral theses – as well as from the perspective of supervisors and research trainers. Students' experience is described in terms of their place within the academy, and highlights how they have resolved the tensions holding between the creative and written components of practice-based theses.

In the opening chapter of this section, Melissa Laird reflects on the processes and motivations of her doctoral thesis, providing a marvellous example of the intertwined nature of the written and creative components in these kinds of doctorates, whereby the two parts are

so interconnected that they can barely be distinguished. Jeni Thornley also reflects on the 'doubled form' of these doctorates, highlighting an alternative model whereby the writing comes *after* the creative work, and providing an example where the polyphony of the creative arts doctoral project is further intensified by specific cultural protocols. George Catsi's chapter provides a dramatic shift in voice, manifesting many of the features of creative practice doctoral writing which are elsewhere discussed, and underscoring the positives stated by Baker, in this case, that "no matter how much we explore and learn on the micro or macro, we are always left with mystery". A solution to some of the challenges faced by doctoral students is proposed by Annalea Beattie, who gives an account of a writing circle as a means of critique, inspiration and development of students' writing capacities. It exemplifies a way of harnessing the power and creativity of writing itself, while overcoming the roadblocks of reluctance and unfamiliarity. The experience of supervision is also drawn upon by Caroline Durré, who proposes a conceptual metaphor of allegory – the idea of parallel texts – as a way of allowing the candidate to be liberated in terms of research, while still operating within the constraints of the academy. The experiences and trajectories of the artist–student are further examined by Jenny Wilson, who explores the path they may then take as artist–academic, using survey and interview to highlight individual experiences. The final chapter in this section, by Thea Brejzek and Lawrence Wallen, returns to the broader institutional context, providing a detailed overview of the personal history behind the founding of a specific doctoral program in scenography, highlighting the important role that genuine, personal collaborations play in establishing new institutional beasts. Solutions are posed to the challenges of distance and isolation for students, and students' subsequent career paths are examined.

The final section, Part III, 'Reflecting: The Nature of the Doctoral Thesis – Researching, Writing, Thinking', specifically examines the doctoral thesis itself in the creative and performing arts, both the written component as a textual product, and the nature of research in these fields where creative and written components are combined. It highlights specific ways in which the written and creative components might be shaped, and their unique contributions to the overall doctoral project. Given the distinctive nature of the creative-practice doctorate, Ken Friedman asks

what must remain 'the same', that is, common to all doctorates, particularly in terms of the writing. He raises the question of tone and style, and compares training contexts around the world, pointing to important resources for developing basic research and writing skills, arguing that research is itself a discipline, as well as an art. In contrast, Anne-Marie Forbes asks not what is the same, but what is unique; in this case, to the discipline of music. Using models of previous theses, she makes numerous practical points about successfully supervising/navigating a creative-practice thesis in music, proposing a conceptual framework of the interrelations between the musical performance and the exegesis.

In turn, Maggi Phillips draws on her knowledge of dance to propose 'choreographies of thought' as a way of interrogating the relations between writing and knowledge. As with so many of the chapters in this volume, she provides a way for the imaginative to 'speak back' to the academy, providing confidence for those who might otherwise be treading 'unstable paths', for both students, supervisors and examiners. Dance is also the disciplinary background for Cheryl Stock, but she examines the nature of ephemeral performance more generally, and how embodiment can be seen to be a contribution to the process, outcome and findings of research. Diana Wood Conroy illuminates a practical response to the challenges of writing, drawing on multiple theoretical, philosophical, creative and experiential influences to enrich and structure the writing process. She highlights the lived experience of a group of senior artists embarking on their PhDs, and further explores the particular problem of explaining creative research as bearing original knowledge to the mainstream of academic research.

The final chapters in Part III all interrogate questions of voice and style, from various perspectives. A more formal voice is argued for in Sean Lowry's chapter, whose experience from a regional university in Australia points to the need for practical tools to guide inexperienced writers towards more polished products. Robert Vincs draws on Deleuzian frameworks to articulate a framework that gives shape to the ephemeral concept that is the multi-voiced exegesis. Such a thesis is described as 'connective' by Hamilton, who analyses the nature of polyvocality in writing and its specific role in unifying the multiple strands of creative-practice research. Ravelli, Paltridge and Starfield explore what might explain the

diversity of styles which arise in creative-practice PhDs, explaining this as a resource, and not a burden. Finally, Iain Biggs argues that good doctoral writing in creative and performing arts is inherently subversive – in relation to both the academy and to art – but that it must hide its subversion 'in plain sight'. Biggs describes how his philosophical understanding of the nature of the doctorate in this field has informed his management of the students and research community in his care, and how essential this community is to the student's negotiation of their place within this crossroads. He argues that these theses are central to cultural life, regardless of the particular disciplinary skills which they manifest.

Together, the chapters in this volume highlight several salient features of the doctoral thesis in the creative and performing arts: it is here to stay; it plays a significant role in the academy; it may take diverse forms in terms of its presentation; and it poses numerous challenges both for students/artists and for institutions, while also creating new opportunities for expression and the pursuit of knowledge. It is significant that so many, from so many different perspectives, wrestle with inflections of the same fundamental questions: how should we manage the clash of cultures, avoid constraining creativity, and equitably evaluate new modes of expression and new conceptions of the doctoral thesis genre? The resolutions are also various, ranging from practical writing strategies to complex models of allegory. In the creative and performing arts doctoral thesis, the nexus between researcher and practitioner is clearly emergent, allegorical, polyvocal and, above all, exciting.

The chapters in this volume reflect on the diversity of style, focus and process in doctoral writing in the creative and performing arts. At the same time, these chapters manifest the same diversity themselves. We hope you enjoy their breadth and scope, and are able to take something from them for your own engagements with these issues.

Acknowledgement

Many chapters in this volume were first presented at the symposium, Doctoral Writing in the Visual and Performing Arts: Challenges and Diversities, held at the Sydney College of the Arts (2011). We thank the Australian Research Council (ARC) for funds which supported this symposium.

Part I

From the Outside: Institutional and Disciplinary Perspectives

REMARKS ON THE STUDIO-ART PHD AROUND THE WORLD

James Elkins

For the USA, it is a potent fact that the creative-practice PhD in visual arts – what I call here the studio-art PhD – is in its infancy. Until very recently, the MFA has been the accepted terminal degree for artists/academics in the USA (Buckley 2009). Elsewhere around the world, the studio-art PhD may have a history of two to three decades – for example, in the UK, Japan, and Australia. What is evident is that the studio-art PhD is taught around the world. And yet, no single person has full knowledge of the diverse ways in which this degree is taught. There are over two hundred institutions that grant the degree, and the literature on the studio-art PhD degree has been growing rapidly. This is significant because it means that no one person can be sure that they are not rehearsing ideas that have been proposed elsewhere, and no-one can speak as an ultimate authority on the field.

Putting aside for the moment the scattered administrative literature on the degree produced in the UK and Japan since the early 1970s, the current explosion of literature can be traced to the twenty-first century.

The first books were, in order:

(1) An Irish publication I edited called *Printed Project* (Elkins 2004) which was the first book-length publication on this subject

(2) A collection called *Artistic Research* (2004), edited by Annette Balkema and Henk Slager

(3) Graeme Sullivan's *Art Practice as Research* (2005)

(4) Holdridge and Macleod's *Thinking Through Art* (2006), another edited volume

(5) A collection of essays on PhDs in Finland (Kaila 2006)

(6) Henk Borgdorff's *The Debate on Research in the Arts*[1]

(7) A volume edited by Lesley Duxbury et al., *Thinking Through Practice: Art as Research in the Academy* (2007)

(8) The first edition of *Artists with PhDs: On the new doctoral degree in studio art* (Elkins 2009).[2]

In the five years between the first and second editions of *Artists with PhDs: On the new doctoral degree in studio art* (Elkins 2009 and 2014), the literature has become inaccessibly vast. Henk Slager's journal *MaHKUzine, Journal of Artistic Research* (2006–) continues to appear; it is the first journal that consistently addresses research and the studio-art doctorate (http://www.artandeducation.net/announcement/mahkuzine-journal-of-artistic-research-first-lustrum/). The year 2010 saw the appearance of *Kunst und künstlerische Forschung / Art and Artistic Research*; the *Routledge Companion to Research in the Arts*; and e-flux's *A Prior* magazine on 'Art as Research', with essays by Victor Burgin and others.[3] The *Journal of Artistic Research* (2011–) is an online journal edited by Michael Schwab, which represents much of the Anglophone European scene. The year 2011 also saw the publication of Martin Tröndle and Julia Warmers' (2011) *Kunstforschung als ästhetische Wissenschaft: Beiträge zur transdisziplinären Hybridisierung von Wissenschaft und Kunst*; Henk Slager's *The Pleasure of Research* (2012); and a special issue of *Texte zur Kunst* on 'Artistic Research'. Then in 2012, Henk Slager published *The Pleasure of Research*; and Florian Dombois, Ute Meta Bauer, Claudia Mareis and Michael Schwab published their *Intellectual Birdhouse: Artistic Practice as Research*.

It is also no longer clear what literature belongs to this subject. *Art School (Propositions for the 21st Century)*, edited by Steven Henry Madoff

(2009), contains mainly contributions by artists, and seems unaware of the administrative and art education literature even in the United States. But the positions taken by Dennis Adams, Thierry de Duve, Shirin Neshat, Hans Haacke, Boris Groys, Liam Gillick, Saskia Bos, Steven Henry Madoff, Ernesto Pujol, Ute Meta Bauer, Paul Ramirez Jonas, Jeffrey Schnapp, Anton Vidokle, Matthew Higgs, Charles Renfro, Dana Schutz, and Brian Sholis can hardly be irrelevant to the development of the PhD. My own book *Art Critiques: A Guide* (Elkins 2011) was an attempt to cover critiques at the BFA, MFA, and PhD levels, but it became apparent that different kinds of conversations count as critiques in the PhD, and those conversations have only a tenuous connection to what art students know as 'crits'. The second edition of that book (Elkins 2012) sequesters the PhD as a separate topic, making a distinction that I think is crucial but problematic. Liora Bresler's *International Handbook of Research in Arts Education* (2007) contains some material pertinent to the visual arts degree. So does Elke Bippus's *Kunst des Forschens: Praxis eines ästhetischen Denkens* (2009); Estelle Barrett and Barbara Bolt's *Practice as Research: Approaches to creative arts enquiry* (2007); J. Knowles and Ardra Cole's *Handbook of the Arts in Qualitative Research* (2008); and *Practice-Led Research, Research-Led Practice in the Creative Arts*, edited by Hazel Smith and Roger Dean (2009). Once the net is widened to include the world of the doctorate in design, the literature is effectively endless. (Good starting points are Ilpo Koskinen et al., 2011, *Design Research through Practice: From the lab, field, and showroom*, and the long-running design listserv PhD-design.[4])

The disarray of the bibliography is easily demonstrated by the lack of overlap in bibliographies and invited authors. Groups and disciplinary interests are emerging, which is natural in any expanding subject: in this case it is possible to distinguish North American art education from European art education; theorists of 'research' in the studio context from theorists of 'research' in other university contexts; art historians from artists; administrators from philosophers. Those overlapping disciplinary allegiances aren't surprising: what concerns me is that the subject is divided principally because the literature is too large for anyone to assess what groups, positions and interests might be out there to be invited.

One of the common concerns in this literature is the nature of 'research' as it pertains to visual art; many writers are also concerned with what counts as 'knowledge' in visual art, and with ongoing critical issues such as the relation of political (non-aesthetic or anti-aesthetic) practices with aesthetic practices.

In the remainder of this chapter I want to point instead to more mundane issues that have to do with the structuring and implementation of existing PhD programs. There are as yet no books that can tell us how programs are structured, how requirements differ, or how assessments are conducted. Day-to-day things like that are crucial, I think, if we are going to understand the worldwide dissemination of the studio-art PhD. It is necessary to be able to compare programs at this level in order to judge the more conceptual issues such as 'research through knowledge', just because research, work, practice, teaching, and learning all take place in classrooms, studios, and seminars, which are parts of institutional structures that give expressions like 'research through art' meaning.

Length of the Programs

PhD programs vary widely in the number of years required for completion. Most programs ask for three years, but a number also require four, and some have only two. The University of Lisbon is among those that require two years. (Some of their curriculum is reproduced below.) Goldsmiths College requires "3–4 years full-time or 4–6 years part-time". The University of California San Diego and Newcastle University in the UK require four years. At York University in Canada the dissertation is required by the 14th semester (which occurs in the 5th year).

These variations have consequences in the EU, where the Bologna Accords calls for a standard three-year third-level education. In the US, doctoral programs in general require two years of residency (taught classes) and no more than five years to completion. There is no necessity to create international conformity, but it would be interesting if PhD programs justified their individual choices.

Supervisors

Usually studio-art PhD students in the USA have two supervisors/principal teachers, with whom the student works throughout their PhD. Typically one is a studio-art instructor and the other is a scholar – usually an art historian, critic, cultural theorist, or philosopher, and sometimes a sociologist, anthropologist, or historian; rarely a scientist, engineer, or lawyer. Often, however, studio-art faculty supervises both the art practice and the research; and in some cases, the principal supervisor helps with both the practice and the art practice. I call the configuration where a non-art practitioner (usually a scholar) collaborates with a studio-art instructor *heterogeneous* and the configuration where both supervisors are art instructors, *homogeneous*. The former is interdisciplinary, and can draw on the contrast between scholarship and practice; the latter is susceptible to a kind of collapse in which a student's video supervisor, for example, might also be the one assisting the student in researching the history of video art. This is not to say studio-art instructors might not be competent researchers, historians, or critics: it's to say that there is great potential in the dialectic exchange between disciplines.

Elsewhere, the supervisory configurations may be entirely different, and systematic study is called for, especially in terms of how the different components of the thesis are addressed.

In some American universities it is the practice to have three readers or supervisors as the student's examiner; often one works outside the institution. In smaller countries, the third or outside reader or supervisor is typically from a neighbouring country; that is a marked difference from larger first-world countries, where the third reader is more likely to be from a more culturally or geographically distant country. This is another subject that needs to be documented in studio-art PhD programs, especially in smaller institutions and countries.

Most of the literature on the PhD is not concerned with these issues. What matters is rather the quality of the supervisors. Michael Biggs, Stephen Scrivener, and others host a useful website on practice-based PhD supervision, which lists a number of books and articles on the subject (ualscopingphd.wordpress.com). There is a useful article by

Stuart Powell and Howard Green, 'Quality Matters in Doctoral Supervision: A Critique of Current Issues within the UK in a Worldwide Context' (www.bangor.ac.uk/adu/docs/QualityMattersInDoctoralSupervision. pdf). They compare standards in China, Denmark, India, and France; their note about Australian supervision is representative: "In Australia," they write, "the principal supervisor should have: expertise in the field of study, hold a doctoral qualification or equivalent, be 'research active' in a relevant discipline or disciplines, have sufficient time and resources to provide a quality learning experience for the candidate, and have training and/or experience in the supervisory process." Of these criteria, the two most contentious are the idea that the supervisor should "hold a doctoral qualification or equivalent," and the requirement that the supervisor "have training and/or experience in the supervisory process". In my experience, supervisors generally have 'experience' but not 'training'. The first point varies widely around the world. I have had letters from people in Malaysia, Poland, Uganda, and Kenya reporting cases where instructors with MFAs were asked or required to take leaves of absence to get PhDs. It has increasingly become the case in countries such as the UK and Australia that the PhD rather than the MFA is required for an academic appointment, a trend that seems to be continuing in some other countries as well. Notwithstanding, if my small sample of correspondence is significant, it indicates that the requirement that instructors have PhDs may still be unevenly distributed worldwide – and that may well also produce problems for academic exchange.

So far I have mentioned four issues to do with supervision: the practice of having studio-art practitioners supervise the research component of the doctorate; the varying numbers and roles of supervisors; the training or experience supervisors should have; and the requirement that supervisors themselves possess PhDs.

Length of the Dissertation

The length of the dissertation varies. Here are some examples:

- 0 words = 0 pp. = this was attempted at Plymouth University (see further below)

- 15,000 words = 60 pp. = minimum at the University of Leeds (as of 2012)
- 20,000 words = 80 pp. = the usual minimum (e.g. at Queensland University of Technology)
- 25,000 words = 100 pp. = minimum at the University of York in Canada (given in pages)
- 30,000 words = 120 pp. = Newcastle University, UK (2012)
- 50,000 words = 200 pp. = maximum at the University of Leeds (2012)
- 60,000 words = 240 pp. = the norm (e.g. Slade School of Fine Art, University College London)
- 80,000 words = 320 pp. = length of a typical dissertation in the UK system
- 100,000 words = 400 pp. = the maximum for most institutions

While there is no need to standardise lengths of studio-art PhD dissertations, it would be useful to have more comparative material because some programs require substantially less than others, resulting in a wide disparity in the scholarship.

Dissertation length in East Asian countries is harder to calculate because of the writing systems involved. At Tokyo Geidai (Tokyo University of the Arts; Tokyo Geijutsu Diagaku), the dissertations are printed at 750 characters per page. If we assume a printed dissertation in the US is 250 words per page, and Japanese character count is three times the equivalent English word count (this is a standard conversion, but there are others), then Tokyo Geidai dissertations could be counted this way: 200,000 characters = 66,000 words = 250 pages. But the conversion is full of approximations.

Weighting

Weighting is the term for the emphasis placed on the practice, relative to the written dissertation. Should the art practice count as the majority of the doctorate, because the students are primarily artists? Or should the dissertation be equal to the art, as a sign of the hybrid nature of the new degree?

Typically weighting is done in percentages. Thus the 2010 Postgraduate Research Student Handbook of the Creative Industries Faculty, Queensland University of Technology, states that "the weighting for the practice component shall be between 40% and 75% of the whole study". Weighting percentages vary, but I have not collected them because they all beg a crucial question: they make it appear as if the art practice can be quantified at all, simply by comparing it with an ostensibly quantifiable outcome (the dissertation). So far I haven't found literature that makes sense of this.

Presence of a Research Component

I noted above that Plymouth University experimented with dropping the written requirement. Their reasoning was interesting: the implicit claim was that no other subject in the University requires two bodies of work from its doctoral candidates. The problem, of course, is that without a written component it becomes even more necessary to say what a PhD-level art exhibition is, in contrast to an MA- or MFA-level exhibition. (It could also be argued, against the original rationale, that PhD candidates in the sciences also produce two bodies of work: their written dissertation and their experimental work.) This issue is discussed further in Elkins (2009/2014).

Varied Curricula

The actual semester-by-semester or term-by-term sequence of modules, classes, studios, and seminars is largely a matter of each individual institution. So far there has been very little comparative work on the subject. In some countries, such as Australia, there may be no requirement to engage in formal classes at all. Figure 1.1 is shown as an example of the reasons this might be of interest; it shows the curriculum for the Faculty of Fine Arts at the University of Lisbon, as of 2012. It is a two-year curriculum:

Figure 1.1 shows the first semester of the first year. T = theory, P = practice, and OT = tutorial. Figure 1.2 shows the curriculum for the second semester.

Faculdade de Belas-Artes
UNIVERSIDADE DE LISBOA

PLANO DE ESTUDOS

1º ANO / 1º SEMESTRE

| UNIDADES CURRICULARES | ÁREA CIENTÍFICA | TIPO | TEMPO DE TRABALHO (HORAS) | | CRÉDITOS | OBSERVAÇÕES |
			TOTAL	CONTACTO		
(1)	(2)	(3)	(4)	(5)	(6)	(7)
Seminário Belas-Artes I	BA	Semestral	420	TP 100 + OT 70	15	Obrigatório
Seminário de Especialidades I *	BA-ESP	Semestral	420	(TP) ou (T) 80 + OT 90	15	Obrigatório

*Opcional: o Conselho Científico da FBAUL divulgará anualmente o elenco de seminários optativos das especialidades. Os 15 créditos são atribuídos a uma especialidade escolhida.

Figure 1.1

Doctoral curriculum for first semester of the Faculty of Fine Arts at the University of Lisbon

1º ANO / 2º SEMESTRE

| UNIDADES CURRICULARES | ÁREA CIENTÍFICA | TIPO | TEMPO DE TRABALHO (HORAS) | | CRÉDITOS | OBSERVAÇÕES |
			TOTAL	CONTACTO		
(1)	(2)	(3)	(4)	(5)	(6)	(7)
Seminário Belas-Artes II	BA	Semestral	280	TP 80 + OT 70	10	Obrigatório
Seminário de Especialidades II *	BA-ESP	Semestral	280	(TP) ou (T) 80 + OT 70	10	Obrigatório
Seminário de Investigação Orientada **	BA	Semestral	280	TP 70 + P 80	10	Obrigatório

*Seminário de Especialidades I e II: o Conselho Científico da FBAUL divulgará anualmente o elenco das especialidades.

**O Seminário de Investigação Orientada dependerá da especialidade de doutoramento que o aluno venha a seguir.

Legendas: TP – Teórico-Prático; P – Prático; OT – Orientação Tutorial; T – Teórico

Figure 1.2

Doctoral curriculum for second semester of the Faculty of Fine Arts at the University of Lisbon

This curriculum includes two seminars, with an additional 'Oriented Research Seminar'. The second year (the curriculum for which is not reproduced here) is dedicated to seminars and the preparation of the dissertation. The next step in this kind of inquiry would be to assemble syllabi and reading lists. I hope that in future a conference, or an edited volume, might be devoted to this kind of basic fact gathering. Without it, the actual contents and structures of the PhD will remain largely unknown to people who do not work at the institutions.

This list is a miscellany, and many issues could be added to it. I have only tried to emphasise a low-level problem: in the rapid expansion of philosophic, sociological, and art-education literature it can seem as if philosophic problems to do with such things as 'research through art' or the 'production of knowledge' are the most important, and in the end they may be. But before we have a solid grasp on *how* the doctorate is actually taught around the world, we won't have a framework to which such discussions can be attached.

PhD Listings

The first step in developing such an understanding is to identify *where* studio-art PhD programs are being offered – and to keep track of ongoing changes.

I have attempted to collate a list of institutions around the world which offer PhD programs in studio art, as published in Elkins (2009/2014).[5] It is the first such listing of PhD programs around the world that I know of. Here, rather than the actual list itself, I present some of the issues that have arisen in collating that list.

Most importantly, it is not possible to produce one, definitive and complete list, for at least seven reasons: there is no international listing body; the listings for some regions, including the EU, include programs that aren't up and running; some programs are on 'soft start' or accept less than one student per year on average; some are being reorganised so that studio-art practices aren't required; some programs are on hiatus, or are suspended; some are in the last stages before implementation; and, most importantly, there are endemic problems in communication

on this subject. Even within a given country, such as Canada, it can be rare to find someone who knows with certainty how many programs there are.

Nevertheless, attempting to provide such a list reveals lacunae and overlaps, and provides a starting point for the collation and comparison of relevant materials (institutional criteria, curricula, supervisory and examination practices, and so on). Importantly, it serves as a springboard for further discussions.

The EU, Except for the United Kingdom

The main source for the PhD degrees in Europe is ELIA, the European League of Institutes of the Arts (elia-artschools.org). Figure 1.3 indicates the density of the distribution.

ELIA has a worldwide membership, but most of this is concentrated in Europe. (The screenshot shown in Figure 1.3 is as of March 2013. The

Figure 1.3

ELIA members, Europe

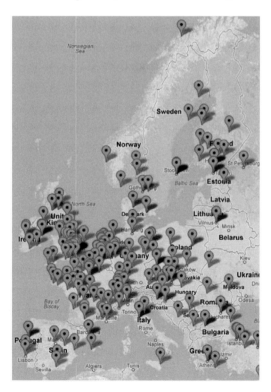

Art Academy in Tromsø is the one in the far north, and the European University of Cyprus is the one I have arbitrarily cut off at the bottom.) Within this larger listing, the SHARE network (Step-Change for Higher Arts Research and Education; see http://www.elia-artschools. org/activities/share) offers a listing of third-level (graduate, or in UK usage 'postgraduate') institutions involved in studio art. As of March 2013, thirty-three institutions were listed; unfortunately a number of those had not yet implemented the degree. (For example, the Academy of Fine Arts and Design Bratislava did not have visual art students in 2012, and the University of Malta, Department of Arts and Languages in Education was only contemplating the PhD, even though it was listed, and in talks with SHARE members.) There is still no reliable online listing of currently active PhD-granting institutions in the EU.

A third organisation in the EU is EARN (European Art Research Network, artresearch.eu). This is a group of ten institutions. Their website cleverly turns Europe on its side, as in a medieval map – see Figure 1.4.

These institutions vary widely in size and structure. GradCAM (Graduate School of Creative Arts and Media) at the Dublin Institute of Technology, founded by Mick Wilson (a contributor to Elkins 2009/2014, and currently based in Gothenburg) takes 10–15 students per year (see www.Gradcam.it). The University of Leeds may be the oldest of the group; they awarded their first PhD in 1998. The degree was introduced there by Adrian Rifkin, and Griselda Pollock wrote the original specifications; they are both art historians, not practitioners. As of autumn 2012, there were approximately 12 students in the program. Another contributor to Elkins (2009/2014), Henk Slager, is central to the MaKHU in Utrecht: the one-year Master programme of the Utrecht Graduate School of Visual Art and Design. As already mentioned, Slager also publishes the MaHKUzine, one of the most visible publications in the field. The Università *Iuav* di *Venezia* in Venice has a fairly large program; it accepts about 20–25 visual art students per year; in 2012 it had 80 students on campus. The Malmö Art Academy at Lund University, Sweden, is a smaller program; in 2011 it had five artists and one curator as students.

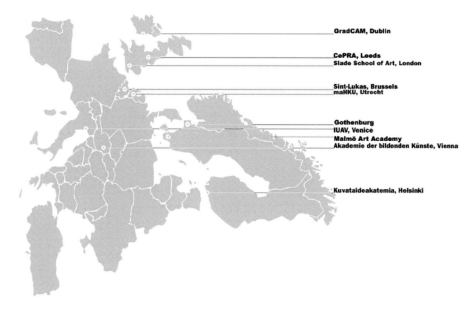

GradCAM, Dublin

CePRA, Leeds
Slade School of Art, London

Sint-Lukas, Brussels
maHKU, Utrecht

Gothenburg
IUAV, Venice
Malmö Art Academy
Akademie der bildenden Künste, Vienna

Kuvataideakatemia, Helsinki

Figure 1.4

EARN (European Art Research
Network) membership map

Outside the EARN network, the picture in Continental Europe is even more diverse. The Aalto University School of Art, Design and Architecture in Finland (*taik.aalto.fi/en/*) is one of the largest. Their first DA (Doctor of Arts) was granted in 1998, in photography. As of spring 2012, there were about 250 students aiming at the DA degree. By December 2011, 96 DAs had been awarded.

There are large lacunae in PhD offerings in Continental Europe. As of fall 2012, France had not yet implemented any PhDs in this area. This is sometimes contested, but it is technically true: PhDs in studio art have been available, and arguably Roland Barthes was the first to approve one in 1979; but institutionally, the consortium that would award PhDs to studio artists had not yet been formed as this chapter was being prepared.

Other gaps have to do with how academic conferences are organised. Given the current activity in Scandinavia and north-western Europe, other regions may sometimes be ignored. Among the larger European programs, one that is often bypassed in conversations is the National University of the Arts Bucharest (Universitatea Nationala de Arte Bucuresti; *www.unarte.org*) which had 45 students as of fall 2011.

With the growing number of institutions that grant the PhD, there will doubtless be more communication between countries and institutions; but it is symptomatic that even within Continental Europe institutions frequently develop their own concepts, curricula, and requirements without broad comparisons. Despite the Bologna Accords and the Tuning Documents (administrative initiatives in the EU aimed at standardising education in different countries), PhD programs differ widely across the EU.

The PhD course in the Faculty of Fine Arts of the University of Lisbon (Universidade de Lisboa, *www.fba.ul.pt),* for example, is a large program: it accepted 67 applicants in its first year (2009), 26 in 2010, and 36 in 2011.[6] Students attend a two-year course and have a final year to complete their dissertation. The Faculty of Fine Arts offers an unusually wide range of specialisations: Audiovisuals, Multimedia, Image Theory, Photography, Painting, Sculpture, Public Art, Installation, Artistic Anatomy, Geometry, Drawing, Equipment Design, Communication Design, Science of Art, and Art Education. It would be interesting to compare this organisation with other comparably-sized institutions.

Institutions in the EU also vary widely in size and scope. Smaller countries necessarily have smaller programs; some countries, and some programs, specialise, offering particular kinds of education, but others do not. In Ireland, for example, five institutions offer the PhD: GradCAM (the Graduate School of Creative Arts and Media Research) (as noted), National University of Ireland, Galway (*www.nuigalway.ie);* the Crawford College of Art and Design at the Cork Institute of Technology (formerly the School of Art, *www.cit.ie/aboutcit/.../citcrawfordcollegeofartand-desi1);* the little-known Warnborough College, Dublin (a low-residency initiative; http://www.warnborough.ie); the Waterford Institute of Technology (*www.wit.ie/);* and the Burren College of Art (*www.burrencollege.*

ie/). Each program is small: NUI Galway (the National University of Ireland, Galway) and the Crawford College of Art and Design each accept one to five students per year; the Waterford Institute of Technology takes a student per year; and the Burren College of art awarded its first PhD in 2012. Of these, only GradCAM and the Burren College of Art have established their visible emphases and profiles. In other countries, such as the Netherlands, there are more institutions with particular 'flavours' and specialisations. It is not yet clear whether the trend is toward individuation or multiplication.

The United Kingdom

The UK requires a separate treatment from the rest of the EU because it developed the studio-art PhD earlier than the Continent, and under different conditions. There are 157 'recognised bodies' with full title and degree-granting capacities that could in theory award the studio-art PhD. Again there is no official, up-to-date source; a good option is to search on prospects.ac.uk, using limiting search terms such as 'full-time' and 'practice'. The UK produces large numbers of PhDs; Figure 1.5 shows data from 2010–11, taken from hesa.ac.uk.

It bears noting, in the context of an international survey, that the official literature of UK programs (on their websites, and in their promotional material) frequently refers to 'research' and 'knowledge' as defining points. This happens, I think, more consistently and frequently in UK programs than elsewhere in the world. The University of Reading, for example, offers a 'Research Platform' in association with the Zürich University of the Arts; Reading's program stresses rigour and learning outcomes. In 2013 Newcastle University's website noted that "in the recent national UK 'Research Assessment Exercise' 85% of our research was rated 'internationally excellent' or better". The University of the Arts, London (a consortium including Camberwell, Chelsea and Wimbledon Colleges) advertises "rigorous... critical examination," resulting in "learning outcomes" including the communication of "new knowledge". Like several other institutions, the Royal College of Art offers a specialised Research Methods Course "to prepare MPhil and PhD students for research at a higher level". At the Glasgow School of Art, "Research Degree Students attend a one-year training program...

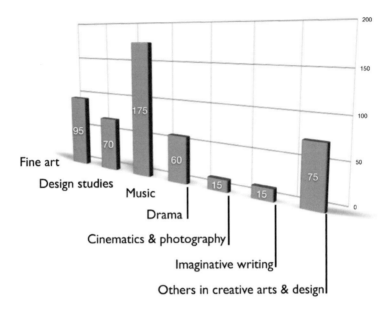

Figure 1.5

Creative-practice PhDs in UK
by specialisation

aimed at equipping them with high level research skills." There are some
exceptions; the Goldsmiths' College, University of London, literature for
example does not stress research. But in general the UK advertises for
students by emphasising rigorous, high-level research.

Australia

In 2007, there were 29 institutions in Australia where students were
enrolled in creative arts doctorates, a total of 1,230 full-time equiva-
lent students (creativeartsphd.com). In 2008, this rose to 1,779 students
(Paltridge et al. 2012a). A good source is the 2009 project report *Crea-
tiveArtsPhD: Future-Proofing the Creative Arts in Higher Education* (Baker
& Buckley 2009) as well as the work by Paltridge, Starfield and Ravelli in
this area (see e.g. Paltridge et al. 2011, 2012a, 2012b; Starfield et al. 2012;
Ravelli et al. 2013). The Future-Proofing project reports that the earliest
program was the University of Wollongong, which offered the doctorate

in 1984, followed in 1989 by La Trobe University and the University of Western Australia (but see Paltridge et al. 2011 for another possible one in 1987). The dates there indicate a gap of about a decade from the programs' inception in the UK to their adoption in Australia, the latter spurred along by the Dawkins reforms (see again Baker & Buckley 2009, and other chapters in this volume).

Judged on a worldwide scale, the number of graduates at Australian universities is very high. It is probably larger than the graduates from EU universities and academies outside the UK, and it is an order of magnitude greater than the number of graduates from the Americas or Japan. Even without refining these numbers, it is clear the international job market is more or less balanced between Europe (including the UK) and Australia – a fact that has consequences for future conversations about the administrative, conceptual, and economic features of the PhD. Clearly, the many chapters in this volume deriving from the Australian context attest to the strength of the programs there.

Canada

Canada has six studio-art PhD programs, with the same caveats about programs that currently aren't accepting students, have been suspended, or are being contemplated. One of these is at Concordia University in Montréal. They have three 'Research-Creation PhDs'; one is Communications; the Humanities PhD takes approximately one or two students per year. The Faculty of Fine Arts at Concordia doesn't have a specific PhD; artists have enrolled instead in the Communications PhD.[7] The University of Calgary's program started in 2009; as of fall 2012 one student had completed and three more were enrolled. The program is mainly theory based.[8] The others are the Université du Québec à Montréal (UQAM) Doctorat en Études et Pratiques des Arts; York University, outside Toronto; the University of Western Ontario Department of Visual Arts, which accepted its first students in 2007 and had its first graduates in 2011; and Ryerson University in Toronto, which began developing its program in 2006. Most of the Canadian institutions known for their MFA programs, such as the Emily Carr University of Art and Design in Vancouver and the Nova Scotia College of Art and Design in Halifax, Nova Scotia (NSCAD), do not yet offer PhDs, but several are contemplating the degree.

The United States

The United States has six studio-art PhD programs. Rensselaer Poly-technic (founded 2006) in Troy, New York, is an interesting program; it combines high technology with politically engaged practices. The University of California, San Diego, commenced its studio-art PhD in 2008, and admits two students per year from a pool of about 50 appli-cants. As of spring 2012, there were two students scheduled to take their qualifying exams, but no thesis proposals. Six students were enrolled in the practice-based portion of the program.[9] The low-residency Insti-tute for Doctoral Studies in the Visual Arts (IDSVA; http://idsva.org) is the only program in the world in which students do not show work or receive studio critiques – it is theory only. The University of California at Santa Cruz has a program that began in 2010; as of spring 2012 they had seven students, and were aiming for a total of 30. The PhD program at the Santa Cruz Center for Visual and Performance Studies is currently discontinued.[10] The University of California Davis has a four-year Perfor-mance Studies PhD; its designated emphases include Critical Theory, and Feminist Theory and Research. Texas Tech University in Lubbock began its program in 1974, more than 30 years before its other five programs; it has an 'artistic practice' track, but is mainly research. It aims to admit two to four students per year.[11]

Of these six institutions, several have distinct flavours. IDSVA has no rivals for what it does; it has a fixed curriculum of theoretical and philosophic texts that are intended to inform any artist's practice. Because the Director, George Smith, has a background in literary criticism, the IDSVA has had a roster of prominent guest lecturers outside of the visual art world. Santa Cruz has a strong program in North-American-style visual studies, which also involves gender theory, postcolonial studies, and anthropology. Rens-selaer Polytechnic is one of the United States' leading technical universities (alongside Georgia Tech), and the nearby State University of New York at Albany houses one of the world's largest nanotechnology laboratories; so students at Rensselaer have a unique combination of political theory, activism, and science. The University of California San Diego is the home of Helen Mayer and Newton Harrison, who have been actively engaged in developing a new, environmentally focused PhD. (As of this writing, the program has not yet been implemented.)

Those six programs are the ones currently accepting studio-art PhD students as of winter 2013. A number of others are either about to begin, are on hiatus, or have been terminated. The early date of Texas Tech's program shows it is one of at least four programs that began in the 1970s, apparently – although this hasn't been verified – independently of the doctoral programs that were starting in the UK and Japan at the same time. At one point NYU had such a program, and so did Virginia Commonwealth. Currently VCU is not running a studio-art PhD. "The program attracts students who come from a studio background," according to Jack Risley, "and some have made work that straddles the line between art, and text, but in the end it is not a studio-based degree." (Letter, May 10, 2012.) The history of these and other early programs in the US has yet to be written.

Among the institutions currently contemplating the PhD are my own, the School of the Art Institute of Chicago (SAIC); the School of the Visual Arts in New York City (SVA); the Rhode Island School of Design (RISD); Maryland Institute College of Art, Baltimore (MICA); and Parsons The New School for Design. Most of these are yet to be consolidated.

Latin America

Information on programs in Latin America has been difficult to locate, but it seems that studio-art PhDs are offered at least the following institutions: USP (Universidade de São Paulo, Sao Paulo's main federal university); UFRJ (Universidade Federal do Rio de Janeiro, the city's main federal university); Unicamp (Universidade Estadual de Campinas, in the state of Sao Paulo); UFMG (Universidade Federal de Minais Gerais); UnB (Universidade de Brasilia); UFRGS (Universidade Federal do Rio Grande do Sul) (unverified); UNAM (Universidad Nacion al Autónoma de México, Mexico City).

China

There are only three PhD-granting programs in studio art in China, although numerous institutions are contemplating the degree. So far there is nothing comparable to the drive, in China, for expanded curatorial programs and positions (50 new provincial museums are planned for the next decade) or for international exchanges in history of art, theory,

and criticism (which have generated at least one conference every year for the past five years). The question at the moment is where China will get the models for expanding its studio-art PhD offerings. In the last few years I have been working on a complete list of art history, theory, and criticism books translated into Chinese; the overwhelming majority of titles translated since the 1990s are from North America; the overwhelming majority translated before then are UK titles. It is to be hoped that as the SHARE network (Step-Change for Higher Arts Research and Education) and other groups increase their contacts in China, Chinese administrators will be able to choose from a wide spectrum of literature and potential models. As of this writing, however, none of the books or principal essays on the PhD has been translated into Chinese.

Japan

One of the main surprises of this research, for me, was 'discovering', in 2010, that Japan has 26 universities that grant the studio-art PhD. Most take their cues from Tokyo Geidai, the principal institution; but there is so far no history of the Japanese institutions. In 2012, Geidai formulated an extensive position paper in English and Japanese, which is evoked in the summary that was written for Elkins (2014).

Africa

As far as I know there are five currently operating studio-art PhD programs in Africa: Kenyatta University in Kenya[12]; the University of Cape Town; the University of the Witwatersrand in Johannesburg; the University of the Free State in Bloemfontein; and Kwame Nkrumah University of Science and Technology (KNUST), Kumasi, Ghana. The last one is a small program; they have one PhD graduate so far.

The infancy of the studio-art PhD, the burgeoning literature in the field, and the varied programs all around the world together point to the significant need to examine, document, and critique this degree and the institutional practices that surround it. While I have focused here on the visual arts, other creative and performing arts, as well as design, face the same challenges. This edited volume, of which this chapter is just one part, is an important and timely contribution to the field.

Acknowledgement

This chapter is reproduced, and slightly adapted, with permission from Elkins (2014).

References

Baker, S., & Buckley, B. (2009) *CreativeArtsPhd: Future-proofing the Creative Arts in Higher Education* Strawberry Hills, NSW: Australian Learning and Teaching Council.

Retrieved from: http://www.olt.gov.au/resources?text=Creative+Arts+Phd

Balkema, A., & Slager, H. (eds) (2004) *Artistic Research.* Amsterdam: Rodopi.

Barrett, E., & Bolt, B. (2007) *Practice as Research: Approaches to creative arts enquiry.* London and New York: I.B. Tauris.

Bippus, E. (2009) *Kunst des Forschens: Praxis eines ästhetischen Denkens.* Berlin: Diaphanes.

Bresler, L. (ed.) (2007) *International Handbook of Research in Arts Education.* Dordrecht: Springer.

Buckley, B. (2009) What is with the glass ceiling! The artist, higher degrees, and research in the university art school. In B. Buckley & J. Conomos (eds), *Rethinking the Contemporary Art School.* (pp. 76–86). Halifax: The Press of the Nova Scotia College.

Dombois, U., Bauer, M., Mareis, C., & Schwab, M. (eds) (2012) *Intellectual Birdhouse: Artistic practice as research.* London: Koenig Books.

Duxbury, L., Grierson, E., & Waite, D. (eds) (2007) *Thinking Through Practice: Art as research in the academy.* Melbourne: RMIT Publishing.

Elkins, J. (ed.) (2004) *Printed Project 04: The new PhD in studio art* Dublin: Sculptors' Society of Ireland. Retrieved from: http://www.docstoc.com/docs/13460127/Printed-Project-4-%E2%80%98The-New-PhD-in-Studio-Art%E2%80%99-James-Elkins

Elkins, J. (ed.) (2014 [2009]) *Artists with PhDs: On the new doctoral degree in studio art.* Washington: New Academia Publishing.

Elkins, J. (2012 [2011]) *Art Critiques: A Guide.* Washington: New Academia Publishing.

Holdridge, L., & Macleod, K. (eds) (2006) *Thinking Through Art: Reflections on art as research.* New York: Routledge.

Kaila, J. (ed.) (2006) *The Artist's Knowledge: Research at the Finnish Academy of Fine Arts.* Helsinki: Finnish Academy of Fine Arts.

Knowles, J., & Cole, A. (eds) (2008) *Handbook of the Arts in Qualitative Research: Perspectives, methodologies, examples, and issues.* Thousand Oaks: Sage.

Koskinen, I., Zimmerman, J., Binder, T., Redström, J., & Wensveen, S. (eds) (2011) *Design Research through Practice: From the lab, field, and showroom.* Waltham, MA: Morgan Kaufman.

Madoff, S. (ed.) (2009) *Art School (Propositions for the 21st Century).* Cambridge, MA: MIT Press.

Paltridge, B., Starfield, S., Ravelli, L., & Nicholson, S. (2011) Doctoral writing in the visual and performing arts: issues and debates. *International Journal of Art and Design Education* 30, 242–255.

Paltridge, B., Starfield, S., Ravelli, L., & Tuckwell, K. (2012a) Change and stability: examining the macrostructures of doctoral theses in the visual and performing arts. *Journal of English for Academic Purposes* 11, 332–334.

Paltridge, B., Starfield, S., Ravelli, L., Nicholson, S., & Tuckwell, K. (2012b) Doctoral writing in the visual and performing arts: two ends of a continuum. *Studies in Higher Education* 37 (8), 989–1,003.

Ravelli, L., Paltridge, B., & Starfield, S. (2013) Extending the notion of text: the creative arts doctoral thesis. *Visual Communication* 12 (4), 395–422.

Slager, H. (2012) *The Pleasure of Research.* Finnish Academy of Fine Arts.

Smith, H., & Dean, R. (eds) (2009) *Practice-led Research, Research-led Practice in the Creative Arts.* Edinburgh: Edinburgh University Press.

Starfield, S., Paltridge, B., & Ravelli, L. (2012) Why do we have to write?: Practice-based theses in the visual and performing arts and the place of writing. In V.K. Bhatia, C. Berkenkotter and M. Gotti (eds), *Insights into Academic Genres* (pp. 169–190). Bern: Peter Lang.

Sullivan, G. (2005) *Art Practice as Research: Inquiry in the visual arts.* London: Sage.

Tröndle, M., & Warmers, J. (2011) *Kunstforschung als ästhetische Wissenschaft: beiträge zur transdisziplinären Hybridisierung von Wissenschaft und Kunst.* Berlin: Transcript.

Notes

1. Available at: tinyurl.com/d39gdhx, or via www.khib.no
2. This is not counting *Practice-based PhD in the Creative and Performing Arts and Design,* edited by Hilde Van Gelder, e-publication (CD ROM), proceedings of an international conference on the subject at STUK, Leuven (10 September 2004); see Van Gelder and Baetens's chapter in Elkins (2014).
3. www.e-flux.com/announcements/20-the-research-issue.
4. blog.gmane.org/gmane.comp.hci.phd-design.
5. I am trying to keep this list up to date, so please email me (via the website www.jameselkins.com or at jelkins@saic.edu) with additions. Please don't send rumours; only let me know if you've actually visited an institution. If you disseminate this list, please keep these paragraphs with the file, so

that I can get corrections and additions.

Even though they can be read in a matter of minutes, lists like this take a long time to create. I owe thanks to many people, and especially everyone on Facebook who made corrections and additions in spring and summer 2012, and to many colleagues and staff in ELIA, the CAA, AICAD, and other organisations for their help.

6 Thanks to Joana Cunha Leal for this information.

7 Thanks to Natalie Loveless and Haidee Wasson, September 2012.

8 Thanks to Paul Woodrow, May 16, 2012.

9 Thanks to Jack Greenstein, May 10, 2012.

10 Thanks to Irene Gustafson and Jenna Purcell, May 2012.

11 Thanks to Connie Cortez, May 8, 2012.

12 Thanks to Elizabeth Orchardson Mazrui, May 7, 2012.

COLLEGIAL CONVERSATIONS: THE ROLE OF WRITING IN CREATIVE ARTS DOCTORAL EDUCATION

Su Baker

Artistic research... distinguishes itself in specific respects from each of these research traditions, whereby neither the natural science model, the humanities model, nor the social science model can serve as a benchmark for artistic research. By virtue of its distinctive context, its studio-based research practice, the specific types of knowledge and understanding it deals with, artistic research occupies its own place in the realm of academic research. This makes artistic research an open undertaking, seeking the deliberate articulation of unfinished thinking in and through art.

(Borgdorff 2012, p. 45)

This chapter discusses questions about the quality and status of dissertation writing in the creative arts doctoral degree. What seems to be the problem? Is it a question about the relative quality and styles of the writing that often accompanies the creative work submission that is of greatest concern? Or is it, rather, the understanding of methodological

issues in artistic research itself? In artistic research outcomes, often embodied in artefacts or performances, the thesis – that is, the proposition being tested by the work itself – includes the dissertation as the scholarly articulation of this, providing context and argument. Is it this new method of framing the 'thesis' and its subsequent articulation that has created this interest? In most cases the 'thesis' is described as being the creative and written components together, as in the central argument of the research proposition.

Artists have been writing over the centuries and have demonstrated an inbuilt method of enquiry at work including, for example, the historic significance of the journals and letters of Eugene Delacroix and Leonardo da Vinci's notebooks, well documented in many places. There is an increasing literature in this area, from collections such as Susanne K. Langer's (1958) *Reflections on Art: A source book of writings by artists, critics, and philosophers* to the more recent *The Writing Artist* by Alberro and Stimson (2009) and many more contemporary discussions in the context of the artist/researcher.

It may be important to declare a position here. While acknowledging the different intelligences and modes of address that artists possess and utilise, if the doctoral candidates understand their field adequately – that is, if they know the literature, the context, relevant critical and historical material – and understand where their project is located in relation to that, they are in a good position to find the gap in that field, just as any research project would, and indeed, as all good advanced art does. This is likely to produce something good. Both the creative work and the dissertation will be clearer for this basic understanding. This requires the preparation for a research degree to be adequate. A good undergraduate degree now, with critical and scholarly skills embedded in it, with an honours year project, should prepare them to understand the field in broad terms. A master's degree also consolidates a deeper understanding of the particulars of the field chosen, and should be the professional norm. With the PhD, the expectations are higher and one might say to the candidate "Surprise me!"

It is only relatively recently that, in the Australian setting, and indeed in the Anglophone academic world, there has been this continuity of

higher arts education where the nature and quality can be properly evaluated. Students entering the academy now can see ahead of them a series of degree levels available to come in and out of or, alternatively, to progress through in an orderly way. There is now a span of 8–10 years in which the levels of study from bachelor's degree to PhD have an increasingly normalised pattern. This was not always so.

This discussion will outline some of the factors that have created this new context and the significance it has for the matter of writing styles in the creative arts PhD dissertation or research report, as it is variously described.

Future Proofing

The twenty-year history of doctoral study in the creative arts in Australia, aligned with trends in the UK and Europe, has created a new culture for creative arts 'research' not previously recognised in Australia. Over this period, the higher arts educational environment in Australia has shifted radically through both generational change and the nature of the arts themselves, and, perhaps most significantly, in structural terms, through changing and centrally driven public funding policy imperatives. These outcomes were not always happy and not at all mindful of the possible unintended consequences, such as were seen in the initial difficulties in determining definitions of research in the arts. The question of whether and how these impacts have been felt is the subject of much conjecture both in Australia and more recently, similarly and eloquently, in Europe. Is this the end of higher arts education as we know it or a new beginning? There is now a considerable literature on these questions and a maturing of dialogue driven by inherent pragmatism and some insights into the increasingly globalised world of the intellectual and artistic pursuits. For example, see the discussion of the *Academy Strikes Back*, where the authors see a possible new way to conceive of higher arts education and perhaps even see some advantages, creating "a space for experiment and exploration" without the pressure of market forces (Rogoff 2008). This will be discussed further below.

One of the constant themes of the past twenty years has been the seeming exceptionality of the creative arts in the higher education

system; that is, how the creative arts don't fit into the university regu-
latory systems, in particular in relation to research. However, other
professional disciplines, such as teacher training, nursing, architecture
and law, relying heavily and appropriately on professional training and
practice rather than research activity, have similar concerns about defi-
nitions and measurements of research excellence. This was the subject
of much conjecture during the development of recent research quality
evaluation exercises such as the Excellence in Research for Australia
(ERA). Discussion of this is beyond the scope of this chapter but there
is, however, a growing confidence that the 'system' is adapting to these
needs. The current attention to the disciplinary-specific criteria for
research evaluation in the recently established Excellence for Research
in Australia (ERA) is an example of some concessions to non-traditional
research outputs, relevant to the professional education of law, architec-
ture and the creative arts.

Since the 1990s, in particular, the amalgamation of art schools, music
conservatoires and other creative arts teaching institutions with the
universities at a national level, determined through changes of federal
government policy, formed a new hybrid culture within traditional
academia. Much has been said and written about these emergent
cultures, in particular in the work of Jenny Wilson whose research,
Artists in the University, explores this specifically. Wilson says in her
article in *Australian Universities Review*, 'Creative Arts Research: A Long
Road to Acceptance':

> The majority of tertiary practice-led creative arts disciplines
> became part of the Australian university system as a result of the
> creation of a unified national system of tertiary education in 1988.
> Over the past two decades, research has grown as the yardstick by
> which academic performance in the Australian university sector
> is recognised and rewarded. Academics in artistic disciplines, who
> struggled to adapt to a culture and workflow expectations different
> from their previous, predominantly teaching-based employment
> continue to see their research under-valued within the established
> evaluation framework. Despite a late 1990s Australian government
> funded enquiry, [referred to as the Stand report, 1998] many of the
> inequities remain. While the Excellence in Research for Australia
> (ERA) exercise has acknowledged the non-text outputs of artists

and academics in its evaluation of 'research outcomes', much of
the process remains resolutely framed by measures that work
against Creative Arts researchers.

(Wilson 2011, p. 68)

Wilson's research examines the variable institutional frameworks
and cultures that have emerged out of this changed policy landscape,
identifying a range of institutional responses to these new conditions.
Indeed in some cases universities have adapted to the new community
of scholars now included in the comprehensive university structure. In
other cases there has been slow acceptance and difficulty in finding a
place for this new disciplinary framework. For example, in some cases,
universities have created equivalents in research reporting, and in
others, adapted existing systems. These include criteria for promotion
and support for research development, such as early career research
support and even the distribution of funds.

A consequence of this nascent development of a research culture was
the emergence of research master's degrees and doctoral study, with the
funding regimes different from undergraduate education. Funding for
research degrees is currently awarded through a *relative funding model*,
one that pays on the completion of the degree, as part of total research
grants given to universities for internal allocation and through complex
formulas. The consequence is that, relative to the number of enrolments,
there are varying rates of return for the teaching and supervision of
graduate students. In the early years of these enrolments, mythically
large figures were circulating that the return for a graduate completion
netted $100,000 and so there was a scramble to develop PhD programs
and expand the research training endeavours, leading in some cases to
an explosion of enrolments.

Since then, the reality of a greatly reduced return on the supervision
of research students has tempered the growth in this area. Over this
period many models of study and examination emerged and each
university within which these programs resided determined the rules
and conventions, with the consequence of almost no two programs
appearing the same. This range and diversity, while understandable, was
seen by some as limiting the capacity to evaluate quality and to find a
standard against which these programs could be judged.

With the integration of creative arts study into universities there is now an expectation that the PhD and/or the professional doctorate is the terminal degree and that all institutions with creative arts schools (almost all of the 35 public universities in Australia) aspire to offer such programs. There is an increasing expectation that new staff will also have doctoral qualifications. There is high demand for places in doctoral programs and increasing competition between institutions. An increase in research training scholarships, such as the Australian Postgraduate Awards (federal-government-granted stipend scholarships) and university-funded scholarships, has also had a significant impact on the quality of the work. It is expected that these conditions will lead to an improvement in the quality of programs and graduate outcomes.

The collegial response to this from creative arts academics was to examine these doctoral study issues so as to build a consensus around, if not standard models, then, the expectations of the PhD in the creative arts as it came to be known. This was a parallel response to work being undertaken in the UK and European context.

Initially, as an Australian Learning and Teaching Council (ALTC) funded project, the study *The Creative Arts PhD: Future-Proofing the Creative Arts in Higher Education, Scoping for Quality in Creative Arts Doctoral Programs* (Baker & Buckley 2009) aimed to find ways to build capacity and to prepare the creative arts academic profession for the future; building research capacity and productivity through a new generation of well-qualified doctoral graduates who will, it is hoped, be the creative arts academics of the future. It found and demonstrated evidence of the maturing field of creative arts research training in Australian university art and design schools. The main driver of this project was to provide a greater focus on the quality of graduate outcomes. In turn, that would assist in the capacity building for research in the creative arts, in the broader sense.

While the initial scope of the *Future Proofing* project was to look at the creative arts as a whole, the limitations on time meant it was more useful to test this investigation initially with the art and design sector, one that has a significant investment in the research training area and with a number of very active participants, and a group to which the project leaders had easy access through the peak body, the Australian

Council of University Art and Design Schools (ACUADS). From this scoping study, it was thought a broader study could be undertaken building on this methodology and applying it to the other discipline groups such as music and performing arts, part of a focus across the sector and of many related projects. There are active programs currently being funded by the ALTC involving film and new media academics, such as the Australian Screen Production Education and Research Association (ASPERA). Forums initiated by this project as a result of these interactions provide opportunities to discuss the sector-wide issues and as a consequence a strong collegial group has formed across the creative arts academic communities (Baker & Buckley 2009).

The *Future Proofing* report recommendations identified some common and collegially supported parameters for the creative arts PhD and, indeed, a number of strongly articulated differences, in particular around the examination models, where in almost no two cases were the processes and procedures the same.

The report, delivered to the collegial community in 2009, recommended that ACUADS (and by implication other peak bodies) continue the collegiate benchmarking and rather than develop codified standards it was thought best to share best-practice models and general principles as a way of building cohesion and compatibility across the sector.

Further investigation was seen to be warranted into the various examination models and their relative merits. This was seen as an important issue, with strongly held views, notably the opposing positions on the merits and efficacy or otherwise of the *viva voce* as a model of examination for the PhD. While not intending to mandate any particular model, it was thought further discussion may lead to more consistent practices. With the increasingly global dimensions of graduate education the report suggested that an international research project be scoped to build a network of peers working in this emerging field and to provide an international perspective on models of examination, thesis submission, research training course design and research preparation.

While there are considerable variations within the research cultures of the visual and performing arts, there are also some particularly close

alignments and this can provide for a strong cross-disciplinary peer group and will build a creative arts culture more in line with current and future research in this field.

One suggestion that came through as a recommendation in the *Future Proofing* project was the wish to establish a national database of PhD theses in the creative arts. Once established, this would tell a very interesting story, revealing patterns of research methodology, which are often emergent and dynamic and in many cases truly innovative.

Similarly, the growing research capacity of the sector through the federal government audit, Excellence in Research for Australia, the first of a number of research assessment exercises, will also have an impact on the effectiveness and critical rigour of the emerging research training culture.

From this project and its many discussions came the desire to build an appropriate scholarly community such as the proposed Australian Academy of the Creative Arts; a community of scholars in this growing group of higher arts education disciplines.

Roll forward to the present and, at the time of writing, progress has indeed been made. In Hobart, at the University of Tasmania, the southernmost state in Australia, on 14th February 2013, the leaders of creative arts higher education came together to form the Australian Council of Deans and Directors of Creative Arts (DDCA). Representatives from twenty-two universities agreed to establish the DDCA and to join with the other Australian Councils of Deans, to build strong scholarly and research leadership of the rapidly evolving and increasingly diverse range of disciplines that includes art, dance, design, theatre, music, film and television, screen arts and writing amongst others.

This enthusiasm for coming together was seen as evidence of the strength of the creative arts in the sector. It also shows the willingness of its leaders to be active participants in the exciting and indeed urgent challenge to create twenty-first-century higher arts education that contributes directly to the sustainability of practices and the resilience of artists, researchers and professionals in the field. It is hoped by the members that the DDCA will build strong and abiding networks

of professionals and emerging researchers in the field, and will expand these links with colleagues in a dynamic and rapidly expanding Asian university and college sector. International collegial groups such as the European League of Institutes of the Arts (ELIA) and the European Associations of Conservatoires (AEC) are both exemplary role models for the DDCA and recent discussion with leaders of both gave great support to the momentum here in Australia. While there are many cultural and systemic differences between Europe and Australia, we are in most cases focused on very similar issues and finding very compatible solutions.

The Pleasure of Research: An International Dialogue

There are many such discussions driven by changes in government education policy, whether it be the amalgamations of art schools into universities in Australia and the UK; or the more sceptical approach of the US, where they are still largely unconvinced; or the so-called Bologna Process in Europe, where the three stages of education created a set of expectations about how a more unified approach to the European educational frameworks might be characterised.

The Bologna Process, a function of the last decade, was one focused on academic principles and not institutional structures. Unlike the UK and Australian experience, in the European context the focus might be said to have been on the educational principles, that is, conceiving it as having three levels, or cycles of education. In Australia, the structural changes dominated and were largely about the government funding regimes and the regulation of a unified system of higher education. Whether or not this was the intention, there seemed to be little attention paid to educational principles throughout the process of the early 1990s in Australia, as distinct from the later European experience. Sceptics will see the Bologna Process as an economic rationalisation par excellence, and perhaps it was. Mass higher education policy makers confront the same issues everywhere. However, with this in mind, we can only imagine what would have happened if, in 1990, instead of merging the Colleges of Advanced Education (CAEs, the home of arts training in the 1970s and '80s in Australia) with universities, a three-cycle academic program had been developed, possibly alongside a transformation of the CAEs into arts academies, such as universities of the arts in each

state or region, complying with an overarching framework of the three cycles of education; a lost opportunity, perhaps.

By establishing and describing a clear third cycle of education, through the Bologna Process, the doctoral and graduate research area, the impact was immediately felt on the models of higher arts education in Europe, and doctoral education began to take on a more formal shape. This has also spawned some interesting work, evidence of the adaptation of the species, perhaps, with academics adjusting to this new framework through a number of important conferences and symposia. The European League of Institutes of the Arts has supported a number of projects – some examples are *The European Artistic Research Network* (EARN), initiated by Henk Slager and others from the Utrecht Graduate School of Visual Art and Design. They have produced a strong focus on artistic research including symposia and expert meetings such as: *A Certain MA-ness* (Amsterdam, 2008); *Epistemic Encounters* (Utrecht, 2009); *Arts Research: Publics and Purposes* (Dublin, 2010); *Tables of Thought* (Helsinki, 2010); *The Academy Strikes Back* (Brussels, 2010); and *Art as a Thinking Process* (Venice, 2011).

Recently, the Europeans have been driving some very useful intellectual enquiry and there seems to be a level of confidence as to where this might lead. Of interest in this area is the work of Irit Rogoff in her essay *The Turning*, where she proposes that:

> an idea of an 'academy' (as a moment of learning within the safe space of an academic institution) was a metaphor for a moment of speculation, expansion, and reflexivity without the constant demand for proven results. If this was a space of experimentation and exploration, then how might we extract these vital principles and apply them to the rest of our lives? How might we also perhaps apply them to our institutions? Born of a belief that the institutions we inhabit can potentially be so much more than they are, these questions ask how the museum, the university, the art school, can surpass their current functions.
>
> (Rogoff 2009)

Similarly of interest is a provocative piece by Dieter Lesage called 'Artists as Researcher', in which he writes an insightful description of the

activities of artistic researchers in the academy and as "a fierce defender of the doctorate in the arts" (Lesage 2009).

Despite all the struggles with accommodating the new academic environment for the arts, there is a serious thread of optimism and even a new progressive mission. Slager says:

> it seems likely that the arts academy on account of its curricular reformulation, incorporating the 'freedom-of-thinking' space, is soon going to be the only location in the cultural field where innovative processes with regard to production, reflection and presentation will be generated in the next decade.

> One prospect for that development lies, I believe, in PhD research – the so-called third cycle – connected with the Bologna agreement: that is to say in doctoral research as *Temporary Autonomous Research* without any need to be led by the formatted models of the established scientific order. This will be a form of research not swayed by issues dictated by the late capitalist free market system and knowledge commodification; in short this will be an authentic research that comes about through an artistic necessity entirely independent of the rhetorics of social-economic relevance. In the development and realisation of such a groundbreaking form of research, Scandinavia plays a prominent pioneering role. In that context, the doctoral programs offered for example by the Finnish Academy of Fine Arts and the Malmo School of Art are constructive and inspiring models for many European art academies. These programs present artists with an intellectual sanctuary where they can reconsider their artistic motives and strategies for a number of years.

> (Slager 2012, p. 14)

So, returning to the topic, doctoral education and in particular the writing practices therein, there is now an international dialogue, well developed and growing, about this level of study and the implications for the disciplines in the arts.

It seems, however, that in the Australian and UK institutional contexts there is still an underlying scepticism or discomfort about the nature, the value and the quality of the PhD or doctoral-level study in the creative

arts, as has been witnessed by the still unresolved structural status of creative art research in the allocation of government funding based on the Higher Education Research Data Collection (HERDC) research recognition in the funding formulas. That is, the creative arts research outputs attract no funds in this formula and so perpetuate the lack of legitimacy and acceptance. This situation is similarly reflected in the history of scientific research data collection in Europe (Borgdorff 2006).

In an essay in *Afterall*, Andrew McGettigan (2011), formerly of the Research Office at Central St Martin's, speaks of the degree overall, but fundamentally about the articulation of the research and artistic outcomes. His comments are, perhaps, sadly familiar. In recognising the diversity of student needs, he makes a case for two different but equal models, distinguishing the PhD and the professional doctorate. In my view this is in a way admitting defeat. However, I am not disagreeing with his observations. He puts it this way: "What animates the scepticism is the fear of bad or weak art, and poor scholarship limited perhaps at times by an overemphasis on the personal exploration."

Quoting Victor Burgin, he also notes that the applicants for art doctorates are those "who [make] works of art and who also read enthusiastically... and [turn] concepts encountered in reading into practical projects". These applicants, according to McGettigan, often have "alongside their practice, an open-ended interest that they are ready to pursue and interrogate. This implies the starting point not necessarily established solipsistically, that is, starting with one's own work, but going beyond a personal exploration and a private individual interest" (McGettigan 2011).

His second point is that anything can become the material for art practice – in research terms, many models and methods are appropriate, from the material sciences to sociology, and everything in between. I would agree with this point and add that this demands the scope of proposed research to be explicit from an informed position. The onus is on the researchers to define distinct research problems based on the context of art, and not to be a second-rate art history, sociology or philosophy.

McGettigan goes on to identify another issue, one that we will also recognise. He says that the complexity around method, that is, methods of research that apply to different disciplines being adopted by the creative arts researchers, has provided a particular focus on supervision and the capacity of supervisors to know the context adequately, and to assist in this search for appropriate approaches to the project (see also the discussion by Elkins, this volume).

He says that without a maturity of these conceptual issues, and perhaps through mixed institutional frameworks and mixed interpretation of 'rules', candidates can be advised along paths that distort behaviours and produce narrow and constrained outcomes. For example, he refers to attitudes that might be characterised by the advice to students to "do the work and worry about the writing later" and so on.

Victor Burgin's point, as quoted by McGettigan, is that in many cases students self-select due to their interest in the broader context, through a discursive engagement with the particular issues of the field. However, there is often confusion about the methodological approach to this work when it comes to the dissertation, even about what it is called: a dissertation, exegesis, the written component, thesis, studio report. Is it self-directed hagiography, "why my work will change the course of art history"? Or is it a confessional report, "why I don't know what I am doing until I do it and then whatever I do it must be good because I am an artist"? Or, from the auto-didact, "I am writing art criticism and I locate this 'my' work in the emerging field of X, and of course this is an exemplar of innovation in that field"!

McGettigan brings up the commonly discussed options presented as the alternative models of doctoral education in the arts. This comes down to bifurcating the options into that of the professional doctorate, with more structure and possibly a more directed program; and alternatively the research-intensive mode, driven by the student's more mature, self-determined enquiry. He suggests that the two models be better defined so that the expectations are better understood.

While I recognise this argument and have some sympathy for it, I fear that it may be driven by the wrong motivations, or that it is based on

accepting the inadequacies of the present conditions rather than seeking a more optimal position. If we see this as a way of dealing with, or in fact, not dealing with levels of scholarship and by implication the quality and nature of the dissertation, that is the scholarly writing, we may never resolve the tension that exists in the current system. If we settle on this separation, we may not build a truly integrated and relevant research mode that is suited for the advancement in the disciplines of the arts.

Coda or What to Do?

We may all have examined theses that should not have been submitted, such was the innocence, naiveté perhaps, of the proposition, the lack of critical depth and relevance to the field in the broader context. I fear this goes to the standards of undergraduate education, selection criteria of doctoral programs and the limitations of supervision – all of which the students are subject to without choice.

It has often been said that if these students didn't have to write they would be better off and could be evaluated on their work alone. It is this impulse that drives some discussion about the professional doctorate where there is greater structure and less independent research required. Perhaps some of the ambivalence toward the importance of the dissertation is driven by the structural issues, through the system of funding, timely completions, being paid retrospectively, and of institutional reputation based on research activity.

Similarly, there are some who feel that artistic research work should be evaluated in its own terms, as art, as an evidential form of innovation in its own right, without the exegetical functions of a written report, or dissertation. In that context we might ask what the real function of the dissertation is in providing examiners with a method of evaluating the standing of the research proposition in relation to the field and how and what the candidate understands that to be.

Let's be clear, the written component of the doctoral submission is primarily directed at the examiners and is there to support the examination process, whatever form that takes. However, we don't want to be making distinctions about examination and presentation forms

based on whether or not candidates can 'write well' or articulate their research. Surely we would expect highly literate and articulate artists when awarding this level of degree. If the ideas, their context and the preparatory education are adequate, that will assist in the articulation of the thesis in its written component.

In the *Future Proofing* study, the written dissertation was probably the greatest point of difference across the sector as were the many diverse models of examination processes. All had exhibition and performance elements, and it was generally understood what was assessable by the examiners without too much debate. However, nearly every institution had a different approach to the dissertation and models of examination. At the crux of these differences was the nature of a research methodology in the arts. There seems to be a somewhat dubious separation of issues around the practice and the writing, and we have to ask: "is this really the problem?" Does this, rather, go to the standard of undergraduate education and research training, that is, prior to the undertaking of a doctoral program? Now that we have the full spectrum of undergraduate to PhD, this sequence can be better understood. This is the effect of the three cycles, like that of the Bologna model and the Tuning Project (see at http://www.unideusto.org/tuningeu/) and indeed in Australia of the new standards project undertaken by the Office of Learning and Teaching (OLT), and now the Tertiary Education Quality Standards Agency (TEQSA) and impacting on universities through the revised Australian Quality Framework.

There may still be assumptions about a hierarchy of value between 'writing' and 'making' art, still some disconnect between hand and brain, perhaps a lack of clarity about how to assess 'visualisation' in the case of the visual arts, or 'kinaesthetic' intelligences and musical languages in others. It seems that the creative arts are still being confused and compared with other disciplines; perhaps we are confusing ourselves, in the absence of a confident and publicly tested alternative and a sector-wide, peer-supported and articulated position.

It is important to include a word about terminology here. 'Practice-based', 'practice-led' and other qualifying terms seem to avoid what it is – simply, 'artistic research'. Dieter Lesage puts it simply:

> There is still a very widespread and persistent misunderstanding
> of the so-called academization process in which the art academies
> have engaged themselves. I would like to be very clear about
> this: for art academies, the academization process is absolutely
> not about becoming more scientific; it is about becoming more...
> artistic. Indeed, the academization process should be seen as
> a thorough reflexion on the mission of the academies. Just as
> most universities consider it an important part of their mission
> to engage in top scientific research, art academies should be the
> places of the most advanced artistic research.
>
> (Lesage 2012, pp. 117–18)

In another discussion, 'Chimera of Method' in *See it Again, Say it Again: The Artist as Researcher*, Jeroen Boomgaard (2011) discusses the form of writing expected in the doctoral degree and makes a clear distinction between the conventions of writing, that is, in a scholarly context, and the art making, and therefore the artistic research. The scholarly context has well understood and reliable methods, and he makes the case that scholarly writing is itself a practice with its own conventions and measures of quality, whereas artistic research, to be effective, has a more emergent and open-ended approach.

> The question of whether or not the method of artistic research
> and especially how it is reported requires a textual component
> sparks heated debate, but questions about the role of the text are
> broached all too rarely. While objectors are of the opinion that
> writing a research report overly compels artists to step outside
> their usual territory, its proponents see it as the only possible
> means of ensuring that artistic research counts as true research.
>
> (Boomgaard 2011, p. 64)

He concludes that there are tried and tested conventions in scholarly reporting, and that these different knowledge systems can sit alongside one another.

> The basic premise is that the academic research and the research
> through art can complement or even comment on each other, but
> they cannot converge. Scholarly research is always reflexive and
> draws conclusions; it always reports on 'something' that is itself
> not present in the account, and no matter how self-critical the

methodology may be, the text of the research almost always reads like a final destination... However, the work of art is never conclusive. The work of art presents itself as a straight fact, as a given... but at the same time it is always open in character.

(Boomgaard 2011, p. 70)

Perhaps, we will eventually convince ourselves to trust our own judgements and those of our peers, as these views are articulated and tested. We will build a robust critical culture of innovation and invention that will eliminate the need for an apologetic, forelock tug to others in the academy. Through this self-scrutiny (such as we are undertaking here) we will create for ourselves benchmarks of quality research and the advancement of the discipline, and models of doctoral study that will satisfy both artistic and intellectual curiosities by which artists are driven, and be able to communicate that to our colleagues.

The issue of whether or not the creative arts disciplines should be in universities continues to sit quietly in the corner of the room, but we should also not assume that universities themselves are fixed and intractable. The inclusion of disciplines such as the creative arts has in fact been an agent of change from within the traditional university, and we should be working from a position of confidence and not deference. We can learn greatly from other disciplines that have been in this university business a lot longer than us, but the aim is to find the right approach for the creative arts and not as a shadow play of other disciplines. To this end, we should take advantage of the full range of intellectual, scholarly and artistic opportunities that these institutions provide for the advancement of the arts.

References

Alberro, A., & Stimson, B. (eds) (2009) *The Writing Artist*. Cambridge, MA: MIT Press.

Baker, S., & Buckley, B. (2009) *CreativeArtsPhd: Future-proofing the Creative Arts in Higher Education*. Strawberry Hills, NSW: Australian Learning and Teaching Council. Retrieved from: http://www.olt.gov.au/resources?text=Creative+Arts+Phd.

Boomgaard, J. (2011) Chimera of Method. In J. Wesseling (ed.) *See It Again, Say It Again: The Artist as Researcher* (pp. 57–72). Amsterdam: Valiz.

Borgdorff, H. (2006) *The Debate on Research in the Arts (Sensuous Knowledge 02)*. Bergen: Bergen National Academy of the Arts.

Borgdorff, H. (2012) *The Production of Knowledge in Artistic Research*. London: Routledge.

Langer, S. (1958) *Reflections on Art: A source book of writings by artists, critics, and philosophers.* Baltimore: Johns Hopkins Press.

Lesage, D. (2009) The Academy is back: on education, the Bologna Process, and the doctorate in the Arts. *E-Flux*, 03. Retrieved from: http://www.e-flux. com/journal/the-academy-is-back-on-education-the-bologna-process-and-the-doctorate-in-the-arts/.

Lesage, D. (2012) Art, research, entertainment. In P. Gielen & P. De Bruyne (eds), *Teaching Art in the Neoliberal Realm: Realism versus cynicism* (pp. 113–130). Amsterdam: Valiz.

McGettigan, A. (2011) Art practice and the doctoral degree. *Afterall*. Retrieved from: http://www.afterall.org/online/art-practice-and-the-doctoral-degree.

Rogoff, I. (2008) Turning. *E-flux*. Retrieved from: http://www.e-flux.com/journal/turning/.

Slager, H. (2012) *The Pleasure of Research*. Helsinki: Finnish Academy of Fine Arts.

Svenungsson, J. (2007) *An Artist's Text Book*. Helsinki: Finnish Academy of Art Press.

Wilson, J. (2011) Creative Arts Research: A long road to acceptance. *Australian Universities Review* 53(2): 68–76.

SITUATING CREATIVE ARTS RESEARCH AS 'SUCCESSOR SCIENCE'

Estelle Barrett

In previous publications on creative arts research (Barrett & Bolt 2007), I suggested that there is a need to shift the focus of critical discourse that accompanies creative arts research away from valorisation and criticism to examining studio enquiry as a process *and also* to evaluating the completed work within the context of the research question or problem, rather than as an exhibition artefact. This approach has been useful for articulating how the methodologies of artistic research have the capacity to produce new knowledge and to shift understandings of the way in which knowledge emerges and functions.

In this chapter, my aim is to demonstrate the importance of including a *meta-discourse* in creative arts research writing to demonstrate the specificity of artistic research as an emerging and valid research paradigm – as a 'successor science'. In order to continue building artistic research as a discipline and indeed to lay claims of its status as 'successor science', researchers need to demonstrate how artistic research operates as a critique of traditional methods and how – together with its particular

interpretive frameworks – it constitutes a paradigm of research that can inform and contribute to the general field of research.

In the first part of this paper, I will examine the analysis of four research paradigms in an essay by Egon Guba and Yvonna Lincoln (1994), entitled 'Competing Paradigms in Qualitative Research', in order to demonstrate some fundamental distinctions between creative arts research and other paradigms of research. I will also address some of the issues raised in Guba and Lincoln's analysis to pinpoint how creative arts research is not only a transversal approach that can inform traditional paradigms, but is one that despite articulating with other qualitative approaches is built on fundamental differences. I suggest that this mode of research may therefore permit a refiguring of the basic ontological, epistemo-logical and methodological assumptions of other approaches. In the second part of this chapter, I will draw on notions of 'objectivity' and 'data' within the context of two influential essays, Eliott W. Eisner's 'The promise and perils of alternative forms of data representation' (1997) and Donna Haraway's seminal essay 'Situated knowledges: the science question in feminism and the privilege of partial perspective' (1991) to outline how and why such a bold approach is necessary. Finally, I will refer to accounts of research presented by practitioner–researchers in a forthcoming publication entitled *Material Inventions: Applying Creative Research* (Barrett & Bolt, in press) and other examples of artistic research to illustrate and support the ideas and position presented here. These projects are presented as 'proof of the pudding', so to speak, since they illustrate the expanding frontiers of this emerging research paradigm.

Competing Paradigms in Qualitative Research

In their analysis of four currently competing paradigms that inform and guide inquiry – positivism, postpositivism, critical theory and constructivism – Guba and Lincoln suggest that 'qualitative' research does not constitute a paradigm, but is rather a description of types of methods (1994, p. 105). They define a paradigm as the basic belief or worldview that guides the investigation. I would argue that rather than being a species of qualitative research, artistic research is underpinned by a worldview that sets it apart from other approaches. So what is the worldview of creative arts research and what are its basic assumptions?

How does the aesthetic paradigm deviate from traditional positivist and post-positivist paradigms and in what ways can creative arts research be distinguished from other forms of qualitative research?

It should be said at the outset that artistic research is intrinsically interdisciplinary and transversal; it does not eschew the methods and approaches used in qualitative research and, moreover, in experimentation within the studio setting can to some extent be likened to what happens in some forms of science research. However, the basis for grasping its distinction from other paradigms is twofold: the first criterion relates to the *logic* that is assumed to be at work in this successor paradigm; the second relates to assumptions concerning implications of matter or materiality as the foundation of all aesthetic enquiry. An understanding of how these two features are mutually implicated may be grasped through notions of the materiality of language, which reveals how human subjectivity is constituted by both social and biological processes. This allows us to recast the aesthetic not as a matter of taste or judgment, but as the entire edifice of human perception and sensation in contrast to the more rarefied domain of conceptual thought – the whole of our sensate life, or what Terry Eagleton describes as "the business of affections and aversions, of how the world strikes the body on its sensory surfaces" (Eagleton 1990, p. 13).

Hence, we can argue that the logic that underpins aesthetic practice is not solely the logic of rational thought, but involves dimensions of a tacit and intuitive knowing that is derived from the senses and is made possible through an alteration of language that occurs in the making of the artwork. This places the aesthetic paradigm outside of the positivist paradigm, which seeks to *verify* findings and generalisations, as well as the postpositivist paradigm, which seeks to *falsify* generalisations. Both of these are founded on the assumptions that a fixed reality exists to be observed and that only rational thought is at work in research. Moreover, both these traditional paradigms involve context stripping, which as Guba and Lincoln point out, limits relevance or applicability of generalisations to individual cases and excludes meaning and purpose related to human actors (1994, p. 106). Guba and Lincoln suggest that qualitative research overcomes this tendency by providing contextual information and maintaining interactive and intra-active relationships

between the researcher and the (human) objects of research.

Let us take a brief look at two additional paradigms that Guba and Lincoln mention in their analysis. What they call the "Critical Theory" paradigm refers to those approaches to enquiry that view knowledge as subjectivist, producing knowledge that is value-mediated by historical social, cultural, economic, gender and other values that have been laid down over time (1994, p. 109). Knowledge in this paradigm emerges through a dialogical and dialectical relationship between newly revealed understandings and what is already established through critical theory. A fourth paradigm, that of constructivism, suggests that all knowledge emerges in relation to socially agreed meanings and local realities. This paradigm produces a relativism that denies personally situated experience, as I will discuss in more detail later in this paper with refer-ence to Donna Haraway's notion of "situated knowledge". As in critical theory approaches, the constructivist paradigm also operates dialogi-cally and dialectically through hermeneutic analysis and interpretation. 'Dialectic' in this context refers to notions of exchange or interaction of meanings and meaning systems: thesis interacting with anti-thesis gives rise to a new thesis. Elsewhere (Barrett 2011) I have drawn on Julia Kristeva's account of dialectics as catastrophe in order to explain how creative practice engenders material processes that rupture meaning and language to allow the as yet unimagined and unrepresented to be revealed. Within the context of catastrophe theory, 'dialectics' differs from notions that are implied in accounts of established research para-digms that draw on Marxist notions. New materialist approaches to epistemology are useful for extending our understandings of this.[1]

Interaction and intra-action in the aesthetic paradigm not only pertain to flows of communication and knowledge between human actors and systems of knowledge but also flows between thought, feeling and the material world. In artistic research, the artist as human actor is both subject *and* object of the research process and, in this paradigm, the movement of illumination always flows first through interaction (and intra-action) with matter and the materials of making, then subse-quently from the particular to the general through the audience's interaction with the *art object* or outcome of the research process. This is a crucial distinction that requires further elaboration through an

explication of what we understand as 'matter' and material process. Iris van der Tuin explains the term onto-epistemology with reference to the work of Karen Barad as "the study of practices of knowing in being". She continues:

> This definition demonstrates how onto-epistemology itself has an onto-epistemological vantage point. Barad wants us to study *practices*. Such practices happen *in being* and they are *of knowing*. 'In being' points to appreciation for refraining from ontological assumptions, such as the assumption of entities being clearly delineated or of entities being mute in the hands of signifying academics.
>
> (van der Tuin, 2014, p. 293)

Barad (2003, 2007) provides us with further scaffolding for grasping *how* material-discursive practices emerge from corporeal responses and are translated into language and thought. In experience-in-practice there is a constant movement between the material world, the biological/material self (the self as 'other') and the social self. This movement gives rise to a performative production of knowledge or onto-epistemology. Crucial to this perspective is an acknowledgement of the agency of materials and matter. Matter is found to be as active as thought, language and form; and matter does not exist in separation from thought; because they are co-existent, they intra-act as material-semiotic process. Barad's new materialist perspective on practice and her notion of "agential realism", the attribution of agency not only to tools and instruments of research but to brute matter itself (Barad 2003, 2007) permits us to articulate more clearly what separates creative arts research from other paradigms. What we see at work in artistic research, then, are assumptions that go beyond naturalistic approaches and naïve realism as well as the humanist and social focus of qualitative research approaches.

The Limits of Data and Representation

In putting forward the idea that research is not a species of science, but rather that science is but one species of research, Eisner suggests that science's use of propositional statements and number to represent data is reductive and limits what can be said about phenomena. Moreover, these representations are not exclusive agents of meaning (1997, p. 4).

Eisner rightly looks toward alternative forms of data representation to overcome the limitations of science and points to artworks as representations that can afford insights beyond what the numerical and the propositional can tell us.

In interpreting the outcomes of research, a key task for researchers is to ask how these alternative forms illuminate and inform our understandings. Eisner tells us that art objects have the capacity to go beyond propositional limits by:

- Giving rise to multiple perspectives
- Creating productive ambiguity
- Engendering empathetic participation and giving access to the emotional lives of others
- Increasing the number of questions that can be asked about the phenomena being presented
- Presenting a sense of particularity that the abstraction of number and generalised laws cannot contain
- Articulating the ways in which the transformation of the personal (what is inside of consciousness) and the private to the public sphere can occur.

Though useful as a basis for a preliminary discussion of artistic research outcomes, Eisner's understanding of artistic products as "data" and as "representations" is not sufficient. It mirrors a tendency in creative arts research writing that fails to break free of the traditional paradigm, or take us far enough towards understanding what is specifically generative about the creative arts research process itself and the nature of the artefacts that it produces.

I'd like to explore why this is the case, and in doing so attempt to extend Eisner's approach to interpretation. *The Shorter Oxford Dictionary of Historical Principles* defines "data" as "a thing given or granted; something known or assumed as fact and made the basis of reasoning or calculation" (Onions 1978, p. 491). For Eisner, films, drawing, theatre and other artefacts are *representations* that illuminate rather than obscure the *message* or *phenomena*. The artworks, then, are symbols that allow us to name certain ideas or objects that the enquiry has permitted us to

observe. Underlying this view is the idea that language can fully capture the referent or stand in for it, that knowledge is static and phenomena are pre-existent, immutable, and waiting to be revealed or discovered. By objectifying the artwork as data, Eisner's approach adheres to science's privileging of reason or rationality and the idea that objects remain external to a transcendent consciousness. For example, in his inter-pretation of the film *Dead Poets' Society*, Eisner suggests that although the film is a fiction, it does capture or reveal aspects of what actually occurs in real schools that are similar to the one depicted. As viewers of the film we are then able to access the new insights and knowledge that have been harnessed by the film and integrate these into rational consciousness. In this context, knowledge is already there, waiting to be captured through the technical apparatus and the language of film. This does not take us away from the scientific notion of objective observa-tion and naming.

Knowledge as Action and Interaction

In order to demonstrate that artistic research reconfigures our under-standings of *how* knowledge is produced, practitioner– researchers need to go beyond this view of language and knowledge production. I have previously drawn on Michael Polanyi (1958) and the work of Ian Suther-land and Sophia Krys Acord (2007) to discuss the way in which art gives rise to experiential knowledge. Praxical knowledge is not *a priori* there to be discovered, but is knowledge as *action* or 'knowing' that emerges from both thought and biological or sensory interaction – that is, from aesthetic experience (Barrett 2007, p. 2). As Ross Gibson (2010) and Donna Haraway (1991) have explained, though often overlooked, this is also the case in more traditional research approaches. One of the strengths of artistic research is its capacity to uncover or reveal the aesthetic dimension of all forms of discovery. Pre-existing knowledge does not merely emerge from objects to be discovered by scientists, but scientists work to emerge this knowledge through social interaction. Artists emerge it through material interaction and social interaction (Gibson 2010, p. 8). The material dimen-sion articulates the subjective and the sensory as an inextricable aspect of discovery. Knowledge through action involves the application of personal knowledge, sensation and tacit and intuitive know-how in order to bring about unexpected changes to the perceived world.

The creation of artworks involves *semiotic activity* – a movement between sensation (our biological responses), the materials of making, and thought. This produces changes not only to the material environment but to language *itself.* The change in language is accessed via the structure of the work (or what I would call the aesthetic image) that not only produces unexpected and surprising transformations in consciousness but also allows these to be articulated. Artistic research can be understood as a 'successor science' in that, unlike science, it does not rely on naming objects through established codes of language and representation, but is rather an emergent production that brings into being new knowledge and altered consciousness through an expansion of language. Reflection during the making of the work and the writing of the exegesis or research paper allows the practitioner–researcher to synthesise and articulate *how* the shift in language has occurred; and through subsequent contextual and comparative analysis, demonstrate how the work takes us beyond what is already known. In artistic research, movement is therefore from the particular/private to the general/ public domain. Knowledge transfer and testing against what is already known occurs first through interaction in the making and subsequently through interaction engendered by the viewing or experiencing of the artwork *itself.*[2] As will be shown later in this chapter, this was clearly the case with Lucas Ihlein's successfully completed PhD project, *Blogging as Art* (2010), where cycles of interaction and reflection are shown to underpin the emergence of new insights and knowledge.

Partial Objectivity

I would like to turn now to Donna Haraway's critique of scientific objectivity and her mapping of what she terms "partial objectivity" in order to emphasise that the *subjective* dimension of creative arts research is a specific *strength* that needs to be convincingly demonstrated. If the field is to be validated as 'successor science', criteria for understanding what might constitute a 'successor science' need to be presented in the meta discourses of doctoral exegeses. Haraway suggests that science has become a game of rhetoric and that the ideological doctrine of scientific method distracts attention from what scientists actually do or ought to do – which is getting to know the world *effectively* by *practising* the sciences. Haraway's description of what might constitute a successor

science bears an uncanny resemblance to creative arts research. As such it provides an analytical framework and rationale for the subjective and emergent aspects of practice-led research methodologies. Underlying Haraway's notion of a successor science is the recognition that:

- Pure objectivity is impossible
- Knowledge claims emerge from subjective and situated positions and knowledge is therefore always partial and provisional
- Situated knowledge may lead to a larger vision through its capacity to produce unexpected connections.

Haraway's critique of science's claim to objectivity turns on two ways in which objectivity is traditionally understood. Her first objection is to the notion that personal biases, emotional involvement and vested interests can be eliminated from the research process. Objectivity is also often linked to the need for scientific measurement that can be tested independently and in isolation from the scientist researcher (the subject) who puts forward propositions and laws. Underlying this is the assumption of the transcendence of consciousness or rational thought. In this paradigm, subject and object are separated by an inside–outside divide. Haraway suggests that this leads to "the view from nowhere" (1991, p. 581).

Her second objection is related to how science attempts to overcome relativism within the context of postmodernism and social constructionist accounts of science; these discourses posit science as just one 'myth' or construction amongst many. To counter this, contemporary discourses in science claim objectivity on the basis of a technological and technocratic capacity to observe for multiple perspectives; this is the view from everywhere which amounts to the same strategy or "God trick" that claims a vision from nowhere (1991, p. 584). For Haraway, scientific objectivity amounts to a disembodied vision of the "God trick" that confers uneven power and privilege, as well as immunity from having to locate and be accountable for knowledge claims.

Haraway identifies the need for a "positioned rationality" or an alternative partial objectivity as a way of arriving at some kind of locatable/situated truth:

> The only way to find a larger vision is to be somewhere in particular.
> We do not seek partiality for its own sake, but for the sake of the connections and unexpected openings situated knowledges make possible.
>
> (Haraway 1991, p. 188)

For creative arts researchers two crucial points can be taken from this:

- An acknowledgment of the particular, the subjective and the personal as an important basis for making knowledge claims
- Within the context of this acknowledgement, the importance of identifying webs of connections for the transfer and application of knowledge claims.

This does not imply an 'anything goes' validation of single and subjective vision, nor does it imply non-accountability. But in Haraway's words, it does necessitate the search for partial locatable critical knowledges that sustain the possibility of webs of connection. These Haraway calls "solidarity in politics and shared conversations in epistemology" (p. 191). In other words, the practitioner–researcher must also consider for whom, how and where else this knowledge may be put to use.

Haraway suggests that a successor science is necessary if we are to live in an ethical, critical and enabling relationship to our own and other's practices. She acknowledges that the knowledges emerging from particular standpoints are subjugated knowledges. However in order to achieve legitimation, such knowledges and their mode of production cannot be exempt from critical re-examination, decoding deconstruction and interpretation if they are to fulfil the promise of providing transforming and more enabling accounts of the world.

In creative arts research this requires situating the subjective within a broader theoretical and historical context, and the application of critical theories that have the ability to at least *partially* translate the knowledge produced. Haraway's observation that translation is always partial and incomplete provides a springboard for discussing the indeterminacy that characterises the aesthetic. Rather than glossing over this indeterminacy, practitioner–researchers can use reflection and analysis

in the exegesis to explore the generative potential of the artefact for knowledge transfer and to acknowledge the crucial role of audiences as co-producers of knowledge that will continue to emerge beyond the immediate research context.

Haraway uses the term "primate vision" to describe the alternative approach that may be a successor science. Primate vision is embodied vision that allows us to go beyond fixed appearances which are only the end products; it invites us to investigate the various apparatuses of visual production including prosthetic technologies, tools, materials and language itself – interfaced with our biological eyes and brains (1991, p. 195). Her notion of semiosis derived from the notion of the subject as material semiotic actor is in accord with materialist views that posit the subject as both a biological organism and an entity of language and thought. This relates to a crucial distinction between creative arts research and other qualitative research paradigms, as I have emphasised in other parts of this chapter. Successful creative arts research projects invariably demonstrate the ideas presented here and I will turn now to some examples.

Lucas Ihlein

Lucas Ihlein's PhD research, entitled *Framing Everyday Experience: Blogging as Art* (2010), investigates the way in which the practice of blogging can be conceived as an art form, and as such is capable of deepening engagement and attention to everyday experience. This project developed from an intensely personal enquiry that was shown to have much wider application. Ihlein demonstrates how blogging as art works to transform social relations within the community of readers and writers who engage with the blog on the Internet. The project demonstrates a new set of tools for social science research based on embedded, immersive experience.

In this project, blogging becomes a method for experientially documenting those social encounters. This experiential documentation is then able to generate a rich body of evidence, revealing new insights into difficult-to-research areas of everyday life. It allowed him to focus on minutiae and to "defamiliarise in order to see the everyday with

fresh eyes. 'Swamped' by the familiar, and without the ability to exoticise my surroundings (which is the luxury of the tourist), I was forced to invent new ways to pay attention to the everyday, which I propose could be useful to the field of relational art, as well as broader methods of study in the humanities" (Ihlein, 2014).

Ihlein frames his research with the following questions: "If life and art can be successfully integrated what new knowledge might emerge in the process? How does the method of bilateral blogging work to produce aesthetic experience and new insights within the flow of everyday life?" (2010, pp. 5–6).

A requirement of the site-specific project was that the artist should remain within the boundaries of Petersham, a suburb of Sydney, for two months and maintain a blog to record his everyday activities and interactions over that period. By devising a new way of making relational artworks and producing an experiential document of the particular environment in which the artwork is situated, Ihlein's project uncovers a new approach to understanding the functioning of aesthetic experience as an integral aspect of the research process.

His method involves the application of a spatial frame (the constraints of the specific site of the investigation); a temporal frame (the duration of the investigation and the synchronous unfolding of the blog); and a material/technological frame (the hardware and apparatus required to maintain the blog). These framing devices are used as a method to draw attention to the minutiae of daily life and to provide a record for further reflection, analysis and practice. What emerged subsequently included an interactive gallery installation, a number of visual articulations of the research process, and a book of the blog narratives. Crucial to the project was the interactivity afforded by the blogging, which engendered a co-emergent production by the artist and other participants from the community.

By generating an impressionistic 'portrait' revealing aspects of Petersham that are not contained in institutional archives, maps and other institutional records, Ihlein's project demonstrates the aesthetic dimension of blogging. For the purpose of this chapter, I will focus on one

component of the project: a series of walks, which involved the artist's attempt to trace the boundaries of Petersham by walking its borders. What emerges is an experiential and embodied map of the suburb disclosing the arbitrary nature of the lines on the official map. Ihlein observes that over the years, local council allocations of land and property development have carved up the terrain in ways that are alienating to human activity. He discovers that the boundaries indicated on the official map pass through fenced-off properties and tenements, cross railway lines and cut through inhospitable highways. At times this necessitates transgressing the imperative to remain strictly within the locale and these deviations reveal uncharted boundaries, interstices and connections. A recording of the experiences of the border walks and chance encounters along the way results in a 'remapping' of Petersham along experiential lines.

Deborah Beaumont: The Agency of the Material

Deborah Beaumont's account of her PhD research project, 'Newspaper Printing Sites and the Spoils of Creative Research' (2014), provides evidence of how the material and matter of research has its own form of agency and operates as a 'co-producer' of the final outcome of the research process. This project elucidates how knowledge has been made through working with the site, materials, and personnel from the newspaper industry. The term 'repropriation' is coined to indicate a working methodology by which the index of a reproduction is appropriated and re-produced. By using the newspaper printing press as a method of production and appropriating rejected newsprint copy, Beaumont invents a new art form or technique of printmaking producing what she calls 'spoilspapers' – the first artworks to employ within their structure the index of newspaper printing and the tabloid format. The making of the spoilspapers reveals how technologies and materials themselves have their own agency and, further, how the slippages of newspaper production challenge the idea that any form of mimesis or repetition can produce exact reproductions. Her use of these technologies reveals that though change is not always immediately evident, subtle and imperceptible differences exist in objects and concepts that are assumed to be similar or identical. Her research demonstrates how knowledge is held *within* the materials and processes of making. Waste material,

failed messages, *errata* – or what is sometimes referred to as 'noise' – is reconfigured as ground and potential for innovation. The making of her artworks preserves a record of the time, place and technologies of local newspaper production and becomes an historical record of the technologies of local newspaper printing.

Conclusion

In conclusion, I acknowledge that achievements of researchers in the field are already surpassing the evidence presented here for the claim that artistic research can be viewed as a successor science or new paradigm of research. Through their collaborations with researchers in other disciplines, creative arts researchers are conducting research that challenges traditional assumptions and offers up new notions of what it means to do research and indeed what it means to be human. For example, a 2012 project of the Australian performance artist Stelarc, *Ambidextrous Arm*, illustrates the generative trajectories often taken in artistic research. His performance work was initially concerned with investigating how the body can be used as a direct medium for making art, but more recent experimentation with human–machine interfaces has since lead to projects with robotics that investigate what humans might be becoming. His *Third Hand* project (1980–1998) sets out to 'test' our assumptions about what an arm is and what it can do. *Ambidextrous Arm* is an artwork in progress. However, its technological innovation and potential applications has attracted the interest of medical researchers working in the field of medical prosthetics.

The close link between art and science is also evident in the work of Oron Catts, the director of SymbioticA, an artistic research centre based in the School of Anatomy, Physiology and Human Biology at the University of Western Australia. Catts' research, initially directed at the aesthetics of tissue culture for creating biological art (living jewelry), has taken on a more critical perspective in its investigations of relationships between living things and the impact of human manipulation of environments and other life forms. The *Victimless Leather Project* (2004) investigates the aesthetics and ethics of tissue culture by using living tissue to create a stitchless garment made from leather-like material.

The work provokes debates about the possible effects of new forms of life as cultural productions.

Artists working with new media technologies are extending research debates about the impact of the non-human, interactive technologies, digital information and virtual space on human sensation, subjectivity and social existence. Such research goes beyond traditional paradigms and is creating new methodological, epistemological and ethical perspectives on our encounters with otherness. Where once technology was seen as a tool or neutral channel of communication, it is now rapidly becoming an active agent in human interactions. Hence, it can be argued that creative arts research, as successor science, is responding to the need for a reorientation of traditional research world views and basic assumptions in order to confront the challenges emerging from the invention of intelligent machines, autonomous decision-making systems and smart devices – all of which, along with the material world as we have known it, are becoming participants in both our ontological and social existence. We are still only glimpsing the early movements of this new and expanding field of enquiry.

References

Barad, K. (2003) Posthumanist performativity: toward an understanding of how matter comes to matter. *Signs: Journal of Women in Culture and Society* 28(3), pp. 801–831.

Barad, K. (2007) *Meeting the Universe Halfway: Quantum physics and the entanglement of matter and meaning.* Durham: Duke University Press.

Barrett, E. (2007) Experiential learning in practice as research: context, method, knowledge. *Journal of Visual Art Practice* 6 (2), pp. 115–124.

Barrett, E. (2011) *Kristeva Reframed.* London and New York: I.B.Tauris.

Barrett, E., & Bolt, B. (eds) (2007) *Practice as Research: Approaches to Creative Arts Enquiry.* London and New York: I.B.Tauris.

Barrett, E., & Bolt, B. (2014) *Material Inventions: Applying Creative Research.* London and New York: I.B.Tauris.

Beaumont, D. (2014) Newspaper printing sites and the spoils of creative research. In Barrett, E., & Bolt, B. (eds) *Material Inventions: Applying Creative Research* (pp. 106–126). London and New York: I.B.Tauris.

Eagleton, T. (1990) *The Ideology of the Aesthetic.* Oxford: Blackwell.

Eisner, E. (1997) The promise and perils of alternative forms of data representation. *Educational Researcher* 26 (4), pp. 4–10.

Gibson, R. (2010) The known world. *TEXT* 8, pp. 1–11.

Guba, E., & Lincoln, Y. (1994) Competing paradigms in qualitative research. In N. Denzin & Y. Lincoln (eds), *Handbook of Qualitative Research* (pp. 105–117). Thousand Oaks, CA: Sage.

Haraway, D. (1991) Situated knowledges: the science question in feminism and the privilege of partial perspective. In *Simians, Cyborgs, and Women: The Reinvention of Nature* (pp. 183–202). London: Free Association.

Ihlein, L. (2010) *Framing Everyday Experience: Blogging as Art.* Unpublished PhD Thesis, Melbourne: Deakin University.

Ihlein, L. (2014) 'Bilateral Petersham': Blogging-as-art, art-as-research. In Barrett, E., & Bolt, B. (eds), *Material Inventions: Applying Creative Research* (pp. 55–66). London and New York: I.B.Tauris.

Onions, C. (ed.) (1978) *The Shorter Oxford Dictionary of Historical Principles.* Volume 11, third edition. Oxford: Clarendon Press.

Polanyi, M. (1958) *Personal Knowledge.* London: Routledge & Kegan Paul.

Sutherland, I., & Acord, S. (2007) Thinking with art: from situated knowledge to experiential knowing. *Journal of Visual Art Practice* 6 (2), pp. 125–140.

van der Tuin, I. (2014) On the mode of invention of creative research: onto-epistemology. In Barrett, E., & Bolt, B. (eds) *Material Inventions: Applying Creative Research* (pp. 291–308). London and New York: I.B.Tauris.

Notes

1 The relationship between new materialist thinking, onto-epistemology and creative arts practice is outlined in accounts by Iris van der Tuin and other contributors to Barrett & Bolt (2014).

2 See my account of the aesthetic Image and material process in *Kristeva Reframed* (Barrett 2011).

RETHINKING THE CONTEMPORARY ART SCHOOL, OR WHAT ARTISTS KNOW THAT OTHERS DON'T

Brad Buckley

We have art so that we do not die of the truth.

<div align="right">Friedrich Nietzsche</div>

...voyaging begins when one burns one's boats, adventures begin with a shipwreck.

<div align="right">Michel Serres</div>

Our word 'history' comes from the Greek word meaning 'enquiry'. It embodies the assumption that men and women are curious about life on earth; that they wish to question the dead as well as the living, and to ponder the present and the future as widely as possible from knowledge of the past.

<div align="right">Shirley Hazzard</div>

If we knew what we were doing it wouldn't be research.

Albert Einstein

The title of this chapter comes from a collection of essays, published as *Rethinking the Contemporary Art School: The Artist, the PhD and the Academy* (2009), which I edited with my colleague John Conomos. John and I began collaborating in 1999 when we organised two successful forums at Artspace Visual Arts Centre in Sydney in the lead-up to the referendum which would decide whether or not Australia would became a republic. Unfortunately for those of us who are republicans, the referendum was lost. The papers from this conference were later published as a book, *Republics of Ideas* (Buckley & Conomos 2001). It was the first book to examine the social, political and cultural implications of an Australian republic in the context of the visual arts and the new global economy.

Thus began a discursive and polemical collaboration with John Conomos that has produced or refined many of the ideas in this chapter. It draws on various published papers, some of which we have co-authored, and also on *Rethinking the Contemporary Art School. Rethinking the Contemporary Art School* examines the reasons for the art school and for its continued existence, its role in society and the question of what should be taught and learnt in what is now a globalised art world. The book also considers various art school models, from innovative graduate programs to independent stand-alone schools such as Rhode Island School of Design (RISD), Nova Scotia College of Art and Design University (NSCADU) and the Royal Danish Academy of Fine Art, to art schools which are departments or schools within major research universities – and the problems the latter face of being "marginalised in university life", as US theorist James Elkins describes it (2006). The relationship of the art school and its academic staff to the university is complex, and at times strained. This creates a range of challenges and issues related to the nature and level of the appropriate terminal degree, when the visual or fine arts can be research, and how this research should be funded.

This chapter is divided into three parts. The first part offers some insights into these issues in the broader Western tradition of educating artists and higher degrees, with an added focus on the extended

writing required for most PhDs, the role of the academic and the problems surrounding research funding. It also looks at the ongoing debate in the US and Canada about whether art schools should offer PhDs, and discusses some of the reasons for there being such resistance to this idea. The second part considers the impact of these issues and difficulties on artists who work in Australian university art schools – these artists are often expected to obtain research funding from the Australian Research Council (ARC), despite there being no ARC categories for creative work. Finally, the chapter considers what artists know that others don't.

The Art School Higher Degree and Why There is Still Resistance to It

What confronts today's tertiary art institutions, their academics and, not least, art students is a complex and shifting geopolitical situation in which art and education are undergoing unpredictable transformations. Simply put, opinions about what role a PhD might play in visual arts education depend on where one is. Everywhere one looks there are substantial 'push and pull' factors – primarily, the battle is between innovation and experimentation on the one hand, and tradition and conservatism on the other.[1] Therefore, one is obliged to rethink what a contemporary art school is and whether a PhD has a viable future in academic institutions. How will a PhD benefit the present and future generations of students who wish to be artists? Whatever our specific socio-cultural and political context, art academics must locate visual arts education between research and the marketplace. Both are multilayered in meaning and significance.

Art students are very aware of the risks, implications and possibilities of becoming 'professional' artists. But how do we define an 'artist' today? Is it just a word that indicates 'professional status' and social acceptance, or does it signify something more? Does it also mean being engaged in a critique of one's place in our shared world? Is it possible for artists to have professional status that is consensually recognised, as other professions that tertiary education is responsible for (accounting, architecture, law, medicine) do?

If art schools are to become merely departments within progressively more corporatised universities, what value will we place on art as "experimentation" (Deleuze & Guattari 2005/1987) and on sociocultural critique? Will art become a profession equivalent to the minor decorative arts? Will there still be art (and art education) as Socratic enlightenment? To echo Louis Menand's recent fine probe (Menand 2010) of what ails our universities today, are they just marketplaces for occupational training and recruitment, or should they maintain their traditional larger role as a marketplace for ideas?

These are some of the more compelling issues that the idea of a PhD in visual arts is raising. Each tertiary institution will respond differently, depending on its context – culture, geography, history, politics and economics – and its willingness to explore the educative, critical and professional value of enhancing the creative, research and occupational horizons of our art students.

Let us now briefly look at what is happening with PhDs in the visual arts in Canada, the United States, Europe and Asia. Few institutions in the United States currently offer a PhD degree in studio art, and the College Art Association (CAA) remains very sceptical of the idea that the PhD will replace the Master of Fine Arts (MFA).[2]

Over the past five years, the debate has shifted somewhat. At least five university art schools in Canada have introduced PhD studio programs and, in the United States, the Institute for Doctorial Studies in the Arts and the University of California at San Diego also offer a PhD.[3] A number of prominent art schools in the United States are considering their options, so it remains a hot-button issue at every CAA conference. But though the debate continues there, Australia, New Zealand, the United Kingdom, Japan and some northern European academies such as the Finnish Academy of Fine Arts and the Malmö Art Academy have, for more than a decade, offered the PhD as the terminal degree in the visual arts (see also Elkins, in this volume, for further discussion).[4]

Given that art schools are riddled with contradictions, schisms and tensions, what kind of PhD program should be adopted once one accepts its validity? Outside the US, the debate has moved to a more

sophisticated level, with widespread acceptance that the doctoral thesis may be of multiple forms, including painting, sound, performance, installation and text. Though even this is not without its critics, it seems generally accepted. What remains unresolved is the role of the written component or what I prefer to call the text in the PhD. How long should it be? What form should it take? Is it an exegesis, which tends to describe the studio process, writing it up in the model of scientific enquiry, or a text that attempts to place the studio work in a conceptual or historical framework? My own preference is for the text to be an elaboration on the research question, to be intertextual with the studio or creative work. By this I mean that there is one research question on which the candidate proceeds to work, allowing different ways or models of knowledge to illuminate and inform both the text and the creative or studio work, thus producing a genuinely integrated thesis.

The work of Australian born, US-based artist Tony Schwensen (2011) is a good model of this integrated thesis. His thesis *Interfluentiality: The influence of the work of Samuel Beckett on the videoperformance work of Bruce Nauman and Vito Acconci* was originally concerned with the broader works of various Australian and American performance artists of the 1960s and '70s. However, over the course of the PhD, Schwensen refined the research question to focus on an examination of the American artists Vito Acconci and Bruce Nauman. His research examined the video performance works of these two seminal artists and the influence and impact Samuel Beckett had on their work during this period. Schwensen's research led to a new understanding of Beckett's influence on these artists and in turn his own creative work (video performance) underwent a highly reductivist use of language, manifested mostly in the form of monologues and stripped-down sets, creating a highly charged and emotionally engaged video performance.

It is a Herculean task for present-day art academics to persuade their university and artist peers of the complexities of the aesthetic, cultural and historical aspects of contemporary art and its teaching and research. Aside from questions of ignorance, indifference and parochialism, there is also the constant problem of the very competitive pecking order among the schools and departments of a university.

The key idea of a PhD as research training in visual art education is slowly gaining ground, though. It is indicative of the dawning realisation among the younger generation of artists who work in university art schools that a PhD should be encouraged for many reasons: it can give art students vital self-empowerment, professional recognition and a qualification, and, most importantly, new research horizons and opportunities, such as postdoctoral fellowships. In Australia, where PhD programs in the visual or fine arts are considered research training and PhD candidates are treated as junior academic staff, with complete access to scholarships and research support grants, it is a strange fact that academics working in the visual or fine arts in these universities have almost a zero success rate when applying for research funding if their project has a creative outcome.[5] This leads me to the second part of this chapter.

How the Australian Research Council (ARC) Continues to Fail Artists

Given the emphasis on corporatising universities and commercialising research, today's art schools face a bleak and unpredictable future. Since the forced amalgamations of art schools in Australia with universities in 1990 and the following decade-long drive to have them mirror the rapidly changing management and funding models of their host institutions, various problems have emerged – and, it must be said, various benefits have also been realised.

There is a flaw that these arranged marriages have brought with them as an unwelcome dowry, a flaw that has dramatically swung the balance against individual artists working in universities and art school faculties. This flaw is funded research. Art schools and their academic staff – who are art practitioners – lead a shadow life in the eyes of their colleagues in other disciplines. In addition to this, and despite some recent (and much appreciated) attempts to ameliorate the situation, they are severely handicapped when applying for ARC (Australian Research Council) grants – the major source of federal funding for arts and humanities research in Australia. Artists are behind the proverbial eight ball because the ARC funding model does not adequately address their creative and pedagogic attributes: to put it another way, creative work

is not recognised as a legitimate field for funded research. It is almost as if C.P. Snow's 'two cultures' debate of the 1960s, drawing attention to the divide between the sciences and humanities, never happened (Snow 2001/1959).

To understand why the ARC continues to resist the recognition of creative work 20 odd years after the university amalgamations of the 1990s, it is necessary to acknowledge the Anglo-Australian-US tradition of art education, in which the handmade or utilitarian is privileged over the discursive. This residual prejudice – that art is essentially a manual activity or only about personal expression, and thus not a legitimate outcome of research – is at the core of the ARC objections to applications from artists. Since Oscar Wilde's time, art has also been acknowledged as a tool for criticising society; this precept is axiomatic in the visual arts today. Shouldn't funded research at university level reflect this? Somehow, the lexicon of what constitutes valid research still excludes all this.

What is the result of this 20-year embargo on the funding of creative work in art schools? As well as the obvious disadvantage that individual artists face through not having their creative work funded, a manipulative climate has grown up in which they are encouraged to develop research projects that do not represent their primary intellectual concerns as artists but which do fit neatly into the ARC funding categories or the federal government's research priorities. Art school faculties are also being penalised in terms of block grants, which are tied to the successful awarding of ARC grants. Fewer ARC grants means a reduced level of funding to the faculty's overall budget. The lack of research income is having a seriously debilitating effect on the core activities of art schools: to produce visual artists who are self-critical, and who are steeped in knowledge and understanding of contemporary art. Many are evolving into faculties that produce graduates who are mute as visual artists. Some of these faculties are being coerced into offering fee-paying courses that produce, paradoxically, graduates who merely service the corporate design and economic needs of globalisation.

If universities house, as George Steiner claims in his elegant memoir *Errata*, "diverse, often rival parishes" (Steiner 1999), where do art schools situate themselves in this more competitive pedagogic ethos? Are art

schools better off being independent of the university system? Is this even possible today in light of what is happening in our universities in terms of their structures and commercialised research? At their best, art schools are sites of experimentation, innovation, learning and the development of professional networks. All of this is invaluable creative and social capital that universities and society could tap into if they were more open to new cross-disciplinary research and pedagogic practices.

It is no surprise, then, that in the April 2008 issue of the *Harvard Business Review*, an article about the creativity index, which uses a measure of technology, talent and tolerance combined as an indicator of a country's ability to achieve growth, rated Australia outside the top 15 countries. While the creative index has its critics, it is patently obvious that the ARC understands 'creativity' – or to use a more contemporary term, 'innovation' – to be the product only of engineering, business and the hard sciences. In the same issue, the author of *A Whole New Mind*, Daniel Pink, is quoted as arguing that the MFA is the new MBA, with big business looking for visual artists. Ironically, it is visual arts graduates who can give companies an advantage because, as he puts it, "the only way to differentiate their goods and services in an overstocked, materially abundant marketplace is to make their offerings transcendent – physically beautiful and emotionally compelling" (cited in Bell, 2008).

These are all signs of a changing world, a world in which creative work and artists play a vital and complex role, and where that role should be acknowledged in universities in terms of funded research. If we accept poet and writer Ezra Pound's idea (2010/1934) that artists are the antennae of the human race, we cannot afford to ignore the important role they play in the creative, innovative, economic and social life of our post-Fordist society. Until the universities and the ARC change their views about the funding of creative work and allow artists to come out from the shadows, Australia will remain a significantly lesser society.

I was struck recently by the Australian literary critic Geordie Williamson's review of a collection of essays by Susan Sontag. He draws our attention to the first essay, 'An Argument about Beauty', in which Sontag writes about how the beautiful "stimulates and deepens our sense of the

sheer spread and fullness of reality that surrounds us all." Williamson goes on to make the following point:

> This is an elegant recasting of [an] old belief, shared by artists and scientists, that attentiveness towards the world is itself an ethical imperative. That this expanding perceptual delight also widens our sense of responsibility for those who share our world is the point of intersection between Sontag's political thought (which serves human freedom) and her thought that pursues private perfection (that is, aesthetic bliss).
>
> (Williamson 2007)

Ultimately, the challenge for artists who work in universities is not to lose sight of this ethical imperative.

And Finally, What Do Artists Know That Others Don't?

This question is always at the foreground for artists who seek to speak of their world in critical and probing terms. This suggests a basic willingness to find new ways of speaking about the present in continuing dialogue with the past, and a constant refusal to accept the current explanations of our contemporary condition. In a word, an artist worthy of the name is someone who sees art as an expression of "untimeliness" (Agamben 2009) – neither now, nor the past or future – but whose creative output is significantly shaped by their own singular relationship to their own time.

Artists are engaged, through their artmaking, in a continuing conversation about the larger questions: aesthetics, culture, economics, ideology, sex, power, space, spectatorship, technology and time. Hence artists who endure have always known that understanding and discovery come through the process of making, that the creation or generation of new knowledge is embedded in the work they make, even if they do not always describe it in such terms. Creating new knowledge is predicated on a basic refusal to accept received wisdom; it relies on doubting everything. In this sense the artist is always a contrarian, and always coming to terms with the paradoxes of creativity and what it means to be contemporary (Agamben 2009).

Research in art uses different ideas, techniques and methodologies than research in the humanities, or the physical and social sciences does. In art it is not just a question of identifying "new untilled fields", according to Samuel Beckett (Zurbrugg 2000), of creative enquiry and production; it profoundly depends on the artist's intuition, hunches, creative instincts and sensory experiences. It also depends on knowing failure as an essential of artistic creativity (Beckett, 1983).[6] Art can and does generate new knowledge as long as the artist maintains a capacity to question the more predictable explanations and norms of their world. In her thesis 'Unsettled Present – The Politics of Space in Contemporary Art', Biljana Jancic (2013) explored questions that relate to historical memory. Jancic came to Australia as a teenage refugee from Croatia, and focussed in her thesis on memory as signified through the building of monuments by the victors in war, and on unintentional monuments created through changed social or political circumstance, such as the Berlin Wall. In Berlin, the only visible war memorial celebrates a battle from the First World War and is almost obscured from view by strategically planted trees, as the stain of the National Socialists or the Nazis permeates every aspect of the German psyche, even today. In contrast, the Berlin Wall itself, used by the German Democratic Republic (GDR) or East Germans as a means to protect the people of the republic from the decadent West, now stands as a monument to a repressive regime that killed hundreds, if not thousands, of people who tried to escape to the West. For artists who have lived through ever-changing belief or political systems, Beckett's words ring all too true.

Paradoxically, then, where visual art research matters most is when it is avowedly suspicious of its own ideological, institutional and pedagogic definitions of research. Artists who go against the grain of what is considered research in the more traditional disciplines can generate exciting new paths of research activity and knowledge. These are the artists who are enthralled by the life project of art as pluralism, art as power, art as mirroring ourselves to ourselves.

In short, if art represents criticism, knowledge and research, and uses its own definitions and methods, and matters precisely because society deems it 'useless' (Wilde 2005/1891), then it demands that we foster it within the university – which should remain a cherished sanctuary of

open debate in our society. After all, artists can see, think, feel and intuit possibilities of research, knowledge, innovation and methodologies that may not be so evident in other disciplines. Artists are concerned with making the rest of society able to see, feel and interact with vivid new uncharted domains of experience, knowledge and perception.[7]

References

Agamben, G. (2009) *What is an Apparatus? And Other Essays,* translated by D, Kishik & S. Pedatella. Stanford: Stanford University Press.

Beckett, S. (1983) *Worstward Ho.* London, UK: Calder Publishing.

Bell, K. (2008) The MFA is the new MBA. *Harvard Business Review,* 14 April 2008 (np). Retrieved from: http://blogs.hbr.org/2008/04/the-mfa-is-the-new-mba.

Buckley, B., & Conomos, J. (eds) (2001) *Republics of Ideas.* Sydney: Pluto Press.

Buckley, B., & Conomos, J. (eds) (2009) *Rethinking the Contemporary Art School: The Artist, the PhD, and the Academy.* Halifax: NSCAD University Press.

Deleuze, D., & Guattari, F. (2005 [1987]) *A Thousand Plateaus.* Minneapolis: University of Minnesota Press.

Elkins, J. (2006) Afterword: on beyond research and new knowledge. In K. MacLeod & L. Holdridge (eds), *Thinking Through Art: Reflections on Art as Research* (pp. 241–247). New York: Routledge.

Jancic, B. (2013) *Unsettled Present – The Politics of Space in Contemporary Art.* Unpublished PhD Thesis, University of Sydney.

Menand, L. (2010) *The Marketplace of Ideas: Reform and Resistance in the American University.* New York: W.W. Norton & Company.

Pink, D. (2005) *A Whole New Mind.* New York: Riverhead Books.

Pound, E. (2010 [1934]) *ABC of Reading.* New York: New Directions Publshing.

Schwensen, T. (2011) *Interfluentiality: The Influence of the Work of Samuel Backett on the Videoperformance Work of Bruce Nauman and Vito Acconci.* Unpublished PhD Thesis, University of Sydney.

Snow, C. P. (2001 [1959]) *The Two Cultures.* London: Cambridge University Press.

Steiner, G. (1999) *Errata: An Examined Life.* New Haven: Yale University Press.

Wilde, O. (2005 [1891]) Preface. In *The picture of Dorian Gray.* New York: Simon & Schuster.

Williamson, G. (2007) A Very Public Intellectual. *Weekend Australian,* 6 October 2007, 8.

Zurbrugg, N. (2000) *Critical Voices: The Myths of Postmodern Theory.* Amsterdam: G & B Arts International.

Notes

1 See my paper 'A New Horizon: what is on offer for the artist with a PhD?' delivered as part of the session PhD for Artists: Sense or Nonsense? Part 1, 100th College Art Association Conference, Los Angeles, US. This session was co-chaired by Professor Bruce Barber, Nova Scotia College of Art and Design University and Dr John Powers, independent artist and scholar.

2 Adopted by the CAA Board of Directors, 16 April 1977, revised 12 October 1991 and 26 October 2008. For the most recent version of the policy, see *Guidelines: MFA Standards, CAA*, CAA, n.d., 29 January 2009, www. collegeart.org/guidelines/mfa.html.

3 See my paper 'Why a Ceiling? The visual arts should embrace the PhD', delivered as part of the session Has the Master of Fine Arts Outlived its Usefulness as a Terminal Degree?, Part 2, at the College Art Association's 90th Annual Conference, Philadelphia, February 2002. This session was chaired by Professor Bruce Borick, Department of Art, State University of West Georgia, US.

4 See 'Future-Proofing the Creative Arts in Higher Education: A Scoping Project for Quality in Creative Arts Research Training', *CreativeArtsPhD*, CreativeArts, 29 January 2009, http://www.olt.gov.au/resources?text=C reative+Arts+Phd. This scoping project was an Australian Learning and Teaching Council (ALTC) funded initiative conducted in partnership between the Australian Council of University Art and Design Schools (ACUADS), the Victorian College of the Arts (VCA), the University of Melbourne and the Sydney College of the Arts (SCA), University of Sydney. The project leaders were Su Baker and Brad Buckley.

5 For a recent discussion on research in the art and design school context see Henk Slager, *The Pleasure of Research*, Finnish Academy of Fine Arts, 2012.

6 For an extended discussion on the concept of failure in higher degrees in the visual arts see Bruce Barber, 'The Question (of Failure) in Art Research' in Brad Buckley and John Conomos (eds), *Rethinking the Contemporary Art School: The Artists, the PhD, and the Academy*, NSCAD Press, Halifax, 2009.

7 For a wide-ranging discussion on the PhD in the studio context and research in visual art and design, see Brad Buckley and John Conomos (eds), *Rethinking the Contemporary Art School: The Artists, the PhD, and the Academy*, NSCAD Press, Halifax, 2009.

CREATIVE PRACTICE, RESEARCH ETHICS AND THE DOCTORAL THESIS

Barbara Bolt, Kate MacNeill, Pia Ednie-Brown

In the 1990s, reforms in the Australian higher-education sector brought post-secondary training in the creative arts into the context of university education (Baker & Buckley 2009). One consequence of this shift from training institution to research institution was the expectation that artists-as-academics produce research outputs and that the creative arts would develop a tradition of doctoral candidates and research. Reframing creative arts as research meant that art-as-research, like all research in the academy, became answerable to the university ethics processes and procedures. Without a history of their own to negotiate the ethics system, the creative arts, in particular the visual arts, looked to the extensive work on visual ethics in the fields of visual anthropology, geography and sociology. Whilst acknowledging this debt, there are fundamental differences between research in the social sciences and in the creative arts. These differences relate both to the methodologies deployed in creative practice and to the way in which some creative

practices approach the question of ethics itself: with a tradition of avant-gardism, many creative arts practitioners seek to confront ethical issues directly as the subject of their art as research. Much creative practice is in-and-of-itself performative – it has its own effects in the world. It is these effects in the world that present particular challenges to the increasingly risk-averse educational institution.

In this chapter we examine the way in which the ethical frameworks of the university interact with art as research and in particular the implications this may have for innovative doctoral research. Drawing on the outcomes of a survey conducted at a university art school, we analyse the potential impact of the ethics approval process on art making in the academy. This is contrasted with the operations of the 'aesthetic alibi' which has long recognised avant-garde art practices and artists as a case apart, leading to the concern that the ethics process may have the effect of limiting avant-gardism on the part of students. We conclude with an examination of a range of methodologies embraced by creative practitioners and speculate as to the ways in which these might be accommodated within the current institutional ethics processes.

Creative Research in the Academy

Following the Dawkins reforms to higher education in Australia in the 1990s, there has been a rapid growth in postgraduate education in the creative arts with the introduction of the creative arts doctorate, the expansion of research master's courses and a subsequent increase in postgraduate enrolments. Over the period 1989–2007, the number of universities offering creative arts doctoral programs increased from 12 to 30 and enrolments in these doctoral programs increased tenfold (Baker & Buckley 2009, p. 22). As a result of this trend, creative arts research has become firmly entrenched within higher-education research institutions. With its place secured, creative arts postgraduate education has been inducted into processes and procedures of a research culture and, of importance for this chapter, the ethical protocols that govern the conduct of research.

Whilst the literature addressing creative arts research has burgeoned over recent years as countries such as Australia, the UK, Canada,

New Zealand and the Scandinavian countries develop their graduate programs in this field, the *work* around research ethics has logically followed rather than led this development. Whilst there is now an emerging literature around ethical issues in the creative arts (Bolt et al. 2009; Bolt & Kett 2010; Ednie-Brown 2009 & 2012; MacNeill & Bolt 2011; and Zurr & Catts 2003) it has been the social sciences, and visual ethnography in particular, that have provided the foundational models and exemplars valuable to creative arts research. The use of 'visual data' – photographs, films, videos, memorabilia and other visual data – in visual ethnography has seen the emergence of a new specialised form of ethical engagement, that of visual ethics. This burgeoning field has witnessed the publication of several key reports in the UK, for example, the Economic and Social Research Council (ESCR) publications *Visual Ethics: Ethical Issues in Visual Research* (2009) and *Ethical Regulation and Visual Methods: Making Visual Research Impossible or Developing Good Practice* (2010). These reports have identified the ethical issues that arise when working with visual data and drawn out the implications these have for research in the visual field.

The research work done by the social sciences, particularly visual sociologists, visual anthropologists and visual geographers, has provided valuable models for the creative arts, and recent publications such as Rose Wiles' *What Are Qualitative Research Ethics?* (2012) and Martyn Hammersley and Anna Traianou's *Ethics in Qualitative Research: Controversies and Contexts* (2012) have responded to this changing research environment, providing a guide to researchers in the social sciences. However, the 'problem' for the creative arts is a qualitatively different one. Firstly, in the social sciences, images, films, photographs and other visual elements become 'data' to be analysed. In the creative arts, on the other hand, these visual elements *are* the research outcome – a film, video, performance, painting, photograph, print or sculpture *is not* merely visual data to be analysed but is a performative and transformative thing-in-itself. Secondly, once artists graduate from the academy, they are not required to subject their work to ethics regulation.

Artists continue to see the arena for ethical determination as resting with the community, that is, with art viewers and the general public, and not with an ethics committee. This has created a tension for artists

working in the academy.[1] The reality is, however, that creative artists undertaking research in an academic setting are now subject to the same research ethics processes and protocols that are applicable to all university researchers, namely the *National Statement on Ethical Conduct of Research Involving Humans* (NHMRC et al. 2007) and the *Australian Code of Practice for the Care and Use of Animals for Scientific Purposes* (NHMRC 2004). The *National Statement* specifies that all research involving humans must be conducted in accord with the following principles: the research must have merit and integrity, be designed and conducted according to the principle of beneficence (that is, to maximise benefits and minimise risks to participants), and be in accord with principles of justice and demonstrate respect for human beings (NHMRC et al. 2007, pp. 12–13). Research involving human and animal participants is scrutinised by university ethics committees before a researcher is given the authority to proceed with a project. With a focus on researcher integrity, justice and beneficence, the role of university ethics committees is to manage risk in a research setting in order to balance the benefits of research against the potential risks. According to the *National Statement*, the likely benefit of the research must justify any risks of harm or discomfort to participants (NHMRC et al. 2007, p. 13).

The implementation of these requirements varies from institution to institution but what is consistent is a requirement that the research needs to be "designed or developed using methods appropriate for achieving the aims of the proposal" and that it pass a test of beneficence prior to commencing the work (NHMRC et al. 2007, p. 12). Oversight of ethics compliance occurs largely through a self-regulating model of ethics committees within institutions, operating under the broad oversight of a research office but always in accord with the *National Statement* (2007) and the *Australian Code of Practice* (2004). In some universities, ethics committees are constituted within interdisciplinary schools or at faculty level and examine all research projects that involve interaction with humans and animals. At the University of Melbourne, minimal-risk projects, for example interviews with subjects over the age of eighteen and with no inquiries of a sensitive nature and with full consent, will be dealt with at a school or faculty level with more sensitive projects being determined by a higher-level committee at the University level. Other universities deal with ethics issues at the university level.

In the sciences, experiments that involve human and animal subjects are commonplace and ethics oversight is routine, with both academic and doctoral researchers having extensive precedents on which to draw. The challenge facing doctoral candidates and artist researchers in the creative arts is to be able to articulate their research project – its aims, design and methods – in such a way as to be able to justify what might otherwise be considered to be sensitive or unjustified engagements with humans and animals. The issue arises when the creative arts research comes up against or is perceived to be in conflict with questions of public good. According to the *National Statement*, research institutions have a "public responsibility for seeing that these interactions are ethically acceptable to the Australian community" (*National Statement*, 4). The question of public good is tied to the principle of beneficence. Beneficence involves a judgment about whether "the likely benefits of the research must justify any risks of harm or discomfort to the participants, to the wider community, or to both" (*National Statement*, 13).

Creative research – particularly in performance studies, performance art and film and television – frequently uses human and animal participants and their engagement with the ethics process requires that they negotiate the level of perceived risk of the project, from minimal-risk to high-risk projects. Creative practices that utilise surveillance techniques or appear to impinge on personal freedom and/or privacy, that include the use of animals in art, and creative practices that involve children or family members are considered to be high-risk research activities requiring ethical clearance through a higher-level determination.

A Clash of Cultures

The relation between creative arts research in the academy and artistic activity in the community raises critical questions for creative arts research and the future of avant-garde artistic practice. Creative researchers become the artists and designers of tomorrow. How do we reconcile the protocols required in the academy with art practices in the wider art world that test the limits of what is acceptable?

French artist Sophie Calle's art deliberately blurs the boundaries between the public and the private. For example, in *Suite Vénitienne* (1980), Calle

stalked a stranger across Europe, and in *The Hotel* (1981), she used her role of a chambermaid at a hotel in Venice in order to go through hotel guests' belongings. These became 'data' for the exhibition. At the Venice Biennale in 2007, her exhibition *Take Care of Yourself* (2007), included 107 different women's artistic interpretations of a personal email that Calle's ex-lover had sent ending his relationship with Calle (Bolt 2011). How might an ethics committee deal with such projects if they were framed as research?

Performance art provides some of the greatest tests to the limits of ethical protocols. The performance artist Marina Abramovic visited Melbourne as part of the 1998 Melbourne International Arts Festival where she presented a work that required the audience to be physically restrained within a holding cell of the Old Melbourne Gaol. In a separate work, Abramovic invited an audience to take up knives and other weapons against her – incurring actual physical harm to her. Through her performance career, "Marina Abramovic has had a stranger point a loaded gun at her head, sat in silence for 700 hours and set herself on fire" (O'Hagan 2010). Vito Acconci's *Claim* (1971) challenged audiences to approach the artist, who was fiercely guarding a stairwell entry, and threatening to do physical harm to anyone who approached. Art involving animals similarly raises ethical issues. In 2000 at the Trapholt Art Museum in Denmark, Marco Evaristti challenged viewers to activate food blenders containing goldfish, resulting in animal cruelty charges against the Museum Director. The charges were successfully defended when it was established to the satisfaction of a judge that the fish did not suffer. The Guillermo Vargas Jiménez installation at Códice Gallery in Managua, Nicaragua (2007) included a stray and emaciated dog tethered in the gallery.

Australian art has its own examples of art practices that would fall within the purview of an ethics committee were they carried out within the university setting. In 1975, Ivan Durrant draped a cow carcass across the entry of the National Gallery of Victoria and was filmed shooting a cow in front of the Monash Gallery of Art. A recent exhibition of Mike Parr's performance work included "Parr sewing up his face and hurling and an abstract text of abusive 'Australianisms', standing with extreme vulnerability in the twenty-hour performance *Cartesian Corpse*, and

asphyxiating in *100 Breaths*" (Garrett-Jones 2012). SymbioticA has collaborated with the Australian artist Stelarc to grow an ear out of cells (Zurr & Catts 2003). When exhibited at the National Gallery of Victoria, the NGV, in response to ethical concerns, displayed a notice assuring visitors that no human tissue was used. Most recently the work of internationally renowned artist Bill Henson was the subject of controversy when complaints were made about his use of adolescent models (see Marr 2008 and MacNeill 2010).

When artists carry out transgressive practices in the community, the community, its laws and institutions will judge the outcome. Some of the work just described resulted in threats of legal action; other work was the subject of institutional anxiety and prescriptive modes of display. If, however, any of these projects had been proposed as a doctoral research project in the academy, a very different test would be applied and indeed the work may never be 'justified'. Such is the nature of the ethics process.

Avant-garde Art Practices

It is clear then that if there is to be interaction with humans or animals as part of a creative practice doctoral project, ethics approval will be required prior to the commencement of the research. This establishes a very different scenario to that which confronts an artist making work outside the academy where the concept of the aesthetic alibi, the suggestion that art is beyond legislative sanction, is often invoked. The aesthetic alibi has long recognised that art has a special place in relation to the everyday. It allows for legal defences that protect works of art and art making which would otherwise be deemed illegal (for reasons of obscenity, pornographic content, or racial and religious vilification) and is implicitly invoked when contributors to public debate argue for the sanctity of a work on the basis that it is 'art'. This claim of artistic freedom has been defined as "a special case of freedom of speech, which raises it to a more purified level... what would be libellous or offensive in everyday life is granted special dispensation, if it is understood to take place within the protective shield of an aesthetic frame" (Jay 1998, pp. 110–111). The notion of artistic freedom is a legacy of avant-gardism that runs through contemporary art and which sees art as a necessary challenge to the status quo. In Australia, the aesthetic alibi has existed in

the form of defences for works of 'artistic merit' and work produced for 'genuine artistic purposes' against crimes such as obscenity. However, more recent legislation has taken a different approach. For example, the Anti-Terrorism Act (No. 2, 2005) omitted the standard aesthetic alibi defence that enables artists to plead the artistic merit of works that might otherwise be regarded as unlawful, preferring the more general expressions 'good faith defences' and 'public interest'. Public interest or public good, as we have already argued, is tied to the *National Statement*'s argument for beneficence.

Increasingly, and perhaps nowhere more so than in the university sector, this spirit of avant-gardism must now be reconciled with the requirement that creative arts research or artistic research operate within ethical codes of practice. The claim that there is something unique about artistic activity that sets it apart from 'everyday life' cannot be taken for granted and is not a defence accepted by ethics committees. Many contemporary art practices sit precariously on the boundary of art and everyday life, and it is these areas of creative arts practice that are particularly vulnerable to assertions of unethical conduct within the educational and professional sector. Indeed the realm of the aesthetic is now meeting that of the ethical in new ways, without any detailed examination of the implications. Jacques Rancière (2009, 2010) asserted a distinction between an aesthetic practice and an ethical practice, and proposes that an ethical practice demands that individuals be treated according to the dominant ethos of the community in which they live. Aesthetic practices on the other hand seek to operate outside these norms and in so doing open up and allow for unthinkable possibilities. In this context, the avant-gardism of artistic activity and its challenge to dominant social mores could be considered to be in opposition to ethical regulation. A belief in the provocative role of art goes hand-in-hand with the notion of aesthetic freedom and the aesthetic alibi. Susan Best encapsulated this tension when she referred to art "being seen as transgressive and lawless rather than being governed by the pursuit of the good" (Best 2004, p. 8).

A Case Study of Risk Aversion

With no explicit guidelines available to ethics committees operating in the field of creative practice research and a paucity of relevant literature,

we know little about the impact that ethical oversight has had on creative practice in the academy. Moreover, what evidence there is suggests that artist scholars believe ethics protocols, processes and procedures operate as silent regulators of conduct and a subtle determinant of content in creative arts practice and research. *Research Ethics and the Creative Arts* is a small-scale survey that documented the attitudes of academic artists to the ethical regulation of art-as-research (Bolt et al. 2009). In the context of this survey, academic researchers both constitute the university ethics committee and oversee the creative practice research of doctoral candidates; hence their attitude to ethical regulation will be extremely influential in terms of the practices of doctoral candidates. The survey sought to uncover the particular concerns that might relate to creative arts research as distinct from the more general criticism of the ethics process across the university. Designed as a pilot and funded through the University of Melbourne Research Office, the study surveyed supervisors of research higher degree students in the creative arts: music, performing arts, film and television and visual art.

Respondents who had sought to apply the ethics process in a creative arts context expressed three main concerns: that it militated against innovation and experimentation in research; that they found it difficult to apply the specific format of the ethics procedures to creative arts research; and that there was a general lack of certainty as to what constituted 'research' in the context of the creative arts (Bolt et al. 2009, p. 8).[2] It is important to note that respondents were not asked to provide actual examples that supported their responses. However, the mere perception of the ethics process as a restriction on artistic freedom and a cumbersome, and therefore to be avoided, procedure is indicative of the current lack of fit between creative and regulatory practices.

The perception on the part of respondents that the ethics procedure introduces limitations on actual creative practices has the potential to diminish the innovation and experimentation that should stand at the heart of art practice. The following comments reflected this anxiety: "the criteria for ethics clearance militate against the kind of exploratory, risk-taking activities identified with the creative process" (Respondent K) and the ethics process operates "as an inhibition, as a silent regulation of conduct and as a subtle determination of content, ambition and daring"

(Respondent K). Further evidence that doctoral students might abandon a particular direction of research can be found in the observation that "the mere mention of these considerations [the ethics guidelines] is enough for the student to self-censor. ... Even students involved in painting portraits begin to wonder if they need ethics clearance and begin to shift their practice to avoid this issue" (Respondent A). There was also the perception that the imposition of the ethics process within the academy operated as a form of censorship, which would not be relevant in the wider artistic community. "The true arena of ethics determination is in the community – art viewers and the public. This is a key function of art. If it cannot be accommodated, we should not be in the University" (Respondent A). And further: "many of the ways artists use oblique strategies in the research and creative production cannot overcome the difficulties of ethics clearance, thus some artistic practices may be deemed unacceptable to the University when at the same time they are perfectly acceptable in the art world and in the broader cultural context."

Recent public controversy around art practices, particularly those involving children, suggests that not all art practices are 'perfectly acceptable' in the community at large but certainly the aesthetic alibi has created the perception within the art world that artistic creativity is unregulated and that it should remain that way. The controversy that surrounded Bill Henson's nude photographs of an adolescent girl put questions of the aesthetic alibi at the centre of public debate. The debate rapidly polarised: on the one hand, demands that the artist be prosecuted and the work banned; and on the other, assertions that, as a work of art, it should inherently be outside of the jurisdiction of the courts (MacNeill 2010). Nonetheless, it is worth noting that the debate about this work of art commenced once it circulated in the public sphere, long after the work had actually been created.

This goes to the nature of artistic practice: that the effects of it are to be found long after the work's creation, and the work itself has agency in the world beyond any intentions of the artist. Where does the research begin and end? This uncertainty about the actual nature of creative arts research was reflected in the second set of concerns expressed by respondents to the survey: that the ethics process was difficult to negotiate and perhaps inappropriate for the creative arts. "At the early

stages, a creative, practice-led project can have broad aspirations with much of the 'actual' still to be discovered 'through' the process. This can be too intangible to explain within ethics approval" (Respondent L). "The limitation this places on the development of visual art images for studio-based research functions rather like censorship. Additionally the methodology has to be adjusted to a constricted form... in order to meet the guidelines" (Respondent M) (Bolt & Kett 2010, p. 18). For one respondent, the need to articulate a methodology was anathema:

> For the visual artist, methodology is another name for a failure to experiment, a failure to invent. There are methods, but not formalised and they should always be ready to be abandoned. Ethics guidelines do frame a research question but in a restrictive way. To invite a pun, in the visual arts you should not consider framing until the work is done.
>
> (Respondent A)

A belief that the ethics process would inhibit creativity can be seen in the following comments: "if you are going to take the ethics process seriously then you are bound to carry out your research exactly as you have stated in the ethics application. Creativity doesn't always work like that and it may be that [it is] only through trial and error that you end up with your art"; "many of the ways artists use oblique strategies in the research and creative production cannot overcome the difficulties of ethics clearance, but some artistic practices may be deemed unacceptable to the University when at the same time they are perfectly acceptable in the art world and in the broader cultural context."

Not all respondents shared these views. Some respondents spoke of the positive role that the ethics process can have in student supervision and stressed its crucial role in defining the research project: "the requirements of ethics approval made us question the suitability and purpose of the investigation and methodology" (Respondent P); and "The requirement for ethical consideration is a reality check and a timely reminder tempering oversights or possibilities of exploitative or damaging practice" (Respondent C).

From the responses, there seemed to be a concern that the requirement to articulate the methodology at the outset of a research project will

compromise the spontaneity of creative practice and the unfolding of creativity. Certainly there is evidence of antipathy towards any form of institutional regulation or codification of creative practice. Equally, some of the responses suggest a lack of confidence about methodology and a deep scepticism as to whether there exists any appropriate methodology by which artists can approach creative practice as research. This outcome implies that creative practice methodologies need to be better articulated within academic institutions and incorporated into the curriculum together with an awareness of ethics at all levels. The question of methodology in creative practice as research is a growing area of interest and methodologies are being articulated which seek to encompass the spontaneity and immersive nature of creativity. These are discussed in the following section.

It is early days in terms of the ethical oversight of creative research practices within a university context, but what is most disturbing from the results reported is that artist researchers in their own projects and in student supervisions may seek to restrict the scope of their creative research so as to avoid what they perceive to be the hurdle of ethics clearance. In this sense, the ethics process itself is not revealed as a form of censorship, rather it is the aversion to it on the part of supervisors and students that produces forms of self-censorship or deliberate non-compliance. By not engaging with the ethics process, the discipline itself is denied the opportunity to test new methodological approaches and to extend existing methodologies unique to creative practice. And importantly, with creative arts research being a relative newcomer to the university, each ethics application is part of educating ethics committees, building precedents and informing creative research more broadly.

Emergent Methodologies

The mere existence of an ethics process may lead to a chilling effect on both academic research and the new work undertaken by doctoral students. However, one would hope that in the longer term, creative arts researchers, doctoral scholars and ethics committees will develop the ethical know-how that enables them to negotiate challenging research problems successfully. After all, in many instances the committees consist of academic peers. As noted, the ethics process requires

researchers to articulate a methodology, something that creative arts practitioners seem reluctant to set in place as a pre-given.

In her introduction to *Practice as Research: Approaches to Creative Arts Enquiry* (Barrett and Bolt, 2007), Estelle Barrett sets out the fundamental character of creative arts research as emergent and suggests that creative methodologies cannot be predetermined but emerge in and through practice. Yet might not this emergent aspect of creativity be described as a methodology in itself? Are there ways to understand methodology that can account for these emergent characteristics? Emergence as a concept is a discursive construct that seeks to explain the way that complex, global forms of organisation come into being through simple, local behaviours and rules, in the absence of any apparent, central-ised or dominant control mechanism (Ednie-Brown 2009 & 2012). At first sight, at least, this absence of a control mechanism suggests that methodological frameworks are an anathema to emergent phenomena; but might the "simple, local behaviours and rules" be thought about methodologically?

The question of methodology is an important one for creative researchers and ethics committees. Researchers across all disciplines are expected to explicate their research methods (what they are actually going to do and what they are going to ask their research subjects to do) and articulate their research methodology (the relation between the conceptual frame-work and its actualisation through the methods applied in the research). In contrast to other research disciplines that have defined methodologies, each creative research project develops a methodology specific to itself. Thus creative research turns the problem of methodology on its head – each research project is an exercise in generating and eventually articu-lating 'methodology' – as the goal and outcome of the activity of creative practice rather than a given way of working. That is, creative research works out, through doing, how to best go about producing desired effects – where the desired effect is often about how best to probe and find out more through certain media and other kinds of armatures.

The challenge is to devise creative methodologies that are commensu-rate with the ethical requirements on educational institutions at the level of the *National Statement* and to ensure that an ethics framework

exists at an institutional and school level that is capable of accommodating this mode of research activity. One possibility is to recognise the ethical as the research process unfolds and emerges, and ideally a creative arts ethical framework would be one that responds to the particularities of each individual research project (MacNeill and Bolt 2011). We might refer to this as a form of 'situated ethics'. There is an emerging literature on situated ethics more broadly (Pope 2011, Simons & Usher 2000), and Francisco Varela's (1999) theorisation of ethical know-how provides a valuable working definition for creative researchers.

Varela's notion of ethical know-how distinguishes between ethical expertise and ethical deliberation. Most Western writers on ethics, he claims, tend to focus on reasoning as the central issue (Varela 1999, p. 23) wherein ethics becomes an issue of deliberation. Ethical expertise, on the other hand, does not centre itself on rational judgments of reasoning or on how this may be applied as ethically instrumental. Rather, it is based on the inextricably specific tissue of circumstances – or situatedness. This expertise, which Varela refers to as 'ethical know-how' involves a "skilful approach to living… based on a pragmatics of transformation that demands nothing less than a moment-to-moment awareness of the virtual nature of our selves" (Varela 1999, p. 75). Thus, to act ethically, one must be acting with sensitivity to the particularities of the situation where there is not a reliance on an overarching set of rules. One could think about this in terms of the "simple, local behaviours and rules" through which complex forms of organisation emerge, where these local behaviours and 'rules' are simply, as Varela put it "a moment-to-moment awareness". This offers exciting possibilities in training doctoral researchers in such a way as to be able to incorporate ethical know-how into activities beyond the academy.

It is important to note that the kind of know-how being discussed does not exclude forms of knowing that are rationally formed, and 'knowledge of' and 'know-how' are not set up in opposition: know-how incorporates both rational forms of categorical analysis and the situated forms of aesthetically inclined knowing (Ednie-Brown 2012). It is not necessary in this paradigm to be making special claims for creative practices; rather, ethical know-how becomes a 'measured' practice of engaging with the world, of how we behave, of what we acknowledge is at stake. Rather than

being framed around the *virtuous*, ethico-aesthetic know-how is about the *virtuoso*: the skilled performer. This property of ethical expertise might also be called 'the art of emergence' (Ednie-Brown 2012).

The concept of 'situated knowledge' on which a situated ethics is built has been articulated by the philosopher of science, Donna Haraway (1988), and has been most usefully applied in fields of scientific inquiry. In her influential essay 'Situated Knowledges: The Science Question in Feminism and the Privilege of Partial Perspective', Haraway proposes that situated knowledge is an ethical form of embodied knowledge that is locatable and able to be called into account (Haraway 1988). Timothy Morton (2012) has argued along similar lines. He proposes the notion of 'the ecological thought': an awareness that a society needs to foster if it is to achieve a more ethical and viable future for its citizens. He argues that the creative arts play a critical role in this future through their considerable expertise and directives around ethical questions. Morton suggests that there is a need to pay more attention to 'ambience' which brings into view the 'environmental background'. An awareness of ambience, he claims, "points us to the here and now" and "opens up our ideas of space and place into a radical questioning" (Morton 2012, p. 104). The appeal of these concepts of situated knowledges and ethics is that they prepare and enable researchers to respond to the unexpected and unpredictable – characteristics of an emergent creative practice research method.

Conclusion

In this chapter we have noted that the creative arts does not have the history in research ethics – and only now is a literature emerging – to provide case studies, examples and precedents to help its artists-as-researchers and graduate artists-as-researchers confidently negotiate the university ethics process. We have also seen the way in which artists as researchers are yet to embrace an ethics process, having had until recently no reason to engage in the procedural form of ethics, let alone take on its stewardship. The implications of the reactions to the ethics process for doctoral research and innovation in the discipline are indicative of the current lack of fit between creative and regulatory practices.

However, underpinning this assessment of the university's ethics process is a fundamental belief on the part of creative arts practitioners and researchers that art's role is to test the boundaries, to create bother and to bring its audience into crisis. Art as experimentation requires us to rethink the notion of risk and ethics that are an integral part of experimentation within the academic institution, but not to dispense with either. Developing creative research projects within a research setting requires adjustments both on the side of the creative researcher and on the side of the ethics committee. For ethics committees, creative research remains an unruly beast, and the notion of the aesthetic alibi is not a valid rationale for an artistic research project that is seen to conflict with the fundamental principles set out in the *National Statement* or the *Australian Code of Practice*. Although it is accepted that creative research within an institution should follow institutional rules, conflicts may arise when the intention of an artistic project is to provoke or subvert those same rules.

We have argued that creative research turns the question of the relationship between ethics and methodology, and hence the ethical assessment process, on its head. Since each research project is an exercise in generating and eventually articulating methodology, creative researchers are required to have the ethical know-how that enables them to negotiate ethics in the process of the research, not in advance of the research as is the current procedure for ethics approval. Thus, creative arts research requires the development of 'ethical know-how' and a situated ethics amongst its doctoral researchers. These enabling concepts offer exciting possibilities in training doctoral researchers in such a way as to be able to incorporate ethical know-how into artistic practices beyond the academy. However, we propose that such approaches to ethics could very well have a great deal to offer to other research disciplines and indeed could serve as a model for rethinking the ethical more broadly. Thus an ethical approach is not a set of rules, but rather a skilful and sustainable approach to living that is based on a moment-to-moment awareness.

References

Australian Commonwealth Government (2005) *Anti-Terrorism Act* (No. 2) 2005.

Baker, S., & Buckley, B. (2009) *CreativeArtsPhd: Future-proofing the Creative Arts in Higher Education*. Strawberry Hills, NSW: Australian Learning and

Teaching Council. Retrieved from: http://www.olt.gov.au/resources?text=C reative+Arts+Phd.

Barrett, E., & Bolt, B. (2007) *Practice as Research: Approaches to Creative Arts Enquiry.* London: I.B.Tauris.

Best, S. (2004) Editorial. *ANZ Journal of Art* 4 (2) & 5 (1), 7–9.

Bolt, B. (2011) *Heidegger Reframed: Interpreting Key Thinkers for the Arts.* London: I.B.Tauris.

Bolt, B., & Kett, G. (2010) The trouble with CARE: creative arts and research ethics. *Quality in Postgraduate Research.* Retrieved from: http://qpr.edu.au/ proceedings_all.html.

Bolt, B., Vincs, R., Alsop, R., Sierra, M., & Kett, G. (2009) *Research Ethics and the Creative Arts.* Melbourne: Melbourne Research Office.

Cazeaux, C. (2003) The ethical dimension of aesthetic research. *Research Issues in Art, Design and Media* 1 (5). Retrieved from: http://www.biad.bcu.ac.uk/ research/rti/riadm/issue5/abstract.htm.

Ednie-Brown, P. (2009) Rising out of the affective sea: emergence and architectural composition. *Architectural Design Research* 3 (1), 103–131.

Ednie-Brown, P. (2012) Supervising emergence: adapting ethics approval frameworks towards research by creative project. In B. Allpress, R. Barnacle, L. Duxbury & E. Grierson (eds), *Supervising Practices for Postgraduate Research in Art, Architecture and Design* (pp. 103–116). Rotterdam: Sense Publishers.

Garrett-Jones, M. (2012) Review :: Art Month :: Mike Parr. *FBI Radio*, 7 March 2012. Retrieved from: http://www.fbiradio.com/ review-art-month-mike-parr/.

Hammersley, M., & Traianou, A. (2012) *Ethics in Qualitative Research: Controversies and Contexts.* London: Sage.

Haraway, D. (1988) Situated knowledges: the science question in feminism and the privilege of partial perspective. *Feminist Studies* 14 (3), 575–599.

Jay, M. (1998) The aesthetic alibi. In *Cultural Semantics: Keywords of Our Time* (pp. 109–119). Amherst: University of Massachusetts Press.

MacNeill, K., & Bolt, B. (2011) The 'legitimate' limits of artistic practice. *Real Time* 104, Aug/Sept, 26–27.

MacNeill, K. (2010) When subject becomes object: nakedness, art and the public sphere. *Media International Australia* 1 (135), 82–93.

Marr, D. (2008) *The Henson Case.* Melbourne: Text Publishing.

Morton, T. (2012) *The Ecological Thought.* Cambridge and London: Harvard University Press.

NHMRC (2004) *Australian Code of Practice for the Care and Use of Animals for Scientific Purposes.* 7th Edition. Canberra: NHMRC.

NHMRC, Australian Research Council and Australian Vice-Chancellors' Committee (2007) *National Statement on the Ethical Conduct of Research Involving Humans*. Retrieved from: www.nhmrc.gov.au/publications.

O'Hagan, S. (2010) Interview with Marina Abramovic. *Observer*, Sunday 3 October 2010. Retrieved from: http://www.guardian.co.uk/artanddesign/2010/oct/03/interview-marina-abramovic-performance-artist.

Pope, C. (2011) We need to talk: visual ethics and the need for conversations. *The Second International Visual Methods Conference*, Milton Keynes, UK.

Rancière, J. (2009) The aesthetic dimension: aesthetics, politics, knowledge. *Critical Inquiry* 36 (1), 1–19.

Rancière, J. (2010) The aesthetic heterotopia. *Philosophy Today* 54, 15–25.

Simons, H., & Usher, R. (eds) (2000) *Situated Ethics in Educational Research*. London, New York: Routledge.

Stengers, I. (2004) The challenge of complexity: unfolding the ethics of science. In memoriam Ilya Prigogine. *E:CO* Special Double Issue 6 (1–2), 92–99.

Varela, F. (1999) *Ethical Know-how: Action, Wisdom and Cognition*. Stanford: Stanford University Press.

Wiles, R. (2012) *What Are Qualitative Research Ethics?* London: Bloomsbury.

Zurr, I., & Catts, O. (2003) The ethical claims of bioart: killing the other or self-cannibalism. *AANZ Journal of Art: Art and Ethics* 4 (2) & 5 (1), 167–188.

Notes

1 In the case study *Research Ethics and the Creative Arts*, the visual-arts respondents did not feel that there was a set of prescribed 'industry standards' in the field despite the National Association for the Visual Art's (NAVA) *Code of Practice for the Professional Australian Visual Arts, Craft and Design* and the Australia Council's protocols for working with children and Indigenous arts. It was felt broadly that questions of ethical practice are negotiated in the public arena. Thus one respondent observed: "The true arena of ethics determination is in the community – art viewers and the general public. This is a key function of art, if it cannot be accommodated, we should not be in the university." (Respondent A) (Bolt et al. 2009, p. 15)

2 A further consideration is the distinction between an art making in the academy and art as research – a lacuna in the ethics processes. If one were to attempt these activities as an artist (student or staff) in a university but not as part of a research project, is it conceivable that this would escape ethics oversight?

EXAMINING DOCTORAL WRITING IN THE CREATIVE ARTS

Donna Lee Brien, Jen Webb, Sandra Burr

Introduction

The doctoral degree is widely acknowledged as the height of educational attainment. There has, however, been a significant level of debate among artists about whether doctoral training adds value to a creative career, and among academics about whether art practice adds value to a research project. Despite the debate, the creative disciplines constitute an important growth area for higher degree research (HDR) programs across many countries, including Australia. In the past two decades, enrolments in doctorates by creative practice in Australian universities have risen markedly, and an impressive number of such theses have been examined in creative writing, dance and theatre, music, and the visual and new media arts. In the early 1990s, there were very few enrolments in, or completions of, creative arts doctorates; however, by 2003 – when 20 of the 39 universities offered creative doctorates – there had been well over 400 such doctorates examined and completed in Australia (CAUL 2011).

The recent notable increase in the number of doctoral offerings and doctoral candidates in the creative arts, and the debate that still circulates around this topic, sometimes obscures how well entrenched such degrees are in the Australian academy. Evans et al. observe that doctoral programs supporting research into, through or about the arts have been offered in Australia since 1948 (2003, p. 8), and note too that one of the first professional doctorates offered in this country was the Doctor of Creative Arts, established in 1984 by the University of Wollongong (2003, p. 3; see also Paltridge et al. 2011). Numbers were, of course, very low until recently, but it is a growing area of study, and one marked by openness to initiatives, experimentation and change.

With the rapid growth in offerings and enrolments over the past two decades comes the need to interrogate how effectively Australian universities manage research training for creative arts practitioners, and this need has been addressed by a growing body of research and publications on the topic. A number of the investigations aim to determine the efficacy, rigour and fairness of institutional policies, supervisory and examination practices and standards of creative arts HDR programs (see, for example, Barber 2009; Bourke, Hattie & Anderson 2004; Butt 2009; Phillips, Stock & Vincs 2009). This chapter reports on another such project and draws on data gathered for a recently completed project titled 'Examination of Doctoral Degrees in Creative Arts: Process, Practice and Standards' (Webb, Brien & Burr 2013). As assessment is a key component of tertiary-level learning and teaching, we focus on examination as a central part of this research training, and in particular address the written component of creative arts dissertations.

Approach

This project was designed according to a participatory action research model: a 'spiral of self-reflective cycles' involving planning, action and observation, reflection, and then re-planning (Kemmis & Wilkinson 1998, p. 21). The aim was to work with our community of practice to improve the status and practice of examination in the Australian creative arts academic community. We therefore engaged in wide consultation with this community over a two-year period in ways that would allow triangulations of perspectives: those held by examiners, supervisors

and students; and those identified in university policies, governmental initiatives and the traditions of knowledge production. This necessitated an approach that included: documentary research (into policies and publications); field research (through focus groups and surveys); and emergent and collaborative practice- and process-based research (through a series of generative roundtable discussions and reference group meetings).

The series of roundtable discussions comprised senior staff in the creative arts disciplines – experienced examiners and heads of research centres; from them we gathered input and ideas on policies, processes, practices and standards related to the examination of creative arts doctorates. A series of small focus groups targeted recent graduates and early career academics as well as more experienced examiners in order to discuss and record their views on, and experience of, the process of examination of creative arts doctoral theses. The survey involved an online questionnaire, which was circulated across the arts academic community, and targeted two distinct groups: recent graduates, and supervisors and examiners. Our aim was to build a broad brushstroke picture of experiences, perspectives and attitudes in the community. We also collected and analysed a body of examiners' reports from creative arts doctorates, primarily from Australia (with some from the UK), and a body of university policies and processes related to the examination of creative arts doctorates. Our aims with respect to the examiners' reports included the attempt to determine the main concerns and foci of the examiners, and their understandings of the quality of creative arts doctorates; our aims with respect to the policy documents was to compare different university requirements and expectations, in order to produce a 'map' of doctoral creative arts in Australia.

Our findings point to generally held uncertainties about examination methods, widely held perceptions that assessment processes are erratic, and lack of clarity about whether formal examination processes in fact deliver the best outcomes for both graduates and the professional, creative and/or scholarly fields for which they are being prepared. In its interrogation of the processes, practices and standards of doctoral examination, the findings of this study pointed, however, to a general confidence about the status and the quality of doctoral-level degrees,

and many common points of agreement regarding the importance of improving the experience and standards of thesis examination nationally.

General Lack of Consistency

We embarked on our project to investigate both the policies and the expectations associated with the examination of creative doctoral dissertations, and to consider what impact differences within and across disciplines and institutions have on candidates, supervisors and examiners. We found a lack of knowledge in all academic disciplines (that is, in the creative arts and others) about HDR programs overall, with a comparatively slight literature available on how they are organised, their pedagogical bases, the standards that are applied by examiners, and the policies that frame and direct the processes of candidates, supervisors and examiners. The situation in the creative arts has further complicating factors. Famously, art is 'messy', reliant on material contexts, methods and traditions, and committed both to autonomy of thought and practice, and to a high degree of variability (Carter 2004). This same 'messiness' allows creative theses to be rich and varied in their forms, content and trajectories, but it also generates the need to develop a robust vocabulary to explain, and write about, current creative arts research practice.

We found a considerable level of disorder in relation to policy in what could be understood as foundational areas – in the range of awards being offered, their nomenclature and their admission requirements – that had not been remedied in the years since we had conducted earlier work on this area (see Carey, Webb & Brien 2008). There are in Australia, for example, doctorates by research and by coursework, PhDs, doctorates of creative arts, creative industries, fine arts, music, and visual arts (among others), professional doctorates, and doctorates by publication (see, Baker & Buckley 2009, pp. 28–31; Webb, Brien & Burr 2012). This is not just a matter of institutional differences; in many cases, a single university offers a variety of possible doctoral awards. One university, for instance, offers four different versions of a PhD depending on the proportion of creative practice to text, and on the candidate's industry experience.

Expectations of Candidates' Doctoral Writing

As is well established throughout this volume, creative arts dissertations traditionally comprise a major creative work (such as a dance or theatrical performance, a work of art, film or music, or a sustained piece of creative writing) and an accompanying written theoretical, critical and/or analytical dissertation (usually referred to as the 'exegesis') that underpins, supports, expands, documents or otherwise relates to the creative output. Though our research demonstrated that the community for the most part agrees that a written component is necessary at doctoral level, there is a considerable range of expectations across the sector in relation to what this exegetical component comprises, how it relates to the creative work and against what standards it is – or should be – examined. Even what this written component is called is the subject of considerable discussion and debate in the creative academy. While many universities use the now-familiar term 'exegesis' for this piece of writing, many other names are used in university policies and other documents.[1]

The variety of nomenclature suggests that different universities have, at policy if not at practice level, quite different ideas about the role that this document is expected to play. Such expectations tend to be predicated on the discipline, the institution and sometimes the supervisor involved in the HDR project; and it ranges from backgrounding to research reporting; and from analysis to (self-)critique. Some universities specify their expectations; others provide a range of optional roles for the written component; others again leave its function quite open. A number of participants in the project felt that this range of expectations can cause confusion to examiners and, thus, disadvantage the students being assessed:

> We have seen doctoral candidates having to defend their theses robustly against examiners who had expected to see, say, a commercially viable creative work, and who dismiss the work on the grounds that it is not 'publishable' (in conventional terms). We have also seen examiners dismiss the critical work on the grounds that it is insufficiently substantial, apparently not taking into account the difference between a conventional thesis of 80,000 words, and a critical essay of 30,000 words.
>
> (Kroll & Webb 2012, p. 169)

Our project participants also repeatedly and markedly noted the variations in the required length of the written component. This is one of the more significant differences in the models of creative arts theses offered across Australia, with policy expectations of the length of the written component varying from 10,000 words to 50,000 words (and see again Paltridge et al. 2011). However, all those who participated in this project, and the policy statements of all the universities, do expect not only that there is a written component to a doctoral thesis, but also that it achieves a high level of written expression.

Another policy variation occurs in the relationship expected between the creative and critical parts of the thesis (see Carey, Webb & Brien 2008). Some policies, and some examiners, expect to be able to identify scholarly or research outputs in the creative artefact, while others require the artefact to demonstrate professional standards in its form and medium, and preserve scholarship for the essay. Some institutions require the critical and creative elements to be fully integrated, while others see them as being only loosely related. Some institutions allow (or even require) the two components to be supervised separately (for example, appointing both a studio and a thesis supervisor to the project) and then examined separately (say, by an expert in the art form and an expert in the scholarly mode), while others insist that the supervisors and examiners should be able to report on the quality and rigour of the whole thesis package.

Modes of examination vary too: in some creative disciplines, the artefact and essay are presented to the examiners as a unit; this is particularly the case for creative writing, where the examiner receives the novel, play script, poetry manuscript or other artefact alongside the critical essay. In other disciplines, especially in the visual and performing arts, there can be a gap of up to six months between the examiner viewing the exhibition or performance, and receiving the written component.[2] Another difference is in the extent to which institutions allow the submission of creative work that was completed before enrolment, such as a public exhibition, a performed concert or published novel; some allow it, others forbid it. While most institutions encourage publication of journal articles, book chapters and conference papers during candidatures, a number of the supervisors and examiners who participated

in our project expressed doubts about the place that such work has in the final thesis submission, given the fact that they cannot be confident that the published/presented work actually represents the candidate's unaided output.

Given this context, it is not surprising that candidates, supervisors and examiners have expressed uncertainty about the nature and function of the exegesis. Another point of commonality among the participants in our project was an almost universally expressed dislike for the term 'exegesis'. When asked what they found unattractive about the term, the most common response was that it does not convey an appropriate meaning for the essay, or for the function it is expected to perform in the dissertation package. As one participant stated, "We really avoid the word exegesis because we don't expect it to be exegetical" (examiner). The level of concern was so high, and so widely shared, that it prompted one of our project's major recommendations:

> 4. That the peak bodies and ACDDCA [Australian Council of Deans and Directors of Creative Arts] work together to establish agree-ment on a preferred term or terms for the critical essay, one that more precisely denotes the role and function of this document; and that this is communicated to universities with a clear recom-mendation that the sector aim to achieve both consistency and clarity of terminology.
>
> (Webb, Brien & Burr 2013, p.7)

Doctoral Examination Reports

While university policies and procedures exist to guide examiners through the HDR assessment process, how examiners incorporate these differing approaches into their examination practice, how they arrive at the commentary they present in their reports, and how these reports add value to research in these disciplines provided another rich seam of inquiry for our study. To investigate this, we attempted to gather as many examination reports as possible. After extensive networking and direct requests for examination reports, 84 reports were provided to the project team. Of those, 70 met the parameters of this project (final reports for doctoral dissertations in the creative arts within the last 10 years) and, of these, 51 were for PhD dissertations, and the remaining

19 for other doctoral types (principally various professional doctorates and Doctorates of Creative Arts). All art forms were included, although (perhaps because of the project team's personal networks) rather more were provided for creative writing than for other art forms.

This limited number was the result of concerns about whether the holders of reports had the legal or moral right to make these reports public, even under the conditions of confidentiality and privacy that the project and its ethical clearance promised. This was an issue consistently expressed by graduates in relation to their own reports; by examiners about reports they have produced for other universities; by supervisors about reports they hold for their own doctoral candidates; and by research officers (who added to their concerns about confidentiality the plea that they were too overworked to provide us with the reports anyway). Even very senior personnel were cautious: in one case, a deputy vice chancellor for research expressed concern over the capacity of that university to provide such materials; in another case, the dean of research required us to submit the project to their own ethics committee (who in fact never responded to our submission). The reports are, therefore, opportunistically gathered and the findings from this analysis are indicative, rather than representative; however, the results are not without interest.

We compared the length of written reports, largely because our project participants were very divided on the appropriate length: opinions ranged from the position that, in their experience, all that is required is a few lines stating whether or not a thesis is acceptable, to the view that every solecism should be identified. The reports we analysed ranged from a cursory single page, to a very expansive 37 pages, with a median length of 4 pages and a mean length of 5.4 pages. Reports on PhD dissertations were longer than those provided for professional doctorates, perhaps suggesting that examiners feel a greater compulsion to engage critically with a more conventionally named research degree.

We noted above that a creative arts doctorate comprises (at least) two distinct elements: the creative artefact and the critical essay. Our project participants almost unanimously asserted that, in their experience, examiners will comment primarily on the critical (written) element, and

any corrections required before the award of the doctorate are typically directed principally, or only, to the critical essay. One participant stated: "I've never known a creative component to be re-examined but almost consistently there are revisions that need to be made to the exegesis" (research centre head). Our analysis of examiners' reports supported this finding. For reports that required major rewrites of the dissertation as a whole, 23 per cent required corrections to the critical work, while only 10 per cent of those reports required changes to the creative work. For reports that required minor rewrites, only 6 per cent criticised the creative artefact while a surprisingly high 26 per cent considered the critical work inadequate. The literature review and fieldwork we conducted also investigated this issue of what changes examiners specified in their examination reports. Our preliminary findings from this investigation supported the findings from our analysis of examiners' reports: that while examiners rarely request major revisions of the creative product, they will ask for anything from minor revisions to complete rewrites of the written component/exegesis. This is, moreover, even the recommendation when the creative work is judged to be barely adequate.

The simple explanation for this apparent anomaly is that doctoral *writing* is accorded considerably more weight than is the doctoral *package*; or perhaps that examiners are more confident to make clear judgments of scholarly writing than of creative objects. However, this is not borne out by the failure rates of the doctorates whose reports we were able to analyse. In terms of overall evaluation, most of the reports were for dissertations that were, overall, of acceptable quality; 66 per cent were passed with no, or only minor, rewrites. However, the overall failure rate was higher than seems to be typical. We have been unable to find empirical evidence of HDR failure rates, but Mullins and Kiley suggest an overall doctoral failure rate across all disciplines of about 3 per cent (2002, p. 376). This is marginally lower than the overall failure rate of 4 per cent of the reports we analysed, and considerably lower than the 9 per cent of failures in the DCA dissertations we identified in our 70 reports (see also Barber 2009, on failure in art research). In the absence of a larger pool of reports to analyse, we can only suggest that when examiners consider a creative artefact to be of unacceptable quality, they are as likely to fail it as to require major reworking of it; but they are willing to detail what is required to bring the written component up to doctoral standard.

Most of the participants in our project stated that they approach the task of examination with a sense of responsibility, privilege and anticipation. Many reported that they felt they were entering into a pact with candidates, who are after all their (junior) peers, being scholars and, potentially, academic teachers. Most of the examiners said they start from the premise that the thesis will pass; and agreed that examiners are generally reluctant to fail a thesis (a situation which is also largely true across the academy beyond the creative arts). Many examiners also indicated that they see their role as including that of mentorship of the next generation of artist–academics (see also Kumar & Stracke 2011).

Of course, examiners also bring to the process what they consider are appropriate expectations of doctoral level work. Examiners expect not only that candidates comply with intellectual and professional standards, but also that they meet the guidelines set out by their institutions in terms of the length, structure and presentation of their theses. This was considered to be an important aspect of the process: most of the participants reported that they require the textual component of a dissertation to be edited and proofread to a professional standard, and to contain very few errors of spelling, grammar or punctuation. Regardless of artistic form, examiners expect that all written material be engaging and reader-friendly, with both creative and scholarly texts demonstrating high levels of creative and critical thinking. Some examiners also expect candidates to show that they have found their own voice in the written component, and not be ventriloquising other scholars in what was characterised as "death by citation" (examiner). There should also be strong evidence of academic rigour and an engagement with scholarly ideas, together with a clear presentation of the new knowledge or enhanced understanding generated by the project, and this should be especially evidenced in the written component of the thesis.

'Non-writing' Doctoral Examination of Creative Arts: The Viva Voce

Just as not all work submitted for doctoral degrees in the creative arts is in written form, so too there are other ways to submit work for assessment than in writing. The best known of these is the *viva voce*

(or 'oral examination', known as the 'dissertation defence' in the USA), widely used internationally and available as an option in a number of Australian universities (an option that is seldom taken up). In our project, the *viva voce* was raised in each roundtable and by both focus groups and questionnaire participants. Many participants were in favour of the introduction of a *viva voce* on the grounds that artists are often less confident in writing than are scholars in other humanities disciplines, and that the process of oral defence and discussion is more valuable and more equitable. However, even those participants who strongly supported the introduction of the *viva voce* offered a caution because of the perceived power imbalances that can occur in this form of examination:

> What happens with the viva voce is you have other power games; the dominant examiner will still override everybody else.
>
> (HDR convenor)

> Actually the colloquial term 'thesis defence' for viva voce tells you as a student that you're going to be attacked, so it's not a negotiation or conversation; it's an assault and a response.
>
> (examiner)

In the UK and elsewhere, the *viva voce* is a standard element in the assessment (Park 2007, p. 31; QAA 2011), but Australian universities rarely include it. Baker and Buckley's 2009 Australian Learning and Teaching Council project report sets out the convention for the *viva voce* in Australian visual art schools, but note that only three schools required an oral examination while two offered it as an option. The majority, their report notes, did not incorporate it at all at this time (2009, p. 54).

Participants in Baker and Buckley's study, like the participants in ours, were ambivalent about the *viva* on the grounds that it is considered likely "to produce consensus in the examiners", and report that:

> One school, which had implemented a *viva voce* several years ago, reported that this practice was withdrawn after a short period due to a range of difficulties experienced with this model.
>
> (Baker & Buckley 2009, p. 54)

Australia is not alone in experiencing and expressing concerns about the *viva voce* model. The main uneasiness in both Australia and the UK appears to be in relation to the way in which the contact between examiner and candidate that is required by the *viva voce* can introduce an overly subjective element into the process. Moreover, in writing about the UK context, Hoddell, Street and Wildblood report that "it is not apparent that the *viva voce* process offers the opportunity for candidates to demonstrate the breadth of their subject understanding and expertise" and is a process during which it is particularly difficult for candidates "to demonstrate successful acquisition of transferable skills" (2002, p. 64). This is despite the many apparent benefits derived from oral examination, which include the opportunity for the examiners to understand more clearly the context and concerns of the candidate, to confirm that the work is the candidate's own, to clarify any under-resolved areas of the thesis, and to assess the candidate's presentation skills (Kiley 2009, p. 39).

Conclusion

On a practical level, our findings indicate that the sector as a whole would benefit from greater clarity, and agreement, about what is expected of the creative artefact and of the critical essay, and of the relationship between the two. Such clarity would be of great assistance to HDR candidates as they attempt to resolve their research questions and their creative practice, to compose their written dissertation, and as they try to understand the standards that are expected of them. Candidates and supervisors alike question whether all of the Australian HDRs in the creative arts are preparing candidates to work as creative practitioners, whether they are preparing candidates to take up places in the academy as scholars, or if they are attempting to provide training within, and across, both modes. Candidates are acutely aware of differences in degrees across Australia, and concerned about what their own degree is going to be worth and how they will be able to position themselves within the scholarly and creative communities after they graduate. The role of writing in candidates' future career paths (whether in industry, the academy or both) is obviously important here, as is the question of the responsibility of preparing candidates for futures they may not foresee upon graduation (Kroll & Brien 2006).

Alongside the diversity of processes and standards across institutions, our findings also point to a certain homogeneity in the values and practices that examiners bring to the examination process. This dichotomy is both worrying and reassuring: worrying because this lack of a set of standards by which creative arts HDRs in Australian universities are administered and measured leads to questions about the quality of the creative arts graduates being produced; reassuring because, despite the difficulty of navigating this labyrinth of standards, policies, instructions and requirements, examiners (as well as candidates and supervisors) largely approach their task enthusiastically and ethically. Despite confusing guidelines and instructions, and the different standards and requirements, examiners remain caring, concerned, positive and very mindful of the current and potential status of candidates. As well, they hold and display deep feelings of responsibility towards maintaining standards at individual, discipline, institutional and industry level, and generally take significant care in writing their examination reports.

Clearly, existing examination policies and procedures in creative arts HDR are in need of significant revision. At the same time, in both Australia and abroad, there is also an interest among creative academics in how our various disciplines measure up against each other and how our graduates are perceived in both the relevant creative and scholarly fields. This is part of a growing curiosity regarding practice in this area, and heralds not only an evident willingness to examine and improve programs and how they are administered, but also a trend towards increased collegiality and collaboration between the creative arts disciplines to identify key issues and problems in academic practice, and share best practice. Nobody, it seems, wants a restrictive code or legislated guidelines, but almost everyone who interacted with our project considers there should be clearer and more consistent guidelines, easily available, to assist candidates and supervisors in their research, and examiners in making their judgments and preparing their reports. It was felt that the lack of such guidelines threatened the integrity and content of each discipline's programs, and so institutions should view and interrogate the policies of other universities, and test their own against these. There was also a willingness in the different discipline areas to conceive of engaging on cross- and multi-disciplinary discussions on these policies and guidelines within, and across, institutions.

One point that emerged consistently across all our fieldwork, and to which we would like to draw attention, is a generally held confidence in the sector in relation to HDR in the creative arts. It is generally believed that the quality of research training is improving and, consequently, that the quality of creative dissertations – and particularly the written component of such dissertations – has also improved. This can be attributed to the efforts of the many individuals across Australia who have responded to various institutional imperatives in a creative and resourceful way, and to the university and disciplinary processes that have built rich HDR programs, good supervisory practice, and strong national networks. In this context, it is clear that doctoral writing, and its examination, will remain not only a central and lively component of university research, but also that it has the potential to grow into a rich object of scholarly research in, and for, itself.

Acknowledgments

This chapter would not have been possible without the support of the Australian Learning and Teaching Council (subsequently the Office for Learning and Teaching), which funded our project, *Doctoral Examination in the Creative Arts: Process, Practices and Standards* (PP10-1801, 2011–2012).

References

Baker, S., & Buckley, B. (2009) *CreativeArtsPhd: Future-proofing the Creative Arts in Higher Education*. Strawberry Hills, NSW: Australian Learning and Teaching Council. Retrieved from: http://www.olt.gov.au/resources?text=Creative+Arts+Phd.

Barber, B. (2009) The question (of failure) in art research. In B. Buckley & J. Conomos (eds), *Rethinking the Contemporary Art School: The Artist, the PhD, and the Academy* (pp. 45–63). Halifax, Nova Scotia: The Press of the Nova Scotia College of Art and Design.

Bourke, S., Hattie, J., & Anderson, L. (2004) Predicting examiner recommendations on Ph.D. theses. *International Journal of Educational Research* 41(2), 178–94.

Butt, M. (2009) Creative writing research degrees: range and rigour. *New Writing: International Journal for the Practice and Theory of Creative Writing* 6(1), 53–56.

Carey, J., Webb, J., & Brien, D.L. (2008) Examining uncertainty: Australian creative research higher degrees. Paper presented at the 13th

conference of the Australian Association of Writing Programs, Sydney. Retrieved 20 February 2013, from: http://www.aawp.org.au/ creativity-and-uncertainty-papers.

Carter, P. (2004) *Material Thinking: The Theory and Practice of Creative Research*. Melbourne: Melbourne University Publishing.

CAUL: Council of Australian University Librarians (2011) *Australasian Digital Theses Program*. Retrieved 20 February 2013, from: http://www.caul.edu.au/ caul-programs/australasian-digital-theses.

Evans, T., Macauley, P., Pearson, M., & Tregenza, K. (2003) A brief review of PhDs in creative and performing arts in Australia. Paper presented at The Association for Active Researchers Newcastle Mini-conference, Newcastle. Retrieved 20 February 2013, from: http://www.aare.edu.au/conf03nc.

Hoddell, S., Street, D., & Wildblood, H. (2002) Doctorates – converging or diverging patterns of provision. *Quality Assurance in Education* 10(2), 61–70.

Kemmis, S., & Wilkinson, M. (1998) Participatory action research and the study of practice. In B. Atweh, S. Kemmis & P. Weeks (eds), *Action Research in Practice: Partnerships for Social Justice in Education* (pp. 21–36). London: Routledge.

Kiley, M. (2009) Rethinking the Australian doctoral examination process. *Australian Universities' Review* 51(2), 32–41.

Kroll, J., & Brien, D.L. (2006) Studying for the future: training creative writing postgraduates for life after degrees. *Australian Online Journal of Arts Education* 2(1), 1–13.

Kroll, J., & Webb, J. (2012) Policies and practicalities: examining the creative writing doctorate. *New Writing: The International Journal for the Practice and Theory of Creative Writing* 9(2), 166–78.

Kumar, V., & Stracke, E. (2011) Examiners' reports on theses: feedback or assessment? *Journal of English for Academic Purposes* 10(4), 211–22.

Mullins, G., & Kiley, M. (2002) "It's a PhD, not a Nobel Prize": how experienced examiners assess research theses. *Studies in Higher Education* 27(4), 370–86.

Paltridge, B., Starfield, S., Ravelli, L., & Nicholson, S. (2011) Doctoral writing in the visual and performing arts: issues and debates. *International Journal of Art and Design Education* 30(2), 88–100.

Park, C. (2005) New variant PhD: the changing nature of the doctorate in the UK. *Journal of Higher Education Policy and Management* 27(2), 189–207.

Park, C. (2007) *Redefining the Doctorate: Discussion Paper*. York, UK: Higher Education Academy.

Phillips, M., Stock, C., & Vincs, K. (2009) *Dancing between Diversity and Consistency: Refining Assessment in Postgraduate Degrees in Dance: Final*

Report. Sydney: ALTC. Retrieved 20 February 2013, from: http://www.altc.edu.au/resources?text=dancing+between+diversity.

(QAA) Quality Assurance Agency for Higher Education (2011) *Doctoral Degree Characteristics.* London: Quality Assurance Agency for Higher Education.

Webb, J., & Brien, D.L. (2008) *Australian Writing Programs Network: Final Report.* Sydney: ALTC. Retrieved 20 February 2013, from: http://www.olt.gov.au/resource-australian-writing-programs-network-uc-2008.

Webb, J., Brien, D.L., & Burr, S. (2012) *Handbook for Examiners: Doctoral Examination in the Creative Arts.* Canberra: Australasian Association of Writing Programs.

Webb, J., Brien, D.L., & Burr, S. (2013) *Examination of Doctoral Degrees in Creative Arts: Process, Practices and Standards.* Final Report. Canberra: Office for Learning and Teaching.

Notes

1 Other names for the written component include: 'analytical comment', 'contextualising document', 'conventional written narrative', 'critical analysis', 'critical commentary', 'critical essay', 'critical explanation', 'critical reflective written work', 'critical work', 'discursive text', 'dissertation', 'documentation', 'durable record', 'explicit critical analysis', 'reflective component', 'reflective dissertation', 'reflective written work', 'scholarly essay', 'scholarly written work', 'scholarly written work of critical analysis', 'theoretical dissertation', 'thesis', 'written component', 'written documentation', 'written reflective component', 'written research', 'written thesis' and 'written work'.

2 This is designed to allow the candidate the opportunity to write up the results of the exhibition or performance, and can add considerably to the knowledge contribution of the work as a whole; it does, however, introduce a difficulty for examiners in how they can write their evaluation of the work as a whole when they have seen it only in widely spaced temporal zones.

Part II

From Within:
Student Perspectives
and Experiences

REMNANT AND RELIQUARY: FRAGMENTARY TRACES RECONCILED AS OBJECT AND KNOWLEDGE

Melissa Laird

Writing on and about the material artefact, both vestigial and original, this chapter articulates the diversity and possibility of a written component interwoven with practice, each serving to reflect and reinforce one another. Drawing on the doctoral project *Remnant and Reliquary: Fragmentary Traces Reconciled as Object and Knowledge. Reading and Writing the Artefact through Material Culture Research and the Lives of Women (Australia 1788–1901)* (Laird, 2009) as a reference point, this chapter investigates linguistic, stylistic and aesthetic approaches to text. The thesis was presented in two unique volumes: an embossed leather-bound edition and a companion artist's book. The written component of *Remnant and Reliquary* functions in a number of ways: firstly as a narrative discourse informing object biographies, then as a means by which to communicate an exhibition of original

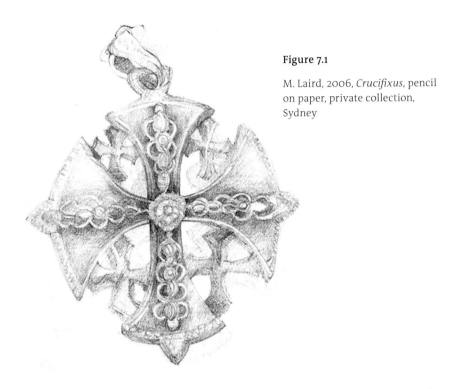

Figure 7.1

M. Laird, 2006, *Crucifixus*, pencil on paper, private collection, Sydney

artworks held at the Hyde Park Barracks Museum, Sydney. Further, the written content is 'read' as a printed landscape, the text analysed in aesthetic terms of the material and considered in terms of its surface and dimension: hand-written script, blemishes and markings are incorporated alongside poetry and quotations weighted for doubled meaning. Finally, the reconciliation of the research, as object and knowledge, is offered through the palimpsest: a unique bibliographic curiosity framing women's historical memory for a contemporary reader. Whilst still a developing field at doctoral level, material culture research is a model through which visual, performing art and design-based studies can flourish. Research methodologies and their frameworks for artefact interpretation and the possibilities afforded to the writing of such are examined in this chapter using seven themes: the role of narrative discourse, particularly the place of object biographies and material culture research; writing art practice, and ways of verbalising the visual; craftsmanship, and ways of recording process and the personal; interweaving text and image to balance authority and possibility; inscribing

the surface; highlighting text and presentation in sympathy with themes of the work; and finally, the palimpsest as a way of reconciling the thesis as both object and knowledge.

Thesis Context

Remnant and Reliquary conducted a number of examinations which placed the artefact at the centre of material-culture research and art practice: reading and writing artefacts as unique object biographies. It traced fragmentary remains as vestigial markers framing the lives of women in Australia in the period 1788–1901. The research framed women's historical memory using fragmentary remains as the focal point for scholarly investigation. The making, dispossession, dormancy, provenance and procurement of the objects enriched readings; artefacts were examined as the ephemera of daily life, as memento, or for the protection and adornment of the fragile and sensuous body considered for their association with memory and collecting. The project also investigated the collection, the museum, the gallery and the archive as repositories which were or could be revealing of cultural or personal identity. The creative practice, which reframed fragmentary artefacts for a contemporary viewer, included drawings, photography assemblage, collage and jewellery works. These artworks further reinforced the themes addressed through the text and were exhibited at the Hyde Park Barracks Museum on 8 March 2009.

The thesis documents were bound into two specially crafted companion volumes in leather and velvet, bearing evidence of seven years of research. They were designed to illuminate the themes explored as a contemporary frame for women's historical memory. The thesis functioned as a unique textual curiosity: a modern palimpsest, embodied with the spirit of the past and the reconciliation of historical memory, presented as both object and knowledge.

Narrative Discourse: Writing Object Biographies and Material Culture Research

> Thinking with things is very different to thinking with words.
>
> (Daston 2004, p. 20)

Narrative is generally associated with childhood, or with the mythologies or cultural messaging of a community, ideas retold through storytelling rich with meaning, and rendered with subtle or nuanced changes to the text over time. It is not something usually associated with research or what we might consider traditional academic writing. While writing the material culture aspects of my research, I realised that a narrative discourse was both legitimate and reliable. Narrative could provide artefacts as the focal point for what became an artefact-centred study. Investigations were carried out, and the findings constructed as a set of unique 'object biographies'. This narrative approach prompted the development of a particular relationship between the nomenclature and the ideas being investigated in this work: fragmentary remains, traces, historical and mechanical memory, aura, gesture; terms which were defined in the Introduction of the work and which informed the particular language of the thesis. The written content has been used to create a nuanced dialogue between the researcher, through the artefact, to the reader, as a means by which to read and register women's historical memory, narrated for a contemporary audience.

Remnant and Reliquary awards material-culture scholarship significance as a model for social, design and economic–historical research, where time and place resonate through the artefact. Artefacts as the ephemera of the everyday can be significant embodiments of the vestigial and the sensual, where the bruised or broken, the frail and fragmentary, revelling in the aesthetics of their own demise, are considered for their particular associations with memory, alongside more complete objects, those whole and functioning, still shining and brilliant. Thomas Schlereth has said that material culture marks "an attempt to see through objects, not just the objects themselves, [but] to the cultural meanings to which they relate or that they might mediate" (1992, p. 31). The philosopher Gaston Bachelard posits that, "by recalling... memories, we add to our store of dreams" (1994, p. 6). *Remnant and Reliquary* articulates the artefact as a carrier of meaning and as a signifier of historical time and place, where the artefact is traced to reveal its particular aureatic character (the qualities associated with an object's markings and craftsmanship), then read, registered and (re)read. Artefacts have been collected, observed, grouped, exposed, used, drawn, described and recorded. Through research, the artefact's own narrative

and mythology are revealed. Former Senior Curator at the Powerhouse Museum, Grace Cochrane, frames the argument as the "need to understand some elements of the language of objects in order to read them" (1997, p. 57). The fragmentary nature of the artefacts I selected for review provides evidence of the imperfect, where the distressed assumes value as a measure of daily practice. The concepts of disposal and dispossession, dormancy, provenance and procurement enrich such readings. *Remnant and Reliquary* provides fragmentary artefacts with a status linked to their age and state of decay: remnants celebrated through the aesthetics of their damage.

Olalquiaga describes such well-worn artefacts suffering "the mortal trials of time and space" as revealing "the wear and tear of age and use... the beauty of the marks of time" (1999, p. 88 and 86). She continues, "As if in suspension in limbo, instead of being empty or blank, [the artefact] carried the imprint of the duration, one that is measured, not in the productive accumulation of years or days, but rather in the subtle persistence of a stubborn anachronisity, the stoic refusal of things to depart once their usefulness is exhausted" (p. 5). In the context of this research, fragmentary remains are considered to be a physical link between memory of an imagined past and the tangible ephemera of the early and developing colony. It is in this context that 'object biography' and its particular nomenclature becomes a significant model by which to research and document artefacts.

The notion of a 'trace', for example, is suggestive of something tenuous, transparent, almost a shadow, transient. It also has connotations of an investigative process, reading through events, deeds or ideas to formulate conclusions. For example, according to Hyde Park Asylum Dispensary (1862–1886) records, a woman called Alice Fry was registered as an inmate, one year before her death on 5 May 1867. I have traced Fry through an artefact ascribed to her, a small glass shard, from the Asylum period of the Hyde Park Barracks to the Pauper's Portion of the Sydney Necropolis, Interment 119. The narrative of this object is founded on a diverse set of investigations. Here is the relevant excerpt from my thesis:

> The Sydney Necropolis Register of Daily Interments for the Years
> 1868–72 gives an indication of the type of burials, funeral practices

and particularly the pauper burial, mortality and infant mortality rates, and a vast array of information on religious affiliations, titles and naming practices at the time of Fry's death. Tangible evidence of the social and economic implications of poverty, illness and pharmocopaeiac practices, particularly for uterine cancer patients in nineteenth-century Sydney and Britain, are also examined – using three case studies. The debate between Sydney Infirmary & Hyde Park Asylum over terminal patients is also revealing (from *Votes and Proceedings of the Legislative Assembly, New South Wales, 'Public Charities Commission', 24 September, 1873, transcription 2373).* Asylum Matron Lucy Hicks (1873) states, "We have very bad cases sent to us at times... We get cancer patients, and I have no ward for cancer cases. It is not right to put such cases with the old women" (2372, p. 76).

<div align="right">(Remnant and Reliquary, 2009, p. 21)</div>

Graphic design, production and recycling of medicinal bottles is also explored. Drawing as a method of participant observation was a significant research methodology used to investigate this archaeology; the illustrator communing with the object through fine black pencil line, using the tools and the aesthetic underpinning of the practitioner and the observation methods of the researcher. Daston observes "how variously *things* knit together matter and meaning" (2004, p. 10; original emphasis). These unique object biographies reveal time and place, and the lives of women. Participant observation such as this was pivotal to the visual research of the project. Through these methods, I was able to construct a narrative around the found object, one which permeated both the written component of the thesis and my visual art practice.

Writing Art Practice: Verbalising the Visual

Artworks have often been accorded a special status as a midway between the objective and the subjective, things that purportedly incarnate themselves... as objects, the word made flesh.

<div align="right">(Daston 2004, p. 20)</div>

Much is written about the 'artist's intention' when discussing original artwork. A contemporary view holds that this is less significant than the work itself, where each viewer is enabled to interpret the work

independently. This, however, did not prevent me from examining my own process throughout *Remnant and Reliquary*, and diligently recording it, in an attempt to 'lead' the reader's perceptions. This approach was supported by theory and ideas appropriate to the timbre of each work. Chapters 4 and 5 were knitted together thematically. Through writing, I am thus able to verbalise key features and ideology underpinning the artwork, again interweaving the two processes of writing and practice.

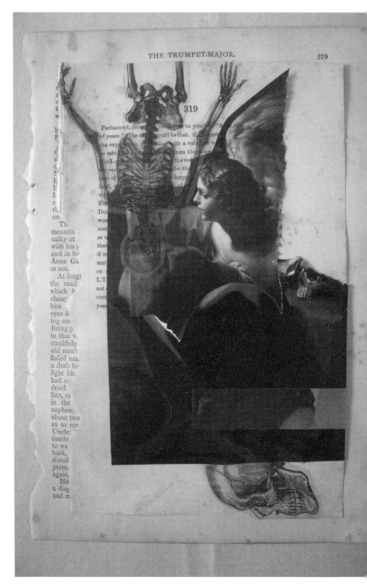

Figure 7.2

M. Laird, 2009,
NARRATIVE: Death,
collage, paper and
acetate, private
collection, Sydney

Much of my artwork was concerned with death, as exemplified in the following excerpt from *Remnant and Reliquary.*

> Death and its representation in art are contingent on the cultural imperatives of historical time and place, and raise issues associated with its power. Foucault states, "Death is at once the locus and the instrument of power" (Foucault 1976; cited in Bronfen & Goodwin, p. 5). Representation of the cadaver in art arouses fear, distress, longing and emotions of bereavement. In this way the body as a material form gives way to the cadaver as a symbolic form; the cadaver as a physical presence and a spiritual one. Literary and art historian Carol Christ (1993) continues: "Neither of this world nor entirely absent from it, the cadaver thus mediates between these two incompatible positions... the corpse, resembling itself, is in a sense its own double" (p. 12). The aesthetic power of the dead is, however, isolated to the artistic frame. The dead themselves have little authority over their own representation (p. 8).
>
> (*Remnant and Reliquary*, 2009, p. 109)

This excerpt from *Remnant and Reliquary* relates to the artwork presented as Figure 7.2.

> The vanitas genre is referred to in this work, an angel and skeleton marking a transition from the earthly to the heavenly. The cadaver, with its physical presence, faces the spectre, the corporeal conjoined with the ethereal. The skeleton as a dominant form, arms outstretched in submission, this mortal frame ascends under the watchful eye of the delightful seraphim.
>
> (*Remnant and Reliquary*, 2009, p. 46)

Craftsmanship: Recording Process and the Personal

> [T]hing-making may be rich in surprises relevant to philosophical questions about evidence and metaphysics and to anthropological concerns about significance and salience.
>
> (Daston 2004, p. 20)

While it is widely recognised that an exegesis is not supposed to be a simple diary or mere introspection, nevertheless, the recording of the personal experiences of the research and creative practice is accorded significance

in *Remnant and Reliquary*. As stated by Paltridge et al., "doctoral characteristics of originality, mastery and contribution to the field are held to be demonstrated through the original creative work" (2011, p. 243). Text is used to augment the reader's understanding of the artworks prepared for the project. The use of 'first person' in such examinations enables a more intimate relationship to develop between the researcher and the reader though the art-object. In this way, the processes, experiments, challenges, weaknesses or even failings of the artwork can be presented for consideration, as they may not be apparent in the finished artwork and might thus remain hidden from the viewer without this written form. The practice-led research of visual or performing arts projects is often rich with both personal and creative outcomes. The written rendering of such brings depth and greater clarity to the discourse.

Process is part of the art practitioner's raison d'être. In this short extract, the recording of process is presented. The rather intimate or personal nature of this recording was what my examiners found to be of interest: the impact of the research on the 'artist–scholar'. The following personal account is excerpted from *Remnant and Reliquary* as an example of the developing relationship between reader and author:

> When crafting the three artists' books shown in Figure 7.3, I became aware of the mechanical memory of newly crafted artefacts – such memory usually the result of use, wear, damage or failure in older objects. Having carved covers from artboard, enveloped them in cotton velvet, and bound in the newly illustrated and stitched pages, I found that the book not only resisted closing, but was equally prone to resist opening. My career as a teacher had not prepared me to consider that the inanimate may need to be taught alongside my daughters and students. I undertook the task to 'teach' the book about its own function. Gently I coerced the book to a closing position, and with commensurate gentle force I repeatedly splayed its covers and leaves. Creaking sounds emitted from the book as the glues gave way, the waxed threads stretched, and the book sighed into the submission of use. Wrapping the book tightly in a cloth each evening to encourage its closure resonated strongly with my activities as a young mother, wrapping newborn girls tightly in their swaddling cloths for security; another salient memory of craft and women's work brought to bear in this thesis.
>
> (*Remnant and Reliquary*, 2009, p. 47)

Figure 7.3

M. Laird, 2009, 'Artists' Books I, II and
III', *Remnant and Reliquary*, private
collection, Sydney

Interweaving Text and Image: Authority and Possibility

[A] community of memory and image.

(Bachelard 1994, p. 5)

By considering the interweaving of text and image, a range of new possibilities for presentation of my doctoral thesis evolved. Gaston Bachelard's (1994) "community of memory and image" resonates throughout this work as fragmentary evidence of lives past is recalled and registered for (re)reading through participant observation research methodologies: photographs and original drawings in pencil and ink (p. 5). These images

interweave the visual evidence with the artefact narratives of the thesis. Drawn onto translucent paper stock, this image rests on the page as though embedded onto its written companion. As such, text and image reinforce and reflect one another, as multiple shadowed perspectives – the research spilled onto the page in diverse ways for the edification of the reader. Lyssiotis states, "I believe that my images are better suited to the page than to the white wall of the gallery. On the page they can collaborate with the text and create echoes, ironies and reverberations of meaning" (Lyssiotis 2007; cited by Alexander 2007, p. 441). In this way, readers are able to reflect on each artefact using a variety of methods to enrich their own perceptions.

My original art-making culminated in an exhibition of 54 artworks and an artist's talk, held at the Hyde Park Barracks Museum, Sydney on 8 March 2009 as part of their International Women's Day events. The art practice draws from the notions of remnant and reliquary, harnesses the cultivation of neglect, the fragment, decay and decomposition, intimacy, secrecy and exposure, and the archive and the library, where books, aged and weary, are revitalised as vehicles for artistic expression. This process enabled a new collection of original artefacts to evolve and contribute to my thesis. The exhibition was documented through the artist's books mentioned earlier, where text and image, authority and possibility, were constantly interwoven.

Inscribing the Surface: Text as Landscape through Barthes and Genette

> The description... [is] a kind of lexicographical artefact...
>
> (Barthes 1994/1975, p. 26)

Surface and structure became of additional interest to me as I forged the editions of the thesis for publication. The final chapters of the thesis became the reconciliation of the research as object and knowledge through the book artefacts. I began to appreciate the text in new ways, according the written content significance in its own right, not just as a means for me to record my findings, but as an artefact to display, with aura and historical memory of its own. The language of the thesis was analysed as an aesthetic form based on the ideas of French literary

theorist Gérard Genette and scholar and bibliophile Nicholas Basbanes, who note the significance of paratext as a structural tool. Paratextual elements, such as titles, dedications, forewords, prefaces, endnotes, illustrations, indexes and appendices were considered as a structure which influenced the readers' perceptions of the ideas. Genette also suggests that these "liminal devices and conventions, both within and outside the book, author, publisher and reader" are as valuable to the reception of ideas as the text itself (Genette 1980; cited in Basbanes 2004, p. 229). This structural framework introduces the landscape of the text to the reader as a progression of ideas; the navigational markers guiding the arguments posed in this thesis.

The following excerpts show paratextual elements as they were used in *Remnant and Reliquary*.

> Joseph Banks' entry from the journal of the *Endeavour* in Botany Bay, 23 April 1770 [may be used] to demonstrate indigenous Australians' perspective at the time of Cook's arrival, and draw... the reader to the author's acknowledgment of the Cadigal people of the Eora nation as Australia's traditional landowners (p. 2).
>
> "They calld to us very loud in a harsh sounding Language... shaking their lances and menacing, in all appearance resolvd to dispute our landing to the utmost... In this manner we parleyd with them for about a quarter of an hour, they waving to us to be gone..."
>
> J. Banks, 1770, 'Endeavour Journal', Vol. 2, 15 August 1769 – 12 July 1771, State Library of New South Wales, p. 299, ML Safe 1/12–13.
>
> (*Remnant and Reliquary*, 2009, p. 2)

Further evidence of paratext is found in the introduction to the work, which can be 'read' through Sonnet I of Elizabeth Barrett Browning's *Sonnets from the Portuguese* on page 4 of *Remnant and Reliquary*. The use of this poem begins to settle the reader into the Victorian framework of the thesis ideals – women and the sensual, love and death, frailty and decay – which permeate the research.

> I thought once how Theocritus had sung
> Of the sweet years, the dear and wished for years,
> Who each one in a gracious hand appears

To bear a gift for mortals, old or young:
And, as I mused it in his antique tongue,
I saw, in gradual vision through my tears,
The sweet, sad years, the melancholy years,
Those of my own life, who by turns had flung
A shadow across me. Straightway I was 'ware,
So weeping, how a mystic Shape did move
Behind me, and drew me backward by the hair,
And a voice said in mastery, while I strove,
'Guess now who holds thee?' – 'Death,' I said. But there,
The silver answer rang – 'Not Death, but Love.'

<div align="right">(Barrett Browning 1995)</div>

The broader rationale of the work may be identified on page 5 of the thesis. The following three quotes reveal for the reader the underlying approach to the research: the importance of the written text as a tangible entity; that the historical study is undertaken with an embodied approach to the research; and that the creative practice and the written text are conjoined to reflect the ideals, or 'truth', of the whole.

> Writing can be displayed as both object and knowledge.
>
> <div align="right">(Stewart 1984)</div>

> Historians are not analysts, they are lovers and believers.
>
> <div align="right">(Clark 1995)</div>

> Any truth can be manifested in two ways: by things or by words.
> (T. Aquinas, 1926, *Quaestiones Quodlibetales*; cited in Gombrich 1972)

Secondly, the timbre of the language was explored through Barthes, as a landscape with surface texture. The landscape of the thesis also contributes to its formation as a material artefact. "Writing can be displayed as both object and knowledge" (Stewart 1984). The idea of an aesthetic analysis of the text is further reinforced by Barthes, who states: "The text needs its shadow... chiaroscuro" (1994/1975, p. 32). Shadow by its nature suggests depth, light, tone and shade, the aesthetic qualities of texture. Numerous devices were used in *Remnant and Reliquary* to alter the timbre of the written component to create such surface diversity for the reader. Poetry and fragments of text are used to create light and shade, rhythm and gradation through smoothness and abrasions in the

edition. Dominance and proportion have been utilised in the headings, sub-headings and section markers within the work. Capitalisation is used, designed to create graphic and typographic reinforcement for the reader through font size, style and placement on the page. In a similar fashion, punctuation creates additional rhythm within the text. Barthes continues: "Thus what I enjoy... is not directly its content or even its structure, but rather the abrasions I impose upon its surface: I read on, I skip, I look up, I dip in again" (1994/1975, pp. 11–12). Some text is read easily and quickly, whilst other text demands more focus. These nuances allow the reader to experience textual harmony and contrast when reading the content, enhancing its significance; skeletal frameworks fleshed by ideas and clothed in argument; concepts swathed in text, some prominently exposed for display, and others more discreetly inferred.

> Any truth can be manifested in two ways: by things or by words.
> (T. Aquinas, *Quaestiones Quodlibetales*; cited in Gombrich 1972)

Text and Presentation: [Typo] Graphic Sympathy with Themes of the Work

> ...the curious reader may have an idea of the taste of the work.
> (Eco 2004, p. 14)

Graphic principles come into play when manifesting such truths by things and words. Text can be impressed into paper by typefaces which may whisper or command. Underpinned by the traditions of nineteenth-century book design, drawings and text are placed onto translucent and aged paper for additional reinforcement. Times New Roman is used in the examination volume and Charlemagne Standard for quotations. Bartram states: "Like much, perhaps most, good type design, it was based on the living pen forms of the time and not some theoretical construct" (2001, p. 17). Hand-written typographic changes marked in quill and ink, made on special application to the Faculty by my supervisor, contribute to the nineteenth-century timbre of the thesis, and were undertaken with a good degree of anxiety. Poetry, quotation and written fragment feature throughout the thesis, their timbre and physical shape on the page redressing the columnar grid and marginalia. With the fusion of colour, typography, stock and graphic elements, the book serves to stimulate the reader; to persuade or inspire. As a repository of knowledge,

the book becomes a framework for historical, emotional and intellectual heritage. As such its graphic principles are significant. Eco extends this idea to the physical: "the curious reader may have an idea of the taste of the work" (2004, p. 14).

The Palimpsest: Thesis Reconciled as Object and Knowledge

> Along the way, the book becomes a spiritual instrument.
>
> (Alexander 2007, p. 441)

The thesis is reconciled as object and knowledge through the palimpsest. Palimpsest derives from the Greek, meaning 'again I scrape'. As a book form most notably connected with Mediaeval monastic scribes, the palimpsest was built on layered text embedded in leather, creating added surface to each page; the vellum often unrelinquishing of its original content. Layered text and image decrease in intensity and become shadows of the ideas of those who wrote before. As such, the palimpsest is a multiple surface. Surface as a carrier for knowledge may be as transient as a motif stroked through a film of dust, or as permanent as a phrase carved in enduring granite. The transmission of ideas has been facilitated in many forms and on many surfaces throughout history. The recording of knowledge, therefore, can be as ephemeral as a poem hastily scratched onto a napkin, a likeness drawn on a discarded postcard, or a love letter transcribed on the leaves of a favoured book.

The palimpsest underpins the reconstruction of a Victorian photograph album for the presentation of *Remnant and Reliquary*, a book crafted as object and knowledge. Reinstated with new knowledge, the volume is a contemporary palimpsest, rich with the ideals of reuse, bearing original content. This palimpsest therefore stands like the cadaver in two worlds: that of tangible time and that of place and the spirit of knowledge continuum. My writing is embedded into a framework which carries the materiality of another time, now hollow and stripped of content, but once influenced by other lives, dreams and ideals – remnant and reliquary: fragmentary traces reconciled as object and knowledge.

> Unencumbered by image, the viewer can look through into the depth of the book as though through a corridor with myriad vaulted ceilings. Board pages now discoloured with the spots and

Figure 7.4

M. Laird, 2009, *Remnant and Reliquary*,
'Palimpsest', University of Technology,
Sydney

markings of age, the book recalls a dignified architectural estate.
(Remnant and Reliquary, 2009, p. 70)

As a spiritual instrument, the book can transcend its binds and its
content. It can hold the fragments of ideas inspired by the content; or the
place in which, or the person with whom, it was read. It can be a holder
of secrets, strewn with papers, drawings and notations, a talisman for
protection, or a reminder of other times. Alexander states: "The book
has a mythic life as well as a material one" (2007, p. 441). This is the
place where the journal or visual diary can provide another type of
contribution to notions of writing for doctoral projects in the visual and

creative arts: point form, quotes, scribble, jottings, doodles, letterforms, accounting for conceptual development, creative process, iterations and experiments, notes to self, notes to others, ideas for further consideration, or those discounted and superseded. The hierarchy of ideas generation may be found in such recordings, as demonstrated in Figure 7.6. Whilst not formal or academic English, these notes may hold valuable and legitimate data for the progression of ideas, concepts, research and outcomes in the visual and performing arts.

I will conclude with Barthes, whose following statement embodies the intent of this chapter: "The whole effect consists in materialising the pleasure of the text, in making the text an object of pleasure" (1994/1975, p. 34). Ultimately, the writer gives authority to the reader; the private act

Figure 7.5

M. Laird, 2009, *Remnant and Reliquary*, 'Architectural Estate', University of Technology, Sydney

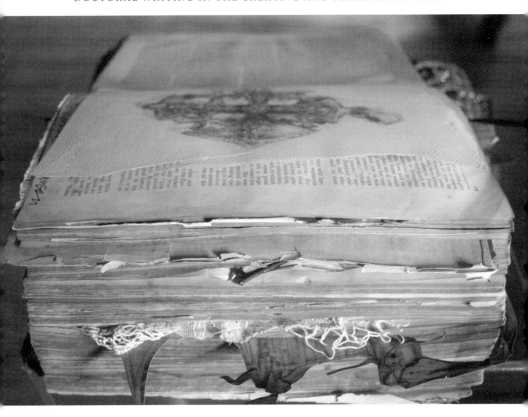

Figure 7.6

M. Laird, 2009, *DIARY: Traces*, workbook,
paper, cloth, organic material, found
objects, shell, gouache, ink, pencil,
private collection, Sydney

of reading where the text is interpreted by the reader, or in the case of
doctoral writing, the examiner. The author beckons to the reader to be
heard. Philosopher Paul Ricoeur states that "the reader is absent from
the act of writing; the writer is absent from the act of reading" (2008,
p. 102). He concludes that writing "replaces the relation of dialogue,
which directly connects the voice of one to the hearing of another"
(ibid., p. 103).

My examiner, Dr Catherine Harper from the University of Brighton,

when introducing me to a group of scholars in Philadelphia in 2010, commented that my thesis had a performative nature. She explained that as she unwrapped the books from a deconstructed Victorian cotton petticoat, and unbound their ties to reveal a heavy volume bound in black leather and its more discreet, velvet companion edition, she had found the process rather erotic. I blushed, but later reflected that the issues of body and memory signposted throughout the thesis had in fact embodied the 'fabric', or materiality, of the edition artefacts themselves: companion volumes in leather and velvet.

> As if writing aloud... the language lined with flesh, a text where we can hear the grain of the throat, the patina of the consonants, the voluptuousness of vowels, a whole carnal stereophony.
>
> (Barthes 1994/1975, p. 66)

To this notion, I aspire.

References

Alexander, G. (2007) Peter Lissiotis: Man of the Book. *Art in Australia* 44(3). Retrieved 10 July 2008, from: http://www.artaustralia.com/contents.asp?issue_id=177.

Bachelard, G. (1994) *The Poetics of Space: the Classic Look at How We Experience Intimate Places.* M. Jolas (trans.). USA: The Orion Press, Beacon Press.

Barrett Browning, E. (1995) *Aurora Leigh and Other Poems.* London: Penguin Books.

Barthes, R. (1994 [1975]) *The Pleasure of the Text.* R. Miller (trans.). Canada: Harper Collins.

Bartram, A. (2001) *Five Hundred Years of Book Design.* London: The British Library.

Basbanes, N. (2004) *A Splendor of Letters: The permanence of Books in an Impermanent World.* New York: Harper Collins.

Bronfen, E., & Goodwin, S. (eds) (1993) *Death and Representation.* Baltimore: Johns Hopkins University Press.

Christ, C. (1993) Painting the dead: portraiture and necrophilia in Victorian art and poetry. In E. Bronfen & S. Goodwin (eds), *Death and Representation* (pp. 133–151). Baltimore: Johns Hopkins University Press.

Clark, M. (1972) *Guide for Research Students Working on Historical Subjects.* London: Cambridge University Press.

Clark, M. (1995) *History of Australia.* Sydney: Penguin Books.

Cochrane, G. (1997) Keeping content: craft, history and curatorship. In S. Rowley (ed.), *Craft and Contemporary Theory* (pp. 53–64). Sydney: Allen and Unwin.

Daston, L. (ed.) (2004) *Things that Talk: Object Lessons from Art and Science.* New York: Zone Books.

Eco, U. (2004) *On Beauty.* London: A. McEwen, Secker & Warburg.

Genette, G. (1980) *Narrative Discourse: An Essay in Method.* Ithaca, NY: Cornell University Press.

Gombrich, E. (1972) *Symbolic Images: Studies in the Art of the Renaissance.* London: Phaidon.

Laird, M. (2009) *Remnant and Reliquary: Fragmentary Traces Reconciled as Object and Knowledge. Reading and Registering the Artefact Through Material Culture Research and the Lives of Women, Australia 1788–1901.* Unpublished PhD Thesis, University of Technology, Sydney.

Olalquiaga, Q. (1999) *The Artificial Kingdom: A Treasury of Kitsch Experience.* London: Bloomsbury.

Paltridge, B., Starfield, S., Ravelli, L., & Nicholson, S. (2011) Doctoral writing in the visual and performing arts: issues and debates. *International Journal of Art and Design Education* 30(2), 88–100.

Schlereth, T. (1992) *Cultural History and Material Culture: Everyday Life, Landscapes, Museums.* Charlottesville: University Press of Virginia.

Stewart, S. (1994) *On Longing: Narratives of the Miniature, the Gigantic, the Souvenir, the Collection.* Baltimore: Johns Hopkins University Press.

ISLAND HOME COUNTRY –
ON THE POSSIBILITY OF PRAXIS
BETWEEN 'ARTEFACT' AND
'EXEGESIS' IN THE CREATIVE ARTS
DOCTORATE: A CASE STUDY

Jeni Thornley

It is always on the border that the most disconcerting questions
get posed.

(Derrida 1998, p. 77)

Duration

In this chapter I use my doctoral film and exegesis, *Island Home Country: Subversive Mourning*, as a case study to investigate some of the risky issues provoked by the 'doubled doctorate'. This hour-long cine-essay, exploring colonisation and growing up white in Tasmania, was produced as a Doctorate of Creative Arts (DCA) at the University of Technology, Sydney (UTS) during 2004 to 2008. The principal writing phase of the exegesis was 2008 to 2010. The Australian Broadcasting

Figure 8.1

"We grew up behind a hedge keeping history out."

Tasmania, 1952, Personal collection of the author

Corporation (ABC) television licence for the film was 2008 to 2011. During the seven years' duration of the doctorate (three-years full time, four-years part time), a range of issues – ethical, social, political and theoretical – intertwined with people, places, memories, films, texts and art works. All this coursed through the filmmaking process, catalysing a "messy" process (Marcus 1998, p. 567), a mix of changing relationships and shifting desires that influenced the film's textual strategies. In writing this chapter several years after completing the doctorate, I draw on the DCA process to reflect on various questions – where does writing take place? Can a film *write* the doctoral thesis? Is the exegesis an afterthought, laden with unfinished business? Or is the interstice between 'artefact' and 'document' a potentially creative space where 'praxis' – volatility between theory and practice – is forged?

Beginnings

> We have been very happy here in the territory of the Nuenone
> people. Has any one of us paused to do a reckoning?
>
> (Pybus 1991, p. 7)

In the midst of the 'history wars'[1] in 2002, these words by Tasmanian-born historian Cassandra Pybus resonated. I was born white in 1940s Tasmania and knew no Tasmanian Aboriginal people and little of their culture. As I came to know more of the island's troubled colonial history, I wanted to penetrate 'the silence' around my childhood imaginary of Tasmania and connect it, somehow, to the reality of colonisation – the forced removal of the Tasmanian Aboriginal people from their homelands and their resilient and dynamic struggle to re-establish a connection to country and land rights. Some named Britain's colonial rule and race-based policies in Tasmania as an attempted genocide, while others denied the violence altogether, claiming Tasmania was peacefully settled.

I had started a film script in 1996 at the time of the Port Arthur massacre, when a lone gunman massacred 35 tourists at the historic convict site. This tragic event seemed to echo Britain's violent colonisation of the island. I wanted to connect it with the emerging 'new history' and the dynamic political activism by Tasmanian Aboriginal people – and also find my own voice as a Tasmanian. Perhaps I could make a film that spoke beyond the limiting frame of the history wars.

As a filmmaker, I knew film offered ways to consider the past other than simple reliance on the historical record. Film's textual strategies can strongly evoke feeling and emotion: 'affect'. In a film I could reach back to my own early childhood memories about Tasmania and link them to the present and the possibility of change. The intention was to expose 'the silence', to *do* something about it – but what? Make a reckoning – and with whom? Myself, my family, Tasmanian Aboriginal people? Moreover, what kind of text, if any, could signify the historical trauma created by Britain's racially determined colonial policies? The extent of the denial about what *really* happened in Tasmania had created a crisis for historical representation and an underlying psychotic split,

certainly in my mind, and perhaps in everyday life and culture amongst settler-colonials. The process of imagining a film inside this fissure was embryonic, but taking shape.

Remembering, Repeating and Working Through

Filmmaking process is a method, often a search for a container to convey both an inner and outer journey. Scholar Homi Bhabha suggests that the imaginary and the performative offer ways to work through the effects of colonial and post-colonising political power "transgressively on the borders of history and the unconscious" (1986, p. xiii). I was interested in how such 'performative' textual strategies might articulate layers of trauma and repression in my own mind and in the Australian nation itself. I was drawn to the way film historian Eric Santner (1990) considered the textual strategies of those post-war German filmmakers of the 1980s whose films spoke into the numbness after the Holocaust. Santner refers to post-Freudian thinking around the "real cause of traumatisation" to examine the way certain films "recuperate affect" (1990, p. 155). I wanted to connect this with the 'Tasmanian silence'. Perhaps it might provide insight into the potential of this project to develop as a 'work of mourning' and draw on the psychoanalytic process of "remembering, repeating and working through" as a textual strategy (Freud 1953a/1914, p. 145).

I developed these ideas into the DCA proposal during 2003 and also planned a film-industry pathway for the project. I anticipated that I could raise the budget via a mix of public broadcaster and government film investment *and* make the film in a university context. I also wanted to work with the intellectual scholarship around memory and history and post-colonial and documentary film studies. The project became a reality, although industry finance was not forthcoming. This lack of financial investment in the film had repercussions, negative and positive. Fortunately, the DCA structure at UTS offered access to camera equipment, production support, editing facilities and doctoral supervision with my principal supervisor, Sarah Gibson, also contributing as the film's project and script consultant.

Filming and gathering material began in 2004. It was an intuitive, almost random process of creating an archive of images – a diary,

bricolage approach. The film evolved in a practice-led process, marked by the history wars at the outset and the Federal Government's national 'Apology to Australia's Indigenous Peoples' at its close (Rudd 2008).[2] During the five years of film production, the ensuing encounter with Aboriginal protocols deeply affected the nature of the film that evolved. It became necessary to let go of control of the project into a process of negotiation and dialogue. There is an inevitable letting go of any imagined, or actual, film script in documentary filmmaking, but this felt different. It was not that it was becoming an Aboriginal film; it was more the challenge of *whose* story is being told here, and *who* is the storyteller? In fact, Tasmanian Aboriginal elder Jim Everett was very direct around an early edit of the film: "I think the story-line should be more yours. Looks too much our story" (J. Everett, personal communication, 7 July 2007).

This connects to a critical issue for documentary filmmakers. "What to do with people?" asks documentary scholar Bill Nichols (2001, p. 6), referring to the speaking position of the filmmaker. Trinh T. Minh-ha, filmmaker–scholar, describes it like this: "Who speaks? What speaks?" (1991, p. 12); "How can one re-create without re-circulating domination?" (ibid., p.15). The primacy of ethics is also taken up by documentary scholar Michael Renov, who refers to ethics as a fifth "fundamental tendency, or rhetoric/aesthetic function" of contemporary documentary film (2008, p. 173).

Protocols

Filming with my own white family and Tasmanian Aboriginal community members involved ethics and protocols (Arts Tasmania 2004). As words on paper these might seem clear and direct but, in practice, observing Aboriginal protocols was a learning process, involving relationship, dialogue, responsibility, trust and, in some instances, lack of trust. As well, Aboriginal protocols involved an intricate web of inter-cultural relations that extended practice-led process in various directions during the years of film production. Indigenous scholar Martin Nakata's concept of the 'Cultural Interface' made sense of these many conflicting forces – "a space of many shifting and complex intersections between different people with different histories, experiences,

languages, agendas, aspirations and responses... a space that abounds with contradictions, ambiguities, conflict and contestation of meanings" (2007, p. 199).

Moreover, there are many layers in documentary film production that influence the development of a film's textual strategies, especially in a work straddling the film industry, the university, family and the Aboriginal community. In this project's case these included multi-layered work around film permissions, music, film and image copyrights; collaboration with film personnel, such as the film editor, assistant editor, composer, sound designer, DVD designer, distributors, film festivals and television broadcasters. The UTS doctoral context required detailed submissions to the Ethics Committee (HERC), the Indigenous House of Learning (Jumbunna, UTS), along with discussion and progress reporting with several doctoral supervisors.

The Tasmanian protocols involved meetings with Tasmanian Aboriginal community members and their community organisations over several years. As well, in a personal essay film such as *Island Home Country*, there were family privacy needs to consider, a complex site with its own ethical reverberations.

These contesting forces pushed my practice-led process into a *site of instability*. Often my encounters with community members triggered uncertainty, influencing the film's development in unforeseen ways – their responses sometimes triggering a rush of affect. I became the 'unsettled settler' and definitely 'other'. I sensed this space as 'the instability of white'. Aboriginal Protocols functioned as a catalyst, pushing the script writing and image-sound editing to become embodied – literally for my 'ghostly' presence to become inscribed in the film.

The *invisibility* of white was so pervasive, that it was only when facing an "Indigenous critical gaze" (Moreton-Robinson 2000, p. xxiii) in encounters with the Tasmanian Aboriginal participants that I began to experience 'whiteness'. The ensuing protocols process moved beyond the film itself, bringing me into direct relationship with community members, along with obligations to make a film that recognised their collective and individual concerns. This "entanglement" (Rose 2004,

p. 213) impacted on many layers of the film production process and its visualization: sound, music, image, rhythm and story telling, alongside a requirement to make a work that contributed something back to community.

Maori educator Linda Tuwahli Smith states this responsibility to community as: "Is her spirit clear? Does he have a good heart? What other baggage are they carrying? Are they useful to us? Can they fix up our generator? Can they actually do anything?" (1999, p. 10) I became aware of Smith's book *Decolonising Methodologies* after the film was finished – during the exegesis writing phase. Reading such a significant text, after the fact, is a good example of what can impinge on the direction of a doctorate. It perhaps reflects the shortcoming of the literature search, or varying notions about the creative doctoral approach and what comes first vis-à-vis the traditional structure of research question, literature search, methodology, experiment, results, discussion and conclusion.

Textual Strategies Evolve in the Groundwork of Practice

In her book *The Skin of the Film*, film scholar Laura Marks defines intercultural cinema as "characterised by experimental styles that attempt to represent the experience of living between two or more cultural regimes of knowledge" (2000, p. 1). This is relevant to the praxis of producing *Island Home Country* as the project traversed what Marks calls the "power-inflected spaces of diaspora, (post- or neo-)colonialism, and cultural apartheid" (ibid.). To be responsive to Aboriginal protocols process and connect meaningfully to the artists in the film *and* their cultural works required a capacity to move between different world views and in that process to be *affected* – and for that affect to find its way into the film. The *praxis* of the filmmaking process became my encounter with specific protocols, in particular "Aboriginal Control" and "Communication, Consultation and Consent" (Arts Tasmania 2004, pp. 20–24).

The evolution of the *unstable* performed 'I' narrator of the film is the outcome of this protocols process. The *affect* of this evolving persona, *anxious white filmmaker,* decentred, fragmented and losing control of the film, irrupts in the face of the challenge – just *whose story* is being told here? How to evolve the authorship of the film and listen to all the

voices, yet tell *my* story, not *theirs* and resist the 'I' narrating voice to hold the film together?

Over time, an unstable narrator develops who admits, "Like in a dream I lose my thread. This film is dissolving" (Thornley 2008). I peer into my own mind and create a performance of white instability, uncertainty and fissure. In this process a shift is taking place from the project as an imaginary artefact in my own mind, or words on a page, to relationships with people in the present. To be present and grounded involves a move from introspection, to what Nunga philosopher and lawyer, Irene Watson (2007) describes as "a meditation on discomfort". This asks me to consider questions such as the lawfulness of settler Australia (p. 30). The focus of the project shifts then from being a *mourning* work, to become an intense experience of Australia's race relations "*within my skin*" (Nicoll 2004, p. 30).

Although my previous films were also produced in this rupture between private and public and the personal and the political, producing *Island Home Country* in a doctoral frame offered a unique context for in-depth work on many levels. In particular, I could more consciously consider textual strategies from a diverse range of film, literature and art-based forms and work with them in response to protocols dialogue. The DCA process provided a structure to contain and work through protocols outside of a commercial film paradigm. This allowed more spaciousness and trust with the Aboriginal participants and family members.

Negotiations with participants – for example, about where to film their interview, what to film, what to keep or what to drop – as well as their incisive critiques of the film enacted something of the protocol 'Aboriginal Control'. It pushed the work into a dialogic process where the film's authorship opened up to include process-based negotiation. Hamid Naficy explores such negotiations as "sites for intertextual, cross-cultural, and translational struggles over meanings and identities" that unfold into the text of a film itself (1996, p. 121). Marks considers this kind of reflexivity to be an intrinsic aspect of "intercultural cinema":

> When a film reflects upon its own production process, its obstacles, and the very cost of its making, it acts as this sort of catalytic

crystal, reflecting the film-that-could-have-been in the complex of its virtual images. ... All the events that prevent the production of images stimulate circuits of memory.

(Marks 2000, p. 65)

Contributions by participants loosened the project's initial theoretical emphasis on the psychoanalytic frame to include decolonising methodologies, critical race and whiteness studies and research on the dialogic encounter as an *altering* event. Norman Denzin refers to "an embodied and moral commitment on the part of the researcher to the members of the community... characterised by the absence of the researcher's need to be in control... nothing is desired for the self" (2003, pp. 6–7).

Make the Film, Make the Film, Make the Film

My filmmaking method is more akin to a craft practice than one based on any film-industry model; and the practice-led process that evolved with *Island Home Country*, strongly encouraged by Sarah Gibson, my principal supervisor, prepared the ground for praxis. There's a link here, too, with the essayist's approach in filmmaking, trying out ideas in words and images – a free-flowing intuitive form. This is a *gathering* process – compiling a visual–sound archive that takes its final shape and form in editing.

Setting off to Tasmania to film with my family, and whoever else I might encounter along the way, the film unfolded more by chance than according to a focused plan. The filmmaking method evolved here – *film often, in a contingent way, film by intuition, film thematically*. This kind of filmmaking tends to develop as an internal process with its own duration, as potter Carla Needleman describes:

> The end product, the finished rug, is in the future, too far ahead to encourage him. It requires a different patience from the patience we are accustomed to – the patience of waiting. ... The principle in craftsmanship that calls us to work with materials may be the same principle which in a larger sense calls us to work with ourselves.
>
> (1979, pp. 66 & 106)

An Ethics of Listening

Indigenous scholar and activist, Sam Watson's (2005) response to a white fella question, "What can I *do*?" resonated early on in the research phase:

> Find out the history of the land on which you are living – just find out. And don't use white academic sources, use Aboriginal sources as your primary sources; and find out whose country you're on and find out exactly what happened to that mob. Find out what the dreaming stories are, the dances and songs. Then when you know, that's the first step on the journey of enlightenment.

This direct, practical response from Watson penetrated, becoming a compass of sorts to connect with Aboriginal voices and not rely on *white* academic sources. Cultural works and writings by Tasmanian Aboriginal community members told the story of *another country* – a different place from a white childhood lived "behind the hedge, keeping history out". A rich stream of thinking by contemporary Tasmanian Aboriginal scholars, activists, artists and writers flowed in; their writings and cultural works spoke *back* into the film through protocols – a site of *praxis* between film, writing and community.

Protocols-based process poses the question of *how* a project might link to community. This linking becomes a *doubled* process – internal within this filmmaker – and also a social process in direct relationship with Aboriginal community members. Writer and activist Arundhati Roy explores this relationship, as cited in *Island Home Country*:

> The search for the individual art, the individual way of expression – how does that link into a community? How does that link to what's important? These are very interesting questions and ones that you can never be comfortable with... a place that you always live in conflict. And that's not a bad thing to live in a conflicted sense... where you're not really sure and you have to pick your way through things and you make a decision every time you take a step.
>
> (Roy, cited in Thornley 2008)

Figure 8.2

Woo Joung Kim, 'The White Ghost', 2003, photograph from *Mad Woman's Mountain* [Motion Picture], UTS Sydney

The Mysterious Process of Creating Visual Metaphor

"I am white, born on a stolen island. This is my story of a journey" is my opening narration to the film. How to find a visual metaphor to express this *instability of white*? How to shift the gaze from the traditional ethnographer's study of 'the other', towards the filmmaker's 'white' colonised–colonising mind *and* look at what's in there? I turned to an image from my own film archive and named it the "white ghost of Australian history".

In Kim's (2003) short film *Mad Woman's Mountain* (see Figure 8.2), I perform a madwoman who kills the Buddha on the road. The day we

film, it doesn't stop raining. It is intense, cold and surreal. The moment reminds me of the Port Arthur massacre and the Super 8 I filmed of the crumbled convict ruins – the dark black of the sky, the greens and grey the trees. As I perform this filmmaker's madwoman, I sense something other than his construct. This white ghost figure bleeds into my Super 8 as an uncanny, ghostly return of 'the silence'. The image is performative, ritualistic – the ghost in *me* is now embodied. Tasmania's repressed colonial story was debated interminably in words, trapped in the history wars. This image broke through, amnesia pierced. Santner's notion that images "recuperate affect" is now given form (1990, p. 155).

The Turning Point

The descent into "affect" triggers a theoretical turn, from Freud's (1953b/1914) concept of the work of mourning at the outset of the research phase, to critical race and whiteness studies visualised in the film as this 'white ghost' of Australian history. Here lies *praxis*. Visual artist and scholar Barbara Bolt analyses the doctoral requirement to contribute to "new knowledge", critiquing its prescriptive adoption in creative arts research as the "shock of the new". Bolt offers an insightful understanding of praxis: "In the 'work' of art, we do not consciously seek the 'new' but rather are open to what emerges in the interaction with the materials and processes of practice" (2004, n.p.).

Bolt turns to philosopher Gilles Deleuze who suggests that "to break through the givens, a catastrophe has to occur" (Deleuze 2003, p. 46). "Whilst we are thinking too much, responding with our intellect", writes Bolt, "we do not attend to the rhythms that constitute the creative process" (Conclusion section, para. 6). "According to Deleuze, the catastrophe provides the turning point, which allows the emergence of another world into the work" (Conclusion section, para. 9). In the case of *Island Home Country*, this 'other world' created a space for the performative image of myself as the white ghost to emerge. This was not a pre-meditated construction. It was fired in the crucible of practice, a direct example of the practice-led thesis. The Deleuzian "catastrophe" becomes my intense experience of the *instability of white*. The praxis of the work develops through attending to poetics – with the very

"materials and processes of practice". This is not realised through writing, but through the intensity of affect enacting in practice.

The 'turning point' irrupts in the face of Everett's challenge to shift the emphasis away from the Aboriginal story – to my story. In setting off to Tasmania to make this film there was no foreseeable way I could have constructed the *instability of white* as a theoretical hypothesis to test. In the combustible space of the Cultural Interface, this swirling space of people, history, politics, protocols and the sheer materiality of film itself, the white ghost emerged. The ghost is this white settler–stranger's un-belonging; and it feels *risky* because one does not know the outcome. It is in *direct encounters* that shifts of consciousness occur, in *reality*, not as theory or protocols in a handbook but, as Marcia Langton suggests, "when Aboriginal and non-Aboriginal people engage in actual dialogue" (1993, p. 35). It is in this site of 'inter-subjectivity' that any projections, objectification or stereotyping are taken back.

During the final sound post-production in 2008 the turn to 'critical race and whiteness studies' begins to influence the film-editing process. Perhaps if I had been steeped in this discourse *before* setting off to film in 2004, I might have made a different film. Yet no amount of preparatory reading in decolonising methodologies or the critical whiteness texts could have provided the intense experience of "falling off my perch" (Nicholl 2004, p. 30) into unsettlement, or to sit in Irene Watson's "medi-tation on discomfort" (2007, p. 30) with any embodied understanding.

Where Does Writing Take Place?

In filmmaking, the term "writing with light" (Storaro 1982, p. 15) suggests we are in a very different place from writing with words. Therefore, the question *where does writing take place?* is a provocative one for the doubled doctorate. A filmmaker's textual strategies may include writing, but they are not necessarily the same as the textual strategies of the writer. Consequently, the film and the exegesis call on very different textual strategies. Media scholar Steven Maras suggests, "The film is the thesis, or, in other words, the mode of expression of that thesis forms a part of the conceptual practice of the film." (2004, p. 87) In *Island Home Country*, the research question is constantly being worked through

while filming, and also in film-editing process. Yet what we finally *see* on screen is determined by a complex interplay of many production forces. Textual strategies aren't always arrived at by choice – they are sometimes desperate moves, intensified by financial and timing constraints.

'Writing with light' enacts in the choice of what to film, in the juxtaposition of shots, and in the use of music, sound design and narration. It is less a *writerly* process than an intricate refining process of image and sound, using various technologies. Karen Pearlman *Island Home Country's* film editor, uses the term "rhythmic intuition" to describe this shaping of the flow of energy between different shots in a sequence of the film:

> The raucous movement, colors, and framing of an Australia Day celebration picnic collide with the flow and grace of the dolphins in the sea. Cutting these two shots together creates an idea through visual collision; in this case, the idea that colonization and nation building conflict with nature and First Nation peoples.
>
> (2009, p. 58)

Both the thesis of the film and affect are worked into the film in an embodied way with sound and image. Here *praxis* unfolds in the interstices – the "space of possibility" (Lionnet 1989, p. 25). This 'space' also emerged when community members gave their feedback on various edits of the film, triggering affect and the shift in my subject position. The whole process stimulated self-reflexivity. Anthropologist Ruth Behar writes about the liminal place of the "vulnerable observer" existing "between places, between identities, between languages, between cultures, between longings and illusions" (1996, p. 162).

The film's chapter structure – Amnesia, Possession, Memory, Mourning, Encounter, Reckoning – developed in the interstices too, during the initial film-editing phase. The chapters were prompted by an insight from cultural studies scholar Stephen Muecke: "Visitors are traders in stories, and visiting is a process which enhances the imagination (story-like in its own movement of anticipation, encounter, exchange, return)" (2008, p. 84). This seemed to offer something akin to the movement of protocols in action. It is *there* in the footage – *encounter* involves *exchange*. Something happens and it affects *return*. Eventually the film evolved into a document of both the research process and protocols

process, an exposition of "ethics around decolonisation" (Rose 2004, p. 31) and the process of "being connected to country" (Everett 2006, p. 92).

The film chapters also provided a structure for the exegesis – yet any consistent exegesis writing amidst film production was almost impossible. It was only after the film was completed that I could approach the writing in a more contemplative and analytic way to consider how the initial thesis question was challenged by practice. I could then establish a thread between the critical discourse and the research findings to think through what might have contributed to the irruption of affect. Then the theoretical shifts could be more clearly articulated.

During this exegesis writing phase I worked with an alternate supervisor, as the writing required a more focused discussion around cultural studies and post-colonial texts. After reading the first draft this supervisor commented, "The writing is exciting. Looking forward to seeing how this writing is also filmic." Having just spent four years making a film, the notion of 'filmic writing' was mystifying to me. *But this is why I make films!* It felt like a puzzle, a conundrum, especially as I wanted to write analytically in the exegesis. A colleague responded, "I imagine that 'filmic writing' refers to the ways we might 'write', inscribe, or represent the past in a cinematic way – how we might remember or 'see' the past, cinematically" (Personal communication, 6 June 2008). But isn't this what my film does? Surely the task of the exegesis writing is more than reproducing the visual in *words*?

Languaging the Exegesis

At times I felt something split or schizophrenic about the doubled doctorate of film and exegesis. The risks were compounding, too, during the writing phase. The whole DCA was to take three years, but now it was mercurial, slipping from my control. The years were ticking by with rising debt, economic loss. It's as if the doubled form creates a greater chance of risk, as one has to create and navigate a self-reflexive discourse *within* each work and *between* two works; one has to listen and intuit the conversation informing each of them. Yet the very crucible for *praxis* lies here, in what Bhabha calls the "borderline work of culture... a contingent 'in-between' space" (2007, p.10).

I sense now, in hindsight, how much this was an inherently "messy" process of "someone who admits he does not know where he is going... a joyous self-contradiction" (Derrida 1983, p. 35). I read Derrida's essay about writing his thesis late in my own process, while completing the film. It helped make sense of the risky *unknown* of practice-led process and work some of it back into the film. This reflexivity, too, inflects forward into the writing phase. Here, the online module *Practice-led Research in Arts Media and Design* (Australian Technology Network (ATN) 2008), which I began *after* finishing the film, while writing the exegesis, was invaluable. This unique course provided a space to explore the *intertextuality* of the doubled doctorate in a theoretical and reflective framework with a moderator, other doctoral candidates and relevant scholarship. For instance, I put the 'filmic writing' conundrum to the ATN moderator. He responded, "I believe the exegesis really helps one *think through the project,* to the extent that it is in the *act of writing* that the research findings actually become clear" (Personal communication, 18 October 2008). Now I began to see the alternate-supervisor's intent as simply encouraging theory to become embodied – to write in a present tense, *lively* way, not only in a theoretical way.

The ATN module offered a crucial structure for the writing process. As Bolt suggests, "This languaging is the task of the exegesis" (2004, para 9), and it requires a different approach than the kind of collaborative practice-led process that underpins the production of a film – with its plethora of textual strategies and myriad technical requirements of post-production. Exegesis writing is more solitary, reflective and analytic – and directly linked to the critical discourse. The structure of the ATN unit recognises this by working through key questions, as well as addressing issues connected to the doubled form. In *writing* about practice and theory in an exploratory way, "this languaging" starts to develop.

Exegesis writing is also a very different undertaking from the process of working with specific Aboriginal protocols in film production, with all the intricacies of the "Cultural Interface" (Nakata 2007, p. 199) and ethical reverberations around 'voice' and 'who speaks'. Writing the exegesis has an internal dialogic – it is you *and* your text. It is thinking through with words, one's own words and the words of others. It is a

self-reflexive conversation with the critical scholarship. Certainly a film's 'voice' needs to embody both enquiry *and* critical analysis of the thesis topic, yet *Island Home Country* also had to function for a broad national and international film and television audience, while remaining 'true' to both its Aboriginal and family protocols process. The 'voice' of the exegesis on the other hand has a different function. It is written for a different audience – a community of scholars. Its circulation as 'text' occurs in quite another realm than a widely distributed film.

Unravelling the Web of the 'Doubled Doctorate'

This chapter has explored some of the characteristics of the doubled doctorate and how praxis occurs "in interaction with the materials and processes of practice" (Bolt 2004, Abstract, para. 2). In the case of *Island Home Country*, the filmmaking process became both crucible and experiment. Aboriginal protocols activated a place of *uncertainty* where the initial thesis proposal became subject to change in a practice-led process. It was as if the film became the 'experiment', and 'protocols' the teacher. I suggest that it is in the interstices that praxis emerges; that these 'in-between' spaces are volatile and full of risk, yet they are also places where practice and theory are combustible and transformation happens.

> Openness is risky because one does not know the outcome. To
> be open is to hold one's self available to others: one takes risks
> and becomes vulnerable. But this is also a fertile stance: one's
> own ground can become destabilised. ... [yet] counterbalanced by
> commitment to the decolonising process.
>
> (Rose 2004, p. 22)

The exegesis phase provided a reflective space to think through and write about this experiment. Here I analysed the film's attempt to 'work through' the historical trauma of colonisation at both an individual and community level. The experiment revealed that the film's initial intention to 'make a reckoning' was flawed. Protocols had transformed my speaking position. As Aboriginal educator Norm Sheehan (2009) suggests, "this scholarship evolves through process. It's not what you listen to, but how you position yourself in listening. It's not what you say, but where you position yourself to speak". This is praxis.

Writing this chapter *now* in 2013 is different from articulating the DCA hypothesis back in 2003, or producing the film during the years 2004–8, or writing drafts of the exegesis during 2007–10. The practice-led process of *make the film, make the film* meets this moment in time *now* to ask, just what has been going on these last ten years?

> It is more like having the reality depicted turn back on the writing, rather than on the writer, and ask for a fair shake. "What have you learned?" the reality asks of the writing. "What remains as an excess that can't be assimilated and what are you going to do with the gift I bestow, I who am such strange stuff?"
>
> (Taussig 2006, p. viii)

The doubled doctorate is "strange stuff" indeed, "the gift" still in the process of being assimilated.

Acknowledgment

Thanks to the Tasmanian Aboriginal participants for protocols process and my family and UTS for support. *Island Home Country* DVD and VOD: http://www.jenithornley.com/.

References

Arts Tasmania (2004) *Respecting Cultures: Working with the Tasmanian Aboriginal Community and Aboriginal Artists.* Hobart, Tasmania: Aboriginal Advisory Committee.

(ATN) Australian Technology Network (2008) *Practice-led Research in Arts Media and Design.* Retrieved 18 August 2013, from: http://www.atn.edu.au/.

Behar, R. (1996) *The Vulnerable Observer: Anthropology that Breaks Your Heart.* Boston: Beacon Press.

Bhabha, H. (1986) Remembering Fanon: Self, psyche, and the colonial condition [Foreword]. In F. Fanon, *Black Skin, White Masks* (pp. vii–xxv). London: Pluto Press.

Bhabha, H. (2007) *The Location of Culture.* London: Routledge.

Bolt, B. (2004) The exegesis and the shock of the new. *TEXT*, Special Issue 3. Retrieved 13 August 2013, from: http://www.textjournal.com.au/speciss/issue3/bolt.htm.

Deleuze, G. (2003) *Francis Bacon and the Logic of Sensation.* London: Continuum.

Denzin, N. (2003) *Performance Ethnography, Critical Pedagogy and the Politics of Culture*. Thousand Oaks, CA: Sage Publications.

Derrida, J. (1983) The time of a thesis: punctuations. In A. Montefiore (Ed.), *Philosophy in France Today* (pp. 34–50). Cambridge: Cambridge University Press.

Derrida, J. (1998) *Resistances of Psychoanalysis*. Stanford: Stanford University Press.

Everett, J. (2006) This is Manalargenna country: clan country of a first nation. In A. Reynolds (ed.), *Keeping Culture: Aboriginal Tasmania* (pp. 89–97). Canberra, ACT: National Museum of Australia Press.

Freud, S. (1953a [1914]) Remembering, repeating and working through. In J. Strachey (ed. & trans.), *Standard Edition of the Complete Psychological Works of Sigmund Freud* (pp. 145–156), *12*. London: Hogarth Press.

Freud, S. (1953b [1914]) Mourning and melancholia. In J. Strachey (Ed. & Trans.), *Standard Edition of the Complete Psychological Works of Sigmund Freud* (pp. 243–258). *14*, London: Hogarth Press.

Kim, W.J. (Director) (2003) *Mad Woman's Mountain* [Motion Picture]. Sydney, New South Wales: University of Technology, Sydney.

Langton, M. (1993) *"Well, I heard it on the radio and I saw it on the television": An essay for the Australian Film Commission on the politics and aesthetics of filmmaking by and about Aboriginal people and things*. Sydney, New South Wales: Australian Film Commission.

Lionnet, F. (1989) *Autobiographical Voices: Race, Gender, Self-portraiture*. Ithaca, New York: Cornell University Press.

Maras, S. (2004) Notes on a genre to come: screenwriting and the 'thesis-film'. *Cultural Studies Review 10*(2), 85–98.

Marcus, G. (1998) *Ethnography through Thick and Thin*. Princeton, New Jersey: Princeton University Press.

Marks, L. (2000) *The Skin of the Film: Intercultural Cinema, Embodiment, and the Senses*. Durham: Duke University Press.

Minh-ha, T.T. (1991) *When the Moon Waxes Red: Representation, Gender, and Cultural Politics*. New York: Routledge.

Moreton-Robinson, A. (2000) *Talkin' Up to the White Woman: Aboriginal Women and Feminism*. Brisbane: University of Queensland Press.

Muecke, S. (2008) A chance to hear a Nyigina song. In *Joe in the Andamans, and other Fictocritical Stories* (pp. 80–93). Erskineville, New South Wales: Local Consumption Papers.

Naficy, H. (1996) Phobic spaces and liminal panics: independent transnational film genre. In R. Wilson & W. Dissanayake (eds.), *Global/Local: Cultural Production and the Transnational Imaginary* (pp. 119–44). Durham: Duke University Press.

Nakata, M. (2007) *Disciplining the Savages – Savaging the Disciplines*. Canberra, Australian Capital Territory: Aboriginal Studies Press.

Needleman, C. (1979) *The Work of Craft: An Enquiry into the Nature of Crafts and Craftsmanship*. New York: Avon.

Nichols, B. (2001) *Introduction to Documentary*. Bloomington: Indiana University Press.

Nicoll, F. (2004) Reconciliation in and out of perspective: white knowing, seeing, curating and being at home in and against Indigenous sovereignty. In A. Moreton-Robinson (ed.), *Whitening race* (pp. 17–31). Canberra: Aboriginal Studies Press.

Pearlman, K. (2009) *Cutting Rhythms: Shaping the Film Edit*. Burlington US, Oxford UK: Focal Press.

Pybus, C. (1991) *Community of Thieves*. Melbourne, Victoria: Minerva.

Renov, M. (2008) What's at stake for the documentary enterprise? Conversation with Michael Renov. In A. Bonotto & G. de Barcelos Sotomaior, *Doc On-line 4*, 166–179. Retrieved 13 August 2013, from: http://www.doc.ubi.pt/04/doc04.pdf.

Rose, D.B. (2004) *Reports from a Wild Country: Ethics for Decolonisation*. Sydney: University of New South Wales Press.

Rudd, K. (2008) Apology to Australia's Indigenous Peoples, House of Representatives, Parliament House, Canberra, 13 February 2008. Retrieved 13 August 2013, from: http://australia.gov.au/about-australia/our-country/our-people/apology-to-australias-indigenous-peoples.

Santner, E. (1990) *Stranded Objects: Mourning, Memory, and Film in Postwar Germany*. Ithaca, New York: Cornell University Press.

Sheehan, N. (2009, December) Indigenous knowledge, ethical social action and Aboriginal health inequity. Paper presented at the Indigenous Knowledges Symposium: Into the Academy, IKRG and Faculty of Arts, University of Sydney, Sydney.

Smith, L.T. (1999) *Decolonizing Methodologies: Research and Indigenous Peoples*. Dunedin, New Zealand: University of Otago Press.

Storaro, V. (1982) Writing with light: an interview with Vittorio Storaro. *Film Quarterly* XXXV(3), 15–25.

Taussig, M. (2006) *Walter Benjamin's Grave*. Chicago: University of Chicago Press.

Thornley, J. (Producer and Director) (2008) *Island Home Country* [DVD]. Sydney, New South Wales, Australia: Anandi Films.

Watson, I. (2007) Settled and unsettled spaces: are we free to roam? In A. Moreton-Robinson (ed.), *Sovereign Subjects: Indigenous Sovereignty Matters* (pp. 15–32). Crows Nest, New South Wales: Allen & Unwin.

Watson, S. (2005) *The Politics of Indigenous Resistance in Australia*. Paper presented at the Third Asia Pacific International Solidarity Conference, Sydney, New South Wales.

Notes

1 The 'history wars' debate escalated over the extent of frontier violence in Tasmania with the publication of Keith Windschuttle's (2002) *The Fabrication of Aboriginal History*.

2 On 13 February 2008, the Prime Minister, the Hon. Kevin Rudd MP, moved a motion of Apology to Australia's Indigenous Peoples, particularly the Stolen Generations and their families and communities, for laws and policies which had "inflicted profound grief, suffering and loss on these our fellow Australians". "Stolen Generations" refers to those Indigenous children separated from their families under the government's laws, policies and practices of forcible removal.

CREATIONISM OR EVOLUTION: ARE YOU THE GOD OF YOUR WORK OR DO THE CHAOTIC FORCES SHAPE YOU?

George Catsi

The Welcome

Framed against my creative doctoral project, this chapter navigates the question of the challenges and diversities of doctoral writing in the visual and performing arts by suffusing academia with religiosity, as I tend to think at times they may be one and the same thing. Then, like an insider's insight, the chapter connects back to my work, as religion is not an arbitrary comparator, but the central theme of exploration in my doctoral and creative studies. My multi-platform creative theatre work, *I Want to Be Slim*, interweaves with deeper driven academic research. Questions of why and how, not unlike quests for spiritual meanings, abound. As my creative work is based in the world of satire, my reasoning will thematically parallel this.

So I invite you to come and meet my maker...

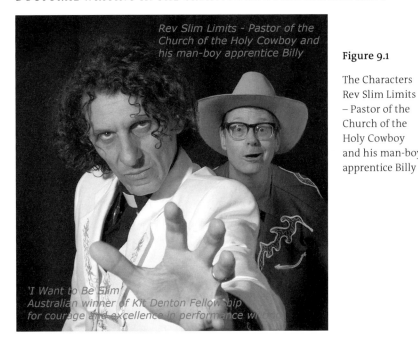

Rev Slim Limits - Pastor of the Church of the Holy Cowboy and his man-boy apprentice Billy

'I Want to Be Slim' Australian winner of Kit Denton Fellowship for courage and excellence in performance wi...

Figure 9.1

The Characters Rev Slim Limits – Pastor of the Church of the Holy Cowboy and his man-boy apprentice Billy

The Hymn (Opening Verse)

I Want to Be Slim (Catsi 2013) is a case-study exploration of Christian fundamentalist evangelism through satirical performance, writing and media. These creative elements emerge from my background in comedy. My project has had to establish connectivity between the research and its direct or indirect influence on the creative outcomes. I concluded that this pathway, though not explicit, was in itself the tension that synthesises both aspects of a practice-based thesis.

The motivator to explore this project through performance and research is that I am drawn instinctively to the polarisation effect of the subject of religion. This derives partly from a mix of an Orthodox followed by a Baptist upbringing that seemed to sit comfortably, so I thought, with a very normal teenage exploration of all things vice. This duality of being fought itself out, with vice the victor; but this certainly wasn't a knock out, more of a point's decision. I see the search for meaning and purpose as valid; however, the institution and, more specifically for me, the people who stood in front of me and sold me the truth

were, I concluded, flawed. Who were these people and how do they go about their business of peddling truth? That was my internal motivator; however, this was propelled by observance of the outer – how the sheer question of religion or even belief was responded to and reported. Individuals position themselves very quickly as to where they sit on a spectrum of acceptance or rejection of religion and its themes. This I observed in debates played out across all media and reflected through opinion pages, commentary and public comments, plus through direct experience of stating the subject of my doctorate and creative work. Everyone has an opinion and is either very clear on telling you or very clear on not talking religion. Concurrently, I observed the responses to those who did choose to talk about their beliefs: non-believers usually responded poorly; and those with extreme beliefs, when responding to 'lesser' or non-believers, likewise responded poorly. I thought that this ideological, spiritual relationship between individuals and groups was relevant and potentially dangerous for a civil society. It too, I felt, made for compelling theatre.

The creative parameters for my project on entering my doctorate were the creation of a theatre work encompassing multi-platform modalities that mimicked the real evangelical churches. This included web, social media and digital devices such as video, audio and graphic design. By opening up the pool of creative output possibilities, I sought to create an expansive interpretation of the real. This was built around a central character, The Rev Slim Limits and his faux church, The Church of the Holy Cowboy.

I Want to Be Slim is a satirical comedy, a hyper-real allegory and/or morality tale about Slim, an ambitious cowboy who missed the point at a Billy Graham Crusade and accepted Billy, not Jesus, into his life. As a misguided evangelist, he sets about building a church – but to whom? It is crafted as a two hander, with no fourth wall, a hands-on theatre experience that endows the audience as the congregation then draws them in. An off-centre exploration of persuasion, projection and posturing that will make you, the audience, want to believe. As will be discussed, this proved complex and broad – just like, as I decree, the parameters of doctoral writing in the visual and performing arts.

Figure 9.2

The Satire
Performance including gospel choir

The Sermon

The Perils of Marriage

The issue of art in the twenty-first century is not as much about if or why one believes in art but, in the case of this discussion, what or how one believes in art, and how one applies that belief. What makes this so exciting and important is the notion that art has profound implications for humanity and for our understanding of it through academia. As far back as I can remember, I have believed in that which we call creation or creativity or 'art', a force that is the creator of all, a creative consciousness into which we can tap. I've sensed it. I've felt it.

Yet I acknowledge that this may be nothing more than a figment of my imagination, for art and creativity exist beyond the realm of that which can be proven scientifically or academically. Moreover, I do not posit that

art in bed with academia necessarily leads to something good or even interesting. But this is the bed we all climb into and being here in this discussion is akin to attending a relationship counselling session with a chaste Catholic priest, one who only knows sex in purely abstract terms.

The university faculties and disciplines, I suggest, are as fractured / aligned / internally confused or contradictory as any or all of the denominations of religion and their segmented, internalised differences. The parallel I'll draw on is not intended to alienate you with a hidden evangelical conversion conspiracy, but to help you enter my creative and research world, which I felt intersects with the complexities, irregularities and conflicting world of practitioner-based research degrees. A place where the notion of the spiritual (the art) must be married with and rationalised against the doctrine (the research or exegesis).

What I and others have found, as can be read elsewhere in this volume, is just how varied and confusing this marriage can be. Those of us who attempt such a union will find that it will either be an arranged marriage or one of convenience. It can be placed somewhere on a spectrum ranging from art, through academic fundamentalism, creationism, evolutionism, to the home of the most struggling: agnosticism. The agnostics are the uncertain ones who don't know where to place their effort and are wallowing in uncertainty as to how to marry the creation of art with the research; for maybe what is really troubling for them is the content of the exegesis. Atheists don't even get a look in, because if you believe in nothing you are most likely enrolled in business or commerce.

I'll attempt to parallel the genesis of why you entered a tertiary institution to receive a higher degree with your relation to the academic and the creative work. For in hindsight I see that the reason that brought you to commence the degree may determine your relationship to the work and the study. A reconciliation of this in your own mind may give clarity to the focus of the journey and subsequently ease the travel sickness we are all prone to conjure along the way. By travel sickness, I metaphorically refer to the sense of unease I experienced whilst on the journey, as opposed to the apprehension felt at the start of the journey. However, this reconciliation I refer to acts as a preparation for the time ahead.

Why Do I Come?

This is a period in which there has been a marked increase in post-graduate studies. Last year, there were 97,000 domestic students undertaking master's programs by coursework in Australian universities. A decade earlier, there were fewer than 40,000. The number of domestic students undertaking doctorates by research also grew, from about 24,000 to almost 34,000 in the same period (Harrison 2011). So why do we enter the university – or as I'll call it to keep the context, the Church of Knowledge – in ever-increasing numbers for an extended time of communion with the spirit?

Is it the opportunity to pursue the core act of creation: the work, the art? The research can be an unfriendly or at-times-irritating consequence of satisfying the desire for use of a free studio or equipment.

Or do you come to the Church of Knowledge seeking community? Community that manifests itself in several possibilities: does the loneliness of artistic creation draw you to be with other artists or like-minded people; or is the thought of time with a guru, mentor or, in secular terms, your academic supervisor the mitigating factor that drew you through those doors?

Is it that your creative meditation, your daily practice is at best shaky, unfocused? You fear you may not be able to be a real believer in yourself as a creative artist so you go to the uni church to validate yourself for another three to four years (or likely more), hoping, yearning that, along the way, you'll have a Damascus moment, like Saul, and the God of talent, good ideas and brilliant execution will shine some light on your path.

Maybe your creative academic journey is driven purely by the notion of Godly charity, commonly known as an APA (Australian Postgraduate Award) scholarship. For 3.5 full-time years, you're earning more doing your creative art than your art has ever earned in the secular world. A full-time three-and-a-half-year indexed scholarship pays $83,629 AU tax free (2010–13) (Australian Postgraduate Awards 2013).

Or is it nothing to do with the art at all but all to do with the prospect of an academic job, as you eyeball the offices of those retiring baby-boomer tenured lecturers who we perceive as 'blocking' the flow of jobs? The practitioner doctorate is what you perceive as an 'easier' choice than a traditional PhD, the paper more important than the process.

One point of my personal experience that was unimagined and that permeated through the years was the quiet sense that this was all an indulgence, that I couldn't justify the time against the outcome. There emerged a need to reconcile this trickling toxicity as it eroded my validation for being in the process. The creative work could have been achieved faster, most likely, without the academic research component. A PhD didn't necessarily give a winning edge to any future arts funding I might go for. Its standing in the broader arts community I perceived as more anecdotal rather than palpable. In this community, the art work produced was all that mattered. Having the PhD wrapped around it was just that: wrapping. The core creative work was ultimately what I would be judged on. So again, why was I doing it?

For me, creating tangible and measurable outcomes was essential to diffusing this uncertainty. As such, I made a clear two-pronged decision: that the creative work would strive for excellence and be developed such that it would find a position in the marketplace; and that the research component placed me in pole position for entry into the academic work place. That both my intellectual and my creative aspirations were reconciled gave validation to the time investment that I was giving and prevented my thoughts of indulgence from constraining me. This was a turning point. The toxicity came when I had imagined my aspirations as *two* separate masters I was trying to serve. As such, the antidote was to re-imagine them both as serving my aspirations, me as the meta-phorical ONE master. This monotheistic declaration appears to state the obvious; however, the practice and the research must serve *your* aspirations. Therefore clarity as to what they are is crucial.

A letter by Pope John Paul II, who I would not have expected to be quoting, gives a papal touch to this notion of creation and purpose, and I seek to stretch this notion specifically for our academic purpose. "Not all are called to be artists in the specific sense of the term. Yet, as Genesis

has it, all men and women are entrusted with the task of crafting their own life: in a certain sense, they are to make of it a work of art, a master-piece." (John Paul II, 1999)

The point at which you enter your post-doctoral practice-based study – how you enter it; what you bring with you; your point on the spectrum between art and academic; your position between artistic belief and artistic despondency; your need for creative exaltation and self (or family) validation – will, I believe (and convincing you about my beliefs is what my research and art is about), have a profound effect on your ability to navigate the path between artistic creation for doctoral assessment and intellectual positioning for academic discourse.

The Gates of Hell

Finding your position in this discourse, truly knowing why you're here and what you want out of it, is achieved via the gates of hell. By hell, reflecting on my own pathway, I mean the tension created by each of the components working against each other, the uncertainty of how to navigate between the creative work and the dissertation, compounded by the multiple and forever differing ways of writing an exegesis for a creative doctorate. This plethora of ways to approach this academic write up is difficult to navigate, as there are multiple paths to our destination on the charts laid down by those who have gone before. More traditional PhDs have, it appears to me, the benefit of tradition within their academy, a clear path and a more fundamentalist set of criteria. Attending or reading about how to do a practice-based PhD reveals variation between each one. Your supervisor plays the role of a localised interpreter in how you approach this. You may find yourself either in step with them or pushing against them. The old adage comes to mind here that choice is not freedom.

A practice-based PhD has the potential to lure you into a limbo zone of trying to serve the two masters of creative and academic output. Here I stand up to the group and share. For my doubts may reflect the conversations that you have going on as you kneel seeking answers to the questions of weight. For how you determine worth consequently determines your allocation of resources. Not being able to reconcile

your relationship with either, you find that one compromises the other: one diminishes the integrity of the other; one draws time and resources from the other; one is not the other. The two different hemi-spheres of the brain – the creative right and the logical left – behave like touts at a brothel, seemingly trying to lure you, your conscious self, into their seedy bars with guaranteed offers of you leaving with a smile on your face. It is a turf war between two different types of thinking that can stifle each and leave you frustrated. Oft I found myself over the course of the current years of my creative arts doctorate saying, "I wish I was just writing 90,000 words, it would be so much easier". Traditional PhD candidates would undoubtedly disagree; however, a nod of agreement from other practice-based students indicates to me a loose consensus about this challenge.

I determined that you must find a working way to compartmentalise your mind, segment your work, separate the two, quarantine them whilst, importantly, visualising them as being within the same room. For I have come to the conclusion that the frisson between the academic and the creative is actually where the spark is, where the communion is taken. It is the opportunity to take your creative work to places you would never have gone to outside the academy. An opportunity to give your work revealing meaning and understanding, give it gravitas, have it be informed. Like a scripture, it gives your practice connection to a global knowledge and maybe, just maybe, makes your work divine. This, I think, is what it is about. In 'The Hymn', below, I look to explain my choices in navigating this path through hell.

A Force of Creation or Destruction

But this does not allay our fears. The reason the topic before us has such significance is the way academia may be – but not necessarily – a force for creative destruction. As the practitioner, you harbour a force of fear that it will compromise your artistic right to make your own choices. The fear that the university will diminish the artistic work through over reflection, interference, shaping it to fit an academic mould. How you weight the creative over the academic may mirror the fear of artistic compromise over encouragement to make it fit for an arbitrary practice-based assessment.

Research can take us to the smallest of our artistic particles with quantum physics and to the edges of the creative universe, back to the origin of our 'Big Bang' creative idea. I feel creative research reveals to us that no matter how much we explore and learn on the micro or macro, we are always left with mystery: that mystery is that which we call the art. What I'd like to emphasise, then, is just that the research can take us nearly to the origin of creative matter and energy, but not fully explain the creation of our artistic consciousness.

Like God, the concealed things are in the realm of ART; the known things are for us to implement. When speaking about ART we must distinguish between speculative creativity and empirical knowledge. I believe that there is a cosmic consciousness that exists beyond the creative Big Bang. It is something concealed, the great mystery, as to how we ourselves become conscious beings.

That conclusion has profound implications for how we choose to approach our research exegesis and how we take responsibility for our artistic consciousness and our creative freedom of choice, within the confines of the academy. I for one am glad that academia is not the definitive word on creative practice, no matter whose thesis or dissertation you are reading. Kamins states, "religion is not art and religion is not science" (Kamins 2011), but I'd like to adapt this, declaring that academia is not art as religion is not science.

Religion is about relationships, about values. It is about applying, across communities and generations, teachings and principles of what it means to develop human consciousness, to take responsibility for our words and deeds, and always to be mindful of the interconnectedness of life. This value set could be transposed as a whole to the notion of art and its relationship to meaning. Both represent our small but potentially significant contribution to the unfolding of the one.

The Hymn (Second Verse)

As stated, the motivator to explore this project through performance and research is that I am drawn instinctively to the polarisation effect of the subject of religion. My challenge was to find a platform that could

The Research
Australia Day Prayer meeting Melbourne 2011 with guest speaker
Pastor Donny Swaggart (Jimmy's son)

Catch the Fire Ministries (Victoria) Pastor Danny Nalliah –
In 2011 formed political party Rise Up Australia based on ideals of US Tea Party

Figure 9.3

The Research
Australia Day Prayer meeting Melbourne
2011 with guest speaker Pastor Donny
Swaggart (Jimmy's son)

embody the breadth of experience that was religion or, as I specifically chose, US-style protestant evangelical religion. This group I felt best represented the political, social and cultural presence of God in current times.

Into this mix, placing the assumed love of Jesus and the need to proselytise (trying to convert non-believers) as givens, religion is amongst other things an industry. Just like any other business, it wants to grow. In Australia, the Hillsong Church follows this industrial approach and is driven by growth through mergers and global expansion that tap new markets, underpinned by a corporate command of branding and media. In contrast, in the US, social commentator Joe Bageant (2010) states that church business is built upon the faithfulness of America's under-educated and neglected whites, who trust their preachers more than they trust their politicians. "The preachers at least lie to them face to face, eyeball to eyeball from the pulpit" (Bageant 2010, p. 122). Because of this immediacy with the preacher, they may be more willing to overlook sexual and financial transgressions.

Once I had established the core creative themes, realistic characters with skin and bones, and a narrative framework, this interrelationship became more free-flowing and essential to the authenticity of the creative work. In fact, the authenticity became more of a core value of the creative work as the writing progressed and decisions were made to sail the writing close to the real (satire) and less to comedy, which manifested as more caricature. This created tension between author and art as a struggle emerged on how to maintain a creative work that had entertainment value (i.e. was engaging, enthralling and inherently seen as a piece of theatre); and the pull to explore and critique the core religious themes and present them in a more analytical way that moved away from theatre and more into commentary. This does not dismiss the need for commentary to be engaging or theatre to be analytical (which hopefully was achieved in the work), but acknowledges the need to pursue the different forms differently. The objective became to make entertaining creative work that had intelligent comment.

The research revealed a broad range of religious groups and individuals who had vastly different interpretations and presentation styles, which made it complex to meld this material into a singular theatrical artefact infused with intelligent comment. In fact, the theatrical nature of the subject and broadness of their presentation styles put me in the position of finding universal elements that identified to the audience a character that was recognisable even to a non-religious or non-informed person. The creative work felt constrained by just theatre and pushed in the natural direction that evangelists themselves strived for – TV, radio and online. After all, evangelists who don't have a syndicated TV and radio show and online network do not rank. So my work seeks to create across multiple platforms built around a central character and faux church. I concluded through observation that embodiment was the way to walk in the shoes of the research and attempt to understand. In fact, to feel the persuasive elements that are at play in an evangelical church, I took it one step further and put myself directly into the evangelists' shoes and became the central character in the work.

Each preacher and religion is seeking its own growing audience, firstly through new converts but more broadly from other religions, almost competing for member numbers as any sporting group, corporation or

community group does. As their core product is sold as the 'truth', this becomes highly interpretable as each seeks a new angle on truth or how to sell it and how to differentiate themselves in a crowded market. This can manifest itself in what appears to an outside observer as extreme or exaggerated, and at times asinine or absurdist, behaviour. The challenge of the project was to creatively write a character and plot that would be seen as authentic yet satirical. A broader audience may consider some of the actions as inauthentic or too unreal, or as parody, even though they had been based on actual events, characters or conversations. This raises issues for any writer exploring actual events, people or situations that are too deviated from the norm. Do you do fiction or non-fiction?

The evolution of the show can best be marked by its central directional challenge: the layering of the comedy. This directly feeds into the challenge of satire and what became evident was the formative influence this had. As a writer of comedy, it became absurdist in itself to be trying to write comedy that wasn't overtly funny – or that may be best described as the knowingly funny. The central point, as it could possibly be termed, was that the heart or the essence of the comedy needed to be found. A positioning of the humour was needed so that it didn't overshadow or distract from the more complex analysis of the subject matter: in other words, it could not be too funny so as to render the character a caricature and as such make the satire impotent. This had to be found across all modalities and the research of the real allowed for the humour to be found *within* the data. All that was required was my creative interpretation of the real. This over-simplistic last statement does no justice to the inherent challenge of trying to achieve all these aims. As with all creation, others will pass judgement and decide whether I have achieved this.

The Hymn (Final Verse)

Breaking through the Gates of Hell, I determined, could only be through reconciliation on 'truth'. To structure the written component of the doctorate such that it moved through the phases of my understanding of the field and then the construction of the creative. The thesis would follow an integrated relationship model with the creative work at its core and four different aspects explored in chapters. It flows firstly from

Figure 9.4

Project Creative Map

an account of religious and social theory to the theatrical aspects of the work. I work to take the reader into the work in the way that I want the work to be interpreted: as a deep and researched piece of theatre with informed nuance that elucidates the satire. The creative work stands side by side with the research, each informing the other. The research infused in the work, the work pushing and guiding the research. Each, I concluded, had equal weight in the final doctorate as each without the other would have been lesser work.

As a participant–observer of a variety of preachers and church services, the Reverend Slim Limits is a distillation of my analysis of their presentations. The show's content and dialogue are distillations of my research on the background and operations of churches. As such, the thesis's final chapter of reflection is a deliberation on how the research manifested in the creative work. Direct examples in the script are highlighted against links to the research. Directional and creative choices and challenges are reflected on.

The voice of the Rev Slim Limits, the show's central character, and excerpts from the creative script will at times be woven into the discussion on religion. This is to highlight how the creative dialogue can be fed back into the research. Interspersed in the discussion are direct examples from the script where the creative has responded directly to the religious and cultural research. This interplay is to highlight the author's attempt at underpinning the work with statements from real pastors as a way of achieving this 'truth' or 'authenticity'.

However, the sheer notion of what is truth or authenticity is at the core of the religion or belief. The old adage, truth is stranger than fiction, is at the centre of many of my creative choices. There were observations of the real that I included in the creative work which, through discussion, I discovered that no-one believed. As noted in my thesis, some were included and others were deliberately left out as they moved the work

Figure 9.5

Bibleland

Bibleland
Theme Park for Sickly Children

©Gods Cowboys

too far into an absurdist nature for my intent to create satire and not parody. This I believe will be highly subjective for the viewer.

In regard to truth, I determined that bad pastors or, one might argue, all pastors make up truths to suit their own interests or their own focus. As such, I do likewise in writing my thesis and creating my project. I select the parts of researched services, sermons, media and promotions that I feel suit my focus. The Church of the Holy Cowboy is a construct based on my beliefs. However, I firmly use rational argument to guide my choices: science for me is good. Whilst some Fundamentalist Christians believe the charring of the earth through global warming is a good thing that prefigures the return of the Messiah, I see climate change as man made. I state clearly that I am not a Christian but have had experiences of Christianity. The project is aimed for production and presentation in 2014.

The Offering

In summary, the interplay between the creative and academic components of the practice-based doctorate is fraught and fractious. Drawing on two, at times polarised, hemispheres of the brain to draw inspiration, explanation, creative flow and intelligent logic requires a fragmentation of work practice and cognitive thinking. This tension is sometimes a battleground and sometimes a chat between friends, who may act like they don't even know each other whilst, at all times, hoping for brilliance. What the research ultimately gave me was a greater respect for the complexity of the subject matter and this informed my creative writing and performance, transforming them into something unforeseeable.

I concluded, as I progressed through my doctorate, that the reason I entered the Church of Knowledge mattered more as I looked to balance the energy and resources given to, on the one hand, the creative and, on the other, the research output. Whilst I entered with dual reasons of funding for creative output and pursuing an academic work life, near the completion of my doctorate considerable weight needed to be given to the creative. This was not without intent, as I believe the success of the creative in the marketplace improved the prospects in the academic. The linking of artistic success with academic qualification was a way of

being distinct in a crowded area of artists flooding into the academic field. Many may argue that this is not the case as the refereed output maintains a potent currency. However, I found solace in putting energy back into the creative flow that had become disjointed from shifting between these types of writing.

This disjointedness between writing hemispheres, the lack of clarity from the academy on how to structure doctoral writing, the diverse reasons for artists entering the academy and their perceived outcomes all combine to make for a fractured and at times dissatisfying journey. However, whilst the structure was fractured, I do conclude that in my case the work, both research and creative, was better because of the relationship. The relationship between these two, once established and understood, created a flow of challenging ideas and questions, and hopefully results in a challenging, engaging academic thesis and creative project.

The Closing Prayer

The thesis may or may not be our creative autobiography. However, it is our attempt to know what is divine in the art we produce, even when sometimes we got it wrong. But what we aim for, much of the time, is having extraordinary insights. Because the question is, if you are an artist and the exegesis is the creation of the analytical and not artistic, why should you be involved in a Scripture-based, analytically based, community? Well, what we have to do is understand that we are here to look at the research and to take out that which is good, which is supportive, which is creative, which is truthful, which is counter/contra, which is how we understand what the frameworks that surround our works are all about, and apply it in contemporary times.

In closing, as the Rev Slim Limits states, "What's bad for politics, what's bad for people is potentially good for religion" (Catsi 2013).

References

Australian Postgraduate Awards (2013) Australian Postgraduate Awards (APA). Retrieved 2 February 2013, from: http://www.innovation.gov.au/research/researchblockgrants/pages/australianpostgraduateawards.aspx.

Bageant, J. (2010) *Rainbow Pie: A Redneck Memoir.* Carlton North, Victoria: Scribe Publications.

Catsi, G. (2013) *I Want to Be Slim* [play script]. Unpublished manuscript.

Harrison, D. (2011) Rise of masters of the universe. *Sydney Morning Herald*, 11 November.

John Paul II, Pope (1999) Letter of his Holiness Pope John Paul II to artists. Retrieved 12 May 2012, from: http://www.vatican.va/holy_father/ john_paul_ii/letters/documents/hf_jp-ii_let_23041999_artists_en.html.

Kamins, J., Rabbi (2011) God in the 21st century. Retrieved 12 May 2012, from: http://www.emanuel.org.au/Page/Articles.cfm.

HOW ARTISTS WRITE IN A
DOCTORAL WRITING CIRCLE

Annalea Beattie

To be open to the experience of portraiture was my problem, not
Cam's – he was already there. He drew on and on with his pencil
barely leaving the page, continuous lines, drawing me, almost
without looking at me, drawing not thinking, as I tussled around
scribbling, rubbing and crossing out, thinking too much. So
watching him, in the thick of it, I wanted to find a way to shift my
focus from making a 'good' portrait, one that 'looks like Cam', to a
work that was a kind of infectious conversation between us. I really
didn't know where to start. I knew I was desperate to generate
conversation but what did Cam want? I decided not to talk about
it and we began, with trial and error, to experiment on the same
page. After a while, this was the way we met.

(Beattie, 2011)

Contemporary art is often defined by the relations it generates rather
than by its object. If this is true, how do we comprehend art as a
kind of learning experience and what can be gained by understanding
how different strands of artistic practice and thought interact? Within

institutions, academic frameworks usually privilege writing over making and although new knowledge is made visible and prized as the outcome of research, its constructions and representations are often unseen. At odds with university traditions, in which research contexts have clear objectives, articulated methodologies and projected significance, the context of the doctoral experience for art and design has a different focus: the emphasis on process means methodologies emerge from the practice.

As artists and educators, we know there are complex pedagogical challenges around building scholarly research communities through experiential learning. Current conversations about how fine art doctorates sit within broader academic frameworks are shaping how art as research might be viewed. Relevant to our discussion here is the role of text in practical languages: how students and supervisors negotiate making–writing equivalences and how these equivalences themselves, their fit and balance, contribute to the evolving research culture of postgraduate art courses.

On an uncharted journey, the School of Art writing circle at RMIT University in Melbourne, Australia, draws out the richness of doctoral practice as it investigates new and embedded ways of understanding research writing as a genre, shaped by the demands of its disciplines. Writing circles are common but they are not common in art schools, as students are primarily makers and writing is too often after the event. Our group has been running for over four years and some students have been members for their entire degree. When students attend they are asked to commit to the group. Required is a level of independence, a sense of purpose, and an interest in and support for other people's work. Students join at all levels of their degree, even in the early stages when there is plenty to do and not much to say.

Our group foregrounds making and writing at the PhD level as entwined, reflexive and interrogative – as more than another symbolic, material representation of ourselves and our work. Writing is viewed as a social act and is closely linked to listening, speaking and reading about the work of others. These shared dynamics of enunciation, dialogue, debate and exchange help students find their voice and understand how it sounds.

As students engage with participatory practices and experiment with fragmented and collaged forms of writing, via critical exploration, they move from making a point, to creating a point of view, through and about one's own work in constant, reflexive dialogue.

> Our writing circle this morning met at ten. There were nine of us
> today. We comprise: one student working on a methodology for
> the execution of sound works using sampling and based upon the
> findings of Pierre Schaeffer and his theory of Musique Concrète;
> another exploring irresolution, installation and the experiences
> of temporal and spatial choreography; a printmaker examining
> the relationship of his work to diaspora and his distant Indian
> past; one student tracing first-hand experiences of mental illness
> within institutions and using sound art practice to develop a
> sonic equivalent to the first-person madness narrative; another
> composer researching the use of sound and music compositions
> to determine their effectiveness in reducing levels of anxiety in
> Emergency Department patients; one painting student thinking
> about contemporary abstraction and the materiality of reflec-
> tive surfaces and another examining notions of land and home
> through the use of earth pigment; plus a photographer researching
> the aesthetics of catastrophe. We fill the Reading Room in the
> School of Art. Our writing circle is going from strength to strength,
> everyone can feel that and lately we are quite pumped up.
>
> Extract from my writing journal, 28 September 2011

How do writing circles work? In our group, students can discuss their research and get feedback from other students on their research writing, both at a conceptual and a structural level. We meet monthly and writing is sent out a week ahead of time, sharing never our best work and never too much. The kind of writing varies – it could be anything: perhaps a reflective task that the group has set for the writer; a concrete poem about the sound of the work; an article for a conference; a description of a technique; or a review of an artist's work evaluating influence on current practice. Our writing circle deals with a wide-ranging repertoire of linguistic practices and speaking is seen as closest to writing. We use informal speech in an unrehearsed context to reflect or to analyse and we take turns to build meaning. For instance, as well as digging deeply into the writing, the conversation might reflect upon how the structure of the document can help define its subject matter, inventing form as

a way of understanding associations. We might explore motives and experiment with genres – for instance, we could focus on the versatile memoir as a research writing space, one that expands from the personal to focus on themes of research. As we unpick relations between image and text, we discuss the impetus for making work, or speak about the music and resonance of the art work in the text, or converse about overall workload and managing motivation, or think about how research itself is a creative process and what this means in the context of making.

A hospitable, low-stakes meeting place is important for a writing group. Our quiet room has a large table and a library where School of Art students can access durable records of past degrees. This is an intimate environment where the suppleness of the imagination is valued and thinking is seen as experimenting. Students often bring resources and research ideas to the session and we discuss their usefulness: a reflective diary is recognised as a deliberate research method, helpful in catching the dynamic, back and forth nature of practice, in defining the field or implementing change. Each time, we share goals and set tasks around our work. Our aim is always to shift shape from the informative or the descriptive or expository, to use writing to find that which is critically interpretive, interior, transactional, literary and scholarly. As we explore the aesthetics of interpretation, we are on the lookout for robust ways of playfully and spatially organising our thoughts. At the same time, we deliberately create ways of connecting fine-grained or subtle moments in text. Writing and re- writing with, about and to the work is encouraged.

Driving to the suburb of Footscray, Melbourne, I started thinking about my art work and then, how I never have any time to think, and then, work and teaching and how I have to get away, straight to thinking about the writing circles. Perhaps it was the intensity of the lights on the freeway but suddenly I understood why writing circles succeed in the School of Art, in Media and Communication, in Fashion and Textiles, anywhere where students undertake a PhD by project and have to bridge between making and writing. Writing circles are successful because their core work draws upon something already familiar for students, something that is imaginative and local. To begin with, it's understood that purposive, methodical and critical contexts emerge from and are returned to

a reflexive art practice via ongoing primary investigation. This is what builds practice and sustains art making. The writing circle also emphasises thinking through methods and materials. Between the emergence of structure, theme and motif, while we actively search for subtext and voice our thoughts, our encounter with the writing circle is investigative and performative. Drawing upon the strengths already inherent in arts practice and the collaborative nature of the group, text can be seen as material, as the product of writerly processes, metonymic and unfinished.

Artists are likely to recognise that talking to other artists about their work enhances learning. Critical enquiry, peer assessment, deep self-reflection and collaboration: these particular approaches to learning are already common in a studio environment where the emphasis is on process and techniques and procedures, and experiences are shared daily. In our group this communal sharing is formalised and focused. Students assume responsibility for their own learning but also for the learning of others. As difference and diversity are acknowledged, as points of view are rehearsed, argued and positions justified, peer learning builds identity, and opens up new, volatile spaces of inquiry. Along the way, opportunities for identifying criteria for self-assessment occur and are applied through a range of circumstances. This self-reflexive key element of assessment is part of lifelong learning (Boud, 1995). Artists know that beyond institutional life, peer learning continues to provide a community of critical support.

So within the group, the desire to hear the sound of the author's voice is a sensory, exploratory experience that is premised upon local knowledge. As Jan Svenungsson notes in his excellent book on artists' writing, "Inspired, shared curiosity of ideas can create addiction. This is the writing artist's active solution." (2007, p. 27) Through notebook entries, drawings, observations, experiments, associations and writing in as many different ways as possible, students claim vocabulary, scatter thoughts and overlay images and text. There is a focus on artists who write and artists who use text in their work. In this spirit, Annette Messenger writes, "For me, writing is something visual, akin to strands of yarn, which are full of down strokes and upstrokes. The word has visual power. A word repeated on a wall turns into an image and, at the same time, it remains a word that conjures up a sound, a feeling" (2008, p. 380).

What is the sound of your voice?

Is it reflective, lofty, raucous, tentative, babbling, didactic, demo-
cratic, cool, overly noun-y, hesitant, ruminative, ambivalent, fiery,
waffling, speculative, dynamic, cautious, conversational, reduc-
tive, ambiguous, evocative, poetic, garrulous, wordy, descriptive,
persuasive, florid, silver-tongued, instructive, ranting, dull, falsetto,
rambling, verbose, analytical, gushing, flippant, longwinded,
loquacious, tedious, informed, concise, laconic, terse, exclama-
tory, breathy, humdrum, grave, vibrant, snuffling, blathering, agile,
snappy, earnest, hearty, enthusiastic, articulate, sonorous, witty,
wearisome, chatty, critical, colourless, illuminating...

Beattie, 2011

Less understood and often totally undervalued is the role of reading
within the writing circle. When students are given the work of others
to read, their encounter with the text is imaginative and spatial. This
is worth thinking about for a moment. As art students read, again
they draw upon local, tacit knowledge: reading is a creative process.
When given a new piece of text, students are encouraged to approach
it imaginatively and intuitively, to trust their initial responses to the
imperfect structure of writing and then explore details or examples to
clarify, challenge and strengthen their sense of reading. As they specu-
late and project, readers attend to the sensation of moments of clarity
or the flat or bumpy spots when meaning is lost. Meaning is made and
remade and interpretations are built beyond juxtaposition to include
notions of authorship and composition. There is a 'felt' connection: a
moment of flux as analysis recreates the writing process. In this context,
disparity in tone, mood and purpose in the sound of the artist's voice
only makes sense when seen as a response to our knowledge of things
rather than as a response to the things themselves. In this way, students
hone and sharpen their own evaluative positions as artists, researchers
and writers. Although reading images critically is part of the way we
see, critical reading is a balance between reading, sensing and thinking.

The writing circle encourages art students to treat their writing as
a conceptual project that investigates writing as form and idea that
sits somewhere close to their work. To avoid the trap of emulating a
traditional PhD, it's important to have one eye on possible ways to

structure and the other on an initial, strategic view of the parts of the whole doctoral process. For this reason academics and supervisors regularly join us to ensure that students are really clear about the necessary requirements of their degree. Then they can be encouraged to imagine, visualise and continually plan and re-plan the terrain of their research, and to evade repetitive chapter writing, particularly in the early stages of their study. As they take charge of their work, students are freed to use situated and embodied knowledge to improvise and build upon their own structures as they write through key themes of research.

To become a writer, to form a scholarly identity, is to draw upon lived experience to imagine, speak and write critically about stories we can believe in. This is often perceived as moving a step away from one's practice. In the School of Art writing circle, our aim is to address this gap, to see writing as a daily process with many interconnected steps: a series of events, something that fits easily into everyday studio work. This means writing every day, in small, purposeful chunks. To find words that narrow scope but also open up relationships in the work requires courage, particularly for early research writers. What is ignored, has disappeared or is missing can be as important as what we see clearly. Doctoral candidates are asked to look for the unexpected and develop writing from that position, to ponder possibilities gained from strangeness or deep familiarity with some aspect of the world, to rethink blank spots and to unpack problems sometimes buried deeply within the experiences of making art. In a writing circle, writing and words are not facts but are used as starting points, or triggers, for speculation into further meaning.

> But what, I can hear your voice, if there is nothing to say? In the
> studio, I do often wonder how I comprehend the experience of art.
> Mostly though, unlike today, in this bright even light of a lovely
> Spring day, I'm not thinking about comprehension. Muffled fuzzy
> voices and barking float in through my window – the kids are
> teasing the dog next door through the hole in the fence. I have the
> television on, I like the background noise and I slow right down
> to small gestures, touching, ripping, scribbling, cutting, pasting,
> tearing, scraping. Then sunlight drifts over my paper, creating
> substance, casting shadows, and to see the work clearly I move

close then far away, close then far. What is there to say? Not much, I think, suddenly feeling a bit melancholy.

Beattie, 2011

For those worried about the nitty gritty, often perceived as the surface features of the text – for instance, spelling and grammar – students do talk about these in our writing group but rarely. Micro-managing those most-easily-seen features of writing can actually be a way of deflecting focus from other writing issues. Usually an intense analysis of writing requires thinking on your feet and moving in and out from the text to build a response. What matters is attention to detail, combined with attention to building a larger case. The idea is to try to grasp the central ideas of the document at the outset and then move in and out from details in a way that advances the overall sense of the writing. *So I read the text. Here's my initial response. Here's how a detail relates to my initial response. This is how a detail advances my overall understanding of the text.* The group might discuss how ideas link, for example, the structural nesting of concepts and their hierarchies or perhaps signposting at the paragraph level of organisation, or how well-chosen topic sentences, phrases and words can bring text to life. Working in this way encourages a topographical analysis of the text that really has a sense of how it works as well as what it says. How we inhabit our own text is informed by how we interpret all these complex, interconnected processes.

To set up a writing circle in your school, encourage academics and supervisors to participate. Negotiate the meeting rules, the mechanics of the group and make sure you cover how to give and receive feedback, rotating roles, how to disseminate the writing, individual needs, the expectations of the group and the expectations of the doctorate. Inviting group members to draw maps of current research is a productive way to begin. Think about making resources that target particular stages of research writing. For example, *The BBQ Statement* is a group resource that names the required parts of the doctoral process as it highlights the strengths and weaknesses in research. It's a bit like the three-minute thesis in that it uses conversational language to name and frame research in a series of moves that construct succinct arguments around a subject. This story begins at a barbeque when, stranger than fiction, the inevitable someone comes up to you and says "I hear you

are doing your PhD. What's it about?" and you hesitate and stutter and think about where to begin. In this resource, the student responds to questions from the group that make explicit the propositions involved. Importantly, she speaks herself into the moves she outlines. In other words, with questions prompting her thinking, she talks through the choreography of the work, acknowledging at the least as much as she knows, as well as what she does not.

> Here you are lost in the philosophical cul-de-sac, chartering the subjective. During the day you go to the library. You read, take notes. There are small revelations. At night you stay awake, reading widely and deeply, taking notes. Lost in speculation you wander about, pondering, worrying about where to put your foot down. You think and think. What if I have nothing to say? How can I become a serial writer? How can I talk to you about your writing if I hate your work? How do I build a response? How do I craft a style? It's good to remind yourself that, at the end of it all, what's important is not really what you know but how you handled your experiences of your doctoral study.

To keep your students on track, ask them to write early, write in the middle of things, write to music, write daily, write freely, write from observation, conversation and perception, write from memory, always write one day then edit the next, write generatively with the work and write collectively. Read aloud, and read the writing of other artists – to name a few, the humble notes, interviews and letters of Henri Matisse, the disturbing Kara Walker, the much-quoted, dense-as-matter Robert Smithson, *Figures of Motion* Len Lye, Tacita Dean, *Que dit l'artiste?*, the scholarly Mike Kelley, witty Duchamp, Manray's autobiographical tones, the plastic art of Piet Mondrian, the poetic and playful use of randomness and accident in the word pictures of Joan Miro, the bucolic writings of Paul Cézanne, the narrative and structure of Mona Hartoum in *Witness to Her Art*, Josef Albers' *Homage to the Square*, emotional Gerhard Richter, Franz Marc in *How Does a Horse See the World?*, talkative Frances Stark, the inherent poetry and mystery in the musings of Bill Viola, word thief Annette Messenger, the secret knowledge of David Hockney, the art text of Dan Graham, the principal writings of Robert Motherwell, the writings of artist–novelist De Chirico, introspective Louise Bourgeois, and so on.

For me, as artist and teacher, pedagogical space within the writing circle continuously opens out and emerges, not as representations of knowledge or strategies, but as a playful space of fluid, continuing aesthetic response to the complexities of text as object, crucial to the experiences of the learning self, both mine and theirs. Artists have always written about their practice and their ideas. As we reflect upon the themes of making and critically interrogate its processes, the School of Art writing circle strengthens authorial identity as it explores peer-focused ways of working that integrate the plurality of art as inquiry with the social act of writing. At the same time new approaches are shaped that challenge existing practices and highlight links between different kinds of imaginative work, adding to current debates around building scholarly research communities in disciplines that are practice based.

References

Alberro, A. (ed.) (1999) *Two Way Mirror Power: Selected Writings by Dan Graham*. London: MIT Press.

Albers, J. (2009) *Homage to the Square*. New York: Junta de Andalucia.

Beattie, A. (2011) *Portrait Exchange, Art Projects, September 2011*. Unpublished paper, Royal Melbourne Institute of Technology.

Boud, D. (1995) *Enhancing Learning through Self-assessment*. London: Kogan Page.

Bourgeois, L. (1998) *Destruction of the Father, Reconstruction of the Father. Writings and Interviews 1923–1997*. Massachusetts, MA: MIT Press.

Caws, M. (ed.) (1996) *Motherwell – What Art Holds*. New York: Columbia University Press.

Cézanne, P. (1941) *Letters*. New York: Bruno Cassirer.

Dean, T. (2011) *An Aside: Selected by Tacita Dean*. London: National Touring Exhibitions, Haywood Gallery.

De Chirico, G. (1992) *Hebdomeros*. Cambridge: Exact Change Press.

Duchamp, M. (1973) *The Writings of Marcel Duchamp*. New York: Da Capo Press.

Elkins, J. (2004) *Visual Studies*. New York: Routledge.

Ellsworth, E. (2005) *Places of Learning: Media Architecture and Pedagogy*. New York: Routledge.

Flam, J. (ed.) (1995) *Matisse on Art*. Los Angeles: University of California Press.

Hartoum, M. (2007) *Witness to Her Art*. New York: Bard College.

Hockney, D. (2001) *Secret Knowledge: Rediscovering the Lost Techniques of the Old Masters*. London: Thames and Hudson.

Hollevoet, C. (ed.) (1996) *Jasper Johns: Writings, Sketchbook Notes, Interviews.* New York: Harry N. Adams.

Holt, N. (ed.) (1979) *The Writings of Robert Smithson.* New York: New York University Press.

Kamler, B., & Thomson, P. (2006) *Helping Doctoral Students Write.* New York: Routledge Press.

Kelley, M. (2004) *Minor Histories, Statements and Proposals.* Massachusetts, MA: Massachusetts Institute of Technology Press.

Lye, L. (1984) *Figures of Motion: Selected Writings.* Auckland: University of Auckland Press.

Macleod, K., & Holdridge, L. (eds) (2006) *Thinking through Art: Reflections on Art as Research.* New York: Routledge.

Manray (1999) *Self-portrait.* New York: Arcade Press.

Messenger, A. (2008) *The Messengers.* Frankfurt: Prestel.

Mondrian, P. (2008) *Plastic Art.* New York: Whitborn Art Books.

Nunan, D. (1992) *Research Methods in Language Learning.* Cambridge: Cambridge University Press.

Partsch, S. (ed.) (1999) *Marc.* Cologne: Taschen Press.

Rendell, J. (2006) *Art and Architecture: A Place Between.* New York: Tauris Books.

Richter, G. (1995) *The Daily Practice of Painting 1962–1993: Writing and Interviews.* Massachusetts, MA: MIT Press.

Rowell, M. (ed.) (1992) *Miro: Selected Writings.* New York: Da Capo Press.

Stark, F. (2003) *Collected Writings 1993–2003.* London: Book Works.

Svenungsson, J. (2007) *An Artist's Text Book.* Helsinki: Finnish Academy of Art Press.

Viola, B. (1995) *Reasons for Knocking at an Empty House.* Massachusetts, MA: MIT Press.

Walker, K. (2008) *Bureau of Refugees.* Rome: Charta Press.

POETICS OF THE STUDIO:
THE ALLEGORICAL IMPULSE

Caroline Durré

Introduction

For the doctoral student, and the supervisor, the relationship between the studio work and the exegetical document is a locus of anxiety. The attempt to reconcile creative practice with the demands of the university may result in an exegesis that is prescriptive or deadening, parasitically over-dependent on the studio work to the detriment of both projects. How can we manage the alliance of these diverse enterprises more fruitfully and less coercively? My response as a supervisor of studio doctorates is explored in this chapter.

Prescriptions for structuring this duality can be found in the literature on studio research and in the conventions of university disciplines; yet so many of them fail to acknowledge that the obsessions of a creative artist have mysterious origins. I assert that this enigma must be given free rein, or else we risk making supervision into a process that constrains rather than liberates creative energy. The sublimated forces

that underwrite the passion and poetry of the studio can, however, be harnessed to rewarding ends. If the attention is directed towards both the historical roots and the contemporary setting of the project, all aspects of the degree are enriched.

This exercise of genuine curiosity can illuminate both the visual work and the exegesis. I argue that this results in two texts in parallel, transforming the research project into a work of allegory. In allegory each text, verbal or visual, is allowed its own integrity and intensity, set in a dynamic of mutual interpretation or interpenetration. This poetics of the studio can enrich and liberate the practice–exegesis interplay.

The University and the Artist

All research students make tough choices as they refine their field of enquiry out of their initial too-inclusive proposal. After a long PhD candidacy, the results of these efforts are on display. Most experienced examiners have encountered a doctoral exhibition that speaks of an artistic enterprise of passion and insight, yet is accompanied by an exegesis that is joyless, deadening and disconnected. Such writing intrudes with conceptual violence on the examiner's relationship to the work. Perhaps students who present an exegesis of this type have been ill advised; perhaps they begin from an unexamined assumption that the PhD necessarily entails a certain sort of intellectual effort. But if so, then this is evidence of a sort of tragedy, a missed opportunity. Years have been spent in striving for self-justification that, in the end, has diminished the real achievement of the artist–researcher.

A particular set of demands arises from the creation of the graduate research doctorate as certified by the university-based art school. These demands can take the form of questions such as "Who will benefit from the results of your research?" or, perhaps more sympathetically, "What is your research question?" "What are your research aims, your anticipated outcomes?" Students are sometimes asked to give a timeline of the research process; in six or eighteen months' time to be reading certain books, learning certain skills, doing such and such a studio work. Appropriate as these questions may be to many academic disciplines, established as they may be as key markers for the research process, we

need to evaluate whether they are a good starting point for the studio research degree and the supervisory relationship.

Such questions model an institutional expectation of tamed, predictable creativity. Unsystematic creative practices such as intuition, reverie, speculation and acts of chance are disregarded by this bureaucratic language. The supervisor is powerfully placed to advise on how best to frame the discursive richness of the research degree from the earliest stages of candidacy, when the student is uncertain as to how to negotiate the multiple tasks of studio research. Are supervisors going to speak for management and conformity, or represent an enabling spirit and support scandalous, subversive creativity?

In an era of anti-sedition laws, of strict protocols for working with children, vulnerable people and animals, of circumspect health-and-safety legislation, art practice is conducted in an atmosphere of increasing state control and social censoriousness. The university is a mini-state that redoubles these controls. University ethics procedures are internalised by anxious visual researchers as self-censorship (2011; Bolt, MacNeill, Ednie-Brown, this volume). For artistic work, censorship regimes are historically directed at the site of reception: the university curbs are felt at the site of production, that is, the studio, limiting the range of what is thinkable. Under this regime, works that might have tested the boundaries negotiated through public debate are aborted, stillborn.

The limits on freedom are properly the subject of vigorous discussion. However, the negotiation between the atélier, with its noble traditions, and the university, with its venerable heritage, has created a new economy. In this site of exchange and mutual obligation, artists benefit from the intellectual esteem, the technological assets and the financial resources of the university. Simultaneously, however, they may be compromising their cherished autonomy. Is the university to be a place where social controls are redoubled or can it be a place that nurtures alterity?

The Methodology of the Marvellous

There are ways of doing art that range from the rigorously intellectual to the playful–intuitive. In the privacy of her working space the artist pushes coloured paste or pixels around, ruminates or reads. In public space, she pursues a vision of social justice, empowering collective action. Perhaps she does preliminary drawings, reviews these, then does final versions. Of these ways of doing, it is the highly adapted artist – a sweet talker, a player – who thrives in the research hothouse. Thus cultures perpetuate themselves.

In 'The Function of the Studio', Daniel Buren asserted that "analysis of the art system must inevitably be carried on in terms of the studio as the unique space of production and the museum as the unique space of exposition" (Buren 1979, p. 51). The university–academy is now, however, interpolated as a third term in this equation, disciplining both the conditions of production and the nature of distribution of the art work, and taking its place with Buren's first two terms, studio and museum, as a "frame" or "limit" (ibid.). The insertion of the university into both the privacy of the studio and the economy of the market has been dramatic. Buren mourns the lost vitality of the art work once it leaves the studio for the museum, and we can speculate whether the movement of art practice into the university has resulted in a comparable loss of animation.

Universities are grounded in an expectation of rigour that underwrites the probity of the historic academic disciplines. These are systematic procedures by which members of that culture reach consensus that the resulting insights are trustworthy. While artists do work systematically, if this means having knowledge of what works for the individual practitioner, the artist has no inherent ethical obligation to method or procedure. Who would commit themselves to follow a set of rules if the destiny of the work lay elsewhere? Stephen Scrivener, for example, suggests a sequence of tests of "norms" of a creative-production research program that can be verified by asking, for example, whether or not the student has enacted cycles of the following:

- Summary of a work episode (i.e. to place subsequent description into context, for example, when it occurred, what the objectives

were, who was involved, how long it lasted, what the outcomes were, etc.)

- Reflection on the work episode (i.e. focussing on moments of reflection-in-action and practice, supported by records of working)
- Post-project reflection on action and practice (i.e. on the project as a whole)
- Reflection on reflection on action and practice (i.e. critical reflection on one's work-focussed reflection).

(Scrivener 2000, p. 13)

Where are delight, discovery, curiosity in this nested narcissism, these sequential solipsisms? The enabling conditions for creativity are absorption, speculation, affect, observation, open-ended engagement with social space – above all, mental freedom. Reflection, Scrivener's greatest good, is certainly an important part of this, but why privilege it as a mechanical procedure?

Art fails as a place to use logic except in the metaphoric sense of 'finding the inner logic of the work'; it fails as a setting in which to make truth claims, except in the restricted sense of seeking aesthetic truth. Our materials, even if we allow them some mystique, are mostly banal, indeed wilfully banal if we work in the Duchampian tradition. In the studio, various sorts of grappling with these materials take place. Marvellous insights may follow. If they can be predicted, the work is probably formulaic.

In the studio, the flow between insight, material and process is so intimate (expression so subtly dependent on a tweak of technique) that they cannot be unpicked and are in constant flux. Critique, the main tool of studio teaching and supervision, reflects these uncertainties; it is, very properly, improvised, discursive and attuned to nuance. When we parrot the language of 'expected outcomes' and 'social benefit' more is lost than our romantic unworldliness; our mental freedom is lost, too. In *The Myth of Sisyphus*, Albert Camus argues that to practise art is inherently revolutionary, because art is always outside usefulness or function; it is done for its own sake, irrationally, passionately, excessively (Camus 1942). Do supervisors, representatives of the university and its power to bestow or withhold validation, tame and co-opt these passions?

Framing, Rhetoric, Address

Practice-based research is both abstract and materialist. Writing itself is also a materialist practice, where one wrestles with the recalcitrant substance of language. The ways that this is analogous to studio practice are underestimated. Contemporary creative practitioners are, compared to our forebears, "monsters of eloquence" (Elkins 2001, p. 45). We need to be highly practised in our addresses to various bodies with money and prestige at their disposal. The practice in written communication that is demanded of the graduate research student is rewarding both for these reasons of self-interest and career advancement. At the same time, it's hard work to make it edifying, and almost all students, no matter what their level of literacy or otherwise, find it the most demanding aspect of the degree.

What have been our structural models for the framing, rhetoric and address of the research proposal and exegesis? The methods that have frequently been co-opted come from anthropology and sociology, art history and critical theory (Sullivan 2005). Sociology and anthropology are handy models because they profess that there are robust and systematic ways of studying the human subject, even though the detached scientific observer has to confess to complicity with the unreliable informant and acknowledge the power relations that tacitly structure discourse in the social sciences. Using this discursive framework, the artist aims to poeticise the human sciences; in order to illustrate 'issues', the artist assembles statistical research, visual 'evidence' and interviews. Meanwhile the university ethics committee weighs on the activist artist, taming the fervour that motivated the project. The methods of art history are also an obvious point of reference. Studio artists, even at doctorate level, are not professionals in the conventions of art-historical rhetoric, archival research, iconology and connoisseurship. A third setting is drawn from cultural studies and critical theory. These tools are so alluring, so influential, that they can overwhelm the student who aspires to 'theorise their practice'.

To these academic disciplines we can add some others: one that is often defended in the discourse of the studio research degree is the autobiographical mode, sometimes called 'researching the self'. In

my experience, it is inimical to curiosity and sets up the student as modernist hero. Also springing out of the same culture of self-regard, supervision can be conducted as a form of psychoanalysis. This is a seductive option if the student presents as wanting to 'make changes', perhaps some neurosis or anxiety is evident, and there may be an unexamined assumption that the artist and the work are self-identical (Biggs & Wood 2005).

Obsessive Ideas, Bizarre Passions

All of these ways of proceeding can be fruitful, and our more literate and cerebral students can master these disciplines and impel them to worthwhile ends. And yet, and yet... it is at the limits of all these discourses that the work of art, and the creative process, comes into its own. Artists are those who, however rational a face they present to the world, have found a way for the repressed to return, and can live with, and, what's more, work with their obsessive ideas and bizarre passions. The visual vocabulary of the artist, the motifs which eternally repeat, the scab we must pick; these hint at the traumas, the fixations, the *jouissance* of the creative enterprise and its origins in sublimation. Let us draw a veil over the workings of this mysterious machine. Why expose its delicate mechanism? Let us deflect attention *away* from the source of creativity. We would do well to honour its mystery.

Graduate students, some of whom have never conducted professional practice outside an educational institution, and artists on a spectrum from the intuitive to the anarchic to the recessive and cryptic – they are in a vulnerable place as we develop the supervisory dialogue of the studio doctorate. Are there still ways to open up the yet-to-be-imagined artwork to communion with the breadth and depth of history and theory, without foreclosing on speculation and without forcing studio practice and its accompanying exegesis to be didactic, or over-theorised, or illustrative?

The term 'history' has a key role here, but it needs to be carefully defined. I don't only mean that the student should demonstrate the awareness of context which supervisors and examiners demand, often under the title of 'literature review'. I certainly don't suggest we return to the canon of

Western heroes so robustly critiqued by cultural studies, post-colonial criticism and feminism.

This 'history' is consistent with Foucault's "genealogy" or "descent", an "unstable assemblage of faults, fissures and heterogeneous layers" (Foucault 1991, p. 82). The cultural formations amongst which we are sited, from which we cannot escape, point us back towards their condition of possibility. Genealogy or history in this sense has both a diachronic and a synchronic scope. That is to say, over *time* we are heirs to the evolution of ideologies, images, materials; time becomes the contemporary *space* to which we accommodate ourselves, which structures our vital relationships, within which we make our creative negotiations. To ask historical questions in this sense is the best way of understanding how we came to be where we are, to think the way we do, to imagine possible futures. To 'assemble' a history of one's subjectivity, 'heterogeneous' as it may be, allows the exercise of curiosity to be a central part of the degree. This also entails valuing experience, identity and the exercise of the critical voice in a direct encounter with primary sources, rather than a scholastic deferral, under the anxiety of influence, to received authority. The poetics of the exegesis is polyvocal, as riven and contradictory as the processes of creativity.

Topologies of Process

If we are neither constrained by conventions of a methodology which governs correct procedure, nor obliged to have concrete outcomes as a result of speculation, how might the subtle counterpoint of the research project be structured? This is not to suggest the abandonment of due process; rather, it is a call to re-imagine the possibilities, and to draw on the potentiality of the artistic process itself as a creative force. Here the topological and spatial metaphors of psychoanalysis, already hinted at in the realm of sublimation, come in handy. A mind of one's own has a spatial aspect, nested as it is within the body, the Deleuzian 'enabling machine', which in its turn is sheltered within the studio space, the exemplary 'room of one's own'. This is the carapace of the artist, an intimate space, within which failure is permitted, and the ground from which the artist encounters the space of reception.

To extend the spatial analogy, if we conceive of the exegetical text and the studio work as two texts running in parallel, rather than the one limiting, justifying, or foreclosing on the other (in whichever direction), then both can be allowed their integrity. The art text and the art works can have discrete identities, which are set in an intimate and dynamic relationship. It is the cross-ties between them that enable the concept of research to be a work of curiosity, investigation and self-empowerment. As a research strategy, the idea of parallel texts can open up the artist to the richness of visual culture, indeed culture in all its guises. One text is where we make and do things in the world, the other is the space of reflection or analysis, where a differently ordered form of enquiry is permitted; neither is subordinate, and the deadening demand to 'theorise the work' can be elided.

Where might we have encountered texts in parallel before? It is in allegory, that intriguing symbiosis that occurs when one text is doubled by another and each one points to, comments on and decodes the other. It was Walter Benjamin who characterised allegory as an authentic form of language that had particular virtues in engaging with the dialectic flux of history (Benjamin 1977/1928). As partners in allegory, each text in the research setting is allowed its own destiny and integrity in a dynamic of mutual interpenetration or co-interpretation. Each side of the equation allegorises the other; neither necessarily has subsidiary or master status. The model is rhizomatic rather than hierarchical.

This is worth thinking about because the studio-and-exegesis method puts us in the middle of a Russian doll of representations, where "all problems about *representing* in artworks... are also problems about the *representation* of those works *in artwriters' texts*" (Carrier 1987, p. 136; emphasis in original). The student, compelled to be both artist and artwriter, history and historian, is mired in the production of meta-texts of dubious insight. Allegory offers a path out of this swamp. For the contemporary visual artist it is also a singularly appropriate form because allegory has been identified as a primary pointer to contemporary practice (Owens 1992, p. 52). Ours is a culture of artworks that demand complex acts of decoding, which address the initiate, whose syntax is esoteric, partial and dependent on text. Allegory may be cryptic; however, it always solicits debate and aspires to coherence.

The supervisor, for example, can direct the student's attention to the ways that each of their chosen materials carries a narrative, each process implies a history, every image is always already entangled in a spider's web of associations. This idea of the allegorical nature of the research degree is one of process, driven by an enriching curiosity that permits desire to flourish as an engaged enquiry.

In considering also the address to the examiner, the ultimate arbiter of the student's success or failure, a non-prescriptive yet sympathetic inter-play between the parts of the examinable material asks for a nuanced and imaginative act of appraisal. This is more flattering to the exam-iner's intelligence and insight than a prescriptive and dogmatic format.

Conclusion

The idea of the graduate art degree as a work of allegory is a liberating pattern for the conduct of research. Rather than writing about the work, or before, or after the work, the student can write *alongside* the work. Moreover, two (or more?) texts in active negotiation is a subtle scale model of the ways that culture makes meaning, intertextually, dialectically and discursively. The exegesis, rather than being arbitrarily concocted to satisfy institutional demand, is deeply connected to the creative process and can also stand alone without compromise.

To juxtapose a set of images, histories and ideas in an unexpected way, and speculate about their relationship, as it has been felt in the past and is still felt in the present; to allow those insights to infect the visual language, because both lines of investigation connect to an enigmatic psychic motivation – that is a fascinating work of research.

References

Benjamin, W. (1977 [1928]) *The Origin of German Tragic Drama.* Osborne, J. (trans.). London: NLB.

Biggs, I., & Wood, A. (2005) Creative practices and the 'stigma of the therapeutic'. In M. Miles (ed.), *New Practices, New Pedagogies* (pp. 117–132). London: Routledge.

Buren, D. (1979) The Function of the Studio. Repensek, T. (Trans.). *October* Vol. 10, (Autumn) pp. 51–58.

Carrier, D. (1987) *Artwriting.* Amherst, MA: University of Massachusetts Press.

Camus, A. (1942) *The Myth of Sisyphus.* Paris: Gallimard.

Dallow, P. (2005) Outside 'The True'?: Research and complexity in contemporary arts practice. In Malcolm Miles (ed.), *New Practices, New Pedagogies* (pp. 133–142). London: Routledge.

Elkins, J. (2001) *Why Art Cannot Be Taught.* Urbana, IL: University of Illinois Press.

Foucault, M. (1991) Nietzsche, genealogy, history. In P. Rabinow (ed.), *The Foucault Reader* (pp. 76–100). London: Penguin.

MacNeill, K., & Bolt, B. (2011) The legitimate limits of artistic practice. *Real Time* 104, Aug–Sep, pp. 26–27.

Owens, C. (1992) The allegorical impulse: toward a theory of postmodernism. In *Beyond Recognition: Representation, Power, and Culture* (pp. 52–85). Berkeley, CA: University of California Press.

Scrivener, S. (2000) Reflection in and on practice in creative-production doctoral projects in art and design. *Working Papers in Art and Design 1.* Retrieved 30 July 2013, from: http://www.herts.ac.uk/__data/assets/pdf_file/0014/12281/WPIAAD_vol1_scrivener.pdf.

Sullivan, G. (2005) *Art Practice as Research: Inquiry in the Visual Arts.* Thousand Oaks, CA: Sage.

ARTIST–ACADEMIC AS DOCTORAL STUDENT: NAVIGATING DIFFERENT EXPECTATIONS, FRAMEWORKS AND IDENTITIES

Jenny Wilson

Introduction

Nearly 70 per cent of all academic staff employed in the Australian university sector hold a doctoral qualification (DIISRTE 2012) and a doctoral qualification, preferably a PhD, is a requirement for a tenured or fixed-term academic position in many disciplines. In artistic disciplines, where recruitment is commonly based on artistic achievement and standing, an "increasing number of staff are in the process of completing a PhD" (Baker & Buckley 2009, p. 80). Those who combine the roles of artist, academic and student navigate a complex environment of expectations set by their employing university, their supervising institution and the external art world in which their practice is located. While significant scholarly attention has been focused on doctoral students per se, little has been written about this distinctive

cohort of students and the specific challenges that they face combining study with academic performance requirements.

This chapter provides an historical context for the growth in university expectations and artist–academic interest in doctoral study. It explores some of the reasons why academic staff within artistic disciplines undertake doctoral study while working, and the challenges and benefits they experience. In the face of a growing momentum to make a doctorate, specifically a PhD, a compulsory requirement for all academic employees, this chapter raises questions about the impact of such a move for future staff in visual and performing arts.

The experiences of artist–academic–students used here are drawn from unpublished data gathered for my larger study of artists in the Australian university system and their relationship with the institutional research management framework (Wilson 2013). The findings include survey responses from heads of arts schools (or equivalent academic units) in Australian public universities and interviews conducted with practising artists employed as academic staff. The survey, which achieved a 21.4 per cent response rate that encompassed 40.5 per cent of all Australian public universities, invited heads of schools to comment upon how their universities responded to artistic research compared to other disciplinary groups in a number of operational areas: staffing; funding; infrastructure; staff support; research student support; profiling of research endeavours and inclusion in policy and decision-making. In a subsequent set of interviews, ten academic staff from different artistic disciplines and at different stages in their careers shared their experiences of working as artistic practitioner–researchers within the university. During these conversations, the issue of doctoral study was raised by several interviewees. Their comments reflect both personal experience and concerns for existing and future academic staff. These respondents are identified by their discipline and stage in their academic career.

Three interviewees in particular provided valuable insights. All are well-respected artistic practitioners whose professional practice preceded their university employment and whose doctoral studies incorporated artistic practice. All were employed as full-time academic staff while

completing their doctoral studies. These interviewees have been given the pseudonyms *Alice, Barbara* and *Collette. Alice* is a visual artist. She began her doctoral studies in the mid-2000s and, following a period of deferral, graduated in 2011. *Barbara*, also a visual artist, undertook her doctoral studies in the late 1990s and graduated in the early 2000s. *Collette* joined the university after a highly successful artistic career in theatre. She enrolled for a PhD, commencing in unison with her academic staff member appointment, and graduated in 2012.

Due to the limited data, this study does not seek to present a comprehensive, or even generalised, picture of the circumstances surrounding artist–academics undertaking doctoral studies, but does provide a snapshot of individual experiences and perceptions that prompt questions and issues for further consideration.

Academic 'Up-skilling' as an Institutional Management Strategy

Encouraging staff to upgrade their qualifications is one of the seven most common management practices adopted by Australian universities to improve research performance (Beerkens 2009). Its roots lie in the amalgamations between universities and colleges of advanced education (CAE) that took place in the early 1990s in Australia (Dawkins 1988). Almost every Australian university incorporated some form of artistic discipline during this period (Wilson 2012). Prior to this reform, the majority of tertiary arts education was conducted outside the university sector and, for many academics in artistic disciplines, their first brush with research was accompanied by the realisation of its importance in academic career progression.

For the universities who were to absorb a significant cohort of 'non-university trained' staff, the issue of research was an important consideration during the amalgamation process. The Australian government had indicated that future funding would be dependent upon institutional educational profiles, which included research as one of the criteria (Marginson 1996). In the 1990s, an official government program of upgrading staff qualifications was put in place to assist universities to incorporate their new academic contingency into the existing

institutional research agenda. By supporting research degree completion for their newly integrated staff, universities were able to ensure that staff members who were incorporated into the university obtained the "necessary research qualifications", gained an understanding of university notions of research and strengthened the institutional research culture (Beerkens 2009).

Between 1992 and 1996, interest in pursuing research qualifications by arts staff was strong. The numbers of creative arts academics holding doctorates increased from 12.9 per cent to 21 per cent by 1996 and those with master's degrees increased from 23.7 per cent to 29.8 per cent (Strand 1998). As Strand notes:

> The visual and performing arts was one of the two fields of study which showed the greatest improvement in the gaining of higher degrees, indicative of important changes in the research culture of many schools of art, music, theatre and dance.
>
> (Strand 1998, p. 26)

During a similar period, the numbers of completed PhDs that involved creative or performing arts increased from only one by the end of the 1980s to over thirty by the end of the 1990s (Evans et al. 2003). It is logical to presume that these doctoral students included a significant number of already established staff seeking to improve their career prospects.

The Contemporary Environment for Artist–academic–students

We do not know with any accuracy how many staff from artistic disciplines are currently undertaking doctoral qualifications, how many complete or how many withdraw before graduation. Indeed, despite a recommendation in 1998 for better statistical record keeping about researchers in creative arts disciplines (Strand 1998), we still have no accurate, publicly available data on the numbers of practising artists who are working within the university sector. However, we know that numbers of academic staff in artistic disciplines have increased significantly in the past two decades and are now represented in similar numbers to those in education and engineering (DIISRTE 2012), and that

the "numbers of staff from artistic disciplines completing PhD programs is increasing" (Baker & Buckley 2009, p80).

Across the university sector as a whole, there is "an increasing expectation that academic staff will hold a PhD or Masters qualification, with the former being increasingly important for research" (Hugo & Morriss 2010, p. 73). Applicants for new positions or promotion from artistic disciplines, however, are also expected to demonstrate high-level achievements and standing within their artistic practice, a criteria that does not factor for non-practising disciplines. Although a PhD qualification has, more recently, "become a strong expectation for newly appointed staff" (Baker & Buckley 2009, p. 80), the situation was different for those who joined the university from specialist arts colleges or the college of advanced education (CAE) sector. As Blackmore recalls:

> Many creative and performing arts (CPA) academics had ceased formal qualifications at diploma levels to concentrate on developing creative practices. Now in universities, CPA academics with many years teaching experience found themselves unable to fully participate in their academic roles, or apply for promotion, unless they upgraded their qualifications with a research degree.
>
> (Blackmore 2012, p. 2)

Australian creative arts schools today, therefore, are likely to contain staff without doctoral qualifications who joined the university sector through amalgamation, and staff recruited more recently on the basis of their artistic standing and reputation. The lack of doctoral qualification at uptake of university employment may be one reason for the continued and increasing interest of these academics in enrolling for research degrees at the same time as holding an academic position.

Artists working within academia need to navigate the different values, expectations and even identities that surround their roles, whether as academic (Bennett, Blom & Wright 2009) or doctoral student (Hockey & Collinson 2005). The following focuses on the perceptions of academic staff in artistic disciplines who, as doctoral students, navigate the institutional frameworks designed to evaluate and credentialise academic research performance.

Artistic Research within Academic Performance Evaluation Frameworks

Australia has been singled out as a country in which the recognition of artistic practice as a research endeavour in its own right has been noted as particularly "problematic" (Kalvemark 2011). Since the Australian Senate reported a systematic disadvantaging of the creative arts produced by the funding model adopted for university research in 1995 (Parliament of the Commonwealth of Australia, 1995), commentators have continued to evidence discrepancies and inequitable treatment of artistic research in staffing (Wissler 2005), funding (Buckley & Conomos 2004; Wilson 2011), recognition of research practice (Strand 1998; Haseman 2006), and the application of inappropriate measures, policies and procedures to reflect creative arts research (Bourke, Haseman & Mafe 2005; Schippers 2007; Draper, Hall & Wilson 2005; Australian Academy of Humanities 2006; Bennett, Blom & Wright 2009). While artistic practice as a component of post-graduate awards has been generally accepted by universities for research evaluation, this is still less settled in relation to academic research performance.

Relating the situation to the institutional focus on funding, Kroll notes that:

> If one consulted the research higher degree manuals of many institutions now, one would find that a variety of modes of presentation of research is acceptable, from static art object to CD-ROM. The students who receive these higher degrees mean money for their institutions, since DETYA rewards degree completions. Yet supervising staff members who produce creative products without accompanying documentation, or ones that do not fit into the narrow present categories would attract no credit for their institutions.
>
> (Kroll 2002)

Although some institutions have adopted internal academic performance evaluation frameworks that are more supportive of artistic research, in general, universities take their cue from the national research evaluations that inform institutional funding returns and thus, inequities present within government research policy are transposed into institutional performance evaluation (Taylor, 2001). Baker and Buckley observe:

> The irony is that universities are comfortable recognising the
> research outcomes of PhD submissions as research but the federal
> government assessment agencies are still not so clear. The impli-
> cations of this are that while the outcomes of graduate student
> research are recognised, the same types of outputs are not recog-
> nised in the HERDC categories.
>
> (Baker & Buckley 2009, p. 98)

This translates to differences in performance evaluation for doctoral students and academic staff, and indeed the perverse situation still exists within Australian institutions where a staff member simultaneously studying for a post-graduate award may have work recognised as research for the purposes of their higher degree, but discounted in terms of their staff performance.

The recent inclusion of creative arts outputs within the Excellence in Research for Australia (ERA) (ARC 2013), while indeed marking a step forward, is still only a very small step in relation to recognition in the outputs that are used to calculate the institutional research block funding provided by the Australian government. This exercise, known as the Higher Education Research Data Collection (HERDC), remains firmly adhered to the valuation of research income, publications within four text-based categories of research output, and research degree supervision (DIISRTE 2013a). It represents a strong influence upon the institutional frameworks that evaluate academic research performance. Australian academic staff are expected to meet research performance levels that are evaluated in these three categories used to inform the institutional block funding (DIISRTE 2013b). Research income has the most influence on institutional research block grants with 53.9 per cent of the funding determined by formulae based on the amount of research income that has been secured in four specific categories. For artistic researchers, opportunities to secure research funding within these categories are limited (Wilson 2011). Despite creative arts outcomes being recognised as performance in ERA, they are still largely excluded from consideration in HERDC, which considers only four types of text-based research publications: books, book chapters, journal articles and refereed conference papers (DIISRTE 2013b). In relation to research degree supervision performance, despite the numbers of academic staff pursuing doctoral qualifications, there are still too few with the appropriate qualifications

to supervise the numbers of post-graduate students seeking to undertake doctoral study (Baker & Buckley 2009, p.60).

Thus, from an institutional financial perspective, an academic staff member undertaking doctoral study may be seen by some universities as representing six or seven years of time diverted from the 'important' business of securing research income. As the government program of support for upgrading has "faded with time" (Beerkens 2009, p. 9), any readjustment of expected performance outcomes or time allocations to undertake further study or professional development is dependent upon the goodwill of the faculty or school and, as the experiences of those interviewed shows, it can vary across the sector.

Deciding to Study and Choice of Doctoral Program

It was clear from the interviews that the impetus to undertake doctoral study was not related to the interviewees' artistic practice. Indeed, the qualification can have negative connotations within the art world. As *Alice* explained: "no-one in the visual art industry cares at all about PhDs... in terms of standing as an artist in the art community, it can mean nothing at all or can mean something negative". A senior visual-arts academic, who rarely lists his PhD and never includes his academic title on his CV, explained that: "being an academic in the art world is a negative thing, it means you are not good enough to be a commercial artist".

The impetus to study appears to be driven by the desire for promotion and stability in academia: "the university wants us to have these qualifications" (*Alice*). *Barbara* explains that without a doctorate, "we had always been told that... eventually you would not be able to supervise or to be promoted".

The requirement that artist–academics hold a doctorate is perceived as a particular characteristic of working within the Australian university sector:

> Here, if you are a young academic in visual arts, you have to have
> a doctorate, and that's not the case overseas. In the US, you can

be teaching at Yale or the Art Institute of Chicago and the MFA [Master of Fine Arts] is the terminal degree. It's a reflection of post-colonial inferiority, to have to prove that we are as good as anyone else and need to demonstrate this, [to] get the certificate, get the trade papers, as opposed to accepting the judgement of our own eyes and ears.

(Senior academic, visual arts)

The encouragement of the 1990s appears to have transformed, in some institutions, to levels approaching compulsion. *Alice* comments how she felt "forced to do a doctorate" and *Collette* was encouraged to enrol for a doctorate at the same time as commencing her employment in the university sector. Rather than encouraging staff to see the benefits of research study, the enthusiastic demands from university management may cause prospective enrolees to question its value to their roles as teachers and artists. *Alice* notes that "anyone who was doing decent work would not have had time to do a doctorate" adding, "I fought against doing it, because I thought things [that were] more rigorous [artistically] were being sidelined". Commenting on his experiences, Thomas recounts:

I began to receive regular emails from the university noting my lack of a PhD and asking me what I was doing about it. This, despite never once being asked by a student in 10 years whether I had a PhD or not. The students did, however, always want to be reassured that I knew how to make a decent documentary film.

(Thomas 2010, para 17)

The comparatively rapid acceptance of creative arts within doctoral study has led to a variety of programs. Academic staff can choose from professional doctorates – for example, musical arts (DMA), visual arts (DVA) or creative arts (DCA) – which are designed to focus on their artistic practice, or within PhD programs that employ varied weightings to incorporate artistic practice with more traditional theoretical and text-based work (Reiner & Fox 2003).

Given the strong influence of academic career aspirations upon the decision to commit to doctoral study, the choice of which program may be influenced by external perceptions of the value of the program to

their academic career. Sone and Crisp noted that artists choosing the professional doctorate route can feel they are "seen as 'suspect' by both theorists and artists" with the holder being seen "as not quite theorist, not quite artist" (Sone & Crisp 2005, p. 8). Different perceptions may be created by the balance between text and creative work where "a greater reliance on the assessment of a text-based component suggests that the research status of the submitted musical works themselves is somewhat downgraded" (Reiner & Fox 2003, p. 3).

All three interviewees believed that the PhD rather than a professional doctorate was a better choice for those working in academia. *Barbara* relates this to the valuation that may be placed on the professional doctorate by the institution:

> I have a great distrust of the university and I feel at some point they could easily make professional doctorates lesser. I would always advise anyone I was supervising that if they are serious about an academic career to move their DVA to a PhD.

The wider consequences of this choice may become apparent for some as they progress through their studies:

> My own creative work has stalled badly as I've spent years strug-
> gling through a theory-based PhD. I personally felt the creative
> PhD road would be just too difficult to achieve as a part-time
> student. In retrospect, this may have been a mistake.
> (Survey respondent, discipline not identified)

The variety of doctoral models and the comparative newness of the creative arts doctorate can lead to "continually moving goalposts" (*Barbara*) and uncertainty for academic staff who are undertaking a doctorate on a part-time basis over a period of time. *Barbara* recalls: "the rules changed all the way along... a lot was changing about word count, or whether there was a word count, and [the] nature of [the] written document that was to accompany. It was changing all the time".

Artwork and Writing

The relationship between text and artwork was a particular discussion topic within the interviews. One interviewee points out that writing is integral to both the academic and artistic practice arena:

> [There] are different kinds of text. There is so-called scholarly text which analyses, there is text which is art, creative writing, and there is another kind of text that sits between those two and it takes you on a journey which captures you in both modes of apprehension. There is an artistry involved in taking ideas and giving them physical form, even if their physical form is only words.
>
> <div align="right">(Senior academic, visual arts)</div>

Alice, Barbara and *Collette* were comfortable with writing as part of their academic role and as artists. As *Alice* notes: "[we have] always had to write about our work". All had included creative and written work as part of their doctoral theses. The exegetical writing was seen as a positive experience although the "real danger of heavily didactic" approaches was noted (*Barbara*). *Barbara*, whose doctorate incorporated several creative outputs, points out that the writing "has to happen after [the artworks] are finished... you can't go back and change because the works [are] permanent" but she notes how the process of writing "absolutely affected the next project, in a really positive way". She equates the creativity of writing with the production of artworks:

> [W]riting in a PhD context requires just as much as immersion and creativity. [It is] by messing around with those words in the same way as messing about with materials in art works that something emerges.

Any dichotomy between text and artwork in artistic research occurred when it came in contact with the university system. Artistic use of words is a standard technique for playwright *Collette* in her research and artistic practice, but as she "takes the words of external contributors, modifies or treats verbatim and then puts them back in as narrative... to be spoken by others in a different context", she acknowledges challenges meeting the university ethics requirements. *Alice* notes differences in

the way that the university views research communicated through artworks and through text when, despite spending "a lot of time that isn't university time" on her artworks, she was required to disseminate her artwork through the university's commercial process which included a shared recoupment of any income generated. As she says: "when people publish books they still get their [own] royalties".

Although valuing the writing component of research, the creative works remained the most important aspect to the interviewees:

> It is the output of all the things that you do. I think about the last project that I did, and think of the reams of drawings and writing that I did for my last piece, but the 'thesis', at the end of the day, is the finished [art]work.
>
> (*Alice*)

Time and Balance

It was noticeable that the obstacles mentioned related predominantly to meeting the academic performance expectations while studying, not to the doctoral program. The core issue related to the requirement to produce annual research outputs, as well as the organisation and management components of an academic workload.

Sufficiency and flexibility of time to undertake creative work alongside academic responsibilities are common challenges for artistic researchers, whether in doctoral programs or not. Bennett, Blom and Wright noted the time-consuming nature of creative practice itself, and the adjustment period needed to resume the specific state of mind needed for creative work and for practice to maintain "gross and fine motor skills at the level required for professional-level performance" (Bennett, Blom & Wright 2009, p. 5). For those who are undertaking doctoral research simultaneous with a full-time academic career, the calculation of workload balance, that allocates time between teaching, research and service, is an important factor. These categories are reflected in the annual academic performance evaluation, and dispensations or allowances for doctoral study may or may not be incorporated.

While *Collette* was fortunate that her doctoral research program was counted within her research workload allocation, *Alice* and *Barbara* recalled that they'd had little to no support, other than perhaps the opportunity to take occasional unpaid leave.

In some academic disciplines, doctoral study may present opportunities for journal publications that count towards the annual academic research performance evaluation. For those in artistic disciplines, particularly where the doctorate culminates in a major artistic work, opportunities for doctoral work to contribute to annual academic performance may be far fewer. Staff may be faced with a choice between ongoing commitment to their doctoral study, undertaking extensive additional work to meet academic performance criteria or risking the consequences of not achieving their annual performance targets.

Alice recalls that during one year she "scored zero outputs" while studying for her doctorate. "That was terrifying because I knew what that meant, that I was extremely vulnerable in the university context". Despite 'private conversations' in relation to recognition of her workload and doctoral studies, she remained in a state of anxiety. "We all know that the wind can turn... and if you have zero outputs, you have zero outputs, and your head will go to the guillotine if someone wants it to". *Barbara* explained that, at the same time as studying for her doctorate, she was also in a senior management position with responsibility for a major departmental restructure. She sees the problem as related to the way that the university compartmentalises the teaching, research and service components of the workload:

> People may be killing themselves on service. I had [a] 50% service [role] so theoretically the research outputs and teaching should have been a lesser expectation. However, it is not really the case because each is seen independently. When you are in trouble, you are only in trouble in [one] area. You could be doing a massive amount in [another] area but nobody cares. It is not really looked at in an equitable policy fashion.

Mentors and Supervisors

The experience and skill of the supervisor in guiding the doctoral process is important for all students; however, for *Alice*, *Barbara* and *Collette*, this extended to an understanding of the difficulties faced by working within the university research framework and their supervisors' skills in advising them on how best to negotiate this environment whilst studying. As *Barbara* explained, "I felt quite safe in doing my PhD because I had an experienced supervisor who knew the game. He knew the problems and was aware of the disparities". *Collette* expressed the challenges of studying in an artistic format and the value of her supervisor's experience:

> Similar to a lot of artists who move into research, I struggled with ALL the tensions and challenges associated with art work as research. I felt I had no idea what I was doing. [My supervisor] continually encouraged me to chase my research in the direction I knew it should take. He might not have completely understood what I was doing initially, but he ensured that my research remained the research I wanted to conduct and not the research others may have thought I should be conducting. This was important to someone like me who initially felt like a fraud and spent the first part of the study bawling, feeling stupid and trying to manipulate the work into unworkable methodological or educational frameworks.

For *Alice*, the guidance and support from her period of post-graduate study has continued to provide supportive mentoring throughout her academic career. She said, "I had no idea of the support I had, until I left. Throughout the horror of working in [the] university, there was always a support that I could call on, and did".

Positives and Negatives: Outcomes and Futures

Perhaps because they had already navigated similar terrain during their academic careers, the identity challenges between artist and academia observed in relation to academic staff (Bennett, Blom & Wright 2009) and doctoral students (Hockey & Collinson 2005) did not feature as particular issues for *Alice*, *Barbara* or *Collette*. The process of doctoral

interrogation provided 'more insight' and a greater personal under-standing of how research related to their artistic practice. For *Alice*, her doctorate seemed a natural progression of her artistic practice: "All of my work has grown out of the work I did for my doctorate, and my doctorate grew out of my practice". *Collette* explained how she was now better able to see the differences, similarities and connections between her practice and research:

> Research is more overt and detailed in recording, in the process of data collection for example, it is less casual than when it is being undertaken as practice. But there is not really a lot of differ-ence in what I did as a practitioner and now what I am doing as a researcher, just the awareness that it is research means that the data gathering is more disciplined and recorded, and it results in publications whereas as a practitioner, the performance is all.

All were enthusiastic about the benefits that they had gained by under-taking their doctorate and their ability to pass on their own learning and experiences to their students. Doctoral study had increased confi-dence in their own ability to advocate for their disciplines, as Barbara explained:

> It is one thing that people from all fields understand. That is the beauty of being an academic. I can talk to the Minister and say, "I am an expert in this field and this is what you need to do" and I can say that quite confidently. It is not an "I kind of think I have a touchy feely idea about this".

Despite positive benefits from their own doctoral journeys, there were concerns for future artist–academics, particularly as a tendency had been noted in some students "to see their whole career trajectory to finish Bachelors, then do Honours and go straight into post-grad and then stay teaching in the university, with their whole exhibiting program just based around the university" (Early career academic, visual arts). As *Alice* noted, "it scares me that people go straight through, as you need time to make connections beyond the institution. There is a danger that people coming straight through don't have the neces-sary immersion within their own community, within the discipline". Fears were expressed that locating an artistic career solely within the

confines of academia can affect both the identity and practice of the artist. "I suspect that some people stay employed at a university a lot longer because they've lost confidence in being an artist separately" (Early career academic, visual arts). A preoccupation with prioritising university assessment criteria over the artistic practice itself was seen as particularly problematic, whether this applies to doctoral or academic progression. *Barbara* notes responses from those in the art world to the work of some of the research students she is now supervising:

> External assessors say that this is all well and good but where is the art? [The students have] ticked all the academic boxes but they haven't produced art. All the ingredients are missing... of what goes into an art work.

A senior academic in visual arts agrees there is a need for art continually to challenge the status quo:

> If you structure higher degree research with a thesis and then you lockstep the process towards that, you can really kill the journey of art which sometimes takes you to a place that you didn't anticipate going. There is the potential to get people who tick all the criteria boxes and do really well, because they are hungry for marks, and yet they are crap artists. They'll never make it as artists. They are so attuned to fitting in with the parameters of the institution that they can't hold their middle finger up.

Conclusion

As a research management strategy to increase doctoral qualifications in artist–academic staff, the exercise appears to be a resounding success, with increasing numbers pursuing research degrees despite the cessation of government and institutional support programs. While only a snapshot, the perspectives of those who have balanced the academic and doctoral student roles provide an insight into the challenges that exist within the system for those who have chosen this route. The uncertainty of process and choice of doctoral program, and the lack of time and balance, contribute to a state of anxiety in the early stages, which gives way, for those who complete, to an appreciation of the benefits to teaching, personal confidence and understanding of the research process as it connects with artistic practice. However, concerns

for future artist–academics remain. How much does, and should, the university sector do to make the process less challenging?

Bennett, Blom and Wright reassert the university's responsibility to its artist–academics:

> Remaining 'creative' becomes a university issue when artists, appointed to universities on the basis of their distinguished arts practice, are expected to continue their practice within a system that fails to recognize it.
>
> (Bennett, Blom & Wright 2009, p. 11)

The experiences expressed by this selection of artist–academic–students is small, but underscores artistic, academic and university expectations. This delicate balance requires constant vigilance and recalibration, especially if Australian universities are to retain sufficient appropriately qualified staff to accommodate the increasing interest from prospective students in artistic disciplines who are seeking doctoral qualifications.

References

Australian Academy of the Humanities (2006) Submission to the Productivity Commission Research Study on Public Support for Science and Innovation. Submission Number 64. Retrieved 10 December 2013, from: http://www.pc.gov.au/projects/study/science/docs/submissions.

(ARC) Australian Research Council (2013) Excellence in Research for Australia. Retrieved 25 April 2013, from: http://www.arc.gov.au/era/.

Baker, S. & Buckley, B. (2009) CreativeArtsPhd: Future-proofing the Creative Arts in Higher Education. Strawberry Hills, NSW: Australian Learning and Teaching Council.

Retrieved from: http://www.olt.gov.au/resources?text=Creative+Arts+Phd.

Beerkens, M. (2009) The effectiveness of management practices in the knowledge sector: evidence from Australian Universities. Paper presented at the European Group for Public Administration (EGPA) Conference, 2–5 September 2009, Malta.

Bennett, D., Blom, D., & Wright, D. (2009) Australian academics: performing the Australian research agenda. International Journal of Education & the Arts 10(17). Retrieved 19 January 2012, from: http://www.ijea.org/v10n17/.

Blackmore, M. (2012) Is being, or not being, the only question? – The dilemma of practitioner research in Australian universities. Paper presented at

the Arts Libraries Society Australia and New Zealand (ARLIS/ANZ) 2012 Conference: Collaborations: Artists, Scholars and Libraries in a Research Ecosystem. Retrieved 30 December 2012, from: http://www.arlis.org.au/ files/blackmorearlis2012_0.pdf.

Bourke, N., Haseman, B., & Mafe, D. (2005) From the management committee post SPIN. Speculation and innovation: applying practice-led research in the Creative Industries. QUT Brisbane. Retrieved 30 December 2007, from: http://www.speculation2005.qut.edu.au/papers/management_response. pdf.

Buckley, B., & Conomos, J. (2004) The Australian Research Council funding model condemns art schools to a bleak future. *ON LINE Opinion: Australia's e-Journal of Social and Political Debate*. Retrieved on 31 December 2007, from: www.onlineopinion.com.au/view.asp?article=2527.

Dawkins, J. (1988) *Higher Education: A Policy Statement*. Department of Employment, Education and Training. Australian Government Publishing Service, Canberra.

DIISRTE (2012) Staff: 2012: Selected Higher Education Statistics Appendix 1.11. FTE for Full-time, Fractional Full-time and Actual Casual Staff by State, Higher Education Provider and Function in an Academic Organisational Unit, 2011. Retrieved 19 January 2013, from: http://www.innovation.gov.au/ HigherEducation/HigherEducationStatistics/StatisticsPublications/Pages/ Staff.aspx.

(DIISTRE) Department of Industry, Innovation, Science, Research and Tertiary Education (2013a) 2013 Research Block grant allocations. Retrieved19 January 2013, from: http://www.innovation.gov.au/Research/ ResearchBlockGrants/Pages/default.aspx#GrantAmounts.

(DIISTRE) Department of Industry, Innovation, Science, Research and Tertiary Education (2013b) Research Block Grants – Calculation Methodology. Retrieved 19 January 2013, from: http://www.innovation.gov.au/Research/ ResearchBlockGrants/Pages/CalculationMethodology.aspx.

(DIISTRE) Department of Industry, Innovation, Science, Research and Tertiary Education (2013c) Australian Competitive Grants Register 2012. Retrieved19 January 2013, from: http://www.innovation.gov.au/RESEARCH/ RESEARCHBLOCKGRANTS/Pages/AustralianCompetitiveGrantsRegister. aspx.

Draper, P., Hall, M., & Wilson, J. (2005) Universities, creativity and the real world? Paper presented at the symposium Speculation and Innovation – New Perspectives in Practice-led Research in the Arts, Media and Design. April 2005. Queensland University of Technology, Brisbane.

Evans, T., Macauley, P., Pearson, M., & Tregenza, K. (2003) *Brief Review of PhDs in Creative and Performing Arts in Australia.* Retrieved 19 January 2012, from: http://www.deakin.edu.au/dro/view/DU:30004959.

Haseman, B. (2006) A manifesto for performative research. *Media International Australia; Incorporating Culture & Policy* (118), 98–106.

Hockey, J., & Collinson, J.A. (2005) Identity change: doctoral students in art and design. *Arts & Humanities in Higher Education* 4(1), 77–93.

Hugo, G., & Morriss, A. (2010) *Investigating the Ageing Academic Workforce: Stocktake.* University of Adelaide. Retrieved 30 December 2013, from: http://www.universitiesaustralia.edu.au/page/policy---advocacy/academic-workforce/.

Kalvemark, T. (2011) University politics and practice-based research. In M. Biggs & H. Karlsson (eds), *The Routledge Companion to Research in the Arts* (pp. 3_23). Stockholm: Routledge.

Kroll, J. (2002) Creative writing as research and the dilemma of accreditation: how do we prove the value of what we do? *Text* 6(1). Retrieved 19 January 2012, from: http://www.textjournal.com.au/april02/content.htm.

Marginson, S. (1996) Power and modernisation in higher education: Australia after the reforms of 1987–1989. *Melbourne Studies in Education* 37(2), 77–99.

Parliament of the Commonwealth of Australia (1995) University Reforms: Rough end of the pineapple for arts? *Arts Education: A Report by the Senate Environment, Recreation, Communications and the Arts References Committee.* Canberra: Government Printers.

Reiner, T., & Fox, R. (2003) The research status of music composition in Australia. *Australian Journal of Music Education* No. 1, 2003, 3–9.

Schippers, H. (2007) The marriage of art and academia: challenges and opportunities for music research in practice-based environments. *Dutch Journal of Music Theory* (12), 34–40. Retrieved 26 April 2008, from: http://dpc.uba.uva.nl/cgi/t/text/get-pdf?c=djmt;idno=1201art03.

Sone, Y., & Crisp, R. (2005) Terrible Twins: Art & the Academy. *RealTime* 68(Aug–Sept 2005), 8.

Strand, D. (1998) *Research in the Creative Arts. Evaluations and Investigations Programme.* Department of Employment, Education, Training and Youth Affairs. Canberra: AGPS. Retrieved from: http://trove.nla.gov.au/work/8485705?selectedversion=NBD13937733.

Taylor, J. (2001) The impact of performance indicators on the work of university academics: evidence from Australian universities. *Higher Education Quarterly* 55(1), 42–46.

Thomas, S. (2010) Victorian College of the Arts: Documentary lecturer rages on the ruin, asks the central question. *ScreenHub.* Retrieved on 16 August 2010, from: http://savevca.org/archives/782.

Wilson, J. (2011) Creative Arts research: a long path to acceptance. *Australian Universities Review* 53(2), 68–76.

Wilson, J. (2012) *Creative arts disciplines featured within Colleges of Advanced Education prior to amalgamation.* Unpublished data.

Wilson, J. (2013) Artists in the University. Study for PhD qualification being undertaken through the University of Melbourne, to be submitted in 2014. Unpublished data.

Wissler, R. (2005) Positioning the Field – Creative Arts, Media, and Design future challenges in teaching and research. Paper presented at the symposium Speculation and Innovation: Applying Practice-led Research in the Creative Industries. April 2005. Queensland University of Technology, Brisbane.

ARTISTIC RESEARCH – COLLATERAL DAMAGE OR EPISTEMOLOGICAL TOOL? WRITING FROM THE INSIDE OF PRACTICE

Some Notes on the Phd Programme Scenography: Vienna and Zurich 2006–2012

Thea Brejzek, Lawrence Wallen

Introduction

This text traces the conceptual thinking and the operation of a practice-informed PhD programme in scenography, a joint programme between the Institute for Design and Technology at Zurich University of the Arts (ZHdK) and the University of Vienna's Institute for Theatre, Film and Media Studies between 2006 and 2012. The term 'scenography' refers to set design in theatre, film and television as well as, in a wider context, to the creating of temporary scenic environments in a visual arts, spatial design and exhibition context. The authors, both from ZHdK, provide a close reading of the programme they co-founded

from their perspective as artist–scholars. It is shown how the unique Swiss tertiary landscape in which academies are assigned the status of 'universities of applied arts', institutions that are unable to award PhD degrees, provided the stimulus to look toward an international collaboration. Emphasis, however, is placed on the fact that collaborations such as the above stem from the initiative, creative input and enthusiasm of all involved, rather than from following institutional or governmental incentives. Retracing the early motivations for initiating the programme as well as the considerations leading to its specific design and structure, the authors argue the case for a writing from the inside of practice as an epistemological tool, in particular where such writing does not relate to one's own practice but rather utilises one's knowledge of the processes of practice for a wider methodological application and contextualisation. The programme's success is measured both against graduates' subsequent career paths as well as against the programme's afterlife in the form of the development of an active, professional network of graduates.

Finally, a detailed case study of a recent graduate's PhD dissertation project illustrates the programme's main foci as well as its outreach toward academic discourse, curatorial strategies and artistic practice in scenography.

Background

The PhD programme, Scenography, was founded in 2006 by the Viennese theatre scholars Wolfgang Greisenegger and Brigitte Marschall, both professors at the Institute for Theatre, Film and Media Studies, and on the Zurich side by the Australian architect and artist Lawrence Wallen and the German theatre and spatial-theory scholar Thea Brejzek, both professors at Zurich University of the Arts. Wallen and Brejzek had been working as an artistic team of scenographer and stage director and had already once before, in 2002, successfully initiated a new study programme, the Master of Advanced Studies in Scenography at Zurich. Greisenegger, an eminent theatre historian specialising in scenography as well as a former Head of School and Rector of the University of Vienna, and Marschall, known for her rigorous political approach to theatre and performance, equally, while not working directly together, had been conscious of each other's research for many years as colleagues

and PhD supervisors. Brejzek, as a former graduate of the Vienna Institute and PhD student of Greisenegger, had stayed in contact throughout her industry career and had been an external lecturer for some years. Thus, the idea of collaboration between the two institutions stemmed from the wish for collaboration between four scholar/artists directly rather than from the realisation of an institutional or governmental and possibly funding-related directive.

As a self-initiated interdisciplinary collaboration, however, the project could not have hoped to be implemented institutionally without the immediate support of the then Vice Dean for International Affairs, Arthur Mettinger, in Vienna and the then Founding Director of the Zurich University of the Arts, Hans-Peter Schwarz, and his then Vice Dean for Research, Gerhard Blechinger. Schwarz and Blechinger, both art historians with an acute sense of the need for an informed practice–theory dialogue within the academy, and Mettinger, as an experienced facilitator of international exchanges and collaborations, were able to secure funding on both sides as well as formulate and finalise the cooperation agreement between the two institutions within an astounding six months.

Context

While Scandinavian academies had pioneered the acknowledgment of artistic research at PhD level as early as the 1980s, academies in the German-speaking countries of Germany, Austria and Switzerland continued to maintain a strict division between the academically oriented university, with a right to award PhDs, and the artistically oriented academy that traditionally awarded diplomas. In order to align their study regulations with the European-wide Bologna reform that was to facilitate unprecedented student mobility, both Germany and Austria moved towards awarding academies university status (and with it the right to award PhD degrees) in the early 2000s. Switzerland, however, maintained what Hans-Peter Schwarz never tired of calling a "historic mistake": Swiss academies agreed to move to the status of so-called 'applied universities', thus forfeiting the chance to attain university status with the mandate to award PhD degrees.

The fact that Zurich University of the Arts and all other Swiss academies of fine arts, music and theatre were 'stuck' with the 'applied' status meant that the highest degree attainable remained at master's level. Additionally, a foreseeable hierarchy between Swiss universities and Swiss applied universities continued to exist, and both internal budgets and governmental research funding possibilities were and still are limited. While an easing from a dialectical thinking that sharply differentiates between a culture of 'making' and a culture of 'reflection' has been noticeable from the side of the Swiss Education Ministry in the last few years, Swiss academies still have no mandate to award PhD degrees. The desire from the academies to participate actively in an active dialogue on artistic research, its canonisation, its evaluation and its meaning for the neighbouring disciplines has led to a high degree of involvement in ELIA (the European League of Institutes of the Arts) conferences, work groups and publications (http://www.elia-artschools.org).

Both within ELIA, of which ZHdK is a member, and within the Swiss tertiary education debate, Hans-Peter Schwarz drove the discussion as to the importance and the value of research within the academy forward. In this respect, the envisaged collaboration between the University of Vienna and the Zurich Academy with its 'applied' status was an ideal testing ground and pilot study for the introduction of PhD research into a Swiss academy via the detour of an international collaboration with an academic university – the University of Vienna. The Institute for Theatre, Film and Media Studies, the immediate partner in the collaboration, had realised similar collaborations with the Music Academy (Conservatorium), the Theatre School (Max Reinhardt-Seminar) and one of the fine arts academies, the Academy for Applied Arts, for some years. In the meantime however, all Austrian academies had gained university status and were now awarding their own, if primarily text-based, PhDs.

Combining Practice and Research Degrees

In Europe, the terminologies surrounding the canonisation of PhD degrees that are based upon or involve creative practice to varying degrees, and where practice or components of practice are evaluated in conjunction with or substituting for traditional scholarly and primarily text-based outcomes, can be regarded as both varied (between

institutions) and dependent on interpretation rather than on definition. The three main descriptors are 'practice-based', 'practice-informed' and 'practice as research'. Helsinki has for many years awarded practice-based PhDs in theatre and scenography, thus allowing practitioners to analyse and interpret their own practice via a text-based exegesis, while UK universities have a wealth of experience in awarding both practice-based and practice-as-research PhDs, where an artistic work or body of work is performed or exhibited, evaluated by a jury of examiners and awarded a PhD. The third and probably least institutionalised 'genre' of PhDs involving creative practice is the practice-informed PhD, which denotes an outcome that may be informed by the practitioner's creative practice in diverse ways, but which does not comprise exclusively creative outcomes. It could be argued that the practice-informed PhD wants to have it all – creative practice output and traditional scholarly output – and it is therefore not surprising that the practice-informed PhD is the least-common variation of the three main forms.

For the Zurich–Vienna collaboration, however, the practice-informed PhD proved to be a structure that closely observed and acknowledged the participating universities' different core *competencies*, and the unique Swiss situation provided both partners with the possibility of awarding an academic degree each for the study. Zurich University of the Arts had since-2003, offered a Master of Advanced Studies in Scenography (MAS), in the form of a two-year postgraduate practice degree, that was held in an intimate master-class environment with a maximum of eighteen Swiss and international candidates, two main staff and guest artists employed on a project basis. The PhD degree in Philosophy at the University of Vienna's Institute for Theatre, Film and Media Studies follows the Bologna model of a three-year study with a tailor-made study plan of seminars, study skills and conference presentations, a written PhD thesis and an oral viva (defence). Combined, the two degrees both demanded an in-depth artistic as well as scholarly output while allowing each participating institution to follow their traditional expertise. The new PhD programme, Scenography, was aiming at accessing knowledge that had as yet not found its way into traditional academic output, by designing the programme in a highly dialogical structure. It was envisaged that each outcome would be influenced or informed by the other.

Design and Focus

Drawing on our own backgrounds as artists who had embarked on PhD study after many years of practice, we – Wallen and Brejzek – were able to articulate clearly the requirements and benefits of a PhD program for participating artists and institutions and subsequently to design the programme in close collaboration with our Viennese partners accordingly. A fear of having to work in isolation is generally cited as the main deterrent for mature-age practitioners, used to working in interdisciplinary teams, to embark on a PhD; while at the same time the desire to reflect on one's field of practice critically and to participate in a theoretically informed discourse is noticeably increasing. Additionally, the adoption of research guidelines and expectations that had been developed for universities engaged in traditional scholarly outcomes (monographs, journal articles and book chapters) by academies has led to increased demands for scholarly outcomes by artists teaching in the academy. Equally, practitioners wishing to embark on a teaching position in parallel to, or substituting for, creative practice increasingly find themselves disadvantaged in their career prospects without a PhD title and a research profile beyond practice.

In designing the structure and curriculum of the envisaged Zurich–Vienna collaboration with high-level practicing theatre artists, curators and architects as a first cohort of international candidates in mind, careful consideration had to be given to the necessity of mobility of both staff and candidates. A full fee-paying study (unusual enough in a landscape of free education across most of continental Europe), the programme was potentially becoming unaffordable due to the candidates' additional travel costs. It was decided to hold quarterly colloquia, each over a weekend in either Zurich or Vienna, with the possibility of also meeting in the framework of a suitable conference or at a location upon invitation by a host institution.

Artist–scholars were invited to propose practice-informed doctoral projects that aim to extend and further both the theory and practice of scenography through their convergence of original research, contextualisation and analysis, accompanied by a work of creative or curatorial practice. As outlined above, 'practice-informed' in our programme refers

Figure 13.1

The PhD Programme Scenography
at the Venice Biennial Design Studio.
Copyright: Lawrence Wallen (co-author)

to a doctoral research activity that relates to a candidate's creative or
curatorial practice by the choice of topic, by specific insights and/or by
methodologies derived from performative practice, such as the creating
and documenting of situations and scenarios. 'Practice-informed'
research also infers that the practice itself is not the topic of the schol-
arly inquiry, even though aspects of it might be. In this understanding,
the PhDs in our programme comprised two separate but corresponding
parts in different materialities, with one part comprising a lengthy
academic text and the other part comprising a creative component,
usually in suitable documentation.

To ensure we had the right candidates who were up to this challenge, we largely headhunted the first cohort of 15 international and established mid-career practitioners for the start of the programme in late 2006. Over the course of (a minimum of) three years, a major artistic work, body of work or curatorial practice was to be realised by the candidate as well as a book-length scholarly inquiry to be completed. To counteract the much-cited solitude of the PhD candidate and to ensure a wide inter- and trans-disciplinary focus, it was established that the programme's central components were to comprise co-supervision by the founding professors, thus enabling the competent supervision of topics encompassing theatre and performance studies, including architecture, design and electronic media, as these related to scenographic space as the thematic backbone of the overall programme. Additionally, the candidates' professional expertise as artists, practitioners and curators meant that their contributions to the colloquia were a rich source of knowledge. Access to this specialised knowledge was enabled via a method of roundtable 'collective critique' where the assumed hegemony between supervisor and PhD candidate was replaced by the understanding that the diverse knowledge sets brought to the table would inform each other through dialogue, exchange and constructive feedback. In contrast to the inclusive, if highly critical atmosphere created by the roundtable sessions, individual two-hour sessions were held with the three supervisors providing highly specialised guidance from their respective disciplines and perspectives.

While internal communication, both in person and, due to the wide geographical distribution of supervisors and candidates, regularly via Skype and email, was intense, external communication and outreach were guaranteed by yearly public symposia, public studios and workshops in host institutions (such as the Vilnius European Capital and the Venice Architectural Biennial). Between 2006 and 2012, three edited volumes were published by the Zurich Museum of Design with scholarly contributions as well as artists' pages by candidates from the PhD programme Scenography and external contributions through peer review.

It had been the overall aim of the programme to extend the field of scenography beyond stage design (in practice) or performance and

theatre studies (in a scholarly context) and to embrace its hybrid nature. Parallel to the theatricalisation of everyday practices and spaces, scenographic strategies are increasingly employed outside an immediate performance context in all areas of spatial design and we felt that this recent development needed to be reflected in any scholarly engagement with scenography. We articulated this position in 2009 in our contribution to the volume *Spatial Sciences* (or *Raumwissenschaften*, in the German original) by German philosopher Stefan Guenzel. This volume aimed at providing a close reading of the (after) effects of the so-called 'spatial turn' in the different academic disciplines roughly thirty years after it was first proclaimed as a paradigmatic shift towards space and spatiality as central to the social production of meaning in the spatial and social sciences:

> Contemporary scenography operates far beyond the theatre in all those areas of spatial design that have inscribed onto them elements of the mise en scène, of narrativity, transformability and mediality. Scenography is understood here as a practice that utilizes trans disciplinary strategies in the design of performative spaces at the interface of theatre, media, architecture and installation. With the emphasis on the performative, the processual and the constructed, formerly separate genres of spatial design merge toward staged gestures of spatiality. Spaces that are thus conceptualized, constructed and realized derive from a trans disciplinary design strategy and are hybrids that cannot be assigned anymore as belonging to a single genre. In this reading, the scenographer emerges not as the spatial organizer of scripted narratives but rather as the author of constructed situations and as an agent of interaction and communication. Contemporary scenography operates with technologies of simulation, interactivity and immersion and strives to evaluate these as to their potentialities for user-participation and (critical) artistic intent.
>
> (Brejzek, van der Haegen & Wallen 2009: 370)

The authors recognised that the field of scenography in its present transdisciplinary practices in architecture, theatre, media and exhibition had continued to be a largely overlooked area of scholarly concern until as recently as the early 2000s. We identified the absence of academic reflection in a field that presented an ever-growing, dynamic and hybrid practice, including an increasing number of theme parks,

themed shopping centres and gated communities, as well as theatrical extravaganzas in public space from Cirque de Soleil to the spectacular Opening and Closing Ceremonies of the Olympic Games. Consequently, *scenography* was chosen as the distinct field of observation and analysis for our collaboration and in the implementation of the joint practice-informed doctoral programme.

Supervision in a Practice-informed PhD Programme in Art and Design

Current transdisciplinary and multimodal practices in art and design comprise fluent transitions between text-based and non-text-based forms in the representation of concepts. A clear distinction between 'theory' and 'practice' can be regarded as both obsolete and non-productive. The term 'aesthetic practice', as suggested by media philosopher Dieter Mersch throughout his 2002 publication *Event and Aura*, encompasses both theory and (art) practice. Mersch's view allows for a view toward research practices that is based not on a hierarchy but rather on inclusion, namely the acceptance of diverse methodologies and their resultant diverse material outcomes.

In accordance with Mersch, research in the PhD programme Scenography was regarded as an intrinsic part of aesthetic practice and thus supervisors had to be able to highlight, distil and aid the process of translation between the different 'languages' of practice. Rather than attempting to avoid a provocatively termed 'collateral damage' between art and science in processes of artist-led and practice-informed inquiry, it is suggested here that it is in fact the colliding of sources, questions and methods that is instrumental in knowledge production.

As the research questions and research topics of practice-informed PhDs emerged from engagement with practice, both closeness to and distance from practice were regarded as integral to the successful mapping out and completion of the research. The co-supervisors' own experience confirmed that practice-informed PhD research constitutes a period of personal and professional reorientation for the candidate that may involve feelings of betrayal towards one's creative practice or that of one's peers. Academic research may be perceived as an invader of the

realm of art comparable to a robber of secrets, and scholarly investigation may be perceived as an irrefutable act of normative reflection that destroys one's creative impulses. These are complex and challenging issues for a supervisor to resolve, and they show that doctoral supervision and responsibility in the academy clearly moves beyond purely academic guidance:

> Supervision... must be understood as a (pedagogic) practice producing subjects, as directly and actively implicated in the socio-symbolic work of subject formation, or the discursive construction of subjectivity: the constitution of the (academic) subject.
>
> (Green 2005, p. 152)

As acutely observed by Green, successful supervision at doctoral level requires the understanding of and the willingness to engage with its critical pedagogical aspects. While Green focuses on (the constitution of) the (academic) subject, the supervision of artist–scholars necessitates the possibly even more complex process of balancing the artistic and the academic subject. This might seem a terminological contradiction to the aforementioned 'aesthetic practices' as encompassing both art and design practice and their theorisation. Our supervisory experience showed, however, that due to the traditional separation of practice and theory in academic and art institutions, the alignment of both practices toward a constructive path of investigative doctoral research for the artist/designer constitutes an often laborious and initially unfamiliar process of reflection, analysis and contextualisation concerning the candidate's own practice outcomes. During this unavoidable process of struggle, supervisors in the programme recognised that candidates benefit greatly from actively participating in the week-long doctoral research colloquia held quarterly. It was in the round-table sessions of the colloquia and the individual working sessions with all three supervisors that an internal epistemological process was initiated and further intensified by work-in-progress reports, presentations and discussions, guided and accompanied by the supervisory team. This was carried out in a deliberate rejection of the traditional model of the Über-Vater as the single (mostly male) dominating figure with the power to influence, to make or to break the emerging researcher. In contrast, a team of three doctoral advisors undertook joint supervision in our programme during extended individual and group sessions. It was recognised that due to

Figure 13.2

The PhD Programme Scenography
at the Venice Biennial Design Studio.
Copyright: Lawrence Wallen (co-author)

the transdisciplinary orientation of the programme, a wealth of exper-
tise was needed to interrogate research topics toward results that tear at
the boundaries of any single art and design discipline. Furthermore, all
supervisors carried equal responsibility during both candidature and
viva.

Beyond the internal supervision and communication structure, the
dissemination of knowledge is integral to the furthering of the disci-
pline of scenography as a whole. The joint PhD programme encouraged
the active participation in the current discipline-based discourse that is

still held predominantly in the field of theatre and performance studies as well as being engaged in its critique and proposing art and design projects for performance and exhibition that articulate transdiscipli- narity, both in method and application. Based on a dynamic working definition of scenography developed by the programme that is widely reflected as an expanded notion of the field, the programme acts as an international network.

Intrinsic to its outreach towards a wide artistic and academic peer group were the programme's yearly public fora and subsequent publications with chapters by PhD candidates, invited academics and artists. Yearly thematic symposia (2007–2011) were curated and steered by the members of the PhD programme. A network of knowledge was thus constructed that consistently employs strategies of transparency, self-organisa- tion and rigorous discourse. This network continues to prove a robust forum for discourse and exchange, and graduates from the programme continue to invite each other to public talks, exhibitions, and publica- tions. A close look at the candidate's career development confirms that promotions (in two cases to professor, in one case to lecturer, in one case to course director) and new responsibilities (in several cases, invitations to join internal research committees) were closely connected to candi- dates' enrolment in the PhD programme.

Case Study: Strategic Scenography – Staging the Landscape of War (Greer Crawley, PhD 2011)

This dissertation by the London scenographer and academic Greer Crawley, concluded in our programme in February 2011, is introduced here as a case study for its transdisciplinary outlook and seamless dialogue between historic research and contemporary artistic, cura- torial and exhibition practice. The material outcome of this dialogue comprised a book and the curatorial and design concept for an exhibi- tion in a specific site. Crawley's PhD dissertation project was concerned with the staging of landscape with scenographic strategies for means of decoy, camouflage and deception during military conflict in Europe and the US in the two World Wars. The practice component of the PhD comprised an exhibition of 'Strategic Scenography', historic and contemporary, for the Imperial War Museum in London. The design for

the planned exhibition is available as drawings and an initial model and follows the structure of the written PhD thesis in terms of thematic foci and in the curating of artists' contributions.

With the research located at the intersection of design, performance and technology, and with a practitioner's insight into each of these areas, Crawley was able to demonstrate the adoption of practices and terminology of the theatre by American, British, French and German military intelligence units and to identify diverse scenographic strategies employed to rehearse and to stage war by means of constructing landscape as a mobile and ever-changing mise en scène. In outlining

Figure 13.3

The PhD Programme Scenography at Vilnius European Capital Symposium. Copyright: Lawrence Wallen (co-author)

the importance of the terrain model for the rehearsal of war and the development of military stratagems, the dissertation further identified the adoption of the (terrain) model and the model box by contemporary visual artists to articulate strategies of manipulation, critique and the construction of both utopian and dystopian alternate realities. During the concept, research and writing phase of the PhD project, Crawley worked closely with five renowned international artists: Gerry Judah, Michael Ashkin, Mariele Neudecker, Hans Op de Beeck and Wafa Hourani. Crawley discussed and presented their works, both in a curatorial capacity and as a dialogical partner in various exhibitions, festivals and conferences, and thus she succeeded in identifying the methods of the scenographer as theatrical artist and creator of spatial narratives in their photographs, installations and video works.

Strategic Scenography considers the 'scenographic' in the *forming* and the *per-forming* of landscape for the purposes of war and provides a reading not from the military historian's point of view, but rather from the perspective of performance, cultural studies and design.

Summary and Outlook

This discussion of the Austrian–Swiss collaborative PhD programme Scenography, active between 2006 and 2012, examines some of the key points and complexities of the canonisation, evaluation and supervision of artistic research at PhD level. In particular, the proven career acceleration and greatly improved academic promotion prospects of graduates of the PhD programme Scenography speak for the relevance of such a thematically clustered and practice-informed, international PhD cohort programme. It was a 'writing from the inside of practice' that the Zurich- and Vienna-based initiators of the programme had hoped to elicit: a writing by practitioners with the explicit aim of revisiting and critiquing existing, conventionalised modes of theoretical reflections on practice.

After six years of active operation, the PhD programme Scenography is at the time of writing in the process of changing one of its partners (Zurich) for a new partner (Sydney), this being a PhD *cotutelle*[1] between the University of Technology, Sydney and the Institute for Theatre, Film

and Media Studies in Vienna. With its geographic reorientation, the programme's thematic orientation will also undergo a shift towards the urban condition and performativity, specifically looking at the design, performance and culture of urban environments.

References

Boud, D. (ed.) (2008) *Changing Practices in Doctoral Education*. London: Routledge.

Brejzek, T. (ed.) (2011) *Expanding Scenography: On the Authoring of Space*. Prague: Prague Quadrennial.

Brejzek, T., Greisenegger, W., & Wallen, L.P. (eds) (2008) *Monitoring Scenography 1: Space and Power*. Zurich: Zurich University of the Arts.

Brejzek, T., Greisenegger, W., & Wallen, L.P. (eds) (2009) *Monitoring Scenography 2: Space and Truth*. Zurich: Zurich University of the Arts.

Brejzek, T., Greisenegger, W., & Wallen, L.P. (eds) (2011) *Monitoring Scenography 3: Space and Desire*. Zurich: Zurich University of the Arts.

Brejzek, T., van der Haegen, G.M., & Wallen, L.P. (2009) Szenografie. In Günzel, S. (ed.), *Raumwissenschaften* (pp. 370–386). Frankfurt a.M.: Suhrkamp Wissenschaft.

Green, B. (2005) Unfinished business: subjectivity and supervision. *Higher Education Research & Development* 24(2), 151–163.

Mersch, D. (2002) *Ereignis und Aura. Untersuchungen zu einer Ästhetik des Performativen*. Frankfurt a.M.: Suhrkamp Edition.

Notes

1 A cotutelle is a joint doctoral degree with supervisors from two international institutions and candidates enrolled at both universities. The cotutelle forms one of the cornerstones of the Bologna process aiming for increased internationalisation, student mobility and knowledge transfer. The cotutelle model originated in France and the name refers to the practice of joint supervision.

Part III

Reflecting:
The Nature of the
Doctoral Thesis –
Researching, Writing,
Thinking

NOW THAT WE'RE DIFFERENT,
WHAT'S STILL THE SAME?

Ken Friedman

One must still have chaos in oneself in order to give birth to a
dancing star.

 (Friedrich Nietzsche 2010/1883, p. 9)

Poets say science takes away from the beauty of the stars – mere
globs of gas atoms. I, too, can see the stars on a desert night and
feel them. But do I see less or more? The vastness of the heavens
stretches my imagination – stuck on this little carousel, my little
eye can catch one-million-year-old light. A vast pattern – of which
I am part... What is the pattern, or the meaning, or the why? It does
not do harm to the mystery to know a little about it. For far more
marvelous is the truth than any artists of the past imagined it.
Why do poets of the present not speak of it? What men are poets
who can speak of Jupiter if he were a man, but if he is an immense
spinning sphere of methane must be silent?

 (Richard Feynman, quoted in Gleick 1993, p. 373)

We're Different, Aren't We?

One of the significant challenges in the university today is the growth of research training and doctoral education, including doctoral education in the creative and performing arts. This development has occasioned many debates – none of them simple. Positions intersect, overlap, concur and contrast. Other chapters in this book describe some of those positions. This chapter will examine a few key issues about the doctorate and doctoral study to ask what aspects of doctoral writing ought to remain the same across all fields.

There may be extensive debate about the various models of PhD, from traditional, to professional, to practice-based (Friedman 2000, p. 371; Durling, Friedman and Gutherson 2002, p. 11) but this chapter will not examine these issues directly. Nevertheless, they bear decisively on the topic of this book: doctoral writing in the creative and performing arts and in design, particularly by doctoral students who practise in the fields they research. The goal of this chapter is to ask what aspects of doctoral writing should remain common across all doctoral fields. To open the inquiry, I begin with a brief review of differences in doctoral education around the world. I then consider what is distinctive – or not – about research in creative fields. Finally, I focus on the core research skills which doctoral students and their supervisors must master to succeed in academic life.

While authors sometimes argue that different types of doctorates reflect differences in field (sciences vs the arts, for example), the degrees of variety and difference are not always as significant as authors believe. The attempt to find new and appropriate ways to bring the author's voice and experience to bear on doctoral research has a long and distinguished history.

When Søren Kierkegaard completed his thesis at the University of Copenhagen in 1841, he was required to request permission directly from the king to write in Danish (Poole 1993, p. 3; Capel 1968, p. 9). At that time, Danish universities required students to write all theses in Latin. Kierkegaard's (1968/1841) thesis on the concept of irony with reference to Socrates made rich use of puns, jokes and irony in Danish. Kierkegaard

argued that he could not fully develop these concepts in academic Latin. The king gave Kierkegaard permission to write in Danish, though he was still required to conduct his seven-hour oral defence in Latin. He did this successfully (Capel 1968, p. 9). While this was Kierkegaard's master's thesis, the master's degree at the University of Copenhagen in 1841 resembled the modern PhD, while the doctorate was the far more extensive DrPhilos. This was only the second thesis for which the king gave royal permission to write in Danish, and the nature and tone of the thesis created extraordinary controversy (Capel 1968, pp. 8–15).

Similar debates about tone and voice have erupted in nearly every field over the past thirty years of our own era. Karl Weick considered the topic in organisation theory and management studies, writing:

> We seem to be in the midst of an active shakeout. What makes this period feel senseless is that half of the players are just beginning to grasp the messages of postmodernism, while the other half – those more partial to postmodernism – are saying, essentially, "Look, it was a necessary episode of disruption, get over it, get on with it, write differently".
>
> (Weick 1999, p. 797)

We have not quite reached this point in doctoral work in the creative and performing arts, or in design. Many chapters in this volume point to the postmodern, or subjective, voice in doctoral writing in the creative and performing arts, but it is the case that the traditional, 'academic' voice remains a key part of the project (see in this volume, for example, Hamilton on polyvocality or Ravelli et al. on diversity). Whatever the 'voice', there is an evident knowledge gap in preparation for PhDs in the creative and performing arts, and in design, due in large part to the relatively recent entry of these disciplines to the university. Relatively few of our doctoral supervisors have had a PhD until recently, and those who did often undertook their doctoral studies with professors who did not themselves have a PhD. Universities appointed many professors of practice without research experience, and only later asked them to take on these responsibilities. A great deal of the knowledge of research skills, research methods and research methodology that doctoral supervisors pass on to their students involves tacit knowledge, knowledge embodied in a traditional master–apprentice relation.

Scandinavian universities acknowledge this, for example, with a colloquial rule of thumb that a professor should have done research to the equivalent of two strong PhD degrees to earn promotion from the rank of associate professor to full professor. In Anglo-American universities, there was once a common motto, "It takes a doctor to make a doctor." This was a way of saying that the skill and experience gained in earning a PhD equips a person to do the work of expert supervision. These traditions never existed for doctoral work in the creative and performing arts or design.

Along with this gap, comes a second gap in knowledge and experience. This is a broader awareness of intellectual issues across the disciplines, ranging from philosophy and the humanities to comparative research methodology and philosophy of science. Here, there is also a major gap between the early specialisation of the Anglo-Australian and Bologna systems and the work required for a PhD at a class-one North American research university. In the UK, Australia and Bologna system, students take a three-year subject degree followed by a subject-specific master's or – in Australia – a one-year honours program. The PhD is a three-year degree program with possibilities for extended work at some universities, but UK and Australian universities generally forbid formal coursework in the PhD program. As a result, students in the creative and performing arts and design move from studio or professional practice degree work or the bachelor's degree to deeper and more extensive practice at the master's level. Then, they move on to a PhD without the kinds of training a comparable student would have had in North America. More challenging yet, these students often arrive in a doctoral program with little or no experience in writing, and none of the basic courses in research skills that precede using research methods.

The contrast with PhD work in a research-intensive North American university is dramatic. These are the universities classified by the Carnegie Foundation as "RU/VH", "RU/H" and "DRU" – Research University/Very High Research Activity, Research University/High Research Activity and Doctoral Research University.

To gain admission to a doctoral program in the United States or Canada, students must first hold a bachelor's degree and generally a master's degree

in the doctoral discipline. This already sets a clear standard. Earning a bachelor's degree at nearly all North American universities and colleges requires that students take both discipline-specific courses and a broad sequence of courses in general studies. This means that students headed into physics take history and art, musicians take math and psychology, historians study science and literature. Everyone, regardless of their own field, will study across other fields on the premise that an educated citizen requires broad knowledge as well as deep knowledge. Along the way, students learn to write, and they learn to understand how scholars and researchers in their discipline field think. The master's degree that follows is a one- or two-year program of subject courses and a research thesis.

In nearly all subjects across all systems, the PhD program is a research-training program. The program culminates in a thesis representing an original contribution to the knowledge of the field. What differs from system to system and sometimes from subject to subject is the prepara-tory work for admission to a PhD program. PhD programs in the US typically require coursework to ensure that a PhD candidate knows his or her field before he or she advances to research candidacy. PhD coursework always includes subject courses, as well as research methods courses and courses in comparative research methodology. It often includes breadth courses for appropriate skills and knowledge from related fields. Many universities assess incoming doctoral students, requiring specific coursework where skills and knowledge are lacking. Most universities have a language requirement, where students must demonstrate an ability to work in one, two or even three languages in addition to their native language or university working language. Before advancing to candidacy, students at most US universities take a series of comprehensive exams. Only after passing the examinations do students advance to candidacy and present a thesis topic.

The differences between the North American and Bologna systems are massive. In the North American system, PhD students typically spend several years in coursework and research methods training before advancing to candidacy. At this point, they know enough about the field and about research to propose a thesis subject and do the research. The North American PhD typically lasts from four to seven years, with five or six years as a common average.

In the Bologna system and the Anglo-Australian system, the PhD lasts three years. In Australia, students propose their research before gaining acceptance. In the Anglo-Australian system and the Bologna system, this is not as great a problem in the sciences, engineering and technology as it is in the humanities. These students typically work in laboratories where much of the work is done in teams under the supervision of an experienced senior researcher. These students still have the benefit of the master–apprentice supervisor relationship, and this makes up for some of the gaps in the system. The case is different in the humanities and in the creative and performing arts and design. The lack of development, mentoring and fundamental skills is often visible in problematic thesis work and later career difficulties with respect to research.

The time dedicated to a task involves practice, experience and mastery. The opportunity to study, learn research skills and methods, and develop the habits of mind required for successful research deepens and ripens with time and expert guidance. All told, a PhD at a good North American university requires an average of nine to 12 years from starting at university through bachelor's, master's and doctoral degrees. The new norms governing the Bologna model and the Anglo-Australian model average between seven and eight years. The extra years and the skills that students acquire during those years make a huge difference.

But these figures on total time from entering university to completing a PhD hide a more serious problem with respect to the PhD in creative and performing arts and design. When comparing the two systems, the North American general education requirement makes an immediately visible difference. Everyone earning a PhD in this system will have a significant amount of work and practice in analysis, logic, rhetoric, writing and some research skills, together with a broad range of subject knowledge across domains, by the time they have completed the five or six years leading to the master's degree. The additional four to seven years build on this foundation.

The 3+2 system in the Bologna model generally focuses on subject-field knowledge and skill. In creative and performing arts and design, this means five years of intensive work in the creative and performing arts and design. Some programs involve a modicum of reading and writing

in the history of the discipline and possibly some work involving writing, typically for personal journals, reflective practice programs or opinion essays. Nearly none of the 3+2 programs in creative and performing arts and design involves analysis, logic, rhetoric, writing and research skills. The demand for subject-field knowledge required by professors and masters of professional practice nearly always leads to a curriculum emphasising the courses that professors and master teachers would have taught in the professional academies of the past. Even fewer 3+2 programs require a broad range of subject knowledge across domains outside the subject discipline.

In Australia, the honours degree system is somewhat different. It often involves a year of analysis, logic, rhetoric, writing and research skills deemed important to prepare a student for PhD work, but one year does not allow time for breadth studies. Neither the 3+2 system nor the honours degree offers the broad and deep foundation of four years in a general education system followed by a research master's of one or two years. The gap in preparation and research capacity grows wider still comparing the difference between two kinds of PhD program. The four to seven years of a North American PhD program offers research skills courses, methods training and an appropriate range of preparation, advanced discipline courses, language work and support courses over the course of a typical degree program. The three years of a PhD program with no coursework offers none of this. In the natural and social sciences and some of the humanities, the undergraduate 3+2 foundation or the honours degree together with skilled supervision and induction into a research field make a significant difference. This is especially the case in the laboratory sciences, where doctoral students work together with a cohort of colleagues. In the creative and performing arts and design, however, the fact that work in cohorts tends to focus on practice means that even cohort training does not typically improve research skills or research outcomes.

The problem becomes worse for doctoral students in the creative and performing arts and design when the Bologna system or English-language universities outside North America take PhD students for doctoral work in a language different to that of their bachelor's and master's degrees. These programs ask students to do advanced research

work and writing in a new language when they have not generally done extensive writing even in their own language. A common practice in North American PhD programs avoids this by using individual assessment to fill knowledge gaps and skills gaps through prescriptive remedies. This requires time and it entails program costs. With many education systems adopting the three-year PhD model, many systems reward universities for every student that graduates within three years while penalising universities for those that fail to meet the three-year norm. The result is an increasing number of PhD awards to students whose work demonstrates problems – occasionally severe problems.

The lack of breadth and the failure to develop an awareness of multiple domains leads to another gap. This is a failure to understand the deep and subtle work taking place in other fields, and the reflective creativity of the people who do that work. Researchers in the creative and performing arts and design often describe the sciences as uniform, abstract and objective. They often describe scientists as positivist without genuinely understanding what the word means, and they describe scientists as lacking in creativity, reflection and psychological awareness because they do not study or read the work that scientists undertake. The creative arts do not possess a monopoly on creativity; indeed, creativity can take many forms and is an intrinsic component of every field, not the least because creativity can encompass both radical innovation and incremental innovation (see Dewar and Dutton 1986; Ettlie, Bridges and O'Keefe 1984; Nord and Tucker 1987).

There are many kinds of creativity – at least as many as the many kinds of intelligence that Howard Gardner (2004; 2009, pp. 77–102) describes. Those who wish to understand the nature of creativity more deeply should read Kaufman and Sternberg (2010) or Gardner (2009, pp. 77–102). My point here is that creativity is not only the province of the creative and performing arts. Rather, society ascribes the property 'creativity' to the arts, to architecture and design as well as to those fields sometimes labelled as creative industries. These fields emblematise the qualities and properties of creativity for the societies they serve. It does not follow from this that the individuals in these fields are in fact more creative than individuals in other fields. Instead, creativity is a human quality that we find among the best practitioners of

most professions. We see creativity distributed in fairly equal proportions across all fields.

Are those of us in the creative and performing arts and design different from those in other fields? Yes. But how different are we? Our traditions differ, our media differ, the things we do and the ways we behave generally differ from the norms found in other fields – much as theoretical physicists differ from theologians, chefs from politicians, and cellists from mechanics.

Nevertheless, we're not as different as we'd like to think. As we become more confident in our research, we will begin to understand just how much we can use from other fields, and how we can use it. Now that we're different, how are we the same?

Research Training, Research Skills, Research Methods

This chapter is addressed to those who hope to develop research skills for work within the academy. The PhD degree is a training program that teaches people to do research. It is for these people that doctoral education bears similarities to doctoral training in other fields.

Research is a way of asking questions. All forms of research ask questions, basic, applied and clinical. The different forms and levels of research ask questions in different ways.

One of the problems in understanding research in the creative and performing arts and in design emerges specifically from this distinction. Creative and performing practitioners are always involved in some form of research, but practice itself is not necessarily research. While many have heard the term 'reflective practice', reflective practice is not research, either, and reflective practice is not a research method. (Admittedly, some of the other authors in this volume may disagree.)

What distinguishes research from reflection? Both involve thinking. Both seek to render the unknown explicit. Reflection, however, develops engaged knowledge from individual and group experience. It is a personal act or a community act, and it is an existential act. Reflection

engages the felt, personal world of the individual. It is part of the learning process (Friedman and Olaisen 1999; Kolb 1984). Reflection arises from and addresses the experience of the individual as a single person or individuals in groups.

Research, in contrast, addresses a question in the world or in the mind. This question is distinct from the personal or communal. In some cases, the issues raised by reflective practice may become the subject of research. This includes forms of participant research or action research by those who engage in reflection that becomes the data. But research also addresses questions beyond or outside the researcher.

Research asks questions in a systematic way. The systems vary by field and purpose. There are many long-established research fields: hermeneutics, statistics, mathematics, physics, history, sociology, ethnography, ethnology, biology, medicine, chemistry, geography, law, philosophy and others. They draw on many methods and traditions. Each has its own foundations and values. All involve some form of systematic inquiry, and all involve formal theorising and inquiry beyond the specific research process at hand.

Comparing two distinct research streams focused on design practice will shed light on some of these issues. The first of these streams is the design research program of Henry Petroski (1992, 1994a, 1994b, 1996, 1997, 2008, 2012) which studies design failures, the role of failure in moving toward success, and the relationship between the different aspects of the design process.

Systemic understanding – understanding the systemic nature of an artefact or process in its full setting – is among the key elements in successful design and design research. This works together with the ability to render tacit learning explicit for analysis and improvement. These factors are also involved in organisational learning and reflective practice (see Argyris 1977, 1990, 1991, 1992; Argyris and Schön 1974, 1978, 1996; Schön 1983, 1987; Senge 1990; Senge et al. 1994, 1999). This, in turn, led to the new work on presence (Scharmer and Kaufer 2013; Scharmer 2008; Senge et al. 2004).

Petroski engages in research on the elements of successful design practice. So do Argyris, Schön, and Senge. Reflective practice is a technique that builds successful practice. It is not a form of research into practice.

However, the second research stream of Argyris and others does involve a range of research techniques linked to reflective practice. Argyris, Putnam and Smith (1985) describe this in their book on action science, a presentation of concepts, methods and skills for research and intervention. Argyris and Schön (1990) later contrasted normal science with action science. More recently, Argyris (1993) wrote on ways to apply the findings of action science to practising professional life, closing the circle in a continuous loop between theory and practice.

What is significant, however, is that neither creative practice nor reflective practice is itself a research method. Instead, reflective practice is one of an array of conceptual tools used in understanding any practice. It can also be applied to the practice of research.

What distinguishes research from other activities is what Mario Bunge (1999, p. 251) describes as the "methodical search for knowledge". Original research, he continues, "tackles new problems or checks previous findings. Rigorous research is the mark of science, technology, and the 'living' branches of the humanities." Synonyms for research include exploration, investigation and inquiry.

There is room in academic life for all of us. Our responsibility is being clear and doing well at what we do. One of our key tasks is to address the issues and skills that all research fields share in some essential way.

The PhD as a Licence to Teach

At this point, it is time to examine what it is that distinguishes the PhD – the research doctorate – from other kinds of doctorate. What is the value of a traditional PhD as distinct from other kinds of doctorate?

The PhD degree has several specific purposes which distinguish it from other kinds of doctorate. It is primarily a research degree and a licence for those who practise and teach research.

The special role of the PhD as a teaching licence determines several aspects of the criteria for a PhD, and covers several kinds of teaching. First, it demonstrates the expertise of the graduated doctor to teach the content of a specific subject field. Second, it demonstrates the expertise of the graduated doctor to teach the research methods of that field. Third, it demonstrates the ability of the graduated doctor to conduct independent research. Fourth, it demonstrates the ability of the graduated doctor to supervise research students and train researchers.

Each of these key purposes determines central criteria for the PhD. The role of the PhD as a licence to teach research methods and train research students involves criteria for the PhD that may serve no purpose in any other research project. Those who earn a PhD must demonstrate specific skills to earn the degree even though they may never use these skills again in their own research. Rather, they require these skills for their future students.

Long ago, I spent two weeks with a master chef who prepared magnificent meals for a conference while he ate tuna sandwiches. When I asked him why, he told me that cooking was an art form, but he did not want to eat food after working with it all day. He said that he tasted most recipes twice: first, when another chef taught him to cook it so that he would know how it should taste; second, when he prepared it to make sure that it tasted the same way. He had the equivalent of a photographic memory for tastes, and tasting was a tool in his work.

Some of the skills that graduate students develop to earn a PhD are like the recipes in a chef's repertoire. They master them in order to cook them for students. They may never eat them again.

The point is that PhD supervisors who cannot work with these skills are not properly prepared to teach research methods or to train research students. As research teachers and supervisors, their own research interests and needs come second to the needs of their students.

As long as the PhD is a licence to teach and supervise, the PhD has specific criteria that may involve none of the research that those who

supervise do for their own work. These conditions establish the criteria for earning a PhD.

Since a PhD is a research degree, the candidate must demonstrate that he or she is prepared to undertake and complete unsupervised research. The student does this by demonstrating the ability to make an original contribution to the knowledge of the field. Because the PhD is a licence to teach and supervise research, the candidate must demonstrate research skills that will eventually qualify her or him to teach research methods and research methodology before moving on to teach and supervise research students.

This entails many skills. Gordon Rugg and Marian Petre (2004, pp. 6–7) offer a useful partial list of skills in their excellent book on earning the PhD:

> [Use of academic language:] correct use of technical terms; attention to detail in punctuation, grammar, etc.; attention to use of typographic design... to make the text accessible; ability to structure and convey a clear and coherent argument, including attention to the use of 'signposting' devices such as headings to make the structure accessible; writing in a suitable academic 'voice'; [Knowledge of background literature:] seminal texts correctly cited, with evidence that you have read them and evaluated them critically; references accurate, reflecting the growth of the literature from the seminal texts to the present day; identification of key recent texts on which your own PhD is based, showing both how these contribute to your thesis and how your thesis is different from them; relevant texts and concepts from other disciplines cited; organisation of all of the cited literature into a coherent, critical structure, showing both that you can make sense of the literature – identifying conceptual relationships and themes, recognising gaps – and that you understand what is important; [Research methods:] knowledge of the main research methods used in your discipline, including data collection, record keeping, and data analysis; knowledge of what constitutes 'evidence' in your disciplines, and of what is acceptable as a knowledge claim; detailed knowledge – and competent application of – at least one method; critical analysis of one of the standard methods in your discipline showing that you understand both its strengths and its

limitations; [Theory:] understanding of key theoretical strands and theoretical concepts in your discipline; understanding how theory shapes your research question; ability to contribute something useful to the theoretical debate in your area; [Miscellaneous:] ability to do all the above yourself, rather than simply doing what your supervisor tells you; awareness of where your work fits in relation to the discipline, and what it contributes to the discipline; mature overview of the discipline.

While other chapters in this volume argue that such traditional academic skills are not the only skills that characterise a successful doctorate in the creative and performing arts and design, it is nevertheless the case that these fundamental skills still underpin the core of the enterprise. A PhD candidate who cannot demonstrate these skills cannot teach and supervise research students. It is likely that he or she cannot conduct research either. Demonstrating these skills therefore establishes the basis for awarding or denying the PhD.

So what remains the same, and how do we build it? Given the lack of deeply rooted master–apprentice skills for the practice of research, we face understandable problems in building a research culture for the creative and performing arts and the design fields. These are new research fields, in contrast to fields with research cultures that go back through decades or even centuries of development. Some research fields, such as mathematics, rhetoric and philosophy, date back several thousand years.

Human beings construct and shape cultures through behaviour and by encouraging specific forms of behaviour. In apprentice programs, modelling and adopting behaviours creates tacit knowledge (see Ravelli et al. in this volume for further discussion). Effective apprentice programs require an environment well populated by skilled journeymen and masters. As this chapter already describes, there is typically a significant gap in cultural knowledge in the creative and performing arts and design for institutional and historical reasons, a gap which hampers further development.

One way to improve the situation is by providing research students with skills and information, and giving them courses that allow them to practise the skills they study.

Today, we are fortunate to have a growing literature of resources to help individuals and schools to solve these general problems. This growing literature outlines and explains the craft, guidelines and traditions of research. These books can help to teach and develop good research habits, habits of mind and habits of behaviour. These resources can help us to shape a research culture. These are not books on research methodology, methods or technique. These books address the larger habits of mind within which specific research acts take place.

The Craft of Research by Wayne Booth, Gregory Colomb and Joseph Williams (2008) is a central volume in the series of books on different aspects of the profession and practice of research. It is a superb introduction to research issues.

Supervising the PhD by Sara Delamont, Paul Atkinson and Odette Parry (1997) covers the issues and skills of research supervision. The skill of tutoring and supervising research is even more difficult to acquire than the skill of doing research. In theory, studying for a PhD should help the doctoral student to develop research skills. No degree programs or general courses train research supervisors. Greater attention to supervising research students means that this literature is an important contribution. This book is one of the first and still one of the few that helps supervisors, whatever field they work in.

Getting What You Came For by Robert Peters (1997) and *The Unwritten Rules of PhD Research* by Gordon Rugg and Marian Petre (2004) are useful and well-structured guides to general research issues and skills, as well as providing useful information on surviving and thriving as a doctoral student. I recommend these books to students and to their supervisors. Several dozen books offer advice on earning a research degree. Most are pedestrian and some are uninformative. A great many bad books mislead students who do not know enough to ignore incorrect information and problematic assertions. Peters (1997) and Rugg and Petre (2004) are filled with useful advice and well worth reading.

One common gap in doctoral education involves helping research students prepare for the transition from study to an active research

career. Two books are particularly helpful. Robert Sternberg (2004) wrote *Psychology 101½* for psychologists and psychology researchers, but the career advice covers all fields. While Peter Feibelman's (1993) *A Ph.D. Is Not Enough!* is written for the sciences, it offers ideas that every scholar can use.

This body of knowledge summarises the experience that a solid, first-rate supervisor would have shared with doctoral students in years gone by. Doctoral supervisors did not always transfer this body of knowledge, but the expectation was that they should do so. The ideal doctoral supervisor had several linked roles and responsibilities. One was tutoring, training the beginner researcher in the craft of research. One was advising, ensuring that the student's thesis was at a standard for successful completion. One was mentoring, preparing doctoral students for a successful academic career. Subject-discipline expertise was a necessary platform for expert doctoral supervision, but it was never sufficient. Good supervisors who take all three responsibilities seriously continually seek ways to improve their supervision skills.

The problem in doctoral education for the creative and performing arts and design is that we have many well-intentioned supervisors with deficiencies of which they are not aware. They do not know that they lack the knowledge, skill and experience to fill the three roles of tutor, advisor and mentor adequately. The shift to mass education in doctorates combined with doctoral awards in fields that lack a sufficient number of well-prepared supervisors means that supervisors and doctoral students alike must work to develop the skills they need. The sequence of books in this section forms the background to a sequence of materials on effective doctoral writing.

This group of books shares information that is the same for doctoral education in the creative and performing arts and design as it is for other fields. What comes next are the skills and knowledge that supervisors and their students need as the background for a solid thesis – and the foundation of a successful career marked by outstanding publications.

Writing for the Doctorate – Information for Supervisors and Doctoral Students

Understanding what a doctorate is and what it involves is a necessary foundation for understanding why research and writing skills matter. The broad, general background explains why these skills are important. These materials present the skills. Much of the material in this section is available on the World Wide Web at no cost.

Good writing is the foundation of good scholarly writing for the PhD thesis and research publishing. There are many style guides and manuals on writing. The best and most useful among these is one of the shortest and most direct. This is *The Elements of Style* by William Strunk and E.B. White (1999/1918). Commonly called Strunk and White, it remains the classic guide to writing good English prose. This short, 105-page volume offers clear, simple advice on how to master clear narrative. (While the fourth edition is well organised and particularly useful, the Bartleby. com website offers the first edition (Strunk 1918) at no cost.)

Over many years, I have developed a workshop to review and summarise the essentials of research writing. In full form, it serves as a hands-on workshop with opportunities to review, edit and actively develop examples of student work. There is also a stand-alone summary lecture to review and discuss the main issues in about three hours. This is available on the web in PDF format with slides for lectures by supervisors or student workshop leaders, and as handouts for those who wish to read the material (Friedman 2013). This workshop reviews the key elements of research and research writing, offering advice on how to write with a checklist of what to include in a research article or a research paper.

Research writing for those PhD students who complete their degree to move on to a career in research is inevitably linked to presenting papers. Conferences and seminars are central to sharing research and becoming visible as a researcher. PhD programs increasingly encourage students to present and publish conference papers as part of the degree program, and some now require it. During the PhD program or afterward those who master presentation skills stand out, and learning to present well

is now a vital aspect of doctoral writing. Conferences and seminars are central for sharing research and for becoming visible in a research field, and they are a crucial mechanism for the visibility that leads to jobs at the start of a research career.

As with other aspects of research training and research writing, there is now a host of books on how to present. The best of many books on this topic is Robert Anholt's (2005) *Dazzle 'Em with Style: The Art of Oral Scientific Presentation*. Anholt is a professor at Duke University Medical Center and has made an art of helping researchers succeed in conference and seminar presentations. While Anholt wrote this solid, concise book for the natural sciences, it offers valuable advice for presentations in any research field. Doctoral students in the creative and performing arts and design will benefit from Anholt's thorough foundation.

A few years back, I developed a short, free guide to presenting papers for the International Association of Societies for Design Research, specifically for researchers and doctoral students in design. It is available on the web (Friedman 2008). While Anholt is deeper and more comprehensive, this is more concise, it is free and it has links to a rich selection of additional free web resources.

Finally comes the issue of writing for journals, the central medium of research communication. Two excellent books address the craft of scholarly publishing. Robert Sternberg's (2000) *Guide to Publishing in Psychology Journals* is the most useful among many guides to writing journal articles. Sternberg and a group of experienced authors and editors tell aspiring research authors what they most need to know about planning, writing, placing and revising an outstanding journal article. While the authors focus on psychology journals, the chapters cover the key issues needed for articles in any research field. Franklin Silverman's (1999) *Publishing for Tenure and Beyond* discusses the relation of publishing to career development, offering important advice on conceptualising and preparing a publishing strategy.

Here, too, doctoral students and their supervisors can find useful free guides and writing resources. Several publishers offer useful guides on topics from impact and writing effectively to getting published and

disseminating the work. Elsevier and Emerald offer a particularly useful range of guides and resources. These materials are so extensive that it is important to spend time browsing and searching to locate everything on any given publisher's website. The time this takes will pay.

My own heuristic device for good writing is simple. Those doctoral students who read widely, read deeply and read carefully build the foundation for a successful research career. They take careful, precise notes and they use the information, ideas and concepts on which they draw to develop careful and robust argumentation for their own work. The heuristic – my rule of thumb for the systematic writing activity that builds the strongest foundation for a research career – is building references carefully, using them precisely, and always citing their precise location in the source text.

There are objections to this approach. One takes the form of a question: "Isn't this what people do in all those other fields of research, scholarship, and science?" The answer to that question is, "Yes. Absolutely." Now that we are different, this is what's the same when it comes to writing up our research.

The other objection is the idea of an exception to careful citation for paraphrase material. Paraphrase occurs where a researcher rephrases the ideas of a source document in his or her own words, using ideas from other writers while changing the words.

This is no longer an exception to the rules of quotation. Many researchers now refer to paraphrasing as 'indirect quotation'. The same standards apply to all forms of quote, direct and indirect (Slade 2003, pp. 55–61; Smith 2000, p. 154). The APA style guide now requires locating all quoted passages to the exact page in the source document. Paraphrases and indirect quotes should be located precisely – the APA style guide now encourages this (APA 2009, sections 6.03 and 6.04, pp. 170–171). When I edit and supervise, I request this because of the simple fact that authors who source their materials precisely typically read them more carefully, understand them better and use them more effectively than those who do not. When I wish to know more as a reader, I can find it more easily.

This change in style takes place against the major shift affecting all research fields in the global knowledge economy and the information age. The amount of information in our era has grown exponentially. Researchers and scholars draw on increased amounts of information, and nearly no-one in any active research field can now master the information in his or her own field. The explosion of transdisciplinary scholarship means that people often draw on research from fields outside their own.

This changes the ethics and requirements of quotation for three reasons. First, it is no longer possible to assume that all researchers in any field will have detailed knowledge of all or even many of the important source documents that everyone was once expected to know when each field was smaller. Second, it is vital to allow readers to learn more about what any source document says on a specific point – and the author must allow readers to learn more without reading the full source document to locate the issue under discussion. Third, an author must allow readers to challenge his or her views, and this is only possible by making the full underlying evidence for any articles transparent and easy to find.

Nevertheless, the most important issue is a fourth point: this discipline requires an author to review and re-read source documents when quoting them either directly or indirectly. This, in turn, helps the author to remember and use the material correctly. It allows the author to deepen his or her knowledge. It often leads an author to see the connections and recall related but possibly forgotten ideas that build and strengthen his or her argument.

One of my professors used to end nearly every lecture by reminding us to read the sources for ourselves, working with them carefully to think the issues through, and drawing carefully on these sources in building our own research. Her motto was, "Be true to your sources and they will be true to you." Over the years, I found this to be a useful tool and discipline in my own work.

The key skills of reference and citation form a simple, effective heuristic device for doctoral writers who want to build a durable career in publishing and research. My students and colleagues occasionally tease

me by referring to them as "Friedman's Ten Commandments", but those who use them publish more than many of their peers, publish in better conferences and journals, and tend to be more widely read and cited:

> Ten Rules of Reference and Citation. 1) Use citations constructively to substantiate the argument of an article. 2) Use citations creatively to advance the argument of an article. 3) The author must argue a case in the explicit narrative of the article. External sources support an argument. External support for an argument cannot replace the argument. Do not confuse the two. 4) Use precise, fine-grained references that permit the reader to locate quoted material at the exact location in the source document. Fine-grained references allow the reader to question and challenge cited sources. 5) Treat direct quotations, indirect quotations, and paraphrases the same way. Give precise references for all quotations and cited sources. 6) Always review and re-read cited passages from referenced sources. This ensures correct quotes and accurate paraphrasing while helping the author to develop the meaning of the source text effectively. It also allows the author to reflect on text surrounding quoted material for added depth and possible use. 7) Never use second-hand references from other authors. Always check cited sources first hand. 8) Never use loose or vague references. 9) Each item cited in the text must appear in the reference list. Every item in the reference list must appear in the text. 10) Each source cited in the text requires an appropriate in-text citation and an entry in the reference list. Every entry in the reference list must be complete. All citations and all references must use the same style. All citations and references must be complete and consistent to be correct.
>
> (Friedman 2013)

This takes work. Every doctoral student in the creative and performing arts and the design fields has a professional goal. Mastery takes time: study time, rehearsal time, time to build skills, time to grow and deepen in the art to which each of us may dedicate a life.

Research is also an art, and if we intend to master the skills of research, we must give ourselves to the discipline of research. For the research doctorate, the PhD, this means writing. Of course, many who seek a PhD also recognise that effective writing and powerful argumentation

will also support client proposals, grant applications, job applications, and even the poetic, personal reflection that we sometimes share with students and colleagues.

The goal of this chapter of *Doctoral Writing in the Creative and Performing Arts: the Researcher–Practitioner Nexus* is to help doctoral students and their supervisors achieve these goals. It is important to understand how and why the educational landscape has changed for those who pursue a doctorate in the creative and performing arts or design. These changes have made a huge difference to how we work in universities.

The new landscape creates massive opportunities for those who are willing to master the skills. As Karl Weick (1999, p. 797) says, "get on with it, write differently." And know when to write the same.

Prior Research

This chapter draws on the author's prior published research for the material discussing creativity (Friedman 2010), and for the section on research and reflective practice (Friedman 1997).

References

Anholt, R. (2005) *Dazzle 'Em with Style: The Art of Oral Scientific Presentation*, 2nd edition. Burlington, MA: Elsevier Academic Press.

(APA) American Psychological Association (2009) *The Publication Manual of the American Psychological Association*, 6th Edition. Washington, DC: American Psychological Association.

Argyris, C. (1977) Double-loop learning in organizations. *Harvard Business Review* 55(5), 115–125.

Argyris, C. (1990) *Overcoming Organizational Defenses: Facilitating Organizational Learning*. Boston, MA: Allyn & Bacon.

Argyris, C. (1991) Teaching smart people how to learn. *Harvard Business Review*, May–June, 99–109. Retrieved from: http://hbr.org/1991/05/teaching-smart-people-how-to-learn/.

Argyris, C. (1992) *On Organizational Learning*. Oxford: TJ Press.

Argyris, C. (1993) *Knowledge for Action. A Guide to Overcoming Barriers to Organizational Change*. San Francisco, CA: Jossey-Bass Publishers.

Argyris, C., Putnam, R., & McLain Smith, D. (1985) *Action Science: Concepts, Methods, and Skills for Research and Intervention*. San Francisco, CA: Jossey-Bass Publishers.

Argyris, C., & Schön, D. (1974) *Theory in Practice: Increasing Professional Effectiveness*. San Francisco, CA: Jossey-Bass Publishers.

Argyris, C., & Schön, D. (1978) *Organizational Learning: A Theory of Action Perspective*. Reading, MA: Addison-Wesley Publishing Company.

Argyris, C., & Schön, D. (1990) *Two Conceptions of Causality: The Case of Organizational Theory and Behavior* [Working paper]. Cambridge, MA: Harvard Business School & MIT Department of Urban Planning.

Argyris, C., & Schön, D. (1996) *Organizational Learning II: Theory, Method, and Practice*. Reading, MA: Addison-Wesley Publishing Company.

Booth, W., Colomb, G., & Williams, M. (2008) *The Craft of Research*, 3rd edition. Chicago, IL: University of Chicago Press.

Boyer, E. (1997) *Scholarship Reconsidered: Priorities of the Professoriate*. San Francisco, CA: Jossey-Bass Publishers.

Bunge, M. (1999) *The Dictionary of Philosophy*. Amherst, NY: Prometheus Books.

Byrne, B., & Sands, E. (2002) Designing Collaborative Corporate Cultures. In B. Byrne & S. Squires (eds), *Creating Breakthrough Ideas* (pp. 47–69). Westport, CT: Bergin & Garvey.

Capel, L. (1968) Historical Introduction. In S. Kierkegaard, *The Concept of Irony, with Constant Reference to Socrates*, translated by L. Capel. Bloomington, IN: Indiana University Press.

Colvin, G. (2008) *Talent is Overrated: What Really Separates World-class Performers from Everybody Else*. New York: Portfolio.

Delamont, S., Atkinson, P., & Parry, O. (1997) *Supervising the PhD: A Guide to Success*. Buckingham, UK: The Society for Research into Higher Education & the Open University Press.

Dewar, R., & Dutton, J. (1986) The adoption of radical and incremental innovations: an empirical analysis. *Management Science* 32, 1,422–1,433.

Durling, D., Friedman, K., & Gutherson, P. (2002) Debating the practice-based PhD. *Design Science and Technology* 10(2), 7–18.

Einstein, A. (1998 [1905]) *Einstein's Miraculous Year: Five Papers that Changed the Face of Physics*, edited and introduced by J. Stachel. Princeton, NJ: Princeton University Press.

Ettlie, J., Bridges, W., & O'Keefe, R. (1984) Organization strategy and structural differences for radical versus incremental innovation. *Management Science* 30, 682–695.

Feibelman, P. (1993) *A Ph.D. Is Not Enough! A Guide to Survival in Science*. Reading, MA: Addison-Wesley Publishing Company.

Friedman, K. (1997) Design science and design education. In P. McGrory (ed.), *The Challenge of Complexity* (pp. 54–72). Helsinki: University of Art and Design, Helsinki. Retrieved 21 September 2013, from: http://hdl.handle.net/1959.3/189707.

Friedman, K. (2000) Form and structure of the doctorate in design: prelude to a multilogue. In D. Durling & K. Friedman (eds), *Doctoral Education in Design: Foundations for the Future*. Proceedings of the La Clusaz Conference, 8–12 July 2000 (pp. 369–376). Staffordshire: Staffordshire University Press.

Friedman, K. (2007) Behavioral artifacts. *Artifact* 1(1), 7–11. Retrieved 21 September 2013, from: http://www.tandfonline.com/doi/pdf/10.1080/17493460600610764.

Friedman, K. (2008) Presenting your research. *Design Research Quarterly* 3(1), 8–13. Retrieved 21 September 2013, from: http://swinburne.academia.edu/KenFriedman/Papers.

Friedman, K. (2010) Heuristic reflections on assessing creativity in the design disciplines. In A. Williams, M. Ostwald & H. Haugen Askland (eds), *Creativity, Design and Education: Theories, Positions and Challenges* (pp. 171–180). Sydney, Australia: ALTC Australian Learning and Teaching Council.

Friedman, K. (2013) *Research Writing Workshop: Research Skills and Methods for the PhD*, 2013 edition. Faculty of Design, Swinburne University of Technology. Retrieved 19 September 2013, from: http://swinburne.academia.edu/KenFriedman/Teaching-Documents.

Friedman, K., & Olaisen, J. (1999) Knowledge management. In K. Friedman & J. Olaisen (eds), *Underveis til fremtiden. Kunnskapsledelse i teori og praksis* (pp. 14–29). Bergen-Sandvika: Fagbokforlaget.

Gardner, H. (2004) *Frames of Mind: The Theory of Multiple Intelligences*, Twentieth anniversary edition. New York: Basic Books.

Gardner, H. (2009) *Five Minds for the Future*. Cambridge, MA: Harvard Business School Press.

Gladwell, M. (2008) *Outliers: The Story of Success*. New York: Little, Brown & Company.

Gleick, J. (1993) *Genius: Richard P. Feynman and Modern Physics*. London: Abacus.

Huber, M., & Morreale, S. (eds) (2002) *Disciplinary Styles in the Scholarship of Teaching and Learning: Exploring Common Ground*. Sterling, VA: Stylus Publishing.

Hutchings, P., Huber, M., & Ciccone, A. (2011) *The Scholarship of Teaching and Learning Reconsidered: Institutional Integration and Impact*. San Francisco, CA: Jossey-Bass Publishers.

Kaufman, J., & Sternberg, R. (eds) (2010) *The Cambridge Handbook of Creativity*. Cambridge: Cambridge University Press.

Kaufmann, W. (1974) *Nietzsche: Philosopher, Psychologist, Anti-Christ*. Princeton, NJ: Princeton University Press.

Kierkegaard, S. (1968 [1841]) *The Concept of Irony, with Constant Reference to Socrates*. Translated by L. Capel. Bloomington, IN: Indiana University Press.

Kolb, D. (1984) *Experiential Learning: Experience as the Source of Learning and Development*. Englewood Cliffs, NJ: Prentice Hall.

McKinney, K. & Huber, M. (2013) *The Scholarship of Teaching and Learning in and across the Disciplines*. San Francisco, CA: Jossey-Bass Publishers.

Monroe, J. (2002) *Writing and Revising the Disciplines*. Ithaca, NY: Cornell University Press.

Nietzsche, F. (2010 [1883]) *Thus Spoke Zarathustra*, edited by A. Del Caro & R. Pippin. Cambridge: Cambridge University Press.

Nord, W., & Tucker, S. (1987) *Implementing Routine and Radical Innovations*. Lexington: D.C. Heath & Company, Lexington Books.

Peters, R. (1997) *Getting What You Came For: The Smart Student's Guide to Earning a Master's or Ph.D*. New York: The Noonday Press.

Petroski, H. (1992) *To Engineer is Human: The Role of Failure in Successful Design*. New York: Vintage Books.

Petroski, H. (1994a) *Design Paradigms: Case Histories of Error and Judgment in Engineering*. Cambridge: Cambridge University Press.

Petroski, H. (1994b) *The Evolution of Useful Things*. New York: Vintage Books.

Petroski, H. (1996) *Invention by Design: How Engineers Get from Thought to Thing*. Cambridge, MA: Harvard University Press.

Petroski, H. (1997) *Remaking the World: Adventures in Engineering*. New York: Alfred A. Knopf.

Petroski, H. (2008) *Success through Failure: The Paradox of Design*. Princeton, NJ: Princeton University Press.

Petroski, H. (2012) *To Forgive Design: Understanding Failure*. Cambridge, MA: Belknap Press.

Poole, R. (1993) *Kierkegaard: The Indirect Communication*. Charlottesville, VA: University Press of Virginia.

Rugg, G., & Petre, M. (2004) *The Unwritten Rules of PhD Research*. Maidenhead & New York: Open University Press.

Scharmer, C. (2008) *Theory U: Leading from the Future as it Emerges*. San Francisco, CA: Berrett-Koehler Publishers.

Scharmer, C., & Kaufer, K. (2013) *Leading from the Emerging Future: From Ego-system to Eco-system Economies*. San Francisco, CA: Berrett-Koehler Publishers.

Schön, D. (1983) *The Reflective Practitioner*. New York: Basic Books Inc.

Schön, D. (1987) *Educating the Reflective Practitioner.* San Francisco, CA: Jossey-Bass Publishers.

Schön, D. (1991) *The Reflective Turn: Case Studies in and on Educational Practice.* New York: Teachers College Press.

Senge, P. (1990) *The Fifth Discipline: The Art and Practice of the Learning Organization.* London: Century Business.

Senge, P. (1999) Creative tension. *Executive Excellence* 16 (1), 12–13.

Senge, P., Roberts, C., Ross, R., Smith, B., & Kleiner, A. (1994) *The Fifth Discipline Fieldbook.* London: Nicholas Brealey Publishing.

Senge, P., Kleiner, A., Roberts, C., Ross, R., Roth, G., & Smith, B. (1999) *The Dance of Change: The Challenges of Sustaining Momentum in Learning Organizations.* London: Nicholas Brealey Publishing.

Senge, P., Otto Scharmer, C., Jaworski, J., & Flowers, B. (2004) *Presence: Human Purpose and the Field of the Future.* Cambridge, MA: SoL Press.

Silverman, F. (1999) *Publishing for Tenure and Beyond.* Westport, CT: Praeger.

Slade, C. (2003) *Form and Style: Research Papers, Reports, Theses,* 12th edition.

Smith, R. (2000) Documenting your scholarship: citations and references. In R. Sternberg (ed.), *Guide to Publishing in Psychology Journals* (pp. 146–157). Cambridge: Cambridge University Press.

Stachel, J. (1998) Einstein on Brownian Motion. In A. Einstein, *Einstein's Miraculous Year: Five Papers that Changed the Face of Physics,* edited and introduced by John Stachel (pp. 73–84). Princeton, NJ: Princeton University Press.

Sternberg, R. (2000) *Guide to Publishing in Psychology Journals.* Cambridge: Cambridge University Press.

Sternberg, R. (2004) *Psychology 101½: The Unspoken Rules for Success in Academia.* Washington, DC: American Psychological Association.

Strunk, W. (1999 [1918]) *The Elements of Style.* New York: Bartleby. Retrieved 21 September 2013, from: http://www.bartleby.com/141/.

Strunk, W., & White, E. (1999 [1918]) *The Elements of Style,* 4th edition. Harlow, Essex: Longman Publishing.

Syed, M. (2010) *Bounce: Mozart, Federer, Picasso, Beckham, and the Science of Success.* New York: Harper.

Weick, K. (1999) Theory construction as disciplined reflexivity: Tradeoffs in the '90s. *Academy of Management Review* 24(4), 797–805.

DOCTORAL RESEARCH THROUGH MUSIC PERFORMANCE: THE ROLE OF THE EXEGESIS

Anne-Marie Forbes

Background

Doctoral research in Australia in the discipline of music has been well-established for decades through the doctor of philosophy (PhD) programs in musicology, ethnomusicology and music education. The extension of doctoral research to include endeavours in the creative and performative aspects of music is a more recent phenomenon and was in the first instance, at most universities, limited to music composition. Although in the United States the doctor of musical arts (DMA) or doctor of music (DMus) degrees had provided a terminal degree in music for performers since the 1950s, there was considerable resistance to developing similar practical graduate research programs in Australia. But from the 1990s, there was growing pressure for the acceptance of music performance into the fold of graduate research, and there are now a range of doctoral programs in music and the creative arts available through Australian universities that offer the possibility

of undertaking doctoral-level study in music performance. These programs provide multiple configurations of the relationship between research and musical performance, as is reflected in markedly diverse requirements during candidature and in the examination processes. Critical to the acceptance of music performance into the hallowed halls of graduate research were arguments pertaining to ways in which performance could indeed constitute research, and at issue were wider concerns about the academic rigour of such an enterprise. Even before the programs were established, the importance of a written component to elucidate the research embodied by a folio of musical performances was foregrounded in these debates.

The research paradigm of the PhD pursued through music performance in Australia was initially modelled on the PhD in fine arts, with its examinable outcomes of a folio of creative works, a doctoral exhibition and an accompanying exegesis or critical commentary. The University of Tasmania (UTAS) was in the forefront of this development over fifteen years ago, and staff at the UTAS Conservatorium of Music[1] were inspired by the arguments that were being advanced by the UTAS School of Art to pursue PhD programs in performance and composition. The fine arts model had some obvious translatable synergies for the development of a doctorate in music performance: the folio could consist of recordings of concert performances made during candidature, the doctoral exhibition could be replaced by a doctoral recital, and the exegesis would perform a similar role in providing a critical explanation of the research content of the submission. The nomenclature of exegesis was retained from that used in the PhD (Fine Arts) model, but even though the UTAS PhD in music performance was the model and inspiration for other music performance doctoral programs around the country, the same terminology is used by relatively few other institutions (such as the University of Adelaide). While Australian universities have generally embraced the terminology of thesis over dissertation, the parallel Greek term, exegesis, for this shorter document contextualising and interpreting a creative artefact, has often been rejected out of hand (Webb, Brien & Burr 2012). The reasons for this are unclear, other than the lack of familiarity of the term and its established association with Biblical scholarship. In other institutions the written component of a doctoral music performance program may be referred to as a thesis

(Sydney Conservatorium of Music 2013; University of Western Australia 2013), while at the University of Melbourne it is referred to as a dissertation (*Melbourne Conservatorium of Music: Graduate Programs* 2013) and at Monash University it is designated as a critical commentary (Monash University 2013).

Essentially, the growing acceptance of the notion of a PhD in fine arts and of practice-led research (Kroll 2008) in other disciplines, as well as the precedent of PhD programs in music composition at other institutions, eased the path for the newcomer. Music performance, however, remained a controversial inclusion for some time. Even a decade after its inception, as the Graduate Research Co-ordinator in Music I was continuing to field questions within the academy, and from the more scientifically oriented members of university committees, as to the nature and even validity of research conducted through the creative and re-creative processes of music performance, and what might constitute appropriate examinable outcomes and standards for a PhD in music performance.

Irrespective of discipline, the understanding of the PhD in the Australian context is that it is a research degree which has the general aim of developing new knowledge and making an original contribution to the field of endeavour, as well as attainment of "a substantial body of knowledge" in the frontier of a discipline and research training in appropriate methodologies (*Australian Qualifications Framework* 2013, p. 64). The specific acknowledgement of the role of the PhD in the generation of new knowledge in "professional practice" (*Australian Qualifications Framework* 2013, p. 18) provides recognition for alternative models and methodologies pertinent to research higher degrees in the creative arts, yet the onus remains on candidates to produce a PhD submission of both creative and intellectual rigour from the viewpoint of practitioners and academics.

Absolutely central to the arguments for the research content and validity of the PhD pursued through music performance has been the written component or exegesis that forms part of the final submission with the folio of recorded concert performances completed during the course of candidature. In the examination process used at the University of

Tasmania, this document is provided to the examiners with the folio prior to their attendance at the final doctoral recital. Reading the exegesis first allows examiners to view the final recital from the contextual perspective of a research project that has been conducted over a period of years, and in several phases as represented by the recordings in the folio. The final recital is perceived then not just as the culmination of study, but as a research outcome.

This chapter will extend scholarship specific to the role of the exegesis (Beilharz n.d.) in the creative arts and will argue for the critical importance of the exegesis in clarifying the research intent and enabling the differentiation of professional practice from performative research (Haseman 2006) or practice-led research within the context of a doctorate in music performance. It will also examine strategies for communicating an appropriate research methodology and trajectory to candidates and performance tutors and, drawing on over a decade of experience with examiners, will outline the attributes of the successful PhD exegesis for a music performance doctoral submission.

Research through Music Performance

Research conducted through the medium of music performance challenges both established research models and constructs of originality. For a jazz musician or contemporary performer where there is a strong emphasis on improvisation or composition of one's own material for performance, the 'originality' in performance is immediately apparent. For a classical performer, however, whose area of research may be grounded in established forms and repertoire, this concept of originality or what might constitute the creation of new knowledge becomes harder to define. The performative process is often seen as re-creative: reinterpreting canonical works or restoring neglected works to the repertoire and bringing them to new life in performance. Nevertheless, in both of these scenarios there is still a strong creative element. Every performance of a Beethoven piano sonata is different, and not just because of the variables associated with the choice of instrument (whether fortepiano or piano, Steinway or Stuart) and externals such as the acoustics of the venue. While the musical score provides notes and some performance indications of articulation, tempo and dynamics, and

perhaps even fingering, there are an infinite number of subtle elements injected by the instrumentalist or singer in performance that shape each individual interpretation. The creation of new knowledge in this context, therefore, can take the form of realisation of new musical works (premiere performances), new interpretations of existing musical works, or investigation of specific performance practices through the performance of historic or avant-garde repertory, to give just a few examples.

The PhD in Music Performance

At the University of Tasmania, the PhD in performance is offered in both classical and contemporary (jazz and popular music) instrumental and vocal specialisations. The performance stream represents roughly fifty per cent of the current PhD candidates in music and has been offered since the late 1990s, with the first graduand of the program in 2002. Since that time the graduands in performance have represented the following instruments: violin (multiple candidates), violoncello, flute and guitar, as well as piano accordion and gospel-style piano and choir direction. Current candidates are undertaking research projects being conducted through performance on pianoforte, flute, horn, jazz saxophone and jazz acoustic bass. There are also several projects that combine dual creative elements of composition and performance in either classical or popular idioms.

According to the University of Tasmania 'Procedures for the PhD in Music' (2009):

> Candidates must present a folio of performances... and an exegesis for examination that contextualizes aspects of the folio and the research that has underpinned its creation.

For the purposes of examination, the performance folio referred to above embraces both the recordings of the recitals undertaken during the course of candidature and the live examination recital. The duration and number of recitals is not specified in the degree procedures as the emphasis is obviously on quality rather than attempting to provide a measure of activity. Nevertheless, the minimum number normally considered for submission would be a folio of four professional-level

recitals of discrete repertoire. The concept of a performance folio is not embedded in all Australian programs – others concentrate on the examination recital for documentation of the performance element of the project.

From its inception, the UTAS PhD in music performance followed a defined proportional weighting of performance and exegesis, with the weighting of the performance folio at eighty per cent and the exegesis of nominally 20,000 words weighted at twenty per cent. The experience of candidates and feedback from examiners over the years resulted in a subsequent amendment to the procedures for the degree to allow for another weighting option. This was in recognition of the variation in the types of research projects that were being undertaken, and the differing career stages of commencing candidates. Over the past five years this amendment has proven to be an appropriate step, as candidates and their projects have consistently received strong endorsement from the external examiners.

The current two-pathway model, which is unique to the University of Tasmania, allows for the weighting of the folio to be either eighty per cent of the submission, with an exegesis of around 20,000 words (the original model), or for the folio to be weighted at fifty per cent of the submission with a correspondingly longer exegesis of between 30,000 to 50,000 words. These two pathways recognise the variation between entry points to the PhD program: the 80/20 model was designed specifically for the candidate who has already established a professional career as a performer and may be mid or late career. The folio in this case may often contain commercially released recordings. The type of research undertaken is often focused on critical analysis of performance-oriented issues, whether of interpretation, technique or subtleties of expression and communication as applied to the repertoire performed. Research of this type, centred on the practitioner and undertaken from as objective a standpoint as possible, can make a significant contribution to the field. The critical awareness that such research fosters in the performer can refine and even change his or her established mode of performance, and the insights produced are likewise of value to other performers approaching the same musical literature or technical or interpretative issues.

The 50/50 model was intended to address the very different needs of younger performers who have come to graduate research directly from honours/master's study (as is the accepted route to the PhD in other disciplines) and it is therefore more directly mapped to traditional modes of research training. For such candidates, specialist tuition on their instrument plays an important role in developing their professional career and interpretative skills, and research projects are more likely to focus on questions associated with particular repertoires and stylistic influences. There is also an expectation that the broader research informing the contextualising document for projects conducted under this model will have publishable outcomes.

Although this was not initially anticipated, the 50/50 model has also proven to be of interest for those seasoned professional performers whose doctoral enquiry has ultimately led to a written component of greater length and import. By nominating an equal weighting of folio and exegesis, the scholarly significance and contribution to knowledge as embodied in the written component, and in some cases, associated publications, can then be fully acknowledged in the process of examination.

Examination of PhD Candidates in Music Performance

The examination of doctoral candidates in the creative arts is considerably more complex when compared to the traditional PhD examined by thesis alone. Examiners are required to deal with artefacts of various types and in a wide range of presentations, and assess these with reference to a written component that serves to clarify the research intent of these artefacts (Webb, Brien & Burr 2012). In the case of candidates in music performance, the written component provides the lens through which to view a concert not just as a performance examination, but as a research outcome, and thus to evaluate the merits of the final recital as an embodiment and form of dissemination of the results of three years of full-time research.

The process of examination for the PhD in music in Australian universities is generally external and undertaken by two or three examiners who are both practitioners and academics in the field of the candidate's

research. An overseas examiner has typically been used for international benchmarking of PhDs in all disciplines, but the direct cost to schools of bringing examiners to attend the final recital in person is substantial, and this financial imperative, along with the increasing numbers of Australian performance academics holding doctorates, has necessarily affected the choice of examiners in recent years. At the University of Tasmania the folio of performance recordings and the exegesis are sent to the external examiners usually a month prior to the doctoral recital. Examiners would then arrive in Hobart on the day of the recital, attend this in the evening and on the following day conduct a *viva voce* with the candidate. The *viva voce* has been a feature of the doctoral examination process at the University of Tasmania in Music since the inception of the program, but this oral examination is relatively rare in the Australian context. The implementation of a *viva voce* as part of the examination process was notably one of the recommendations of a recent survey of the examination of doctorates in the creative arts (Webb, Brien & Burr 2012).

The *viva voce* provides an opportunity for the candidate to present the main points of his or her research arguments in summary and to answer directly any questions from the examiners about the various elements of the submission: the folio of recordings, the exegesis and/or the doctoral recital. The most common questions from examiners, in my experience, engage with the synthesis between the exegesis and the final recital. While the performances in the folio will have been subjected to critical analysis and contextualised in the exegesis, the final recital does not actually take place for up to two months after the date when the exegesis and folio were submitted. The positioning of the final recital as research is inferred from the exegesis, thus the candidate's ability to assess that performance critically, which occurred less than twenty-four hours previously, in terms of its representation of the ideals, values and themes that had characterised the research, is a critical aspect of the examination process. The *viva voce* is not intended to substitute for a U.S. style thesis defence process, for the recital is manifestly a very public defence of the research that has taken place. The integrated nature of the research submission in the performance PhD and both the projected and unanticipated performance outcomes of the final recital require a forum for clarification, before the examiners write their final examination reports, and this is provided by the *viva*.

Constructs of Performance-led Research Methodology

The central issue for doctoral research undertaken through music performance is the concept of enquiry, or a central research question that underpins the research project. This research question may not be well defined at the outset (Borgdorff 2010) but may evolve from and be led by practice. The interdependence of performance and research is paramount and the conduct of the performances in the course of candidature must be integral to the research. The role of the performances can be to provide public dissemination of the research as mentioned previously, or to showcase the techniques and interpretative principles being explored, or to provide the raw material or data for research. For the practical musician, research is readily identified when associated with musicological or ethnomusicological endeavours, but it is not necessarily linked as readily with rigorous enquiry rooted in their own discipline. The nexus between research and musical performance is built through reflective practice (Schön 1991) but surprisingly, even though these processes are embedded in training in musical performance, performers do not recognise this as being a mode of research. Generally, the term 'research' is linked exclusively with the academic pursuit of writing, and therefore mentally divorced from the creativity and perception of freedom and flow experienced in performance. Applicants for the program generally approach from one or the other extreme: either they focus on their instrumental accomplishments and then ask "What project can I do?" or alternatively suggest a topic that would be best suited to a musicology thesis, in which performances would provide only an illustrative role.

In essence, there needs to be an understanding from the outset of the forms that research conducted through musical performance might take, and what the outcomes of such research might look like. Although this seems to runs counter to the topic of this chapter, de-emphasising the exegesis in the initial discussions with a performance candidate can help crystallise the notion of research conducted through performance more quickly, by maximising focus on the dimension of performance. Discussion of the written element at the outset often encourages an almost instinctive compartmentalisation, as referred to earlier.

Yet by focussing on specific musical repertoire initially, a performer, by dint of personal experience, will have the ability to identify readily issues or problems that present themselves when this repertoire is performed. The identification of what needs to be known about the target repertoire in order to give a stylistically informed yet original interpretation can often yield a research topic or lead to enquiry into specific techniques or stylistic interpretations. Importantly, the discussion is all about the practice and act of performance, and the topic then grows out of the artistic curiosity of the performer. Consideration of the expected contribution to knowledge in the planned performances brings attention back sharply to the research imperative of the doctorate. Such questions about the potential for originality, innovation and contribution to the field are best evaluated when the project is in the developmental stage, as they will eventually be the crux of the determination in assessment.

In developing a topic and a research proposal, examples of projects are invaluable. While it is a reasonable concern that using previous projects as models may limit the scope of future projects within the parameters of existing manifestations, nevertheless the opportunity to see the completed projects of past candidates can spur the imagination and also give a rapid introduction to expectations regarding contents of the folio and the integration of the performance and written components.

Usual methodologies proposed for qualitative research, such as those proposed by Creswell (2013) and in Knowles and Cole (2008), as well as in Denzin and Lincoln (2005), often do not align well with the nature of performance-led research in music, although there are elements of several methods that may provide helpful guidance. While the primary data for research is encapsulated in the performance video recordings, there is other data that can be garnered for phenomenological research from the observations of the researcher and other participants during or after the performance and by the keeping of written or recorded journals (van Manen 1990) that have reflected on the phenomena to be studied, documenting the preparation for performance, the trajectory of rehearsals and the processes in performance. The nature of the research enquiry may be autoethnographic, dependent on participant observation, and thus could be subsequently developed from these

journals to provide a "thematic narrative... a story constructed out of a series of thematically organised units of fieldnote excerpts and analytic commentary" (Emerson, Fretz & Shaw 1995, p. 170).

Reflective research conducted through the mode of musical performance is naturally qualitative and often experiential or phenomenological with the researcher as an 'insider'. Consequently, the researcher must be "conscious of the biases, values and experiences that he or she brings to a qualitative research study" (Creswell 2013, p. 216) and have an awareness that these elements may inadvertently shape the interpretation of his or her findings. The role of the researcher in enquiry of this nature needs to be explicit. As Creswell notes, "the researcher is center stage in ethnographies and possibly in case studies where interpretation plays a major role" (2013, p. 279).

The applicability of case studies for research conducted through performance is immediately apparent, as any given performance could be considered as a case study and subjected to critical analysis. Although the focus of research of this type can be a single case study, multiple cases are often compared, looking for common themes (Yin 2009) to provide the foundational material for the interpretative phase. With a folio constituted by multiple performances frozen in time, this mode of research enquiry has significant resonance for candidates. A common theme can be provided by a central research question for the individual research project such as, "What techniques and compromises are required to give an historically informed performance using a modern instrument?" or "What are the most effective communication strategies for free improvisation in small ensembles?" Using the central research question as the point of reference, all the case studies can be analysed for their representation of the aims of the research.

Conceptual Framework for Performance-led Research

In undertaking a doctoral research project through music performance, it can be advantageous for candidates and supervisors to have a visual conception of the project and the interrelationships between the performance and the exegesis from the outset. I have designed a concentric three-dimensional model inspired by a two-dimensional research design

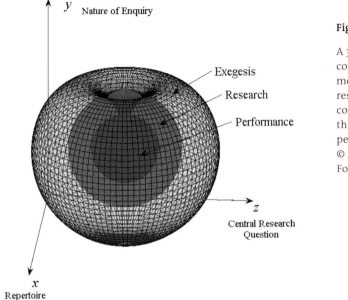

Figure 15.1

A 3D conceptual model for research conducted through performance © Anne-Marie Forbes

of Geroy and Wright (1997) in order to represent a conceptual framework for doctoral research conducted through performance (Figure 15.1).

As is immediately apparent in Figure 15.1, performance is placed at the core of the research sphere, with the research enquiry itself focussed on performance and enveloping it completely with an appropriate methodology. The exegesis is represented as the outer layer, not only encapsulating the entire project but mining the acts of performance for data, a process informed by the research methodology. This data is then brought to the surface and evaluated and contextualised in the exegesis. The three concentric spheres are situated in and interrogated across three axes: the x-axis represents the choice of repertoire; the y-axis asks, "Why do you want to play it?" (or, "What do you want to do with it?"); and the z-axis represents the central research question or hypothesis that underpins the enquiry being undertaken through the medium of performance.

Reflective journals can be used to document the action-learning process of reflection in action and reflection on action (Schön 1991) during

and after rehearsals and performances, and to capture the surprising moments and the unexpected events for later interpretation. In isolation, these reflective journals have limitations due to a perceived lack of objectivity, but their usefulness and methodological soundness in documenting both the research in progress and the reflections that have provoked new actions is without question. Reflective journals should be an integral part of the research process for performers from the outset, as whatever the methodology later decided upon, they can be referred to for invaluable source material for the research.

Role of the Exegesis

The encapsulating and interrogative role of the exegesis allows the contextualisation and interpretation of the performances contained in the folio by means of the central research question or theme. Research in the creative arts can be somewhat subversive in that it does not strictly follow the scientific model of a clearly defined purpose or problem, and consequently the presentation of the written component may not align directly with the standardised structure of an introduction, literature review and outline of methodology followed by the presentation of data, discussion of results and conclusion (Gouzouasis & Lee 2008).

The exegesis will necessarily have an introduction to the repertoire and an argument as to why this particular repertoire has been selected. This may include reflection on the materials performed, the manner of performance, stylistic antecedents and influences, impact of performance spaces, specific techniques employed and so forth. Candidates need to be able to articulate the main point of the performances and what was intended to be achieved or conveyed to the listener. The performer's analytical understanding of the repertoire and how this is represented in performance should underpin the reflection on the folio.

It is important that the candidate determine the audience for his or her writing. While the primary audience for an exegesis is necessarily the examiners, and acknowledgement of this will shape the tone and discourse of the document, there must be recognition that the exegesis should contain original research outcomes and reflections that would

be of value to other practitioners in the field and that have been or will be submitted for refereed publication.

The exegesis has a critical part to play in contextualising the research project in the field of enquiry. In addition to the standard books, dissertations and journal articles, a review of the literature pertinent to the focus of the project will include influential performances by other artists on CD and video. It is also important that the exegesis outlines the reasoning behind the research and the underpinning methodology, thus explicating the nature and conduct of the research that has underpinned the creation of the performances. There is no need for this to expand into a lengthy methodological discourse, but it should be clear that the pattern of enquiry has been thought through and will sustain academic rigour.

The exegesis performs an important evaluative role by articulating how the research project has influenced the performance outcomes as documented in the folio and in the examination recital. The candidate must provide the artistic justification for performance choices; repertoire, instrumentation, performative style and nuances of interpretation. This requires far more than the background to the works performed, as might be provided in extensive program or recording liner notes; it requires scholarly evaluation of the established norms of performance within those stylistic confines and the objective critique of the folio performances. The originality of the performance folio may be inherent where the concerts consist of premieres or where the performance mode is highly reliant on improvisation, but when more standard repertoire has been performed, then the nature and quality of the candidate's original contribution to the field needs to be clarified in the exegesis. Importantly, the exegesis is critical for situating the performances themselves as an active mode of scholarly enquiry and critical reflection – and therefore for the very recognition of the folio as representing research rather than a documentation of professional practice.

If the exegesis becomes an *apologia*, an intensely personal and subjective reflection on activity, rather than a more objective research enquiry into the creative or re-creative process, then this can prove extremely problematic for examiners, as it may undermine the research imperative of the doctorate. To the other extreme is the situation where the

exegesis has largely become divorced from the folio and reads instead as an essentially independent thesis where the performances function effectively as extended musical examples. The litmus test here is whether the written component refers directly to and reflects upon aspects of the performances in the folio. If it stands fully independently, then although it may demonstrate the candidate's writing and research skills, it does not fulfil its stated function of contextualising the folio and the research that underpinned and informed its performance.

It is the chief function of the exegesis to testify to the centrality of the research endeavour throughout the duration of candidature by articulating an objective context for the content of the performance folio and including a critical assessment of whether the aims of the research were achieved and the manner and extent to which these were realised. This latter is absolutely crucial for examiners to be able to make a judgement on the quality of the submission. As has been observed by Richards, high-quality research conducted through the medium of performance is distinguished by:

a) Rigorous reflections and investigation

b) The clarity and specificity of its research questions

c) The openness of its processes to question and evaluation by others.

<div align="right">(Richards 1995, p. 10)</div>

Conclusion

For musical performance to be perceived as research, it must be conceived as research. Attempting to retrofit a research component to a performance portfolio is rarely successful and will leave the candidate poorly prepared for critical scholarly engagement with his or her own performance practice beyond the doctorate. By establishing from the outset a clear conceptual framework of the project that puts performance and the creation of the performance folio at the very core, the research will not lose its focus and performance will be integral to the research methodology and the outcomes. Although the exegesis may receive a minor weighting in a PhD submission, because it is presented in a traditional and broadly accessible mode – the written word – it takes on particular

importance for academic examiners. As the written component, the exegesis carries the burden of responsibility for the communication of the objectives and context of the research and the design of the project and methods employed. It interrogates and interprets the contents of the folio and argues for the performances as research outcomes. In short, the exegesis makes explicit the implicit decision-making that has attended the creative act of performance and establishes the originality of the endeavour, the generation of new knowledge and contribution to the field – the very hallmarks of doctoral research.

References

Australian Qualifications Framework (2nd ed.) (2013) South Australia: Australian Qualifications Framework Council. Retrieved from: http://www.aqf.edu.au/.

Beilharz, K. (n.d.) The exegesis: the role of the exegesis and its relationship to the creative work. Retrieved from: http://www.kirstybeilharz.com.au/PDFs/SlideSummaryCPCE-role-of-exegesis-sm.pdf.

Borgdorff, H. (2010) The production of knowledge in artistic research. In M. Biggs & H. Karlsson (eds), *The Routledge Companion to Research in the Arts* (pp. 44–63). Hoboken, NJ: Routledge.

Creswell, J. (2013) *Qualitative Inquiry and Research Design: Choosing Among Five Approaches* (3rd ed.). Thousand Oaks, CA: Sage.

Denzin, N., & Lincoln, Y. (eds) (2005) *The Sage Handbook of Qualitative Research.* Thousand Oaks, CA: Sage.

Emerson, R., Fretz, R., & Shaw, L. (1995) *Writing Ethnographic Fieldnotes.* Chicago, IL: University of Chicago Press.

Geroy, G., & Wright, P. (1997) Research design decisions: An integrated quantitative and qualitative model for decision-making researchers (You too can be Lord of the Rings). *Performance Improvement Quarterly* 10(3), 22–36.

Gouzouasis, P., & Lee, K. (2008) Stick knot Danish. In G. Knowles, S. Promislow & A. Cole (eds), *Creating Scholartistry: Imagining the Arts-informed Thesis or Dissertation* (pp. 15–25). Halifax, Nova Scotia: Backalong Books.

Haseman, B. (2006) A manifesto for performative research. *Media International Australia Incorporating Culture and Policy.* Themed issue, *Practice-led Research* 118, 98–106.

Knowles, G., & Cole, A. (eds) (2008) *Handbook of the Arts in Qualitative Research.* Thousand Oaks, CA: Sage.

Kroll, J. (2008) Creative practice and/as/is/or research. *Creativity and Uncertainty: AAWP 2008.* Retrieved from: http://www.aawp.org.au/files/Kroll.pdf.

Melbourne Conservatorium of Music: Graduate Programs (2013) Brochure.
Retrieved from: http://conservatorium.unimelb.edu.au/assets/brochures/
MCMGraduateBrochure_FINAL.pdf.

Monash University (2013) Doctor of Philosophy (Music Performance). Retrieved
from: http://www.monash.edu.au/pubs/handbooks/courses/4088.html.

Richards, A. (1995) Performance as research/research by means of
performance. Discussion paper presented to the Australasian
Drama Studies Association Annual Conference, Armidale NSW,
July 1995. Retrieved from: http://www.adsa.edu.au/research/
performance-as-research/performance-as-research.

Schön, D. (1991) *The Reflective Practitioner: How Professionals Think in Action.*
Aldershot: Ashgate.

Sydney Conservatorium of Music (2013) Handbook – Doctor of Musical
Arts. Retrieved from: http://sydney.edu.au/handbooks/conservatorium/
postgraduate/research.

University of Tasmania (2009) Procedures for the PhD in Music.

University of Western Australia (2013) Handbook – Doctor of Musical
Arts. Retrieved from: http://courses.handbooks.uwa.edu.au/courses/
c1/10940#structure-tab.

van Manen, M. (1990) *Researching Lived Experience.* New York: State University
of New York Press.

Webb, J., Brien, D., & Burr, S. (2012) *Examining Doctorates in the Creative Arts: A
Guide.* Canberra: Australasian Association of Writing Programs.

Yin, R. (2009) *Case Study Research: Design and Method*, 4th edition. Thousand
Oaks, CA: Sage.

Notes

1 The University of Tasmania Conservatorium of Music (Hobart), the School
of Art (Hobart) and the School of Visual and Performing Arts (Launceston)
are now combined in a single school in the Faculty of Arts. The combined
school is the Tasmanian College of the Arts.

CHOREOGRAPHIES OF THOUGHT: DANCING TIME BACK INTO WRITING

Maggi Phillips

In seventeenth- and eighteenth-century court perspectives, choreography as a term was widely understood to apply to the "writing of dance/movement" (Lepecki 2004), where documentation rather than composition of bodies in time and space in a twenty-first-century sense formed the principal definitional focus. That is, this definition focuses on choreography as a way of writing down what has been performed. In this sense, choreography suggests a gathering of the forces of moving in and through conscious experience or, pertinent to this discussion, an analogy of thought itself; some way of wrestling with, pursuing and grasping the intangible and ever-restless shifts of meaning in whatever form that meaning may appear. As conveyers of thought, languages in all their modes and forms constitute the substance and/or medium of research. This substance, language, acts as a documentation and compositional channel for the unruly acrobatics of perceptual and sensory awareness, an expression of Merleau-Ponty's proposition (1968) of "being in the world".

Now with an official 'academic' recognition of alternative languages (or modes of communication, such as performing, painting, dancing and singing) as mediums of research, university systems are faced with problems of how to understand and manage the polyvalent expressions of knowledge. Fiona Candlin (2000) discusses the provocations arising when artists assume positions formerly reserved for academics and the resulting clash of two institutional value systems that invariably ensues. Do both systems alter to accommodate the relationship or is it inevitable that the new discipline bends to the rules and regulations of the host institution, the university? While recognising the validity of Candlin's observations, this chapter adopts another, though related, angle in order to explore how crucial protagonists in the quest for thought, postgraduate researchers, might approach the epistemological challenge within, and push against institutional constraints in the area of the construction and presentation of theses. In many ways, the chapter is an attempt to address the neglect of "ways of thinking and talking about the central role of writing in knowledge production" (Paltridge et al. 2012, p. 1,000), except that I am interested in peeling away the layers of language/s to ask questions about thought itself.

Thought as a Structural/spatial Formation

This discussion, influenced by Lakoff and Johnson's studies into "conceptual metaphors" (2003/1980), speculates on patterning as being a fundamental constituent of thought. The human physiological system seems neurologically constructed so as to recognise patterns whether directly from experience (animal classifications) or transferred into abstraction (mathematics). However, one limitation to a base notion of patterns is the tendency, given particular emphasis in the early- to mid-twentieth-century structuralist turn of the humanities and social sciences, to assume patterns are somehow fixed spatially even if the pattern or structure proposed encompasses time. On the other hand, my experiential knowledge gained through dancing 'knows' that patterns operate across time in manifold and complex ways. Like life itself, everything moves. Hence, the patterns encoded in this quest for the expression and marking of different forms of knowledge are complex and labile, filtered as they are through political, philosophical and emotional dynamics, which should not be an impediment to the

attempt to grasp or make some sort of malleable form out of the elusiveness of the most significant factor, thought.

Starting with Foucault's excavations (1972) into the 'visibility' of previously 'unthought' viewpoints and skipping through Calvino's intimations (1993) on writing and time, metaphorical conceptualisation and embodied cognition, this chapter speculates on what choreographies of thought or the documentation of moving patterns of thinking might contribute to manifestations of artistic knowledge in academia.

In using the term *choreography*, I wish to emphasise the way in which specific disciplines approach and, therefore, encapsulate thinking about research. If that statement sounds logical and commonsensical to some people and an anathema to others, then the point is well taken. The notion of choreographies of thought is a means to interrogate relationships between writing and knowledge in artistic as well as wider disciplinary understandings of those terms. Writing/explicating/recording as concepts have been intricately tied to marking/calligraphy/composition/notation throughout history so that extricating meaning from those enduring traces is difficult. Nonetheless, activities of making marks appear imbued with a primordial defiance against the inevitability of death and have, thus, inherited a sense of stasis or a holding back of time. Writing and all of its ancillary markings emphasise, if inadvertently, thinking which is mapped out in spatial terms. This stasis of structure has acquired a legitimacy that privileges markings because they literally resist death.

Thought and the Dynamics of Time

I am intrigued with a position which reinstates a documenting process as maintained in communal memory, an active conceptualisation and composition which manifest a greater reliance on and consciousness of temporality. The evanescence integral to choreography is an intentional ploy to complicate the hierarchy of scriptural language and its implied structural spatiality, which words, numerals and diagrams subtly represent, in order to contemplate thinking which falls or spins into discovery and, thus, into knowledge.

Writing on paper and stone represents, in my terms, the surface of thought captured spatially. This proposition carries over from a childhood fascination with languages across modes of expression – I wanted to dance, write and paint. Circumstances narrowed such broad-brush desires and specialisation invariably gained precedence, until the first encounter with 'foreign' language plurality, the linguistically 'other', in my case, of French and Spanish. From incomprehension, I had to re-learn sound, articulation and tenses, involving anxieties which eventually led to a realisation that the surface linguistic stuff determined, to some degree, the way one thinks. This was never so clear as when I encountered the Spanish differentiation of the verb to be, *estoy*, which denotes 'being' as a transitory state and *soy* as that which denotes the 'whatness' (courtesy of Joyce) or the indelible aspect of 'being'. As an English speaker, I did not 'think' in the differentiation of these terms so, apart from the difficulty in speaking/communicating in *Castellano*, I was faced with problems of thought. Later, when challenged by the linguistic dominance and 'discursive' rules of academia, awareness centred on a mistrust of undetermined and, thus, unacceptable multimodal thought. This bifurcation between writing and other modes of expression appeared to lie deeper than the Cartesian split between mind and body, and threatened by the sheer force of its legitimacy to annul childhood explorations and cultural encounters, not to mention the unsaid overlays of years of dance practice.

While academic perspectives encourage curiosity, encrusted conventions impose parameters on how that curiosity might be pursued. Through constantly struggling with that contradiction, I now have a degree of confidence to challenge the rhetoric because I am convinced that the issue of thought is ultimately more important as a puzzle with which to grapple than any determined set of linguistic (and/or institutional) rules.

Thought in Fiction and Academia

The key question concerns what knowledge may be and, for the purposes of postgraduate 'examination', how that knowledge might be 'written' and subsequently assessed in equitable and just terms. Resolutions tend to rely on disciplinary determinants where conventions take over

as a kind of technical logic – or seemingly so. Here, with my experiential 'background' knowledge, I tend to suspect conventions, even in my own discipline, dance. Thought is distinct from disciplinary conventions although thought is thoroughly embedded in the shaping of each and every discipline. So how is it possible to extricate the one from the other?

Michel Foucault's excavations (1972) on the changing visibility of knowledge point to a form of rhetorical blindness. His 'histories' "share an aim with fiction: the aim not of explanation, or of showing how our ways of seeing and doing are historically necessitated, but, on the contrary, of showing how things might be otherwise" (in Rajchman 1988, p. 95). In other words, Foucault's painstaking 'histories' dig into the sediments of visibility, language and rhetoric to try and 'see' past the limiting frames of contemporaneous knowledge and access what is yet unknown. Foucault is, of course, primarily acknowledged for demonstrating the 'constructedness' of knowledge and the ramifications of structural paradigms set in place by the society in question. If John Rajchman (1988) is correct in his account of Foucault's recognition of the partial visibility encountered within these epistemological paradigms, then Foucault does present a re-visioning of thought in a pre-disciplinary, pre-epistemological state. Thought in such a conception is akin to an underground agent in the territories of the imagination, scratching away in the formlessness of chaos. Thinkers and artists grapple with this unregulated realm of yet-to-be-knowledge, straining to delineate incipient patterns in the flux through whatever means of articulation might be at their disposal. Rajchman's reading of Foucault employs the term 'fictions', the suggestion being that Foucault envisaged the trajectory of thought to knowledge as passing through imaginative 'fantasies', ideas or, in a loose sense, speculations. In that simple suggestion of "how things might be otherwise", Foucault raises, not so much a revolutionary approach to the surface of knowledge by way of writing but, as in his treatment of the perspectival explorations of Velasquez's painting, *Las Meninas*, in the beginning of *The Order of Things* (2012), he forges an attitudinal inroad to knowledge via articulations of imaginative impossibilities (or paradox). I seize that suggestion from a master of investigation to argue for imaginative/alternative/rebellious means to write within and back to academic conventions. In plain language, a story (fiction) may be a thesis.

Of course, the writing issue in academia is not so simple because not all storytellers are researchers. The question concerns that line when fictions or practices become research and vice versa. There is also a distinct Foucauldian side to this questioning in the surveillance of control by interested parties within the social order that I would like to circumvent here, except to acknowledge that the control mechanisms of power institutionalise ideas whether those ideas be on the practice or scriptual side of the debate. However, in returning to Foucault's suggestion that intimations rather than actualities of knowledge are borne in incipient phases of knowledge development, I would like to suggest that artistic articulations be, in their ultimate formation in which time plays a dominant role, acceptable as writing. Distinctions between practice and research lie less in alliances with pre-determined theories than in the clarity of multi-modal utterance and in an attention to wide perspectives on the topography of thought. However, the clarity of artistic exposition may foreground perspectives of chaos, ambiguity and doubt, characteristics which are not always acceptable in the theses of other disciplines.

For all their rebellious traits and resistance to regulatory impositions, creative arts' students often flounder in this crucial expectation that they tread unstable paths. In the literature of academia as well as in the rhetoric of artistic practice, there is much talk about the in-between, but willingness to go into that conceptual space of disorientation is often constrained by personal needs to be acknowledged, to be affirmed as a definitive identity within society. In many ways, most of us are caught between Foucault's reading of transforming chaos/imaginative connections into knowledge (the vision) and his darker demonstration of knowledge as institutionalised by invisible, yet potent, forces of control (legitimisation).

For some guidance on this unstable path, creators or compositors of knowledge can turn to Italo Calvino's *Six Memos for the Next Millennium* (transformed by the 'accident' of death into five[1]): Lightness, Quickness, Exactitude, Visibility and Multiplicity, which spell out an idealised set of instructions for any creator or compositor of knowledge, especially when the absence of the final point is taken into account. True to Calvino's sophisticated structural sensitivity, that unwritten final 'memo' or

lecture was intended to focus on consistency, a kind of rigorous mathematical closure to the quest to encapsulate meaning: "the proper use of language, for me personally, is one that enables us to approach things (present or absent) with discretion, attention and caution, with respect for what things (present or absent) communicate without words" (Calvino 1993, p. 77). It is as if the interruption of absence celebrated his observation that "in representing the density and continuity of the world around us, language is revealed as defective and fragmentary, always saying something *less* with respect to the sum of what can be expressed" (ibid., p. 75).

Curiously, Calvino's thought is utterly present for his readers in its fine traceries, its audacious puzzles and the remarkable structures which cluster around imagination, as in *Invisible Cities* (1974) where he builds structures/cities from "the tension between geometric rationality and the entanglements of human lives... a network in which one can follow multiple routes and draw multiple, ramified conclusions" (Calvino 1993, p. 71). This exemplary 'writer' knots disciplinary divisions into strange configurations which, at once, appear familiar, if de-familiarised with luminescence. Could it be an illuminated theatre of science? It is that and more.

I want to suggest that you can place Foucault and Calvino as two thinkers (of the many who may be cited) side by side as exemplifying a traditional binary between the dark and the light, between the academic and the artist, the serious and the playful and so forth. This suggestion is much too simplistic but, unfortunately, such binary encrustations impinge on cultural values and the human capacity to think which, in turn, causes anxieties about artistic interventions in academic life. Maybe optimistically, I'm convinced that Foucault would revel in Calvino's trajectories of thought – his fictions – as much as Calvino would value Foucault's insights into social behaviour. It is as if both thinkers of thought (and please excuse the limitations of my language) excavated the same territory – thought – but had different 'languages' through which to communicate what they 'saw'. Foucault assembles structures of control, with cracks where alternative understandings occur, while Calvino dreams structures of non-being, which are possibly the cracks Foucault foresaw.

While Foucault and Calvino exhibit a certain affinity to structure, they both in their distinctive ways employ movement within the structuration of ideas and behaviour. Both thinkers belong to the cusp when modernist values give way to the postmodern condition of fragmentation, overlays, juxtapositions and uncertainties. Those stirrings of mistrust in structures or certainties reveal other influences which seem to emerge in twenty-first-century conceptualisation, the ideas of flux, chaos, endless manipulations, digitalisation and ecologically interdependent systems. Movement, which arguably existed to form structures and their subsequent fragmentation, takes centre stage. Vanishing time, exemplified in dance, has ironically become an academic focus. A choreography in performance involves live bodies in space and time and thus, unlike painting or writing, disappears the moment it is actualised. Performance, according to Peggy Phelan (1993), is thus "unmarked" which she claims, in contradistinction to normal readings, constitutes performance's strength. Performance for Phelan denies reproduction and therefore is unintentionally aligned with other unstable phenomena, such as the extinction of species, climate change, patterns of human movement across the globe or the instantaneous, distributed forces of economics and social media. Structures have not been made redundant, but their static two-dimensionality and/or linearity lie in question. Structure does not seem to hold because it is forever disturbed by interventions of time.

'Moving' from Spatiality to Temporality

When alerted to the phenomenon, it is relatively easy to detect this shift to temporality in cultural studies, indeed across the humanities and the arts, for example, in Butler's "performativity of gender" (2004) and Deleuze and Guattari's ever-emerging immanence (1988). But stirrings are apparent, if less audacious, in the fact-driven domains of science too. Even if scriptural conventions obscure the import of the shift, the signs surface in the following observation by cognitive scientist, Giovanni Bennardo.

> After decades of structuralism, the generative paradigm moved the
> focus of linguistic investigations... to the universal characteristics
> of language, seen again as a relevant part of the mind (or thought).

The advances obtained in the study of other mental systems, such as the visual system and the auditory system, made possible proposals for a cognitive architecture that encompassed findings both about language – obtained by linguistic analyses – and about these other systems. Research within cognitive science now suggests intra and intermodular organization of these systems [which] allows us to hypothesize, find substantial support for, and convincingly argue about new forms of relationships between language, conceptual (or knowledge) structures, spatial representation, and other modules – including action.

(Bennardo 2003, p. 55)

If you consider that Bennardo's focus is cognition, then that afterthought, "including action", is telling and leads to the important sub-branch of the discipline now known as embodied cognition.

As I see it, there are two avenues to pursue at this point: the significance of multi-modal languages as intrinsic components (or flows) in knowledge, implying that the writing within postgraduate degrees may be something other than scriptural; and the less-evident suggestion that all structures, including that of thesis 'writing' in terms of style and format, should not be exempt from the shape-shifting characteristics of time. The first pathway enters the intensely debated terrain of artistic practices as stand-alone art-works as research. This argument has not been exhausted, though until such point as documentary methods of research encapsulate the theoretical/conceptual knowledge embedded in the various art-works in manners accessible to the general population, the shared communication of words seem an inevitable adjunct to the practices. However, what those words might be, or what their assemblage might denote, deserves further scrutiny. This is where choreographies of thought could become significant. There are a few detours (or by-passes) involved here: thought as a capacity underlying conceptual metaphors (Lakoff & Johnson 2003/1980), choreographies as compositional organisation (Forsythe 2011) and dynamic assessment. Words may make these journeying strands seem definitive but they are rough tracks, subject to the infinite malleability of surface and force.

Recently the phenomenon of skipping set me off on a search for what might appear as a lost movement and, at times, a lost cause. Indeed,

skipping does appear to be redundant after it appears amongst the complex attainments of childhood motor-location developments. Non-dancing and non-moon-walking adults, so I discovered, simply leave this skill for dead. However, skipping, in its transition from bipedality to a notional one-sided step-hop or irregularity, and if understood as physical activity subject to time, fits with Lakoff and Johnson's argument that all human experience is embodied, constructed into the architectonic complexities of consciousness through the 'natural' presence of metaphors (Lakoff & Johnson 2003/1980, p. 117). Metaphorical conceptualisation enables relationships between the various domains of experience by way of "cross-domain mappings, in which a target domain inherits the inferential structure of the source domain. For instance, the concept of an argument maps on to the concept of war" (Anderson 2003, p. 105). According to Lakoff and Johnson, this mapping, modelled on mathematical patterns, embraces the puzzle of imagination:

> Metaphor is... *imaginative rationality.* Since the categories of our everyday thought are largely metaphorical and our everyday reasoning involves metaphorical entailments and interferences, we can see that the products of poetic imagination are, for the same reason, partially rational in nature.
>
> (Lakoff & Johnson 2003/1980, p. 193)

However, Lakoff and Johnson's insights are experientially limited, since their investigations focussed only on the body and its functions as conceptual springboards. While they took the initiative to give imagination its due credit, they seem not to have considered how imagination may play with movement *per se* and what this might imply for the conceptual movement of thought itself – or that capacity of germinating consciousness that lies beneath or within any 'language'. Here Bennardo's action afterthought (2003) comes into the equation. Apart from the curious childhood development and subsequent dismissal of skipping, I have been struck by the conceptual potential of this movement to seed untapped avenues of thought. For a dancer, there is an obvious variation in bipedal understanding embedded in the action of skipping's step-hop – a double action on one side of the body – which immediately enables understandings of irregularity and, subsequently, regularity over longer temporal patterns. The child, let us suppose, learns the physical irregularity and regularity in the action

which, according to locomotion studies, is crucial for further physical skill development. That is one conceptual possibility which arguably has ramifications in terms of structural semantics, but there are other factors, like the gravitational resistance of the single-legged hop and the rhythmic potential of skipping, its contrapuntal propensity, to take into account.

The point is that the multi-modal metaphorical activity which artists pursue, regardless of their principal discipline, actually suggests how thought can be embedded in sensory enactments. This observation concurs, uncannily, with neurological findings – neurons are fired by sensations and dispersed across multiple pathways of the brain until 'repetition' or some sort of feedback mechanism establishes 'a thought' expressed linguistically (Bennardo 2003).

In the section 'Afterword 2003' of the revised edition of their seminal 1980 text, Lakoff and Johnson acknowledge that, while neural patterns may have been found to be characteristically diffuse, they hold fast to the view that the conceptual blueprint is the metaphor, intimating in my mind that the significance lies in the patterning capacity of metaphorical thinking, rather than in a specifically 'named' conceptual metaphor. Thus, the skipping unit as it tinkers with the fundamental binary concept from a dancer's perspective is already a conceptual metaphor as a physical action. Word patterning, as such, encounters difficulties in explanations of this embodied thought, although skipping, like the word tree, stands in for an incredible multiplicity of manifestations (enabled by metaphorical thinking) for those who understand what the idea of skipping-ness, like that of tree-ness, might signify.

As Bennardo notes above, "intra and intermodular organization of... systems" (2003, p. 53) has nudged a structural reassessment of the structural dominance of interconnections between the brain and linguistics. Neurological findings underline the shift. The grounding for knowledge involves:

> the original neural state that occurred when the information was
> initially acquired. If this is true, then using knowledge is a lot like
> reliving past experience in at least some (and sometimes all) of
> its sensory, motor, and affective modalities: the brain captures

modality-specific states during perception, action, and interoception and then reinstantiates parts of the same states to represent knowledge when needed.

(Niedenthal 2007, p. 1,003)

Consequently, knowledge or, more precisely in my terms, thought, is infused with time and sensation. Very little of this scientific exploration has as yet tackled imagination as such but this puzzling element of thought/consciousness, raised by Foucault and Calvino and, indeed, by Lakoff and Johnson's insistence on metaphors, seems like an inevitable extension of current neural projects. Having admitted embodiment and alternative languages, investigations would appear to become locked into a structural stasis, unless conditions for change are considered.

Questions about Choreographic Objects: Time–space Indivisibilities

To backtrack across this terrain, I return to choreographies. Here, I enlist the observations of a prominent practitioner in the art form, William Forsythe, who observes that the word choreography itself:

> like the process it describes, is elusive, agile, and maddeningly unmanageable. To reduce choreography to a single definition is not to understand the most crucial of its mechanisms... Each epoch, each instance of choreography, is ideally at odds with its previous defining incarnation as it strives to testify to the plasticity and wealth of our ability to re-conceive and detach ourselves from positions of certainty.
>
> (Forsythe 2011, p. 90)

Can postgraduate writing and the conventions of examination be detached from 'positions of certainty'? Uncertainty is an untenable position to adopt in any endeavour but I become increasingly convinced that human experience has no other alternative: from disbursed neural activity to the restlessness of innovation, uncertainty or older traditions of doubt intrude on the so-called rage for order in the human experience. Discovery may not in fact be a shaving away of misconstrued knowledge but a deeper immersion into the flux of meaning. Forsythe's current preoccupation with 'choreographic objects' may predict a future

where writing born of uncertainty gathers form. As such there is the propensity for communication on a reversed logic of knowledge:

> Choreography elicits action upon action: an environment of grammatical rule governed by exception, the contradiction of absolute proof visibly in agreement with the demonstration of its own failure. Choreography's manifold incarnations are a perfect ecology of idea-logics; they do not insist on a single path to form-of-thought and persist in the hope of being without enduring.
>
> <div align="right">(Forsythe 2011, p. 90)</div>

What might writing 'in time' – not inferring to time on the beat as pursued in poetic enunciations, but to writing in the action of writing – reveal as distinct from the wondrous accumulations of documents within libraries and archives? Scriptual language becomes, as Calvino observes, deficient in such a quest: not invalidated by any means, simply emasculated in comparison with the plenitude of experience. Forsythe's current solution, 'choreographic objects' invites an alternative way to 'mark,' as he would have it, the organisation of the temporal paradox. Even though I suspect his solution falls back on a spatial pattern or structure to hold back unimaginable death and its loss of time and space, I do think that, as an alternative perception about knowledge and its encapsulation as is required by postgraduate theses, the reading of choreography within a marked pattern of writing is worth contemplating.

> Are we perhaps at the point in the evolution of choreography where a distinction between the establishment of [choreographic] ideas and its traditional forms of enactment must be made? Not out of any dissatisfaction with the tradition, but rather in an effort *to alter the temporal condition of the ideas incumbent in the acts,* to make the organizing principles visibly persist... a choreographic object... an alternative site for the understanding of potential instigation and organization of action... choreographic thinking.
>
> <div align="right">(Forsythe 2011, p. 92, my emphasis)</div>

In short, Forsythe proposes a notational image or an alternative means of marking which enables multiple interpretations, distinct from musical notation and writing scripts in that the purpose of the marking is not to contain and/or control but to enable multiple organisational

patterns, understood temporally as well as spatially, because the two are indivisible. It is as if Forsythe had taken the blueprint of Lakoff and Johnson's metaphorical conceptualisation and laid it out in modes which are simultaneously mathematical and imaginative. Ideas are not abstractedly disembodied but rather physically distributed multi-modally in accordance to the presence/absence grid.

While Forsythe may not have cracked the nut of existence, his artistic explorations of movement, its relationships with thought and communication indicate the potential of artistic endeavours to be involved with that seemingly impossible aim of research as contributions 'to the sum of human knowledge'. And Forsythe is a practitioner, not an academic scholar.

Writing as a Complex Act of Life in Time

This observation also implies that writing for any purpose and in any mode is a complex act of life. My plea is thus for demands on and assessment of writing to acknowledge the challenge and achievement of that act of life as embedded in unknowingness, impossibility and time with as much respect given to its vulnerability as to its advancement of knowledge. In essence, candidates' writing and examiners' interpretations will inevitably be, in Calvino's terms, "something *less* with respect to the sum of what can be expressed." The candidate is challenged to express their thought, not in terms of conventions but, rather, in the context of how that thought in its temporal embedded-ness, including organisation and interrelationships, exposes the broader terrain of that particular strand of thinking. If an appropriate articulational clarity is achieved, the examiner's role is then to follow the dance, to experience the dynamics of a choreographic journey in the markings/patterns of thought and, hopefully, to discern in the destination some indication of value beyond its limitations. Discovering 'how things might be otherwise' is no easy task. Indeed, that leap of faith involves an un-danced choreography of thought.

Time remains a challenging aspect of analysis, just as much as thinking about time confounds understanding in the everyday sense. The axis of time–space that confronts scientists and dancers alike offers a way

both of projecting forward and, in looking back on what invention may have instigated, of beginning to think about thought and how doctoral students might 'write' beneath and beyond what is proscribed for their studies. There is safety in structure, in mapping our understanding to a moment of time, but the difficult decision is to enter into time itself and recognise that structures are mobile, forever subject to an organisation of understanding that may be encapsulated in choreographies.

References

Anderson, M.L. (2003) Embodied cognition: a field guide. *Artificial Intelligence* 149(2003) 91–130. Retrieved from: www.elsevier.com/locate/artint.

Bennardo, G. (2003) Language, mind, and culture: from linguistic relativity to representational modularity. In M. Banich & M. Mack (eds), *Mind, Brain, and Language: Multidisciplinary Perspectives* (pp. 23–60). Mahwah, NJ: Lawrence Erlbaum Associates.

Butler, J. (2004) *The Judith Butler Reader*. S. Salih (ed.). Malden, MA: Blackwell.

Calvino, I. (1974) *Invisible Cities*. New York: Harcourt, Brace, Jovanovich.

Calvino, I. (1993) *Six Memos for the Next Millennium*. New York: Vintage International.

Candlin, F. (2000) A proper anxiety? Practice-based PhDs and academic unease. *Working Papers in Art and Design* 1. Retrieved 30 October 2006, from: http://www.herts.ac.uk/artdes/research/papers/wpades/vol1/candlin2.html.

Deleuze, G., & Guattari, F. (1988) *Mille Plateaux*. (Trans. B. Massumi). London: Athlone Press.

Forsythe, W. (2011) Choreographic Objects. In S. Spier (ed.), *William Forsythe and the Practice of Choreography: It Starts from any Point* (pp. 90–92). London and New York: Routledge.

Foucault, M. (1972) *The Archaeology of Knowledge*. (Trans. A. Sheridan Smith). New York: Pantheon.

Foucault, M. (2012) *The Order of Things: An Archaeology of the Human Sciences*. London and New York: Routledge.

Lakoff, G., & Johnson, M. (2003 [1980]) *Metaphors We Live By*. Chicago: University of Chicago Press.

Lepecki, A. (2004) Inscribing dance. In A. Lepecki (ed.), *Of the Presence of the Body: Essays on Dance and Performance Theory* (pp. 124–139). Middletown, CT: Wesleyan University Press.

Merleau-Ponty, M. (1968) *The Visible and the Invisible*. (Trans. A. Lingis). Evanston, IL: Northwestern University Press.

Niedenthal, P.M. (2007) Embodying Emotion. *Science* 316, 1,002–1,005.

Paltridge, B., Starfield, S., Ravelli, L., & Nicholson, S. (2012) Doctoral writing in the visual and performing arts: two ends of a continuum. *Studies in Higher Education* 37(8), 989–1,003.

Phelan, P. (1993) *Unmarked: The Politics of Performance.* London: Routledge.

Rajchman, J. (1988) Foucault's art of seeing. *October* 44 (Spring, 1988), pp. 88–117.

Notes

1 Harvard University had commissioned Calvino to present six lectures for the Charles Eliot Norton series (1985), five of which were written before his untimely death. When his wife, Esther, oversaw the preparations for the manuscript's publication, she felt obliged to retain the title designated by Calvino, although the sixth 'memo', 'Consistency', never materialised.

WRITING EMBODIED PRACTICE FROM THE INSIDE: OUTSIDE THE EXEGESIS

Cheryl Stock

> The textual turn is a good friend of expert spectating, where it assumes the role of writing-productive apparatus, but no friend at all of expert practices or practitioners.
>
> (Melrose 2003)

Introduction: The Challenge of Time-based Embodied Performance when the Artefact is Unstable

As a former full-time professional practitioner with an embodied dance practice as performer, choreographer and artistic director of three decades' standing, I somewhat unexpectedly entered the world of academia in 2000 after completing a practice-based PhD, which was described by its examiners as 'pioneering'. Like many artists, my intention was to deepen and extend my practice through formal research into my work and its context (which was intercultural) and to privilege

297

the artist's voice in a research world where it was too often silent. Practice as research, practice-based research, and practice-led research were not yet fully named. The field was in its infancy and my biggest challenge was to find a serviceable methodology which did not betray my intentions to keep practice at the centre of the research.

Over the last 15 years, practice-led doctoral research, where examinable creative work is placed alongside an accompanying (exegetical) written component, has come a long way. It has been extensively debated with a range of theories and models proposed (Barrett & Bolt 2007; Haseman 2006; Hecq 2012; Pakes 2003 & 2004; Philips, Stock & Vincs 2009; Piccini 2005; Stock 2009 & 2010; Riley & Hunter 2009). Much of this writing is based around epistemological concerns where the research methodologies proposed normally incorporate a contextualisation of the creative work in its field of practice, and more importantly validation and interrogation of the processes of the practice as the central 'data-gathering' method. It is now widely accepted, at least in the Australian creative arts context, that knowledge claims in creative practice research arise from the material activities of the practice itself (Carter 2004). The creative work explicated as the tangible outcome of that practice is sometimes referred to as the 'artefact'. Although the making of the artefact, according to Colbert (2009, p. 7), is influenced by "personal, experiential and iterative processes", mapping them through a research pathway is "difficult to predict [for] the adjustments made to the artefact in the light of emerging knowledge and insights cannot be foreshadowed". Linking the process and the practice outcome most often occurs through the textual intervention of an exegesis which builds, and/or builds on, theoretical concerns arising in and from the work. This linking produces what Barrett refers to as "situated knowledge... that operates in relation to established knowledge" (2007, p. 145).

But what if those material forms or 'artefacts' are not objects or code or digitised forms, but live within the bodies of artist–researchers where the nature of the practice itself is live, ephemeral and constantly transforming, as in dance and physical performance? Even more unsettling is when the 'artefact' is literally embedded and embodied in the work and in the maker–researcher; when subject and object are merged. To complicate matters, the performing arts are necessarily collaborative,

relying not only on technical mastery and creative–interpretive processes, but on social and artistic relationships which collectively make up the 'artefact'.

This chapter explores issues surrounding live dance and physical performance when placed in a research setting, specifically the complexities of being required to translate embodied dance findings into textual form. Exploring how embodied knowledge can be shared in a research context for those with no experiential knowledge of communicating through and in dance, I draw on theories of "dance enaction" (Warburton 2011) together with notions of "affective intensities" and "performance mastery" (Melrose 2003), "intentional activity" (Pakes 2004) and the place of memory. In seeking ways to capture in another form the knowledge residing in live dance practice, thus making implicit knowledge explicit, I further propose there is a process of triple translation as the performance (the living 'artefact') is documented in multi-facetted ways to produce something durable which can be re-visited. This translation becomes more complex if the embodied knowledge resides in culturally specific practices, formed by world views and processes quite different from accepted norms and conventions (even radical ones) of international doctoral research inquiry. But whatever the combination of cultural, virtual and genre-related dance practices being researched, embodiment is central to the process, outcome and findings, and the question remains of how we will use text and what forms that text might take.

Embodied Knowledge Embedded in Dance Practice

It is beyond the scope of this chapter to discuss the broad and diverse understandings of embodiment from a philosophical, cultural studies or cognitive/neuro science perspective. A dance perspective is quite particular although it may share commonalities with embodiment theories from other fields. Weiss and Haber claim that "embodiment is a way of living and inhabiting the world through one's acculturated body" (1999, p. 14). Acculturation can occur in many ways, through social and familial relationships and through bodily habits informed by our geographical place and environment. In the dancing body, acculturation also occurs through formal encoding acquired over many years via

daily practice of specific or hybrid techniques, practices and overlapping processes; where 'thinking' occurs through the body. The latter infers a holistic process of the brain and the body working together. These movement-based practices encompass more than physical knowledge around energy, weight, space, effort and time but provide the basis for communicative and aesthetic languages of transformative meaning making.

According to Block and Kissell, embodied knowing from a dance perspective is an "integrated power network [that] includes neural elements, efforts, memory, language, perception and attunement and [is] found integrated throughout the body, not just in the brain" (2001, p. 6). This knowing, they argue, integrates inner pulses with neural memory, activated in and by dance (ibid., p. 11). In addition, Warburton (2011, p. 67) reminds us that embodied knowing has dance-specific qualities centred on the affective, kinaesthetic, somatic and mimetic. Key to this integrated network of dance embodiment is action and perception; that is, the making and performance of dance and its reception. Anna Pakes (2004, np) asserts that "dance work is made through, and manifests itself as, patterns of intentional activity, and without choreographic making and dancers moving, there is no dance art". Intentionality of action or movement is thus a link to the brain–body integration of embodied knowledge in dance.

Block and Kissell, drawing on the theories of Rudolf Laban, refer to 'agency' occurring through 'effort' in movement – the inner impulses which are the origination of movement (2001, pp. 8–9). From this Laban believed "dance flows as embodied thought" (in ibid., pp. 9–10). Embeddedness becomes another fundamental aspect of dance embodiment where intention (agency) and action (movement) are inseparable. Or as William Butler Yeats asked in his poem *Among School Children*, "how can we know the dancer from the dance"? Such embeddedness occurs not only in relation to danced outcomes and the individual dance maker–performer, but to the social relationships inherent in dance's collaborative processes, as well as that between dance artists and their audiences in a live setting.

In coming to terms with some of these complexities surrounding

embodied dance knowing, which privilege the experiential, physical and tacit domains, how can we re-language embodiment in dance-centred research? And if we want to move beyond representation to at least partially capture the fleeting ephemerality of the live dance experience and its potential for not only meaning-making, but for making knowledge claims around embodiment in research, what tools do we have?

An Enactive Approach – "Talk from the Body" (Warburton 2011, p. 68)

Across the creative arts, including the dance discipline, debates continue on the nature of exegetical writing to support doctoral-level practice-led research and appropriate lenses and tools to enable the centrality of practice as the major claim to knowledge, through publically verifiable peer appraisal. The key concept of emergence, in tandem with criticality, is an approach in practice-led research gaining acceptance – with theories emerging from practice. At the same time, existing theoretical perspectives also inform practice. Predictably, a practice-led 'canon' of theory to underpin such research has arisen, drawing predominantly on cultural theory, with major authors such as Deleuze and Guattari, Foucault, Bourdieu, Heidegger, Kristeva and so on, providing a philosophical framework for many doctoral creative arts candidates. This canon can be a useful conceptual tool to discuss and validate the fluidity, intersubjectivity and intertextuality inherent in practice-led research. In dance, artist–researchers are increasingly drawing on cognitive and neuro science perspectives to support analysis of experiential responses and processes in dance. Nevertheless, there remains a gap in capturing dance practice that articulates findings through experiential embodiment.

As a way to "language experience" in dance, Warburton proposes the construct of *dance enaction* (2011, p. 67) or "talk from the body" to build a theoretical language embedded in practice in which dance is acknowledged as a relational and emotional situated activity. Warburton points out that dance writings have tended to focus on talk 'of', 'about' and 'on' the body, but these approaches "leave out of account what it is like to perform, watch or make dance" (ibid., p. 68). He proposes the concept

of "talk from the body" (first coined by Drid Williams from an anthropological viewpoint in 1991, in Warburton 2011, p. 68). This enactive approach "generates insight into dance experience" by foregrounding "knowledge as constructed in action through emergent and self-organising processes" (ibid., p. 68) that are simultaneously cognitive and emotional; where dance is experienced and understood through feeling as much as seeing. Melrose (2003, np) likewise places an emphasis on "affective intensities" generated from within the work itself and, I would argue, through the conscious and unconscious input of choreographers and dancers.

In a similar vein, Warburton refers to empathetic connectedness from the point of view of responding to dance and dancers. He describes these from three perspectives as:

- Somatic empathy – feeling 'in' the dance which involves sensing within the body
- Mimetic empathy – feeling 'for' the dance, not through representation, but as a "materiality grounded in bodily experiences"
- Kinaesthetic empathy – feeling 'of' the dance – the sensation of participating in observed movement.

<div align="right">(Warburton 2011, pp. 73–74)</div>

Warburton's arguments stem from an interrogation of the relationship between phenomenology and cognitive science. Investigating these concepts can assist artist–researchers to frame their practice in dance-specific ways that favour the experiential, the kinaesthetic and the affective by "thinking through dance enaction from the body... and prob[ing] the complex relationships between the object of the dance and the subject who dances" (2011, p. 76).

Knowing and Knowledge – A Dynamic Interlinking

It is feasible, then, that an enactive dance approach that talks from the body forms the basis for capturing embodied 'knowing' in dance practice research, whereas embodied knowledge is more often captured in studies 'of', 'about' and 'on' the body. This experiential knowing, however, does not pre-suppose a Cartesian binary (which I would argue is an

historical, political and cultural construct) of tacit–explicit, emotional–rational, conscious–unconscious or cognitive–intuitive. Rather, it is a dynamic interweaving of many aspects of knowing and knowledge in which the 'knowing' is most often foregrounded within the practice itself but does not preclude that knowledge co-exists and is formed and employed simultaneously during certain types of activities (intellectual and physical).

Hecq, in relation to creative writing, similarly describes "seemingly mutually exclusive discourses, one recognising the reality of the unconscious, and the other the importance of rational and critical process" (2012, p. 3) positing this nevertheless linked relationship as both a triangulation of tacit knowing and explicit knowledge, and an 'interplay'. In creative arts practice research, this triangulation is partially bridged by engaging in reflective practice strategies before, during and after action (see Schön 1983 & 1987; Polyani 1967 and the wide range of recent literature on reflective practice). Indeed Pakes (2004, np) claims that the key difference between artists making work per se and the artist–researcher is "the extent of her awareness of, and explicit reflection on, her art as an appropriate creative response to the initial questions". This, as Pakes points out, privileges the maker's intentional processes and the meaning which s/he embeds in the work. In seeking to uncover and articulate the kinds of knowing revealed through an artist's practice, the above concerns and strategies eschew a representation of the work. Instead, they engender what Hecq refers to as "a material transformation" (2012, p. 10). In this process, she suggests that "[m]eanings emerge by accretion, oscillating between intuitive and reflective modes of knowledge creation" (ibid.).

The 'Architecture and the Poetry' of Dance Knowing

In examining how processual, intuitive and intentional knowing in action might manifest itself and then be articulated in embodied dance research, a helpful analogy is what Warburton refers to as "the architecture *and* poetry of the dance" (2011, p. 76) which I view as the 'structure' or scaffolding *and* the aesthetic content. The "performance mastery" (Melrose 2003) of the expert dancer – encompassing skills, techniques, stylistic expertise, movement invention, physical virtuosity

and compositional craft which act as architectural 'tools of the trade' – the practising of the practice; while the poetry is created through the imaginary, affective, aesthetic dimensions – the less tangible and indefinable aspects of the practice as well as the work. In this entwining of architecture and poetry, we can articulate and evaluate more acutely the role that technical mastery plays in informing the aesthetics of the work.

It could be argued that emergent meanings in the work derive not only from these shared creative processes of maker–performer expert practices but also through the viewer's empathetic responses – kinaesthetic, somatic and mimetic – thus forming a three-way relationship between creator, performer and receiver in contributing meaning to the 'artefact'.

At the core of this collaborative meaning-making is an understanding of embodied knowing – not totally shared but rather recognised in multiple ways through a form of bodily thinking, leading to what Pakes (2004, np) refers to as "embodied insight" produced by "artistic action". Particularly in the collective action of the performing arts, the researcher–practitioner reveals and articulates knowledge, not only related to her/his creative processes but also to the social relationships within those processes (ibid.) in what Melrose (2003, np) refers to as a "relational dynamic" primarily between choreographers and dancers but potentially with the audience.

Pakes (2004), however, questions the reliance of much practice-led research on the artist's "knowledge-generative process" to make meaning, suggesting differentiated insights also emerge in interrogating the "autonomous structures" within the work. This additional triangulation of maker–dancers–audience together with the structures within the work itself reinforces the complex embodied inter-relationships that Melrose (2006) terms "practitioner-theoretical practices" which are collaborative and negotiated in situ, "between heterogeneous practitioner undertakings, and different types of expertise." Melrose further contends that "they tend to take onboard the impact of contingent factors, of a noetic creative-problem-solving that seems to come from a nowhere of rational thought; and of happy as well as unhappy accident."

However, there is a fundamental difference between what maker–performers contribute to a work and what viewers experience in that work, even those viewers who are "expert spectators" (Melrose 2003) or dance literate. A primary distinction, according to Melrose (2003, 2006), is that a viewer or dance-studies scholar sees the product as work that is 'finished' (that is, relegated to the past) whereas the choreographer–performer lives the work in a state of becoming, where outcomes are not fixed but in continual transition and transformation. This distinctiveness returns us to the conundrum of meaning generation and 'knowing' though the bodily processes of the artist–performer versus, or alongside, the active meaning-making of the viewer, scholar or novice, embodied by association rather than from within.

Affective Intensities

To return to the relationship between embodiment and the 'artefact' in terms of dance practice(s), one needs to go beyond the notion of performance mastery of the practitioner in realising the dance work, into the broader concept of "discipline mastery" which Melrose suggests (2003, Part 2) is teleoaffective. Practitioners (and makers) "tap into the affective potential of the discipline" and thus "refer onlookers to the possibility of affective intensity, rather than to the thing itself – and in this sense the work performs its own metacommentary on the affective." In other words, meanings and research findings in the work are both created and experienced through affective intensities from inside the work and from inside the dance discipline; talking from the body and reflecting through the body using discipline-specific language that is not necessarily textual.

With regards to a practice-led research environment, Melrose (2003, Part 3) further claims that it "is mastery alone of that core practice which enables endless unfoldings and branchings-out" and the ability to innovate... because each production marks a particular stage in an ongoing, affectively charged and practitioner-driven research quest." Such a statement pre-supposes an embodied dance practice acquired over many years. It is therefore not surprising that it is predominantly mature dance artists who tend to move into doctorates and push the boundaries of both affective capacity and bodily intellectual capacity.

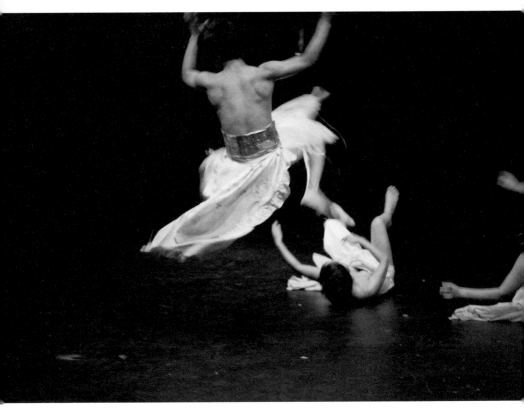

Figure 17.1

Tak Hoyoung (foreground), Dale
Thorburn, Katrina Cornwell in *Deluge*,
choreography Jeremy Neideck,
photograph Richard Clifford

Writing from the Inside

How do we go beyond the personal and professional acquisition of
highly articulated embodied knowledge to an articulation for others
of the theories, insights and discoveries practice engenders? How do
we "pursue the appropriate meta-discursive commentary which will
enable others, within the university, to grasp the complexity of the
professional's creative mixed-mode meta-practice" (Melrose 2003, Part
3)? Is an exegesis the right vehicle for such an undertaking? How do
we replace the insistent binaries of theory–practice, despite attempts

towards a unifying praxis? Melrose (2003, Part 1) proposes "the formulation of 'mixed-mode disciplinary practices', none of which is necessarily writing-based or mediated, but some of which may call upon discipline-specific metalanguages". Such an intervention involves practices interrogated through other practices which contribute to a 'metapractice'. In relation to music, Vella similarly proposes that:

> [The] exegetical perspective does not always have to be a written text because, like the creative work, it is an interpretation. Metaphor, analysis and criticism are some devices that explain difference and similarity. The exegetical perspective can also be another creative work by the artist that provides critical context.
>
> (Vella 2005, p. 2)

Despite these suggestions for non-textual theory generation in practice-led research, it seems inevitable that text will be used in some form in doctoral outputs. So the question is not so much shall we use text, but how shall we use text to accompany our practice and what kind of text will it be? And specifically in dance, how do we write from the inside and not betray our own bodily languages? How do we articulate the theory generated inside the doing and making, and perform the intrinsic as extrinsic?

In considering these questions, we need to be mindful, that "[t]he issue is not so much one of bodies and words, but of overcoming the problem of researching what, as an artist, is essentially one's own practice" (Stock, Phillips & Vincs 2009, p. 54). Researching from the inside may well provide insights not available by other modes of research but it is also a privileged position that can easily slip into self-referentiality and thus "courts the danger of becoming a tautology – of presenting as 'findings' ideas or artefacts that are simply the inevitable products of their epistemological genesis" (ibid.).

One way of partially avoiding this is to ensure that disciplinary practices of knowing and knowledge frame personal processes so that the site of practice is clear and in turn that the broader context or field around the site of practice is addressed. Whilst context and framing the work may use propositional text, this becomes more difficult in the effort to extrapolate research findings that 'talk from the body'.

It may be argued that propositional text distorts rather than clarifies meanings arising from experiential and embodied research, not only in dance but in other creative arts disciplines. We are tasked in practice-led doctorates with rendering the tacit explicit and the reflective reflexive in order to generate theory and claims to knowledge that are transparent and sharable. In the performing arts in particular this embedded knowledge:

- Resides in the deeply immersive and intuitive practice of 'performance mastery'
- Communicates through its aesthetic and imaginative dimensions
- Embraces "the role of contingency and accident in performance invention" (Melrose 2003)
- Is manifest via expert technical skills which are a "gateway to non-linguistic thinking" (Siegesmund 2004, p. 80).

The above performative elements, conscious and unconscious, thus highlight affect in dance, described by Gilbert as "an expressive and transformational art form" (1992, p. 47).

In order to move from these forms of bodily knowing to making explicit connections that lead to meaning making and shared understandings, Philips, Stock and Vincs (2009) encourage a more open written language that complements conceptual thought arising from the practice. For theory to emerge from the practice of non-linguistic thinking, and to attempt to capture its ambiguities, written texts are therefore likely to be allusive, metaphoric, poetic and embrace liminality. Vella (2005, p.2) suggests that meaningfulness in a creative work occurs through its combination of "sensations, signs, ruptures, phenomena" and adding that the role of the artist–researcher in his view is to "formulate an exegetical perspective, a lens that provides discovery and coherent understanding, yet at the same time embraces the creative work's contradictions, anomalies and ambiguities". Marshall and Mead (2005) in writing on first-person action research studies similarly suggest written reflective practice as a way to "stay present to a range of emotional responses" and "conceptualise the learning from... experiential and iterative processes".

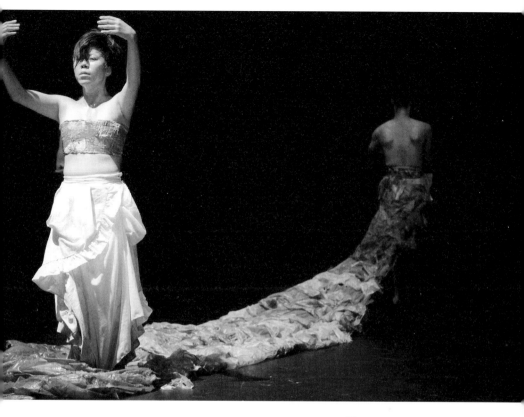

Figure 17.2

Park Younghee (Foreground)
and Jeremy Neideck, in *Deluge,*
choreography Jeremy Neideck,
photograph Richard Clifford

The struggle to articulate in textual form the seemingly unknowable, the ineffable and the ephemeral and to make holistic sense of practice as a research project challenges us to resist the binaries that can deform and trivialise the meta-level findings present in the work through its processes, generative theory and emergent knowledge. Unhelpful binaries in dance include: practice–exegesis, mind–body, theory–action and thought–feeling.

Lost in Triple Translation?

Trying to avoid binaries and textualising the affective and 'empathetic connectedness' defined by dance practice requires a kind of alchemy or translation that captures and explicates one form of experience and knowing to another, whilst retaining meanings derived from both. Only then can we claim a contribution to knowledge in academic research terms.

In translating the bodily knowing of a live performance work into mean-ingful texts for those who cannot read it from the processual inside, critical dialogue interwoven with an evocation of the practice through metaphoric or poetic text can play a significant role. It has become increasingly common to see both critical and poetic text designed on the page or screen to reflect texture and movement through non-linear means that also play with spatial, font and scale juxtapositions. These visually based experiments, when thoughtful and purposeful rather than merely decorative, can encourage a reading of the practice in less discursive ways than explanatory or interpretive text alone. But of course, these strategies to support and negotiate the tricky terrain of translation can only ever be an approximation of the primary medium of dance in other mediums... be they text or digital footage. Such interventions are not the thing itself – the artefact. Indeed, to extract transferable shared data and generative theory a triple translation takes place: from the time-based, ephemeral, fleeting and ungraspable live performance, to a digital documentation that freezes in time, to a text that turns movement and feeling into words. In eliciting a contribution to knowledge that communicates across practices, art forms and diverse knowledge domains, it would appear that such translation is essential.

One important aspect often overlooked in a viewer's (or examiner's) response is how the live work becomes embodied in memory – the recall of visceral and kinetic sensations, intuitive responses, imaginaries and ambience which provide different 'data' to the kinds of meaning generated from content, design and intention. The latter is assisted by the digital documentation which can be re-visited over and over again. Recalling the memory of the one-off experience is more difficult and probably best captured and investigated in terms of meaning-making

as soon as possible after the performance, through oral recall or associative written text.

In much practice-led research it is often the processes of the practice rather than the resultant 'artefact' that contribute new knowledge through interrogating insights arising from those processes and generating theory from them. However, immersion in the process is not possible for examiners, and often not for scholars either, except in 'translation' by the researcher–practitioner. This is a twofold problem: "evaluating *in situ* processes as well as product is not only impractical but also assumes that examiners have a depth of embodied as well as academic practice" (Stock 2009, p. 6).

Although it is possible for supervisors to immerse themselves partially in the processes in the studio, too often supervisors concentrate on the 'translations' of the work rather than looking at the work itself and how it was arrived at. I would suggest that critical dialogue and a reflective co-presence at regular intervals in the studio are invaluable for supervisors and candidates to share the experimental, experiential knowledge gained through such immersion. This provides an authentic environment to probe serendipitous and intuitive discoveries, and identify critical moments to contribute insights to the field and articulate emergent theory.

Incorporating Other World Views and Approaches

In internationally recognised doctoral programs at progressive institutions, current practice-led research:

- "Is predominantly secular in outlook" (Stock, Phillips & Vincs 2009, p. 55)
- Normally acknowledges fluid and emergent methods of practice (ibid.)
- "Favours an individuated" and at times "ego-driven approach" (ibid.)
- Comprises mainly single practitioner–researchers investigating their personal practice, albeit situated within a broader field, often in collaborative settings.

Even when research designs in practice-led or multi-modal thesis models encourage use of metaphor, poetry and allusion in trying to capture symbolic languages in textual terms, it can be argued that Western-based forms of analytical and critical discourse are still expected. Fundamentally different world views by artist–researchers working in specific or hybrid cultural contexts may be at odds with the conceptual underpinnings in these approaches. It is beyond the scope of this chapter to discuss this issue in depth but it is one that cannot be ignored in a global environment if we purport to open up new ways of seeing and contributing to knowledge in our creative practices and articulating them in flexible and appropriate forms that encompass difference.

As dance ethnographer Buckland (2001, np) notes, "dance has a particular propensity to foreground cultural memory as embodied practice by virtue of its predominantly somatic modes of transmission". In dance there are artist–researchers working through Indigenous or traditional forms and beliefs who also wish to locate themselves in a contemporary cultural context. Their world views and processes may challenge and at times discomfort those researching in more familiar modes of practice-led research. Similarly the hybrid identity of many artists working across distinctively and even opposing cultural and practice traditions suggest modes of research practice that go beyond defining cultural context and 'explaining' traditions. Whilst we can argue that the prime elements of dance are space, time and the body, these elements may be understood quite differently in different cultures. For example, in shamanistic dance, of which there are many contemporary manifestations around the world, "the dancing body is the representation of a spiritual force or entity that transcends the individual performer" (Stock, Phillips & Vincs 2009, p. 55). This practice is based on key philosophical and metaphysical notions fundamental to the world view of the artists and their cultural lineage.

Such informing beliefs and resultant practices can of course be translated via Western analytical and interpretive tools. But this negates the experiential and informed voice of the artist to create and use criteria which is appropriate to that practice and what it reveals in terms of a contribution to knowledge. Accommodating cultural differences requires that we not only foreground context more fully to value the local within the

global, but that we allow alternative modes of reporting and 'writing' to more accurately reflect the knowledge claims in the translation of practice to academia. Where the contexts of oral traditions are significant as in Indigenous cultures, or where intricate formally codified gestural languages are a key to understanding cultural knowledge, 'translation' entails other forms of interpretive intervention. Well-planned and structured video interviews which combine gestural and verbal elucidation (in more than one language, if it's necessary to reveal cadences of voice as well as gesture), together with demonstrations of movement exemplars of the practice, may assist in translating processes that stem from distinctive temporal and spatial understandings and their relationship to each other and the body. This is particularly critical in capturing holistic approaches when embodied spiritual values underpin the investigation.

Dealing with Intertextuality – Intermedia and Flexible Doctoral Packages

Inclusion of this *vox pop* kind of presentation through video interviews as partial accompanying 'text' to practice might appear crude or lightweight; but, as with all research, it is the rigour and relevance of the contribution to knowledge which is the over-riding factor. In multimodal research, the coherent combination of multiple forms also adds validity and richness to the representations of knowledge claims. Not only in dance but across the creative arts, experimentation abounds in how to include the practitioner's voice, as do the formats in which doctoral research can now be packaged and submitted (Rye 2003; Stapleton 2006).

A greater acceptance of the diversity of submission formats has been enhanced and validated by the inclusion of non-traditional research outputs for ERA (Excellence for Research in Australia), often referred to as rich media packages which capture the work in digital formats with an accompanying research statement and project description. Doctoral practice-led submissions are likewise evolving in innovative ways in an attempt to simulate the non-linear processes and outcomes of creative arts research. Increasingly, the leather-bound thesis with a pocket to include a DVD or CD documentation of the practice is disappearing.

Interactive PDFs with embedded video and hyperlinked text and imagery are now an acceptable format in some universities as are web interfaces in which the navigation bars are often not dissimilar to the contents section of a more traditional thesis or exegesis format.[1]

Moving doctoral writing to the multi-textual (and intertextual) through such integrated rich media packages has been explored by doctoral candidate Daniel Nel who refers, in the context of ERA, to a "hybrid publication" which he describes as "content created with the intent to record evidence of existence, happening, appearance – demonstrative not of the original, but a 'likeness of' or an 'existence of'". This statement goes some way to acknowledging that the durable outcome necessary for research to be a verifiable contribution to knowledge in time-based live performance is not the thing itself but a translated memory and approximation. Nel goes on to claim that:

> When it comes to the peer reviewing of the performative element the evidence of occurrence and demonstration of research or knowledge via *the captured representation becomes the key performer.*
>
> (2012, np, original italics)

Nel continues that this hybrid publication, in the creative arts, is a "multimodal, distributed and dynamic" package in which the evidence of scholarly work "can be poetically enhanced with its own language and dialects of artistry".

Thus intertextuality is no longer about different kinds of explanatory texts. For the current dance practitioner–researcher, intertextual practices may include mediated and virtual connectivity and interactivity between bodies, across geographical boundaries and in immersive dialogues between the real and the virtual – temporally, spatially and kinetically. Complex interdisciplinary structures and elements occur within the dance and in the research articulations of the dance – through the triple translation of documentation of practice, polyphonic articulations of findings, and textual theorising. This becomes the integrated danced research. Whilst not as sophisticated as the Nel model (a sophisticated 3-D software package still in development), Figure 17.3 is a guide as to what might be included in the dancing and danced thesis

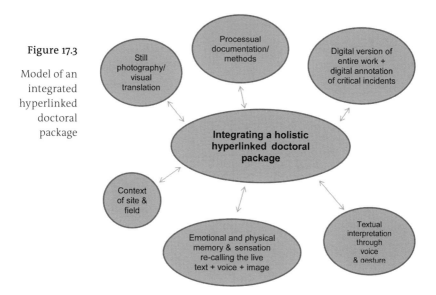

Figure 17.3

Model of an
integrated
hyperlinked
doctoral
package

in its translation from the ephemeral live performance to the durable research outcome.

Conclusion – Untapped Potential

In writing embodied practice from the inside, dance has quite specific and unique challenges for doctoral research where dancing in the present moment is central to the thesis. Harnessing dance-specific theories based around embodiment such as 'talking from the body' through a dance enactive approach, in a way which privileges deep expert practitioner knowing and acknowledges the affective dimensions of dance and the place of memory, positions the artist in a highly relevant and authentic research setting for the practice. Documenting the contexts of the disciplinary site of practice and the broader interdisciplinary field further allows the artist–researcher to engage with ways to critically analyse and articulate theory and findings residing in and emerging from dance knowing embedded in practice. Flexibility of reporting through forms of digital documentation cannot re-capture the ephemeral nature of the live performance, but can, through various forms of 'translation', articulate for others the knowledge claims residing in the

embodied experience. As Maggi Phillips, in looking to future possibilities, claims:

> Resourcefulness in documentation, if legible in the chosen media, befits the pursuit of new knowledge in the context of the as-yet un-thought/un-danced potential in interdisciplinary and culturally perceptive manifestations emerging in these multi-modal theses...
>
> (Stock, Phillips & Vincs 2009, p. 57)

References

Barrett, E. (2007) Foucault's 'What is an author?': towards a critical discourse of practice as research. In E. Barrett & B. Bolt (eds), *Practice as Research: Approaches to Creative Arts Inquiry* (pp. 135–146). London: I.B.Tauris & Co.

Barrett, E., & Bolt, B. (eds) (2007) *Practice as Research: Approaches to Creative Arts Inquiry*. London: I.B.Tauris & Co.

Block, B., & Kissell, J.L. (2001) The dance: essence of embodiment. *Theoretical Medicine* 22, 5–15.

Buckland, T.J. (2001) Dance, authenticity and cultural memory: the politics of embodiment. *Yearbook for Traditional Music* 33, 1–16. Retrieved 16 February 2013, from: http://www.jstor.org/stable/1519626.

Carter, P. (2004) *Material Thinking: The Theory and Practice of Creative Research*. Melbourne: Melbourne University Press.

Colbert, E. (2009) Accommodating the experiential within practice-led research. Paper presented at 14th Annual Australasian Association of Writing Programs (AAWP) Conference, Waikato Institute of Technology, Hamilton, New Zealand. Retrieved 18 December 2013, from: http://aawp.org.au/margins-and-mainstreams-papers.

Gilbert, A.G. (1992) A conceptual approach to studio dance, pre K-12. *Journal of Physical Education* 63(9), 43–48.

Haseman, B. (2006) A manifesto for performative research. *Media International Australia incorporating Culture and Policy* 118. Retrieved 21 February 2009, from: http://www.ingentaconnect.com.ezp01.library.qut.edu.au/content/griff/mia/2006/00002006/00000118/art00013.

Hecq, D. (2012) Beyond the mirror: on experiential knowing as research mode in creative writing. *In S. Brook & P. Magee (eds), TEXT: Beyond Practice-led Research (pp. 1–13). Retrieved 17 February 2013, from:* http://www.textjournal.com.au/speciss/issue14/content.htm.

Marshall, J., & Mead, G. (2005) Editorial: self-reflective practice and first-person action research. *Action Research* 3(3), 235–244.

Melrose, S. (2003) The curiosity of writing (or, who cares about performance mastery?). Conference paper, PARIP 2003, University of Bristol. Retrieved 12 March 2009, from: http://www.sfmelrose.unet.com/curiosityofwriting/.

Melrose, S. (2006) Not yet, and already loitering: loitering with intent between expert practitioner at work and the archive. Performance as Knowledge Symposium, Centre for Research into the Creation of Performing Arts (ResCen), London, May 2006. Retrieved 15 January 2009, from: http://www.rescen.net/archive/PaK_may06/PaK_transcripts4.1html.

Nel, D. (2012) Performative digital asset management: 'A moment in time'. Unpublished project submission for Doctorate of Creative Industries, Queensland University of Technology.

Pakes, A. (2003) Original embodied knowledge: the epistemology of the new in dance practice as research. *Research in Dance Education* 4(2), 127–149.

Pakes, A. (2004) Art as action or art as object? The embodiment of knowledge in practice as research. *Working Papers in Art and Design* 3. Retrieved 17 February 2013, from: http://sitem.herts.ac.uk/artdes_research/papers/wpades/vol3/apfull.html.

Phillips, M., Stock, C., & Vincs, K. (2009) *Dancing Between Diversity and Consistency: Refining Assessment in Postgraduate Degrees in Dance: Final Report*. Sydney: ALTC. Retrieved 20 February 2013, from: http://www.altc.edu.au/resources?text=dancing+between+diversity.

Piccini, A. (2005) A historiographic perspective on practice as research: proceedings of the PARIP conference, 29 June – 3 July 2005, Wakefield, University of Leeds, UK. Retrieved 29 December 2006, from: www.bris.ac.uk/parip/artexts.htm.

Polanyi, M. (1967) *The Tacit Dimension*. New York: Anchor Books.

Riley, S.R., & Hunter, L. (eds) (2009) *Mapping Landscapes for Performance as Research: Scholarly Acts and Creative Cartographies*. Basingstoke, England: Palgrave Macmillan.

Rye, C. (2003) Incorporating practice: a multi-viewpoint approach to performance documentation. Reproduced with permission from *Journal of Media Practice* 3, 2. Retrieved 14 April 2008, from: http://www.bris.ac.uk/parip/s_cr.htm/.

Schön, D.A. (1983) *The Reflective Practitioner: How Professionals Think in Action*. New York: Basic Books.

Schön, D.A. (1987) *Educating the Reflective Practitioner*. San Francisco, CA: Jossey-Bass Publishers.

Siegesmund, R. (2004) Somatic knowledge and qualitative reasoning: from theory to practice. *Journal of Aesthetic Education* 38(4), 80–96.

Stapleton, P. (2006) Documentation in performance–led research. *Media International Australia incorporating Culture and Policy* 118, 77–85.

Stock, C. (2009) Choreographing research: supervising the dancing thesis. *TEXT*, Special Issue No. 6, October 2009. Retrieved from: http://www. textjournal.com.au/speciss/issue6/content.htm.

Stock, C. (2010) Aesthetic tensions: evaluating outcomes for practice-led research and industry. *TEXT*, Special Issue No. 8, October 2010. *Symposium: Creative and Practice-led Research – Current Status, Future Plans.* Retrieved from: http://www.textjournal.com.au/speciss/issue8/Stock.pdf.

Stock, C., Phillips, M., & Vincs, K. (2009) Dancing the thesis: potentials and pitfalls in practice-led research. In A. Goswami, U. Sarkar, A. Ghosh, S. Saha, S. Sahai & R. Sharma (eds), *Re-searching Dance: International Conference on Dance Research* (pp. 53–59). India, New Delhi: India International Centre.

Vella, R. (2005) Keeping the degree creative. *RealTime* 68, Aug–Sep. Retrieved 20 February 2009, from: http://www.realtimearts.net/article/issue68/7916.

Warburton, E.C. (2011) Of meanings and movements: re-languaging embodiment in dance phenomenology and cognition. *Dance Research Journal* 43(2), 65–83.

Weiss, G., & Haber, H.F. (1999) *Perspectives on Embodiment, the Intersections of Nature and Culture.* London: Routledge.

Yeats, W.B. (1928) Among School Children. In *The Tower* (p. 68). London: MacMillan and Co. Ltd.

Notes

1 The images in this chapter form part of the digital documentation of doctoral candidate Jeremy Neideck, whose cycles of creative development for the work *Deluge* are presented as an interactive PDF with embedded photos and video excerpts. The transcultural creative work is the product of a long-term collaboration between Australian and Korean artists exploring a process interweaving *butoh* and *pansori* (traditional Korean theatre forms).

GLEAMS OF LIGHT: EVOLVING KNOWLEDGE IN WRITING CREATIVE ARTS DOCTORATES

Diana Wood Conroy

From the mid-1980s to the present, art schools have embedded themselves within university structures in Australia. Around 35 universities now offer research degrees in creative arts (Baker & Buckley 2009). Accompanying this development, the teaching of art practice and theory has followed the humanities in embracing philosophies of semiotics and post-structuralism from Europe and America through the lenses of feminism and postcolonialism. At the same time, exhibitions such as the Sydney Biennale (since 1979) and the Asia-Pacific Triennale in Brisbane (since 1993) have allowed a new familiarity with international movements in countries beyond the centres of Paris, London and New York. In this crucial thirty years, Indigenous arts in Australia have moved from a museum context to penetrate major galleries and to enchant international audiences. This whirlwind of evolving parameters in art has changed not only the writing of art theory but also the voice of the artist. Doctoral candidates since the late 1990s have worked in

seminars with international students from non-English speaking back-grounds from China, Taiwan, Indonesia, Malaysia and Iraq, permitting a transnational approach to research. Increasingly, the artist as doctoral candidate has become not only the subject of critical analysis, but also the author presenting his or her work through a process of self-reflexivity that has been vital to the new thinking, especially in feminist writings of subjectivity such as those described by Sidonie Smith (c.1993). This chapter explores the idea of a new kind of 'canon' emerging through the experimental research and writing of creative doctorates in Australia.

To state the obvious: because the writing of practice-based doctorates happens within the institutional framework of the university, candidates are subject to the academic rigour applied to all PhDs. It is not 'creative writing': there are structures and conventions to observe, such as word length and format. Creative arts doctorates in the intellectual space of the university have had to contend with the perception that creative arts research is grounded in intuition and feeling, through the necessity of the use of the 'first person' to discuss practice. Rather than denying this often-inflammatory notion of 'intuition', I would like to extend and develop it as a crucial aspect of visual and performance disciplines.

But first, to understand where we are now in Australia it is helpful to trace the relatively short time span in the development of the creative arts doctorate. Janis Jefferies (Goldsmiths College, London) pointed out in 2010 that the practitioner–theorist came to the fore only during the 1980s, an era in which scripto-visual, or text and image, production dominated debates within the studio and the academy.[1] In 1984 at the University of Wollongong (UOW) in New South Wales, the University Senate endorsed an entirely new Doctor of Creative Arts degree for arts practitioners. Nicholas Krauth describes the enormity of such an inno-vation in the university system at the time (Krauth 2011). Devised by Professor Edward Cowie of the freshly established School of Creative Arts, it put forward a model where exhibitions and performances in visual arts, music and drama could be assessed as research, together with a thesis. The degree was entirely research-based, with no course work, and was judged equivalent to the conventional PhD (Bunt & Miller 2013). The first graduates were all mature practitioners of high standing

in the arts, such as the painter Peter Shepherd (thesis entitled *More than the portrait: the intangible with the immediately visible as a painter interprets his subject*, 1989); Irene Amos (thesis: *Relationship to tradition: an investigation of the process from invention to communication*, 1989); installation sculptor and sound artist Joan Brassil (thesis: *The Poetic Vision*, 1991) and sculptor from Holland, Jose Aertes (thesis: *A touch of loneliness: from loneliness, emptiness and silence to essence*, 1992).

Since I began supervising creative arts doctorates at the University of Wollongong in 1998 (after graduating myself in 1996) I have been involved, like many colleagues, in the effort to explain creative arts research as bearing original knowledge to the mainstream of academic research; that is, to university research committees composed of individuals from the faculties of Arts, Law, Engineering, Informatics, Science, Education, Health Sciences and Medicine. These are the battlegrounds for attaining doctoral scholarships in competition with other areas, scholarships that pay fees and living expenses. Scholarships are essential for the transmission of knowledge, for training the next round of creative arts academics and arts professionals across the wider society.

What stands out when moving from faculty to faculty (in broad processes of assessment in promotion rounds or sitting on appointment committees) is the necessity for discipline-specific doctoral writing, even when theories from philosophy, anthropology or literature may contribute to the visual and performing arts research. Exegetical writing about creative work is very testing because of the expectation and understanding of the place of subjectivity within the wider university. The 'first person' is still a radical space even when supported by a critical context of reference and scholarship. Rather than concealing what Vice Chancellor Gerard Sutton used to call 'the soul' in arts practice, the best writing in creative arts doctorates does embrace what could be called a 'critical subjectivity', placing the body of work in context, allowing affect and feeling through a variety of strategies. The 'first person' may intersect with sections in the 'third person'. Highlighting the intrinsic direction of the particular practice by staging its materials and objectives within the specific discipline (e.g. textiles, sculpture, photography) allows the creative arts doctorate to compare favourably to long-established PhD research in, say, Geo-science or Archaeology. Scientists and

archaeologists want to comprehend creative arts doctorates as speaking to a distinctive realm of knowledge with its own exacting standards. They assume that the best research will intersect with the crucial ideas within a discipline. It is understood that intuition and sensory experience may be central to this idiosyncratic arena of creative arts but the understanding of this works best when situated in the context of a particular discipline. In a 2012 forum at the University of Wollongong, the 'citation' science disciplines and the 'peer reviewed' humanities disciplines were compared in terms of the 'Excellence in Research for Australia' (ERA) rankings. ERA was an assessment system evaluating the quality of the research conducted at Australian universities in 2010 and 2012 by measuring performance in every discipline. This ensured public accountability for money spent on research and provided detailed information about the research strengths of universities (http://www.arc.gov.au/era/faq.htm). The Humanities were asked to give defined benchmarks in order to clarify research quality and achieve the higher rankings of science disciplines. Quantifying research for its greatest strategic reach is the current university position and can be alarming and challenging to experimental contemporary arts.

Valuable studies (some noted by Janis Jefferies; see endnotes) have highlighted the parameters of 'practice as research', such as Paul Carter's book *Material Thinking* (2004), in which he emphasised the intellectual calibre of art works by Australian artists. James Elkins provided examples of what he called 'visual literacy' which acts as a counter weight in its complexity and range to textual description and analysis (Elkins 2008, pp. 1–2). Supervisors such as Elizabeth Grierson[2] have taken to writing overviews of the creative doctorate to give lucid and practical suggestions not only in organising content but also to building a coherent and articulate text. The issue of writing is linked inexorably in the minds of both supervisor and candidate to the nature of supervision itself. It is the supervisor who oversees the birth of writing in artists who may have written little until this point, in a process that is comparable to the task of a midwife. The issue of writing for candidates also attaches ultimately to examination, which is the object and aim of the exercise.[3] The end purpose of doctoral writing is to be examined by experts, who need to see that the research question, the body of work, is linked to the thread of an argument throughout the supporting text. These examiners are for

the most part academics engaged actively in ERA or Australian Research Council (ARC) assessments and review. Creative arts examiners, just like examiners in the sciences, want the research of creative doctorates to be both specific in focus and an original contribution to knowledge in the overall discipline, bringing us back to thinking about ensuring quality within the creative doctorate beyond the tenets of pedagogy.

After supervising to completion more than thirty doctorates and research master's (and seeing many others fade away before completion), I think I can say that there is a new form emerging, an experimental yet cogent and articulate doctorate that is comprehensible and acceptable across the academy – and yet there are difficulties. I found the difficulties located in myself as supervisor, as much as in the candidate, so that each supervision brings the necessity of listening to every glint of direction, being open to the emotional tenor in what is not said, as well as maintaining an intellectual detachment in bringing to bear wider ideas and contexts to the particular fiery feelings and vulnerability of practice. I am always aware that there is a certain element of non-literacy in artists – who, like myself, may think through images, not in abstract language, nor in sequences of texts. There is a reason why artists or performers with a mature and well-recognised body of work find it difficult to write: their first recourse is their particular vocabulary of practice. Discursive thinking links ideas in writing in a way that may not appear logical to artists. So often what the postgraduate artist speaks and thinks is not in the text, although the ideas may sound coherent and persuasive in discussion. The action of making comes easily compared to the often-agonising textual component. Many drop out of their research degrees through their inability to conceptualise in text. A vivid imagination does not interfere with coherent and articulate speech, but it may inhibit the learning process involved in obtaining an ease of writing.

As the ancient world, and current indigenous worlds, know well, the spoken word does not really relate to the written word. "*Logos* in its spoken form is a living, changing unique process of thought. It happens once and is unrecoverable," wrote Anne Carson (Carson 1986, p. 132). She goes on to discuss Socrates speaking in Plato's *Phaedrus*. Socrates is amazed that the written word is static and not interactive:

> Writing, Phaedrus has this strange power, quite like painting in fact; for the creatures in painting stand there like living beings, yet if you ask them anything they maintain a solemn silence. It is the same with written words. You might imagine they speak as if they were actually thinking something but if you want to find out about what they are saying and question them, they keep on giving one message eternally.
>
> (*Phaedrus*, section 275 d–e; cited in Carson 1986, p. 132)

This seeming fixity of text may seem deadening if it can't be allied with the perceptive imagination, and I think this has been my constant challenge as a supervisor: to illuminate writing, to make writing as 'intuitive' as practice, by using perhaps lateral strategies. (Interestingly Socrates related the same fixity to painted images, compared to the flow of movement and light in the perceived world.) Once the writer knows the craft of writing, said Socrates, the text will become like a living organism, "a live creature with a body of its own, not headless or foot-less but with middle and end fitted to one another and to the whole" (cited in Carson 1986, p. 132, Phaedrus, section 264e).

It is striking that the word 'writ/write' comes from an Old High German word *riz* meaning stroke or written character, implying an act of making (OED). One doctoral candidate was not able to write with any degree of fluency until he had unleashed a torrent of strokes and marks in blue pen onto the long interconnected pages of a concertina notebook as a simulacrum of 'writing'. The 'living text' is often grounded in the artist's journal, drawings or notebooks. Like anthropologists working in the field, artists observe and experience with a heightened sensitivity in their given area. The anthropologist Michael Taussig pointed out the value of the fieldworker's notebook as an alternate form of knowledge, because it has "at least one foot grounded in sensuous immediacy" (2011, p. 49). Another quality of what he calls 'new thought' is highly physical and theatrical. "It is something that happened and continues to happen in your language and memories involving real people talking about other people in situ" (ibid., p. 51).

Here I want to highlight the strength and wonder of the artistic position and then show how inherently visual or performative faculties might translate into writing. Of central importance, as mentioned before, is the

fact that the candidate is enmeshed in the larger issue of the place of creative arts within the academy. Doctoral research is the cutting edge of new knowledge in any discipline of the university. How can we deal with intuition and feeling in an intellectual space? First, before looking at strategies to bring the text alive, it's useful to understand this strange business of the intuitive faculties that are so central to art practice. Discussions by Elizabeth Grosz (2004), Ruth Lorand (1999) and Charlotte de Mille (2011) reconsider the impact of Henri Bergson's early-twentieth-century ideas of the interaction between intellectual modes of enquiry with their scientifically measured time, and the faculty of intuition, which Bergson related to artistic perceptions and a felt, inner experience of time.

Ruth Lorand (1999, p. 401) wrote: "the concept of art serves for Bergson as a means of illustrating his brand of dualism across intellect and intuition. In this chapter I reverse directions and examine Bergson's theory as a means of understanding art". She describes his belief that art was 'paradoxical' in that it was unpredictable, yet imbued with a certain kind of order. Despite their duality, in some loose sense, there is an asymmetrical, negative interaction between the two orders of intuition and intellect: Lorand puts forward that "from intuition one can pass on to analysis, but not from analysis to intuition" (ibid., p. 407). She argues that art demonstrates that the intuition is not only capable of operating on geometrical or intellectual orders, but also that the interaction between the orders is necessary as artwork involves both formal (intellectual) and intuitive invention across language and materials. Being an artefact, a work of art cannot be completely detached from and independent of intellectual thinking.

Stating that "Bergson claims that the two orders reflect the operation of the mind" (ibid., p. 409), Lorand pointed out that this implied a bond between the two distinct orders: "It could not have been the *same* mind if its faculties were to operate independently one of each other. The mind is able to move from intellectual order to intuitive order and back again; therefore the two orders cannot be entirely alienated" (ibid., p. 410). She goes on to discuss the necessity for an idea of 'disorder' in comprehending art. "The fragmented, disordered chunks of experience initiate us to put them in order; each order answers different needs. Art offers new vital orders that consist of materials taken from our chaotic experience or from orders that no longer satisfy us" (ibid., p. 415).

In an earlier discussion of ideas about the aesthetic and the sensuous, Duke Madenfort (1974) wrote that intuition for Bergson is a form of immediacy, and meant the kind of sympathy by which we place ourselves within an object in order to coincide with its inexpressibly vibrating qualities flowing in duration. He identified the aesthetic as an experience of entering into direct communion with reality itself and that art could "bring us into direct contact with sensuous immediacy" (ibid., p. 10), the same phrase used by Taussig. Intuitive knowledge, Madenfort thought, was "unmediated by any conceptualisations, is itself perfectly rational as a product of sensuous immediacy, widening a conception of rationality far beyond traditional boundaries" (ibid., p. 15).

Further reflections on the contemporary ambience of the creative doctorate come from Charlotte de Mille, who in 2011 used Virginia Woolf's writing to explore intuitive processes in accordance with what she calls "the most thorough expositions of intuition as method, that of the philosopher Henri Bergson" (2011, p. 371). De Mille arrives at the idea that the spark that ignites the process of art is material and physical sensation and therefore it is crucial for the art historian or writer to articulate art from within the experience of it. How can the writer, who may also be the artist, seek what the artist does not say, what is intuitively enmeshed in the work? Is it possible to make a re-affirmation of immanent possibility in an artwork, of exploring the multiple referents beyond surface appearance? She points out that in Woolf's world "subject and object oscillate alarmingly in correspondence to shifts in the author's, narrator's, or reader's capacity for intuition" (ibid., p. 376). In Woolf's search for the new, the modern, she required a radically new method, not founded on rational analysis but rather in "a fluid psychology of intuition and empathy" (ibid., p. 377). De Mille's study identified "an intensely empathetic vision as the crux of intuitive perception, and re-negotiated a role for an experiential, sensation-based methodology which in its lack of self-interest nevertheless retains those prizes of disinterest and objectivity" (ibid., p. 384).

Another useful approach for self-reflexivity comes from the cultural theorist and critic Mieke Bal, in discussing the work of sculptor Louise Bourgeois. Bal says: "The concept 'autotopography' refers to autobiography while also distinguishing itself from the latter. It refers to a spatial,

local, and situational 'writing' of the self's life in visual art" (2002, p. 184). She emphasises that what is most characteristic of the artist's work is its visual nature. The inherent visual nature of the artist, like the textual nature of the writer, relates itself to the wider patterns of the visual culture it inhabits.

It is often the case that contemporary art practice stretches the boundaries of genre. For example, Volume 1/3 of the dOCUMENTA catalogue includes 100 'documents' that accompanied the 2012 exhibition in Kassel, Germany. It illustrates a range of modes and the actual documents of research – the detailed notebooks of Walter Benjamin, the writings of the Norwegian tapestry weaver, Hannah Ryggen, and recovered and battered archives from artists probing what the curator, Carolyn Christov-Bakargiev, calls the 'striations' of art – all combine as 'visual evidence' for the way art comes to change perceptions through leaps and stabs in experiencing the world as it is. As with this catalogue, the creative practice doctorate sits comfortably in this company; it can be written in a variety of genres with the same longing to excavate meaning.

Having described the contemporary ambience of the creative doctorate, the next step here is to flesh out the idea with actual examples of inserting the individual artistic self into an institutional, scholarly context. Between 2010 and 2012, I coordinated an experimental seminar for a fast-track doctorate, the Senior Artists Research Forum (SARF), and supervised the group of eight mature artists with colleagues Dr Penny Harris, Associate Professor Brogan Bunt, and professors Sarah Miller and Amanda Lawson. The four men and four women were between the ages of 43 to 59 with a high level of attainment in their fields.[4] Their fields ranged across sculpture, photography, design, architecture, scenography, performance, sound and theatre. Three managed to complete their doctorates by the end of 2012, despite competing professional commitments, and the others are on track to finish in 2013–2014. A crucial observation here is that there is a world of difference between young artists who have just graduated and are beginning the PhD, and mid-career artists with a highly resolved practice and professional experience. The resilient competitiveness necessary for success in the art world made for an immensely lively group and a determination to grapple with writing as a necessary career achievement.

A key point emerging from these seminars became a vital area for me as both artist and supervisor, and that is the one constantly put forward by the inner critic: how do I stop the exploration of self from diving into narcissism and therefore becoming of less value to the world of scholarship? How can I maintain that intuitive individuality of practice and, at the same time, an 'objectivity' towards self?

Professor Peggy Phelan, visiting from the US, made precisely this point in a seminar she gave to the Forum in August 2011.[5] She suggested that in taking on a practice-based doctorate, you have to confront the self and different relationships to the self – on the page. She used the term 'radically pragmatic' in admitting to a certain level of narcissism in order to push self-reflectiveness further: "to see as if for the first time how I don't understand my flickering image reflected in the deep pool". In order to take up one's own archive – the artist's documents and files – you have to emulate Narcissus briefly. But in order to avoid sheer egotism it was imperative to think through major influences and make clear your own epistemology and particular way of knowing within the discipline. What does practice teach us that is worth knowing, rather than poorly understood 'philosophy lite'? One of the women said she would be "grateful to adopt narcissism as self-expression was often last on the to-do list." Peggy Phelan advised the candidates: "Keep alive the sense of a narrative voice that has the capacity to surprise, re-tell your sense of discovery in a work and bring other artists/thinkers who relate to the work along with you. It is great to document work that might otherwise be lost. Lead with the work and who has inspired you".

The intrinsic force of intuitive modes of thinking discussed above by De Mille, Bal and others can therefore be brought to bear on archives of practice and the zone of affiliations that they represent. The doctoral candidates among the SARF group who most quickly became writers began with documenting a selected archive of their own exhibitions and performances that encapsulated a particular question that led forward, a query that needed urgent addressing. Learning to archive and describe accurately honed research skills.

At the same time, the underlying research focus and question became clearer as each person read widely into the context of, say, a particular

year. I emphasised linear chronological sequences in making sense of sometimes-inchoate material. Simple modes of writing a description of an installation and how it came to be that way, even in 'rave' form as a transcription of spoken discussions, were the beginning of understanding the coherently structured chapter. "Write first, research later", as Australian author Rodney Hall said once in a seminar, can be a useful strategy in beginning.

In some cases, lurking insights of what was most significant might draw on the wounds of childhood or early adolescence and the passion of the doctorate was to mitigate and comprehend this subjectivity within the objective knowledge of art-theoretical and historical contexts. The breadth of experience in the group encompassed the sub-cognitive worlds of animals, place, sleep and violence as forces that shaped practice. Being excited about the personal field of research enabled writing to emerge, although the first chapter might often go through three or four drafts. And then suddenly, it became easier.

The textual choices that were made by the senior artists in their final submissions varied. One sculptor chose to focus on a personal archive, documented as if it were a museum collection, and learnt to write clearly through the discipline of describing. A performance artist wrote from a holistic bodily approach, particularly the senses of sound and touch. An installation artist who was also a photographer struggled to write anything in the beginning, but overcame barriers to writing by first telling me key stories that had informed his practice, and then writing them down as poetic texts that were interspaced through more scholarly writing. Another architect and designer, who had travelled widely, structured his writing around a postcolonial narrative of place in an elegant, succinct style. In all cases the initial 'rave' storytelling identified the main focus and allowed the more formal texts to emerge.

Sometimes it seemed to me that around the edge of the seminar table stood another idiosyncratic circle of participants – those thinkers and artists whose work was constantly referred to by individuals in the group and whose influence had formed what might be called the 'cutting edge' of contemporary practice. From the very beginning of our discussions these included such classic artists as Pieter Brueghel (*The Fall of Icarus*

with the corpse in the thicket), Rembrandt (*Flayed Ox*) or Von Guerard's paintings of New South Wales. More predictably, the philosophers Jean Baudrillard, Pierre Bourdieu, Gilles Deleuze, Felix Guattari and Julia Kristeva were constantly present, as were cultural theorists and critics Marina Warner and Elizabeth Bronfen; writers Roland Barthes, Samuel Beckett, Jorges Luis Borges and Italo Calvino; art historians and theorists such as Georges Didi-Huberman, Rosalind Krauss and Michael Fried, among many others. Local thinkers Paul Carter, Ross Gibson, Stephen Muecke, Elizabeth Grosz and Ann Stephen and Tony Fry sat among throngs of Australian artists. A great crowd of directors, dramatists and installation artists came to the table: influential ones included Thomas Struth, Barnett Newman, John Cage, Marina Abramovic, Mary Kelly, Bill Viola, Joseph Kosuth and Susan Hiller. Those candidates involved in performance referred to August Strindberg, Edward Albee, Harold Pinter, Howard Barker, Peter Brook, Elia Kazan, Amelia Jones, Dennis Oppenheim, Alfred Hitchcock, Percy Grainger, Jerzy Grotowski and Roma Castelluci, among many contemporaries. As explained below, being in Cyprus became a catalyst for exploring Vitruvius, Plato, Aristotle and Euripides, sometimes through the writing of the poet and critic Anne Carson. European and American culture was at the forefront for this group of mature artists. In the shadows stood unnamed but formidable Indigenous artists, a shaping presence in contemporary Australia. Reading and writing are intimately connected – you learn to write by reading – and the richness of language across many texts began subtly to permeate those halting chapters until they became fluent. Each candidate had a group of such mentors to refer to, like the little figurines of ancient deities that clustered on Sigmund Freud's desk.

Thesis writers can obscure the clarity of written expression through a desire to sound more 'academic'. In his book *The Legacy of Rome* (1992, p. 12), Richard Jenkyns quoted George Orwell on the heavy Latinising of English. Orwell set out a sentence from the Book of Ecclesiastes in the King James Bible: "I returned and saw under the sun that the race is not to the swift, nor the battle to the strong, neither yet bread to the wise nor yet riches to men of understanding, nor yet favour to men of skill, but time and chance happeneth to them all." He translated it into a modern English version: "Objective considerations of contemporary phenomena compels the conclusion that success or failure in competitive activities

exhibits no tendency to be commensurate with innate capacity, but that a considerable element of the unpredictable must invariably be taken into account." Concrete nouns and shorter words of Anglo-Saxon and Germanic origin give the older text a poetic strength and resonance compared to the familiar obscurity of the later one.

In taking a group of seven SARF candidates to Cyprus, I hoped to demonstrate the relevance for artists of concrete activities of working in the earth and with excavated objects. Doing fieldwork became possible because of my annual involvement with the University of Sydney's Paphos Theatre excavation in western Cyprus.[6] We joined the large team of around fifty archaeologists and students drawn from Australia and Europe and worked with them for a week. Practice as a way of knowing is mirrored in archaeology. Learning the principles of the horizontal grid of space and the vertical stratigraphy of time in the sides of trenches made the chronological sequence and the mapping of the site comprehensible. Photographing and drawing objects precisely required detailed scrutiny of texture, weight, and dimensions from all angles. Reading plans became an analogy of laying out a text. Archaeology is a discipline that veers towards science because it is dominated by the interpretation of material evidence of the past. The visual evidence presented in plans, graphs, drawings and photographs (and increasingly, forensic and microscopic analysis) forms the actual contribution to knowledge, as it does in a creative arts doctorate. The ability to describe and analyse objects, and place them in the context of parallel sites, is central. Knowledge can be drawn out of the object's materiality, the scale, texture, fabric, colour, shape, style and context with other objects of the same space and time. This is thinking through the object itself, not through abstract terms, and this approach was a kind of epiphany for those struggling to write. As well, for many in the group, working in teams in the excavation trenches of the ancient theatre became like another kind of performance in real time.

As the excavation progresses, a great archive of fragments and objects is lifted from the earth to be inventoried and classified. The artist's or performer's archive mimics this highly disciplined process of archaeology, and the objective methods of the archaeological archive can make the individual inventory more restful and attainable by comparison

with the great flux of stuff from the past. Time as visually constituted in vertical stratigraphies and spatial grids became a useful tool in setting out sequences and typologies in the artist's own archive. It becomes clear that drawing and writing are closely related, and that one leads to the other through intricate processes of documentation joining subjective and objective modes. The space of the inventory of works can open doors for visual and performative thinkers in communicating their physical and metaphysical positions.[7]

I was not sure how the remarkable Byzantine painted churches of Cyprus would affect Australian artists. Being in the dim spaces of domed medieval churches high in the mountains was like entering another time when imagery had a different and redemptive power compared to the ubiquitous contemporary image. In fact, the intensity of dark colour among gleams of gold and the refraction of light in the painted spaces shook up the photographers and sculptors to think freshly, and the intermittent music of the liturgy that floated up to the house where we worked together became part of a later performance.

To conclude, my reading into the articulation of intuition and intellect in the written component of the creative arts doctorate shows that there is indeed a kind of reason (*logos*) inherent in artworks that can stand beside other disciplines and be understood by them. The format, sophistication and rigour of the textual component of the creative arts doctorate continue to crystallise since its inception in the 1980s through the joint labour of supervisors, examiners and the researchers themselves. My experience in supervising creative arts doctorates suggests that an interactive milieu in seminars in museums, libraries or sites has great impact on quicker completions, although individual one-on-one supervision sessions continue to be essential. The Senior Artists Research Forum was a special case that showed the effectiveness of providing a supervisor dedicated to a group of research candidates, a supervisor who could provide both continuity and stimulation. Candidates who all start together learn from observing others in a similar stage and learn to trust the group's varied responses. The process pinpoints individual positions as intrinsic to that group ethos. Comprehending the larger theoretical scope in 'intuitive' ways provides momentum for individual artist–writers. From within the academy, the mature artist–researcher

makes a gift to the wider knowledge systems in the university. For the creative disciplines, the doctorate is a compelling way to present the 'sensuous immediacy' of arts practice in a rational, discursive text that, in the end, will open up contemporary arts to new audiences.

References

Baker, S., & Buckley, B. (2009) *CreativeArtsPhd: Future-proofing the Creative Arts in Higher Education*. Strawberry Hills, NSW: Australian Learning and Teaching Council.

Retrieved from: http://www.olt.gov.au/resources?text=Creative+Arts+Phd.

Bal, M. (2002) Autotopography: Louise Bourgeois as builder. *Biography* 25(1), 180–202.

Barker, C. (2012) *Aphrodite's Island: Australian Archaeologists in Cyprus: The Cypriot Collection of the Nicholson Museum*. Sydney, Australia: University of Sydney.

Bunt, B., & Miller, S. (2013) The boundary riders: artists in academia/artists and academia. Unpublished conference paper, Effective Supervision of Creative Arts Research Degrees Symposium, Queensland University of Technology, 7–8 February.

Carson, A. (1986) *Eros the Bittersweet: An Essay*. Princeton, NJ: Princeton University Press.

Carter, P. (2004) *Material Thinking: The Theory and Practice of Creative Research*. Melbourne: Melbourne University Press.

Christov-Bakargiev, C. (2012) *dOCUMENTA (13) The Book of Books, Catalog1/3*. Ostfildern: Hantje Cantz Verlag.

Elkins, J. (ed.) (2008) *Visual Literacy*. New York and Oxon: Routledge.

Grosz, E. (2004) *The Nick of Time: Politics, Evolution and the Untimely*. Australia and New Zealand: Allen and Unwin.

Jefferies, J. (2010) Situated knowledge: the subjective and the personal in Creative Arts Research. Conference paper, Faculty of Creative Arts, University of Wollongong.

Jenkyns, R. (1992) *The Legacy of Rome: A New Appraisal*. Oxford: Oxford University Press.

Krauth, N. (2011) Evolution of the exegesis: the radical trajectory of the creative writing doctorate in Australia. *TEXT* 15(1). Retrieved 29 July 2013, from: http://www.textjournal.com.au/april11/Krauth.htm.

Lorand, R. (1999) Bergson's concept of art. *British Journal of Aesthetics* 39(4), 400–415.

Madenfort, M. (1974) The aesthetic as immediately sensuous: an historical perspective. *Studies in Art Education* 16(1), 5–17.

de Mille, C. (2011) Sudden gleams of (f)light: intuition as method? *Art History* 34, 370–386.

Paltridge, B., Starfield, S., Ravelli, L., & Nicholson, S. (2011) Doctoral writing in the visual and performing arts: issues and debates. *International Journal of Art and Design Education* 30(2), 88–100.

Smith, S. (c.1993) *Subjectivity, Identity and the Body: Women's Autobiographical Practices in the Twentieth Century.* Bloomington: Indiana University Press.

Taussig, M. (2011) *I Swear I Saw This: Drawings in Fieldwork Notebooks, Namely My Own.* Chicago and London: University of Chicago Press.

Notes

1 Janis Jefferies (2010) in a lecture 'Situated Practice' at UOW referred to: Sullivan, M. (2005) *Art Practice as Research: Inquiry in the Visual Arts.* London: Sage; Smith, H., & Dean, R. (eds) (2009) *Practice-led Research, Research-led Practice in the Creative Arts.* Edinburgh: Edinburgh University; Elkins, J. (2009) *Artists with PhDs: On the New Doctoral Degree in Studio Art.* USA: New Academia Publishing; Makela, M. (2007) Knowing Through Making: The Role of the Artefact in Practice-led Research. *Journal of Knowledge, Technology and Policy* 20(3); Bourdieu, P. (1990) *The Logic of Practice* (trans. R. Nice). USA: Stanford University Press; Bourriaud, N. (1998) *Relational Aesthetics,* (trans. Simon Pleasance & Fiona Woods 2002). Les presses du réel; Bal, M. (2008) Research practice: new world on cold cases. In M. Holly & M. Smith (eds) (2008) *What is Research in the Visual Arts? Obsession, Archive, Encounter* (pp. 196–211). New Haven: Yale University Press.

2 Grierson, E., & Forrest, D. (eds) (2010) *The Doctoral Journey in Art Education: Reflections on Doctoral Studies by Australian and New Zealand Art Educators.* Melbourne: Australian Scholarly Publishing; Grierson, E., with Laura Brearly et al. (2009) *Creative Arts Research: Narratives, Methodologies and Practices.* Rotterdam: Sense Publishers.

3 An 'Asynchronous Workshop' was organised online, 27–30 August 2012, for the Australian Postgraduate Writers Network by Professor Jen Webb (University of Canberra), Professor Donna Brien (Central Queensland University) with Dr Sandra Burr and Dr Antonia Pont (Deakin University). Co-ordinated by myself, the response to the theme 'Examining Higher Degrees in the Creative Arts' indicated a depth of feeling in the participants about supervision, the lack of training of supervisors, and preparation for assessment in combining scholarly and creative aspects of the doctorate.

4 The then Dean of Creative Arts, Professor Amanda Lawson, initiated the formation of the group with an ad in the Higher Education Supplement of the *Australian* newspaper in October 2009. Out of 18 respondents, 8 were selected.

5 Professor Peggy Phelan holds the Ann O'Day Maples Chair in the Arts at Stanford University USA and was a Visiting Professor at the Faculty of Creative Arts, University of Wollongong, 1–15 August 2011. Her books include *Mourning Sex: Performing Public Memories* (London: Routledge, 1997) and *Art and Feminism* (London: Phaidon, 2001).

6 Works from the Senior Artists Research Forum appear in *Aphrodite's Island: Australian Archaeologists in Cyprus*, Nicholson Museum, and in the exhibition *Response to Cyprus* at the Centre for Classical and Near Eastern Archaeology at the University of Sydney, 2012–2013.

7 See Walter Benjamin's notebooks and archives: dOCUMENTA (13) 2012: No. 001, Michael Taussig, 'Fieldwork Notebooks', p. 60; No. 045, Nikola Doll, 'Walter Benjamin Paris Arcades', p. 316.

STRATEGIES FOR ARTISTS BECOMING WRITERS: TACKLING THE WRITTEN COMPONENT OF PRACTICE-BASED RESEARCH IN THE CREATIVE AND PERFORMING ARTS (A REPORT FROM THE REGIONS)

Sean Lowry

There are clearly already many debates across the creative arts and performing arts concerned with the various ways in which creative practice might constitute research within a postgraduate degree. Some debates directly address the question as to when (and if) it is appropriate to consider artistic practice as a vehicle for communicating new knowledge, whereas others are more concerned with establishing models for preparing and evaluating the written component that typically accompanies practice-based artistic research at a postgraduate level.

Although, as some have argued, the accompanying written component need not always assume the form of a scholarly text (and there

are certainly good reasons for entertaining this possibility), this chapter will nevertheless assume a preference for the production of a substantial and clearly structured written dissertation working in concert with practice-based components. Moreover, in this chapter, I will argue that this relatively conventional format actually presents some surprising advantages for artists who are relatively inexperienced with research culture. Given that it is the symbiotic configuration of an artistic outcome *and* a scholarly text that together facilitate a full comprehension of the overall thesis, and given that artistic practice is characteristically resistant to *specific* comprehension, I will argue that it is paradoxically within the maintenance of something of the conventions of a scholarly text within the overall thesis equation that the more discursive, speculative and experimental creative component project can be experienced as new knowledge.

With the parameters of artistic practice constantly expanding, and disciplinary categories continuously blurring, it is probably reasonably sensible for artists who are relatively inexperienced with academic research culture to opt for a relatively structured approach when it comes to preparing the accompanying dissertation component. Alert to the potential danger of overly prescriptive definitions of the relationship between thesis components, and responsive to ongoing debates about the legitimacy of such research, I will nonetheless argue that – given that it is now a reality (for better or worse) that more artists are applying to undertake doctoral research, that more institutions are accepting doctoral candidates with relatively limited academic experience, and that academic staff are expected to supervise such candidates – a modest collection of pointers directed at the task of assisting artists in the task of becoming writers is something worth assembling.

With notable exceptions, and despite the centrality of text within much contemporary art practice, many artists are relatively less familiar with presenting their ideas in writing than they are in utilising what Canadian philosopher David Davies has usefully nominated as their "vehicular medium"; that is, the physical elements constituting a creative work or performance (Davies 2004, p. 59). After all, although artistic works may contain words, the philosophical condition of art presumably requires the distinction that art is framed as something other than

parallel activities such as writing or speaking about art in order to form a cultural object capable of being perceived as art. Given that producing art and writing about art are distinct activities, the development of scholarly writing skills for artists is clearly a requisite ingredient if these two fundamentally different activities are to be happily married. In many cases, relative unfamiliarity with scholarly prose is particularly exacerbated in the case of candidates from regional, lower socio-economic, or non-English-speaking backgrounds. As a supervisor working at a regional Australian university at which many students are the first in their family and peer group to contemplate higher education, the prospect of translating ideas seemingly locked within the languages of artistic expression into the structural expectations of the academy presents a consistent challenge.

At the same time, as competing participants in the institutional race to conscript more and more doctoral candidates, regional universities are perhaps even more predisposed to accept candidates with little or no academic experience into their doctoral programs. Although this tendency has enabled more artists to avail themselves of the opportunity to undertake academic research, the role of the supervisor in terms of managing the often-difficult transition from artist to artist–researcher is obviously fundamental. With many regional students geographically and socially positioned outside of direct access to metropolitan artist networks, the supervisor is often the key to facilitating connections between candidates and suitable art institutions and communities. Here, the supervisor can even build confidence by pointing to some of the benefits of a regional perspective in terms of providing a point of difference within global networks. Just as many artists have critically framed or thematically positioned their geographical or cultural distance from global centres as significant to the development of their respective practices, so too might the regional artist-becoming-researcher potentially see afresh some of the limitations embedded within the often-solipsistic concerns of metropolitan institutional contexts and artist networks. After all, a predilection to question the legitimacy of a perceived centre is preferable to the falsely knowing nod of a so-called insider. Significantly, the strategies for artists becoming writers presented within this chapter have been developed within the context of working as a supervisor in a satellite campus of a regional university.

Getting Started: Artists Becoming Writers

Broadly speaking, the increased use and legitimacy of text in the visual arts is symptomatic of a desire to communicate a critical response to the image inundation that defines much contemporary human experience. Although activities such as writing, reading and listening are often substituted for looking, or in some other way for extending an aesthetic experience, it is nonetheless important to draw a distinction between the creative use of text *in* art and scholarly writing *about* art. In other words, to acknowledge that there is an important (yet of course not necessarily mutually exclusive) difference between writing creatively and analytically is the first step toward developing a scholarly text that might serve as a suitable vehicle for transmitting new knowledge via a reflection upon, and in concert with, an aesthetic conduit to *experiencing* new knowledge. This distinction is often worth making to candidates setting out to radicalise the form of the written dissertation: although this aim is understandable and perhaps even commendable within the context of art education, it is ultimately potentially counterproductive to the task of legitimising a platform for artists to communicate their ideas academically. With exception, in conforming to the structural expectations of academic prose, the candidate is arguably freer to explore the experimental possibilities of the creative component of the overall thesis – an option that is invariably attractive to many artists.

Unfamiliarity with academically structured language, coupled with a default to descriptive accounts of art making, are both tendencies that remain inadequately addressed at an undergraduate level at many universities. This can be particularly exacerbated at some regional universities. Although undergraduates are expected to write, the reality is that writing is not as central in the creative and performing arts as it is in most academic disciplines, and this is compounded by a still broadly institutionalised separation between theory and practice. Thus, a delay in the development of a critically analytical relationship between practice and writing is unsurprising. This situation leaves many candidates ill prepared for undertaking the written component of research. Postgraduate research is a complex undertaking, even without adding an inexperience with academic writing to the mix. Fortunately, the speculative and maverick processes of imagining through creative

production, paired with a structured supervisory approach, and patient attention to the form and relationship of the overall thesis to each of its constituent parts, can foster increased confidence and autonomy as the research project grows. Once confidence evolves, candidates can start to evolve from the simpler processes of evaluation and reflection toward the process of developing an accompanying critical analysis of the ideas that underpin their practical work.

There are clearly many ways in which the divergent nature of contemporary creative practice might influence approaches to the dissertation component. Just as *anything* might potentially become material for an artistic project, the manner of research methods and models available to artists can vary enormously. If we start with a comparison of approaches at polar ends of the spectrum, the range of difference is obvious. Some conceptually or linguistically grounded forms of practice, in which the process of making is relatively perfunctory to the realisation of the creative work, are clearly far removed from more process-oriented or intuitive approaches, in which constitutive parts might more typically remain dynamically responsive to one another whilst they evolve. Within the latter scenario, research outcomes generated through a process of *thinking through making* are generally more likely to call for the next move as they develop. At any rate, the practical component has evolved both within, and in historical relationship to, a specific network of contextual relations. Although *context* is invariably both boundless and fuzzily defined, all we are really looking for is sufficient context within which to frame a specific research question. There are invariably many questions that one could potentially explore in relationship to a discursive artistic practice. It is generally sensible to accept in advance that attending to *all* possibilities is beyond the scope of a single candidature. If we instead recognise the candidate's artistic practice more broadly as something which, at this particular juncture, serves to facilitate the framing of a research question whilst, at a later date or in a different context, potentially serving quite separate and distinct ends, we are at least part of the way toward making a useful distinction between art (in and of itself) and the specificities of artistic research.

Notwithstanding the aforementioned distinction between conceptually defined and more intuitively generative creative practices, and

despite the inherent dangers and contradictions that are incontrovertibly associated with the institutional nature of the whole undertaking, the first task invariably becomes that of establishing a coherent topic of investigation. Given that institutional demands to develop a plan at an early stage can prejudice artists without conceptual previsions, candidates without the confidence to resist the deformation of research can require additional supervisory support in order to limit the potentially prescriptive hand of institutional hoops. Meanwhile, since practical and scholarly written components are typically inter-responsive, the dissertation needs to be considered right from the outset in order to avoid becoming an adjunct illustration formed in retrospect. To this end, a series of dynamically interrelated structural components should be considered, and then consistently revisited. Here, delineation of the field and the confidence to discard peripheral issues becomes crucial.

The investigation might start within the language of the candidate's own creative practice. In this way, in the words of U.S. art historian Richard Shiff, "a work of art becomes a hypothesis-in- the-making, as if it were calling out, 'explain me, put me in order, give me a lasting purpose.' Why this, not that?" (Shiff 2011, p. 11) Yet communicating a research hypothesis using artistic practice as a vehicle for communicating new knowledge is not the same activity as that of producing or beholding art. At this juncture, it is also probably worth reminding the candidate that the research topic may reflect a focus other than art as aesthetic experience, and perhaps more importantly within the context of defending practice as research, that it is finally the originality of the claims that are at stake rather than the originality of the art itself. Being mindful of this distinction can potentially reduce any self-expectation that the entire creative work in and of itself need somehow be both defensibly 'original' and wholly accounted for within the dissertation.

Once a provisional list of elements begins to develop, the task of gradually transforming this provisional list into a map can commence (this part of the process is the beginning of forming the literature review or equivalent). In this context, a 'map' is differentiated from a list in terms of its emphasis upon relationships between constituent parts, whilst an 'element' can potentially be anything from a related artist's work to a theoretical model or historical political, philosophical, technical

or social tendency that has in some way informed, underpinned or provided a point of departure for the candidate's practice (either directly or indirectly). As these elements are grouped together, the following question might be asked of each potential element: "How and why does this element serve the emerging thematic of the group (i.e. provisional subheading) and, in turn, serve the emerging thematic of the overall thesis?" If a connection cannot be made, the element can be placed back on a list for later consideration. Stressing that this provisional list is dynamic and open to constant revision, it is important to remember that in many ways the real value of this process here is that of breaking the enormity of the whole undertaking into manageable, snack-sized portions.

Considering the Relationship between Practice-based Components and the Scholarly Text

Although the creative work might be directly discussed where appropriate as a case study, the prospect of devoting an entire exegesis to the candidate's own work in the same breath as its historical exemplars is arguably often a recipe for the very worst kind of writing in the field. The candidate should remain mindful of the important difference between describing one's own practice and the task of analysing the ideas that underpin it against a carefully framed ground. This is an important characteristic of art scholarship. It is not an argument for or against the relative merits of artists doing PhDs (good and bad artists clearly both do and don't do PhDs). Regional programs in particular are often afraid to really stress this distinction. The challenge here is to encourage speculative and experimental creative thinking without supporting fluffy scholarship. The relatively open and pluralist playing field of the creative and performing arts arguably avails an opportunity for both advanced and muddy scholarship to try its hand. Moreover, its speculative and discursive nature understandably often makes it difficult, and in many cases extremely problematic, to mark a clear distinction between the two. Thinking through making and thinking through writing are not the same thing, yet at the same time neither activity is equivalent to its relatives outside the academy. In any case, it is worth noting that the criteria for evaluating practice-based research and evaluating art are not the same thing. Or, as Australian artist, writer and academic Adam

Geczy has controversially put it, "art is not research" (Geczy 2009, p. 207). For Geczy, given that orthodox research models require an implicit idea to be made explicit, in the case of art, that which is made explicit is not necessarily clear to organised reasoning. It is for this reason that Geczy supports the idea that the written component of a PhD thesis should conform to conventional research definitions (ibid., p. 209).

Ultimately, the research degree, which might include practical, creative works of any kind alongside a written component, is finally assessed in terms of its perceived contribution to knowledge. Since art operates in a distinct realm that playfully muddies clear distinctions between repetition and difference, making a defensible claim about art, in and of itself, and its contribution to new knowledge is extremely tricky. The slippery slope toward the contradictory assertion that all art is at once original by virtue of the unique and unrepeatable conditions of its individuated context, and yet unoriginal by virtue of the necessity of a relationship to previous works in order to be even read as art, can be avoided by simply regarding the creative component as a vehicle for the experiential comprehension of new knowledge. In other words, it is what the art specifically does within the context of the research outcome that is important. Significantly, this is not the same thing as its *raison d'etre* when operating as art. Working in concert, all components must advance a case or set of claims that are significant, original and robustly supported. A research degree is an apprenticeship in becoming a researcher. It is not a validation for artists. For Robin Nelson, a champion of practice-based research: "it is time to speak less of practice-as-research and to speak instead of arts research (a significant methodology of which just happens to be based in practices)" (Nelson 2006, p. 116).

Remaining mindful of the value of artistic practice as a more useful conduit for certain aesthetically based forms of communication and knowledge transference than the more conventional forms of written language that still dominate the academy, it is still important to remind the candidate that although the creative work might play a central role in supporting the overall thesis, it is not necessarily literally translatable into the scholarly text and vice versa. In playing these distinct roles, it is ultimately what the practice-based and scholarly text components do

together that is important. It is the dynamic potential of this relationship that really differentiates practice-based research from the wholly text-based paradigm. Given that research aims to uncover and communicate new knowledge, the distinguishing features and legitimacy of practice-based research are based on an assumption that some tacit forms of knowledge are potentially discoverable and communicable through the production and experience of creative works. Consequently, although the significance and context of claims to knowledge are described in words, a full understanding can only be obtained through direct experience of all outcomes. In this sense, an aesthetic experience can be regarded as something that might assist in the task of unlocking forms of insight and understanding that are potentially elusive in an exclusively theoretical proposition. To this end, British philosopher Elizabeth Schellekens presents a convincing argument for the necessity of aesthetic interpretation even in cases of hard-line dematerialised (and so-called anti-aesthetic) forms of conceptual art. Accordingly, she describes the way in which an aesthetic experience can help both to "instantiate" an idea and to turn a prosaic and abstract proposition into something experiential or, as Schellekens describes it, "experiencing the idea" (Schellekens 2009, p. 81).

An acknowledgement of the partial or complementary role of the scholarly text is of course something that the text itself might articulate. Highlighting this acknowledgement upfront can also provide comfort to artists who are driven toward postgraduate research as a way of validating their creative practice (either as a promotional tool, or in order to get a job teaching art in the university culture that has, for better or worse, entirely taken over art schools). In this context, the dissertation is simply performing the requirement that otherwise tacit or implicit forms of knowledge be made explicit.

How Do I Talk about My Own Work?

Just as the distinction between 'outcomes' and the 'documentation' of creative outcomes is often (and sometimes deliberately) blurred in contemporary art parlance generally, and given that exegetical elements are sometimes included within exhibited creative works, approaches toward the discussion of practical work within the

dissertation component of a thesis can vary enormously, especially in creative projects containing conceptual, interdisciplinary, dynamic and unfolding outcomes. Generally speaking, however, although each outcome attends to the same overall thesis, the text need not literally 'explain' the work in and of itself. In a limited sense, the text provides a form of explanation, but it does so via an analysis or interrogation of some kind, and in concert with a realm of discourse that evokes expanded comprehension. The candidate might choose to devote a section to their work in the form of a case study. Here, success is somewhat dependent on whether the decision to transform artistic motivation into a research project was necessarily the best option in the first place. Unless some form of a frame is constructed in order to place the creative work in relationship with a significant question or problem, the solipsism that potentially emanates from simply grandstanding one's own creative work can invite a situation in which distinctions between art and research are further confused (whilst doing neither any favours). Such confusions also potentially compromise the worthwhile conviction that practice-based research both fills a gap in established models and addresses bias toward the stand-alone thesis as the only appropriate forum for the presentation of research.

For British philosopher David Pears, "practice nearly always comes first" in knowledge production, for a discriminatory response typically precedes an ability to codify that response (Pears 1972, p. 29). For Pears, this pre-emption is evident "if only because the use of distinct symbols to codify them is itself an example, indeed a sophisticated example, of a discriminatory response" (ibid.). Yet despite the seemingly defensible nature of such arguments, the validation of thinking through making still often finds itself on shaky ground, especially within the new world order of university research measured against economically determinable 'key performance indicators' (or KPIs). Notwithstanding the historical challenge that embodied forms of knowledge have posed to the locus of knowledge and power in the Western academic tradition, we are still invariably drawn back to a perceived need to justify the value of practice in words. Consequently, for better or worse, our postgraduate research candidates need to be ready to operate in this still-dominant paradigm.

Having taken on-board the function and necessity of the scholarly text component within the overall thesis equation, it is of course also extremely important that the candidate remain mindful of the central function of the practice-based component. The challenge of balancing creative experimentation and the structural constraints of the candidature involves leaving sufficient time and space for the overall thesis also to remain informed through and by the process of creative production. Quite aside from the specificities of formalised artistic research within the context of the academy, the process of the artist being directly and consciously informed via the feedback loop of artistic production itself is well documented in relationship to the history of modernism. This process, which is very clearly articulated by Shiff, is one in which the artist affects the work and, in turn, the work affects the artist, and is often revealed through hitherto unexpected turns (Shiff 2011). To lose sight of the generative value of this process is to lose sight of the potential for creative production to exercise its point of difference within the academy. Of course, since research is generally described as the creation of new knowledge and/or the use of existing knowledge in new and creative ways in order to generate new concepts, methodologies and understandings, critical analysis of these 'hitherto unexpected turns' is perhaps more easily distinguished as research than the more problematic claim for originality in the artwork itself.

In stressing that the component parts of the overall thesis should not be comprehended separately, and therefore by extension not assessed separately, we dispel the myth that the function of the text is simply 'theory' in the form of an apparatus through which the practice is presented. It is not the case that imagination is assessed through the creative work and intellect via an exegesis. Although a cogent argument might be made for a specific relationship between the dissertation and the overall thesis, and correspondingly a specific relationship drawn between the creative work and the overall thesis, this parallel conception does not predicate a literal equivalence. Although many artists are very capable of historically and culturally contextualising their chosen subject and identifying and analysing key ideas, many still fall over when addressing the task of writing about their own work. Once again, we encounter an additional reason as to why it is generally advisable to think about the scholarly text as something that specifically addresses the ideas that underpin

the particularities of the creative process, which assists in facilitating comprehension of the research question, rather than as a descriptive and solipsistic account of the relatively more discursive qualities of the whole practice. After all, the often-discursive nature of an artist's entire practice is bound to be much larger than the specialised forms of knowledge production expected of institutionalised postgraduate research.

Keeping Things under Control

Right from the outset, and in conjunction with the aforementioned mapping exercises, it is also important to address formal aspects such as layout, clarity, style and referencing. Time invested early in setting up repeatable patterns in the use of appropriate language and structure can potentially avert an insurmountable editing task near the end of the candidature. Inexperienced writers and candidates from non-English speaking backgrounds can respond well to repeated and rigorous co-editing of early fragments of text, particularly if it is done in such a way that it is related to developing the actual content. Here, whilst pointing to the value of clear writing and maintaining an analytical tone, the supervisor also can repeatedly ask the candidate how and why each sentence relates to the next, how each paragraph serves the specific contents of the subheading or chapter in which it is contained, and in turn how it serves the overall thesis. This way, whilst developing formal language skills, superfluous material is more quickly and efficiently discarded. Consistently maintaining this approach is a great way of keeping a relatively inexperienced writer on topic, particularly (generalisations aside) inexperienced writers in possession of the characteristically wandering mind of an artist.

Meanwhile, it is also important to stress some of the structural idiosyncrasies of writing in the creative arts – a field that is characteristically speculative, and in which lines of argument are typically better accommodated within an air of modesty and deference to the art of disclaimer. In this sense, the difference between declaring that "it is" and modestly suggesting that "in some cases, it might therefore be argued that" can potentially distinguish reasonable from indefensible arguments in the eyes of the final examiners. Given that cultural interpretation is contingent, inescapably influenced by the social and

historical context of the author, it is generally best to avoid fixed and singular interpretations that appear to make a claim to legitimately reflecting truth. Consequently, the use of language is very important. Language designed to reflect upon or weigh up nuanced possibilities (e.g. "on the one hand *this*, yet on the other hand, *that...*") generally works better than polemical hyperbole. To a certain extent, we handle specifics by generalising, and in doing so we might reflexively acknowledge paradox and contradiction where appropriate. After all, paradox and contradiction are inextricably linked to the whole enterprise of generating, framing and understanding cultural production. For U.S. critic Eleanor Heartney, "the tension between the demands of the individual and the demands of the collective can never be completely resolved" and moreover, "it is out of this tension that culture grows" (Heartney 1997, p. 7). If we accept that irresolvable dialectical tensions underpin the very nature of cultural evolution, we might in turn accept that new knowledge in the creative arts is also often bound up in processes of becoming rather than found in fixed and immovable destinations. Consequently, for artists becoming writers, it is often the case that these tensions and processes of becoming tend, in themselves, to become the subject of our analysis. Remaining mindful of these tensions, and that a key point of difference that practice-based research brings into the whole equation is that of experientially embodying these processes of becoming, the writing is potentially less likely to get carried away with problematic claims. Luckily, artists are often characteristically suspicious of the potential for generalisation to slip into ideology. Ultimately, careful framing, limiting, and the use of moderating disclaimers will likely attenuate the possibility of being accused of making unsubstantiated claims by the final examiners.

Is it Good Enough?

There are currently widely differing conceptions as to what constitutes an appropriate quality of intellectual argument and written expression acceptable at a PhD level in the creative and performing arts. There are also many different conceptions as to the nature and relative weighting of the relationship between the written and practical components. In any case, it is important to reflect consistently upon whether the candidate is communicating the intent and realisation of the thesis effectively.

Does the overall project demonstrate knowledge of key critical ideas, research methodologies and professional standards within the field, and more specifically those underpinning the specific research project being undertaken? Does it demonstrate competence in research and execution? Does the creative component demonstrate a technical and/or material proficiency appropriate to the communication of the claims being made in the overall thesis? And finally, is the overall thesis of publication and/or exhibition standard? If the specific methodological, theoretical or formal requirements of the project are clear, it should be assumed that the thesis be judged on those grounds. Although some argue that broadly applicable criteria for excellence are unnecessary, and that an experienced assessor should be able to comprehend some theses on the strength of the creative component alone, the context is usually manifestly unclear without a well-articulated dissertation.

Although broadly speaking, aesthetic judgment is a subjective union of sensory, emotional and intellectual responses, it soon becomes clear that the position of using sense perception (such as visuality) as the only criterion for forming an aesthetic judgement is potentially problematic. One alternative option is to employ functional analysis – i.e. to look at how the work functions to convey meaning – as an additional aesthetic criterion for judging the 'success' of a creative work. Another is to consider the social and cultural context of the work's production and reception. Once we start to introduce these expanded forms of evaluation, we are already looking outside of the work itself – and potentially toward the domains of speaking and writing. At any rate, without a good contextualising argument, it can be difficult to determine anything other than professional skill or formal qualities in the work, and harder again to determine its specific context and contribution to knowledge.

Despite the enormous workload that is often created for supervisors, the task of supervising a candidate with sophisticated ideas yet lesser academic writing skills is arguably still preferable to the task of supervising relatively empty-headed candidates armed with all the prerequisite academic bells, whistles and rhetorical flourishes. Artists, particularly from regional, lower socio-economic or non-English-speaking backgrounds, are often relatively more sophisticated within the specific language of their chosen medium than they are within the

structural confines of academic writing. The challenge is somehow to strive to balance the value of the scholarly dissertation as a key element within the overall thesis equation against the danger of unnecessarily prejudicing otherwise strong candidates without confident academic language skills. In a climate in which more and more artists are taking up postgraduate research, and in which academic staff workloads are increasing, we should nonetheless endeavour to facilitate the translation of advanced practice-based artistic activity across the full diversity of the creative arts into the structural expectations of the academy without losing sight of the key points of difference that characterise artistic practice as a form of knowledge production.

Ultimately, the creative and performing arts are central to our society's cultural and political discourse, and consequently form an essential part of the way in which we understand ourselves and the society that we live in. Although practice-based creative research is becoming relatively more established in the academic world, for some, its legitimacy as an outcome is still misunderstood. Perhaps, for the time being, and in order to avoid prescriptively limiting the experimental and speculative potential of advanced artistic research, the task of legitimisation is made easier in conjunction with a clear and coherently structured dissertation component. As artists operating within the somewhat foreign lands of university culture, let us (in repurposing the words of Friedrich Nietzsche) keep our "bird flights into cold heights" (Nietzsche 1878) as free as it is humanly possible – if only by way of a partial concession to the role of this structural formality.

References

Davies, D. (2004) *Art as Performance*. Oxford: Blackwell.

Geczy, G. (2009) Art is not research. *Broadsheet: Contemporary Art + Culture* 38(3), 207–209.

Heartney, E. (1997) *Critical Condition: American Culture at the Crossroads*. Cambridge: Cambridge University Press.

Nelson, R. (2006) Practice-as-research and the problem of knowledge. *Performance Research* 11(4), 105–116.

Nietzsche, F. (1996 [1878]) *Human, All too Human* (trans. M. Faber). Cambridge: Cambridge University Press.

Pears, D. (1972) *What is Knowledge?* London: Allen & Unwin.

Schellekens (2009) The aesthetic value of ideas. In P. Goldie & E. Schellekens (eds), *Philosophy & Conceptual Art* (pp. 80–81). Oxford: Oxford University Press.

Shiff, R. (2011) Every shiny object wants an infant who will love it. *Art Journal* 70(1), 7–33.

DELEUZE'S HAMMER: INTER-TEXTUAL TOOLS FOR DOCTORAL WRITING WITHIN PRACTICE-LED RESEARCH PROJECTS

Robert Vincs

Context

As practice-led research in the creative arts has been admitted as a relatively new, and perhaps slightly dishevelled, member of the academy, it is fair to say that many of the practice-led research projects that have occurred over the past decade or so have demonstrated, with various levels of success, a pioneering approach to the methodology and writing style that seemed appropriate to each individual research project. To its credit, the academy has demonstrated a large degree of trust and tolerance in the fledgling concept of the artist as researcher. Equally, pioneering artist–researchers and their supervisors have been strong advocates for the inclusion of arts practitioners by way of practice-led research into the academy. However, although diminishing, the role and style of text expressed as an exegesis within the practice-led research project still remains a source of vigorous debate.

A question is now emerging as to whether there should be an orthodoxy developed to regulate the nature of doctoral writing within practice-led research projects for the purposes of achieving a minimum scholarly standard. This is not to suggest that early research has been unscholarly, rather, that the diversity of approaches to knowledge production within the creative arts arguably makes it more difficult for the artist–researcher to have confidence that his/her individual approach will be validated by an examination panel. If knowledge is an economy, then an equivalent metaphor might be the European Central Bank's regulation of the monetary policy of the EU member states for the purpose (ostensibly) of facilitating an easy flow of money across the EU. The proposition that a large, over-arching body has an absolute power over its constituents may seem frightening and particularly likely to be resisted by artists; however, it may be argued that minimum standard frameworks are useful in communicating information flows efficiently, thus allowing the artist–researcher to concentrate on the substance of their argument, embracing a more or less standardised approach to the exegesis.

This discussion will identify issues that work against practice-led research and complicate the notion of writing within practice-led research projects. I will then propose one model for articulating text within a practice-led artistic research project based principally upon ideas arising from the writings of Gilles Deleuze. Using some of the philosophical tools that Deleuze proposes, it is possible to construct a research methodology that situates the role of text as a rational, 'active' observer and interrogator of both the creative process and the subsequent artefacts that are developed within the research question. This methodology does not destroy the integrity of the artefact and deepens the artist–researcher's ability to explicate the study in a manner that may communicate with an expert peer group and lay audience alike.

The Problem

As an academic, I welcome the efficiency and transmissibility of text to communicate an idea or proposition. As an artist, I am suspicious that text is overly valued by the academy because of its efficiency as a commodity, one that is heavily weighted against experience, which

some would argue is the 'true' knowing. Writing in the academy is difficult for artists not because the skill of writing eludes them, but because, as poet Rainer Maria Rilke (1903, p. 1) expresses, "Things aren't all so tangible and sayable as people would usually have us believe; most experiences are unsayable, they happen in a space that no word has ever entered, and more unsayable than all other things are works of art, those mysterious existences, whose life endures beside our own small, transitory life." The problem for artist–researchers then is how to formulate an approach to doctoral writing within practice-led research projects that maintains the work of art as a "mysterious existence", yet which is able to communicate the nested web of questions that the artefact, and the process of creating the artefact, transmit without allowing the text to stand as a surrogate for the artefact.

In developing a set of tools capable of shaping a practice-led research project, it is useful to take a step back (or perhaps forward?) and return to ask the question, what is knowledge? This is a useful question because it separates 'knowledge' (knowing) from 'information'. However, this chapter will focus upon the concept of knowing arising from experience and developing a framework that can account for the artist observing the self from multiple points of view (an inter-textual dialogue). Nevertheless, a key proposition of this chapter is the idea that the artefact/s that are generated within practice-led research projects possess qualities of knowing/experiencing that cannot be transduced into a representative textual account; hence, practice-led research projects do not convert easily into the currency of knowledge trading. Mao Tse-tung had an interesting perspective on this. Mao (cited in Andresen et al. 2000, p. 229) states:

> All genuine knowledge originates in direct experience... human knowledge can in no way be separated from practice... practice is higher than [theoretical] knowledge. Whoever wants to know a thing has no way except by coming into contact with it, that is, by living [practising] in its environment... practice, knowledge, again practice, and again knowledge... such is the dialectical-materialist theory of the unity of knowing and doing.

Mao's perspective identifies knowledge as "living [practising] in its environment." If this is so, then the artist–researcher is obliged to move

from living (practising) within a studio environment to, living (practising) within an academic environment.

The essential difference is that the academic environment obliges the artist–researcher to observe their individual creative process, artefact and context critically. The artist becomes the observer and the observed. I argue that this duplicity of being is the origin of difficulties artist–researchers have in writing about their work. Science writer Michael Frayn (2006, p. 65) neatly expresses the question: "How do we select what we observe without first having a theory that determines what's relevant and what isn't?" From the artist–researcher's perspective, do we have a theory of self prior to entering the academy? How do we observe ourselves 'knowing and doing' if we cannot understand 'what's relevant and what isn't' with regard to our practice? What theoretical lens do we bring to the act of self observation and observation of artefact as 'mysterious existence?'

Practice-led research projects could either be initiated from a theoretical premise or an experiential phenomenology. In either case, to maintain the writing as an equal partner in the research, and not a surrogate for the work itself, an observational style of writing is appropriate. However, Frayn reminds us of the twentieth-century philosopher Karl Popper (in Frayn 2006, p. 66) who instructed his Viennese physics students to:

> take a pencil and paper; carefully observe, and write down what you have observed!' They asked, of course, what I wanted them to observe. Clearly the instruction, 'Observe!' is absurd... Observation is always selective. It needs a chosen object, a definite task, an interest, a point of view, a problem. And its description presupposes a descriptive language with property words; it presupposes similarity and classification, which in their turn presupposes interest, points of view and problems.

For Popper, the act of observation implies a problematisation of the observed phenomena where there is an immediacy to adopt a theoretical standpoint from which to make an observation. Visual artist and theorist Barbara Bolt, in discussing Heidegger, takes a different view where she argues that there needs to be a space for contemplation and a sense of 'handling' prior to theorisation. Bolt (2007, p. 30) states, "we

do not come to 'know' the world theoretically through contemplative knowledge in the first instance. Rather, we come to know the world theoretically only after we have come to understand it through handling."

Bolt's use of the term 'handling' is useful in this context because it reminds us that practice-led research has an experiential aspect that has a sometimes physical, emotional, social, spiritual, rational, irrational, psychological reality that may be beyond the capacity of a single theoretical lens to account for; and also, that the 'knowing' that arises from a practice-led research project is often latent and needs time for rumination. Therefore, practice-led research, because of its experiential nature, almost invariably occupies an inter-textual space that arises prior to theorisation. As a result, our initial problem – balancing the work of art as a 'mysterious existence' yet communicating the nested web of questions the artefact and its process of creating transmit – needs to be expanded to include space for the exegesis to layer multiple ways of knowing simultaneously, without necessarily needing to tie the research to a singular narrative. This may sound difficult, yet this mode of expression is modelled for us everyday through our use of *hypertext* on the Internet where information and knowledge is nested within concurrent narratives navigated at the reader's discretion via embedded *hyperlinks* or other meta-textual devices, such as *wikis*.

Whilst hypertext and hyperlinks may or may not be used as a structuring device for the research in question, the concept provides a useful model for inter-textual dialogue that has the distinct advantage of de-territorialising the 'point of view' observation that Popper (in Frayn 2006, p. 66) speaks of. However, a 'point of view' observation is arguably more usual in the traditional knowledge economy of the university because the point of view observation insists that knowledge is territorialised into discrete disciplines. A discipline will partition knowledge from 'all' that is observable through the language dynamics of that discipline and the tools of measurement appropriate to that discipline. When Popper (in Frayn 2006, p. 66), "presupposes a descriptive language with property words" it is easy to see how a knowledge modality emerges based upon the inclusive or exclusive use of 'property words'[1] that fortify the boundary of a discipline. From my own discipline, music, a good example of this partitioning is the distinguishing of 'music' from 'noise'. From

the perspective of a music artist who works in the medium of so-called 'noise', this distinction is false. However, for many music institutions, noise has no validity within music because the descriptive language of music that is understood within a music department cannot assimilate the property words that belong to noise.

Having been territorialised, knowledge can then be commodified and traded within the orthodoxy of peer-assessment and within an eco-system of knowledge production. Perhaps lacking the alchemical ability of turning practice-led research into the currency of the university 'proper', artist–researchers find it difficult to trade in the knowledge economy of the academy. For the artist–researcher, this presents a problem. At the moment of knowledge production, where the researcher is actively engaged in generating new knowledge and potentially expressing this knowledge via a multi-layered or inter-textual dialogue, the artist–researcher, within a doctoral program, cannot be sure that an examination panel will validate the knowledge generated as worthy of admission into the academy. This may be because the examiner deter-mines that the knowledge expressed does not sufficiently embrace the descriptive language and property words that populate and territori-alise the knowledge modality to which an artefact is said to belong. This is particularly true where the research maintains a concurrent inter-textual approach.

The problem of doctoral writing within practice-led research now reads in two parts:

1: How do we formulate an approach to doctoral writing within practice-led research projects that maintains the work of art as a 'mysterious existence' yet is able to communicate the nested web of questions the artefact, and the process of creating that artefact, transmits without allowing the text to stand as a surro-gate for the artefact?

2: How do we apprehend and/or value the knowledge that is made explicit through practice-led research as an inter-textual, multi-layered dialogue that is independent of discipline-specific territorialisation?

A Solution – The Mode of Existence

Gilles Deleuze offers a knowledge construct that may be adapted by the artist–researcher to construct a methodology and style of doctoral writing within practice-led research projects that resolves the identified problem. Deleuze (2006, p. 10) calls this tool a 'mode of existence'. He states,

> For any proposition is itself a set of symptoms expressing a way of being or a mode of existence of the speaker, that is to say, the state of forces that he maintains or tries to maintain with himself and others.

If we substitute the term 'artistic work or process' for Deleuze's word 'proposition' (arguably, an artistic work or process is a proposition), and substitute 'indications' for Deleuze's word 'symptoms' and 'the audience' for 'others' then it could be said that "Any work of art or artistic process is itself a set of indications expressing a way of being or a mode of existence of the artist, that is to say, the state of forces that the artist maintains with him-/herself and the audience."

Deleuze's statement is significant because it addresses the work of art not as an endpoint or artefact that may then be deconstructed for the purpose of ascertaining the work's meaning; rather, Deleuze introduces the idea that a work of art may be an assemblage of 'symptoms' or indications expressing a 'way of being'. By implication, the way of being may be in a constant state of flux with ever-changing relationships to the artist. Deleuze (2006, p. 3) states:

> We will never find the sense of something (of a human, a biological or even a physical phenomenon) if we do not know the force which appropriates the thing, which exploits it, which takes possession of it or is expressed in it. A phenomenon is not an appearance or even an apparition but a sign, a symptom which finds its meaning in an existing force.

The artist as researcher is then compelled to investigate the 'forces' that 'appropriate' the artist in the act of creation and the forces that 'appropriate' the artefact. The work of art in and of itself has meaning only to the observer to the extent that the observer, in this case the

artist–researcher, engages with or 'handles' the object. Bolt's concept of 'handling' within a contemplative space comes into play here. When the artist–researcher is the observer to both the creative process and the artefact of their making, there needs to be a time for unrestricted documentation, contemplation and playfulness with points of view. It may not be immediately apparent which forces come into play, which forces have appropriated the artist, which forces have appropriated the audience or which point of view to adopt.

The tools of observation include journaling, casual writing, video and audio documentation, and these are essential to establishing the *prima materia* or data set relevant to the research project. Writing at this level can be casual, scattered, non-sense as it forms part of the generative oeuvre of the research. However, it is within this domain or data set that, upon investigation, themes or the essence of the research question itself may emerge that challenge the artist to explain what he/she is observing and to find critical pathways into the apprehension and contextualisation of the artefact. Importantly, what property words does the artist researcher use to identify the 'symptoms' that have expressed themselves within a work of art and the associated data set? The words the artist–researcher uses offer significant clues in determining what 'forces' compel the researcher to choose a point of observation. To restate Popper (in Frayn 2006, p. 66) "Observation is always selective" – but what motivates the artist–researcher to the selection of that point of view?

In Deleuzian terms, the artefact is also a 'symptom' or indication of a mode of existence for both the artist and the audience. What is the state of 'forces' that the artist maintains with him-/herself? As the artefact is an expression of those forces, how does the audience become appropriated by those forces? And, what might those forces be? Deleuze's concept of forces allows for the possibility that an individual or collective is an *assemblage* of social, political, economic, spiritual, psychological and physical influences that express themselves through the artist. Significantly, those forces may include states of being that do not have representation within the academy, or are thought to be symptoms of mental illness, but are nevertheless to be accounted for as generative within a mode of existence rather then as pathological to knowledge

proper. Hence, an act of creativity is the real-time balancing of these forces and the consequent artefact becomes the physical expression of those forces as an articulation of a mode of existence.

Compared with the rigid boundaries that territorialise the various disciplines, a mode of existence acts more like a semi-permeable membrane or a balloon that filters new knowledge into an expanding consciousness. The mode of existence draws into itself the raw materials of 'intensity' from Deleuze and Guattari's conceptualisation of the plane of consistency. Deleuze and Guattari (1988, p. 70) describe this paradigm thus:

> The plane of consistency, or planomenon, is in no way an undifferentiated aggregate of unformed matters, but neither is it a chaos of formed matters of every kind. It is true that on the plane of consistency there are no longer forms or substances, content or expression, respective and relative deterritorializations. But beneath the forms and substances of the strata the plane of consistency (or abstract machine) *constructs and combines continuums of intensity*: it creates continuity for intensities that it extracts from distinct forms and substances.

Unlike Popper's concept of descriptive language and property words, the mode of existence within the plane of consistency is like a machine that continually creates and destroys intensities. Intensities here are defined as the moment-to-moment experience of human beings, understanding 'being' not as a fixed construct but rather an emergence of human becoming. For the artist–researcher writing within the academy, this can be a vital tool in understanding his/her work in a space beyond structure and semiotics into an assemblage of forces that form into an existential artefact.

The Exegesis

An exegesis may be defined simply as "a critical explanation or interpretation of a text, especially of scripture." (Stevenson 2010) If we leave out the idea that an exegesis is necessarily scriptural, then we could also say that an exegesis is a 'critical explanation or interpretation of an artistic work'. If we substitute the idea that a critical explanation or interpretation is actually, in Deleuzian terms, an expression of the forces that find

expression within an artefact, then we could say that an exegesis is an articulation of the artist's mode of expression. Therefore, an exegesis is also a text-based articulation of the forces that manifest themselves within an artefact. This is significant because it is only the artist that can identify the forces that were present in the making of artistic work and is therefore justified as an internal observer, observing the self. Conversely, a simple understanding of the term exegesis leaves open the possibility that the 'critical explanation or interpretation' could be achieved by someone other than the artist.

In this context, the exegesis is an expression of a mode of existence that illuminates the artefact from a variety of observational vantage points, not only discipline-specific observations. For example, the discipline of music, when understood only through the interaction of melodic, harmonic and rhythmic patterns and excluding from observation its psychological, spiritual, socio-political and economic dimensions, has a limited value. By way of metaphor, imagine going to America's Grand Canyon and taking the view from only one observation deck, compared with the experience of hiking and camping in the canyon, rafting down the Colorado river, flying over the canyon in a helicopter, observing the micro-climate and animal behaviour unique to the canyon, learning about the Hopi Indians indigenous to the region and so forth. Arguably, this latter form of exploration is a richer experience for the observer having immersed him-/herself in the experience of the observed.

In this context, the exegesis is expressed in a naturalistic way where observation and the handling of phenomena prior to theorisation is restored to a place of value within the academy. However, Frayn (2006, p. 65) demonstrates the weight of the opposition to this way of being within the academy:

> Popper, like Einstein, rejects the traditional view of science as proceeding from the observation of phenomena to the construction of theories that explain the phenomena. How do we select what we observe without first having a theory that determines what's relevant and what isn't?

The mode of existence, upon handling, allows for the artist–researcher to determine what's relevant and what isn't, crossing discipline boundaries

to arrive at a truth that may be expressed as an exegesis. The mode of existence is able to examine the interaction of forces as they continually self-organise up until the moment an artefact is completed. Arguably, single-node knowledge theorisation does not have similar flexibility and always becomes entangled in its own jargon. Frayn (2006, p. 8) reminds us of Dawkin's Law of the Conservation of Difficulty, which states that, "obscurantism in an academic subject expands to fill the vacuum of intrinsic simplicity." Therefore, the language that the exegesis adopts is the language of the mode of existence of the research project and maintains simplicity (naturalistic observation) prior to utilising discipline-specific language conventions. Discipline-specific language conventions are then integrated into the play of the mode of existence as the artist–researcher determines, rather than the artefact being reverse-engineered to fit into an existing concept. This maintains the integrity of experience prior to theory.

Developing the concept of the exegesis as an inter-textual, multi-layered dialogue independent of discipline-specific territorialisation – that is, as an expression of a mode of existence – is still missing one crucial aspect: that of the audience. Theorist David Cerbone (2010, p. 50) states, "The significance of my activity of writing a book is bound up with the idea of an audience for the work." From the perspective of the artist–researcher within a doctoral program, the harder question to answer is who is the audience for this writing? This question is crucial because it determines the literary style of the exegesis.

Ideally, the style of the exegesis will communicate to an expert examination panel and a lay audience alike. Where an exegesis is expressed as a creative work in-and-of itself, it may fail to engage an examination panel unless it can be guaranteed that the members of that panel are sympathetic to that particular mode of expression. However, as knowledge exists within an eco-system of publishing, the esoteric exegesis may have been admitted into the academy by the examiners, but may be of little significance to other artist–researchers who arguably form the largest (critical) audience for the research. The lack of ability to render a mode of existence within the context of a field of artist–researchers will lessen the contribution the research can make to the field.

It was earlier stated that "the exegesis is an expression of a mode of existence." The word 'expression' allows for the development of an esoteric exegesis. For the purposes of the academy, the above sentence could be restated as "the exegesis is an argument for a mode of expression." The word 'argument' has a number of definitions that make it more suitable in engaging the examination panel, the field of artist–researchers and the lay audience. *The Oxford English Dictionary* (Stevenson 2010) defines the word 'argument' as, "an exchange of diverging or opposite views." The word 'exchange' is significant here because, for there to be an exchange, there has to be an equal understanding of the currency of the language used where the artist–researcher is able to engage the examination panel and then the broader researcher community and the lay audience. *The Oxford English Dictionary* definition of the word 'argument' continues: "a reason or set of reasons given in support of an idea, action or theory." Again, for the purposes of the academy, an exegesis should be a reasoned document where the internal construction of the mode of existence is made explicit and the audience can follow the reasoning that created the particular mode of existence; in doing so, the audience will be able to engage with the exegesis in what Sartre might call 'good faith'.[2]

Doctoral writing in artistic practice-led research projects is rigorous, insofar as it is 'extremely thorough and careful' and authored in 'good faith', whereby the writing does not deny or obfuscate other peoples' modes of existence, yet honestly articulates the mode of existence of the artist–researcher. The artist–researcher does not express beliefs or opinions because doctoral writing is ultimately a precise, unambiguous and reasoned articulation of a mode of existence. Rather, the writing style is formal because it is necessary to facilitate the precision of terms and concepts essential to the research that render the research unambiguous. This is essential so that the audience, particularly the examination panel, understands the conceptual framework of the argument and can engage with the exegesis as it is, rather than the audience being given space to territorialise the essential terms and concepts made explicit through the research into knowledge partitions that were not intended by the artist–researcher.

Conclusions

A work of art (artefact), whether it be a painting, a piece of music, a play, a dance, a poem, a film or something from digital media, is an invitation to an experience. The nature and quality of that experience is left entirely to the audience. However, "most experiences are unsayable, they happen in a space that no word has ever entered." (Rilke 1903, p. 1) The artefact then is a solicitation to an unspoken knowledge that exists between artist and audience.

Once the artist has been admitted into the academy, there is an obligation for the now artist–researcher to make explicit the internal creative language of a work of art for the purposes of investigating the creative mind and the generation of meaning. To be clear, the artist–researcher is required to investigate not what something means (that job is given to the discipline-specific humanities departments) but rather: What influences does the artist observe in the making of new work? How does the artist explain these influences? Who else does the same thing? How is the artist the same as, or different to, other practitioners in his/her field? The artist–researcher continues asking question like: What issues/feelings/intensities does the work bring up for me? What issues/feelings/intensities does this work bring up for others? Why are these issues/feelings/intensities significant? What technical processes do I use to create the work? Why? To what extent do the creative processes used to make a work enable or restrain creativity? What filtering methods do I use to shape a work? How do I assess what 'works' and what 'doesn't work'? What is the best way for me to ask questions through my work? How do I know what I know? What are my embedded assumptions about my work and the work of the field of practitioners? Are there any theoretical texts that explain my work, even if only partially? How do I express my mode of existence through these other theoretical models? Have I uncovered anything new? Have I expressed anything new? If so, what is it? How do I know? Why is this significant? What conclusions can I draw from this? Who else could benefit from this knowing? And so forth.

These questions may be interrogated via Deleuze's concept of a mode of existence where the mode of existence is defined simply as a proposition (artefact) that is an analogue of the forces that play together and

find expression through the artist. In examining the mode of existence of the artist in the act of creating a new work, the artist as observer is able to bring a different insight into the human creative process and the manufacture of meaning. However, for this mode of existence to be useful to an audience of experts, fellow researchers and lay people, there needs to be a language convention that communicates the mode of existence as a reasoned argument that illuminates the original artefact without standing in the place of that artefact. It is likely that no single theoretical perspective will account for an artist–researcher's mode of existence; therefore an inter-textual approach is necessary where terms and concepts are borrowed from a variety of disciplines and fused into the assemblage of the mode of existence, expressed in text through the exegesis.

From the perspective of the academy, the de-territorialisation potential of practice-led research is enormous and has the ability to populate other creative non-arts-based disciplines. In doing so, the potential exists to create genuine interdisciplinary opportunities for knowledge creation as the rigid fortification of discipline boundaries gives way to the interaction of knowledge as a mode of existence between fellow researchers. For artist–researchers and researchers from the traditional academy, across all disciplines there is a commonality of truth that binds all research endeavour. Michael Frayn (2006, p. 37) explains:

> So the world around us is irregular and confused. Its most
> enduring and solid features turn out to be transient and deliques-
> cent to the touch. Its fabric is a series of events, fleshed out in our
> minds from an even sketchier set of events – the highly restricted
> and fleeting contacts that we have with it. Understanding this is
> where any inquiry into the nature of things has to begin.

References

Andresen, L., Boud, D., & Cohen, R. (2000) Experience-based learning. In G. Foley (ed.), *Understanding Adult Education and Training* (pp. 225–239). Sydney: Allen & Unwin.

Bolt, B. (2007) The magic is in the handling. In E.B. Barrett and B. Bolt (eds), *Practice as Research: Approaches to Creative Arts Enquiry* (pp. 27–34). London and New York: I.B.Tauris.

Cerbone, D. (2010) *Understanding Phenomenology*. Durham: Acumen Publishing.

Deleuze, G. (2006) *Nietzsche and Philosophy* (trans. H. Tomlinson, foreword by M. Hardt). New York: Columbia University Press.

Deleuze, G., & Guattari, F. (1988) *A Thousand Plateaus: Capitalism and Schizophrenia* (trans. B. Massumi). London: Athlone Press.

Frayn, M. (2006) *The Human Touch: Our Part in the Creation of a Universe*. London: Faber and Faber.

Mao T.-t. (1992) *The Writings of Mao Zedong: 1949–1976. 2. January 1956 – December 1957*. Armonk, NY [u.a.]: Sharpe.

Rilke, R.M. (1903) *Letters to a Young Poet, No. 1*. Retrieved 12 March 2013, from: http://www.univforum.org/pdf/431_Rilke_poet_1001_ENG.pdf.

Solomon, R. (1995) Definition of 'Bad Faith'. In R. Audi (ed.), *The Cambridge Dictionary of Philosophy* (p. 711). Cambridge, New York: Cambridge University Press

Stevenson, A. (2010) Definition of 'Exegesis'. In A. Stevenson (ed.), *Oxford Dictionary of English* [electronic resource]. New York: Oxford University Press.

Notes

1 'Property words' are nouns that are used in relation to a 'point of view' or 'definite task' that define a noun in terms of its territorial function.

2 Robert C. Solomon (1995, p. 711), writing in *The Cambridge Dictionary of Philosophy*, defines Sartre's term 'bad faith' in part as, "to view oneself as a being of infinite possibilities and ignore the always restrictive facts and circumstances within which all choices are made." Therefore, it is reasonable to speculate that Sartre would have understood the 'mode of existence' expressed as an exegesis as an act of 'good faith' since it is the opposite of 'bad faith'.

THE VOICES OF THE EXEGESIS: COMPOSING THE SPEECH GENRES OF THE PRACTITIONER– RESEARCHER INTO A CONNECTIVE THESIS

Jillian Hamilton

Introduction

As a medium for exploration, planning, reflection and drawing conclusions, writing is integral to the research process. And, as a mode of communication, it provides the means to articulate the contexts, methodologies and outcomes of research. Just as this is the case for 'traditional' research, so it is for the relatively new field of practice-led/practice-based research. While creative practice may sit at the heart of the research, lead the research process, and provide the substantive outcomes of the research, it is through writing that the case for its contribution to the field is made. Indeed, in creative practice higher degrees by research, it is the combination of practice and written exegesis/dissertation[1] that forms the thesis.

Writing an exegesis is a uniquely challenging process however. This is not simply because the practitioner–researcher may be more 'fluent' in another medium (such as music, dance, visual art or design); nor is it entirely because the exegesis is a relatively new genre that is without long-established precedents and conventions. It is primarily because the model of exegesis that has begun to predominate is a particularly demanding genre of writing. Unlike the traditional thesis, it requires the practitioner–researcher to adopt a dual perspective – to look both out towards an established field of research, exemplars and theories, and inwards towards the experiential processes of the creative practice. This dual orientation provides clear benefits. It enables the practitioner–researcher to situate his or her research within its field and make objective claims for the research outcomes, while maintaining an intimate, voiced relationship with the practice. However, it also introduces considerable complexities into the writing. It requires the reconciliation of multi-perspectival subject positions: the disinterested academic posture of the observer/analyst/theorist, and the invested, subjective stance of the practitioner/producer. It requires the negotiation of writing styles and speech genres – from the formal, polemical style of the theorist to the personal and emotive voice of reflexivity. Moreover, these divergent styles, subject positions and voices must be integrated into a unified and coherent text.

While the issue of the exegesis has been raised implicitly before (Sullivan 2005; Barrett & Bolt 2007; Biggs & Büchler 2009), the challenges posed by its writing have received little attention so far. Yet finding the 'right' voice(s) and composing a harmonious, integrated exegesis is one of the most perplexing problems that practice-led and practice-based postgraduate candidates face in writing up their research projects.

In this chapter, I provide a conceptual framework for the dual-oriented exegesis. After first summarising its characteristics, I go on to frame it against theoretical and philosophical discussions on non-linear, polyvocal texts, and consider precedents from creative fields that connect differently oriented perspectives, subjectivities and voices. I then draw upon the archives of examined exegeses to illustrate how the challenges of the exegesis have been resolved through experimental approaches by higher degree research (HDR) candidates.

The Connective Exegesis

In 2010 a colleague, Luke Jaaniste, and I undertook a content analysis of 60 examined exegeses in a local archive (Hamilton & Jaaniste, 2010).[2] We identified a persistent structural model that has come to predominate in the archive. It is quite unlike the 'traditional' analytical or expositional thesis, but it is also markedly different to early forms of exegesis identified by Milech and Schilo (2004), which they described as 'Context' and 'Commentary' models. In summary, the Context model provides an historical or theoretical contextual framework for the creative practice. Echoing the traditional thesis by assuming the third-person posture of academic objectivity, it presents a 'minor thesis', which serves to situate the practice in its field (although it may not refer to the practice itself at all). The Commentary model on the other hand focuses (sometimes exclusively) on the practice. In the form of a first-person commentary, it presents a reflexive account of the challenges, insights and achievements of the practice. The model we identified, which is evident in around 85 per cent of the sample we analysed, integrates these two, seemingly dichotomous approaches into a single, hybrid text. We called it a 'Connective exegesis' because, by looking out both towards the established field and inwards towards the practice, it serves to connect the research outcomes to the ongoing research trajectory of the field.

While there is variation in clustering, content and inflections, we generalised the overall structure of the Connective exegesis as follows:

1. *An introduction* frames the research project by introducing the topic and field; outlining the research questions, aims and objectives; and describing the overarching methodology. It may also explain the impetus for the research.

2. A section on *situating concepts* provides a theoretical and conceptual framework for the research, outlining the key ideas, issues and concerns of the field(s) in the literature.

3. A section on *the precedents of practice* situates the practice within its field(s) by identifying exemplary practice and establishing relationships (and distinctions) between them and the research project.

4. A section on *the researcher's creative practice* explains the creative process, methodology and methods, and describes how the research unfolded. It often includes a description of the resulting artefacts and sometimes offers a reflection upon their reception, and how the work is situated within, and advances, the field.

5. *A conclusion* summarises the outcomes of the research, including what was achieved, discovered and argued, and may point to potential directions for future research.

(Hamilton & Jaaniste 2010)

It is the combination of situating concepts and precedents of practice with reflection upon the processes and outcomes of the practice that defines the Connective exegesis. In this regard, it might be considered to be an amalgam of the Context and Commentary models. But it is more than this. While it situates the research project within a field of established research as the Context model does, and provides reflection upon the research processes and creative practice as the Commentary model does, *in combination* it enables the practitioner–researcher to connect the practice and the field and to show how the methodologies, processes, experiences, discoveries and outcomes of their research advance the field in a particular way. In this way it positions the project and its outcomes within an ongoing research trajectory. And, while it enables the researcher–practitioner to make objective claims for advancement of the field, it enables a reflexive, subjective relationship to be maintained with the practice.

We concluded by noting that the Connective exegesis (see also Paltridge et al. 2014) gives rise to considerable complexities in the writing, which the traditional humanities thesis, as well as the Context and Commentary models, manage to avoid. This is because its dual perspective requires the writer to inhabit multiple subject positions, including the objectivity of the analyst/historian/theorist and the invested stance of the practitioner/producer. It requires negotiating a range of writing styles, postures and speech genres: from formal academic exposition and the polemical voice of the theorist to the emotive voice of reflexivity; and assuming a polyvocality – from the singular, third-person voice of objectivity, to the first-person voice of commentary. As the practitioner–researcher becomes adept at occupying these differing

perspectives, subject positions, postures and speech genres, a further challenge arises. To avoid a fractured thesis, which awkwardly conjoins divergent parts, or abruptly shifts between expressive forms, the author of a Connective exegesis must reconcile differently situated perspectives (objective, subjective and tacit). They must transition between subject positions – the intimate 'I' and 'my' (methodology, practice, reflection) and the objective 'it' (the field, the data) – and they must harmonise seemingly discordant voices into a coherent composition.

While we acknowledged these challenges, we did not, within the scope of that paper, offer strategies for negotiating them. Here I take up the issue of writing a Connective exegesis and establish a conceptual framework and strategies for writing the multi-perspectival, polyvocal text. I will first draw upon recent discussions in the fields of philosophy and critical theory, and examples drawn from a range of creative texts.

Critiques of the Monologic Text

The problem of integrating perspectives, subjectivities and voices is not entirely new, and neither is it unique to the creative practitioner contending with writing up an exegesis. Arguments around textual structure and authorial voice have played out in a variety of ways in contemporary philosophy, post-structuralism and critical theory, and new models developed for muti-perspectival, polyvocal texts provide useful precedents for us to consider.

Since Foucault (1980) critiqued the notion of a unitary body of theory that filters, systemises and orders knowledge in the name of an 'objective truth' cast by the privileged voice and centralising powers of institutions, there has been considerable theoretical and philosophical discussion on the viability of the academic 'authority' and the mono-logic text. Donna Haraway (1991), for example, argued that texts (writing as well as other 'texts' such as photographs) are inevitably invested with the author's 'situated knowledges', which are drawn from prior lived experiences and subjectivities. Her argument (which is tied to feminism, gender and sexuality) echoes Mikhail Bakhtin's (1981) earlier discussions on 'accented social orientation' (which he related to class and political position). Both suggest that a 'text' is necessarily inflected

by the author's point of view. This recognition of authorial partiality provides the first step in dislodging the thesis from the traditional notion of a singular, neutral objectivity. It supports us to accept – and perhaps even to embrace – the writer's individual and unique orientation to their subject, and so gives rise to an expanded field of authorial possibilities.

Critical theorists have also critiqued the centralised, linear narrative. Deleuze and Guattari challenged the structural model that assumes a central pillar of knowledge and binarised branches (which they describe as an 'arboreal' model of reason). The alternative they proposed is a decentred, multi-linear and temporal text. Metaphorically based on the rhizome, its nodes interlink and intersect to form an *assemblage*, composed of 'lines of flight'. With their own book *A Thousand Plateaus* serving as an example, they explained that: "the tree imposes the verb 'to be', while the fabric of the rhizome is the conjunction 'and... and... and...'." (1988, p. 14) Roland Barthes also countered the structural logic of the traditional text and, in *S/Z* (1974), described an 'ideal text' comprised of *lexia* (speech forms), interconnected through *réseaux* (networks). And, in *Driftworks* (1984), Lyotard urged the writer to engender a fluid mobility through dispersed and discontinuous fragments of text.

As George Landow (1992) noted, this poststructuralist theory prefigured the emergence of hypertext. The Internet's instantiation of a decentred system of nodes, networks and multi-linear links between content, opinions and inflections has placed unprecedented pressure on the monologic, formal structures and practices of academic writing. The structural dispersal and polyvocality of the Internet and the coming to pass of what Foucault described as an "insurrection of subjugated knowledges" (1980) has applied additional pressure upon the unitary, singular voice of academic authorship. And the participatory, dialogic form of social media provides an even sharper contrast with the traditional academic monograph. However, the intersection of voices that we see online is shaped by multiple speakers and their inter-twined texts or speech acts. The exegesis must be sole-authored because it must evidence an original (i.e. singular) contribution to knowledge (a requirement of the academy). It is also a single text, which must unfold as a coherent narrative with constituent and contingent parts, rather

than an endless possibility of navigable paths. We must therefore turn elsewhere.

A useful model for integrating voices into a singularly authored text is provided by Bakhtin's dialogic theory. In his interpretation of Dostoyevsky's novels, Bakhtin (1981) described a heteroglossia – a hybrid construction of utterances by a narrator and cast of characters. Translated from the Russian term 'raznorechie', 'heteroglossia' literally means 'different-speech-ness', but it is more than a textual device for arranging multiple voices in dialogue. It allows different characters to take part in what Bakhtin describes as an ongoing clash between 'centripetal' and 'centrifugal' or 'official' and 'unofficial' discourses. Bakhtin contends that it is dialogic counterpoints in the text – and the tensions that the juxtaposition of subject positions, accented social orientations and voices gives rise to – that create a push and pull upon meaning and the contestation of established discourses. This provides a useful way of thinking about polyvocality.

Not only does it offer a device that can assist in the advancement of narrative, it provides an assurance that the positions assumed by interlocutors need not necessarily be unified, or even in accord. In the exegesis, a dialogic approach could drive the unfolding argument of the research, and apply pressure on established orthodoxies. We might employ it to manage the tensions that arise between 'official' academic discourses and the 'unofficial' reflexive voice of the practitioner, for example. Just like the author of a dialogic novel, the author of the exegesis might assume different orientations, subjectivities, voices, postures and forms of address, which may not be homogenous, or even harmonious, but can nonetheless be combined into a dialogic text that drives narrative, purposefully combines discordant discourses and shapes discursive meaning.

We might also usefully consider the perspectives and speech genres of other forms of creative 'text'. In *Transcultural Cinema*, David MacDougall (1998) describes the expression of subjects/characters in a film. Rather than focusing upon the subject's social orientation, he focuses on the *stance* of the speaker. MacDougall argues that expressive form is not inherent; that is, it is not the only possible mode of expression that

a character could assume. Rather, expressive stance is a formal device, which is intentionally assigned and orchestrated by the director, who has responsibility for the narrative coherence of the film, to enable the viewer to grasp the shifting perspectives of the narrative. He writes:

> perspective is not a function of who [in a film] is seeing or speaking but rather an indicator of a primary locus of expression. It can be most usefully understood as an emphasis placed variously upon first person *testimony*, second person *implication*, and third person *exposition*.
>
> (MacDougall 1998, p. 121).

Testimony, in MacDougall's terms, assumes the speech form of 'I' and is a mode of direct address; implication draws the viewer ('you') into the film experientially through devices such as shot and countershot; and exposition involves the observation/study of the activities of others ('they') from a distance. He goes on to add a fourth perspective: the subjective voice, which, he argues, "is usually evoked in the intersection of... testimony, implication and exposition" (ibid.). MacDougall goes on to conclude that the shifting interaction between various perspectives and expressive stances enriches and deepens the experience of the film. He concludes:

> [In] recent years one sees a movement away from the monologue toward – not even polysemic or polyvocal expression – but a polythesis: an understanding that comes out of the interplay of voices rather than merely their co-presentation.
>
> (MacDougall 1998, p. 121)

This idea of an interplay of voices and expressive stances provides another way of thinking about shifting perspectives and speech genres. It enables us to move beyond thinking about the Connective exegesis simply as a polyvocal text. Like the director of a film, we can orchestrate an interplay of voices and expressive forms – with all of the pitches, tempos and tensions that this gives rise to – to produce a deeper resonance in the text. But taking the experience of the reader into account, it is also our responsibility to guide the reader through the shifting perspectives of the narrative.

Bakhtin and MacDougall both provide useful frameworks for the composition of speech genres, relationships between subjectivities, and modulation of expressive form and tone. However, we must be mindful that there are substantial differences between novels and films populated by characters, and the exegesis. The exegesis is more than a story. It provides an argument on the validity and import of the research. And variations in expression and perspectives do not emanate from multiple characters within it. Its polyvocality arises from a single subject who writes from different perspectives within a single text. Nonetheless, the author of the exegesis can adopt the range of expressive forms that MacDougall describes. First-person *testimony*, second-person *implication*, third-person *exposition* and first-person *subjectivity* can all occur through different postures of a single subject. And it is through the assumption of these different postures in relation to the field, the practice, the reader, the data and the outcomes that the dialogic tensions Bakhtin describes as a clash between 'centrifugal' and 'centripetal' or 'official' and 'unofficial' discourses can be brought to bear.

An example of academic writing that fulfils this possibility is an analytical text by Andrea Fisher. Her book, *Let Us Now Praise Famous Women* (1987), on women photographers in the US Government's Farm Security Administration project establishes a clash between centripetal and centrifugal discourses from the outset. Its title, a play on the classic *Let Us Now Praise Famous Men* by James Agee and Walker Evans (1941), interjects the voices of women photographers into 'official' history. Criticised by some for its lack of conventional historical and biographical detail, which one might expect in an academic history book, Fisher assumes a range of subject positions. She first reads the photographs as historical documents within the context of their making (as an historian), then reconsiders them by recounting her experience in the rarefied setting of a state archive (as a researcher). So at odds is this experience with her initial contextual framing that she sets out to interview photographer Esther Bubley, in order to establish the 'truth' of the images. Fisher comes to realise that there is no definitive meaning of the images. Echoing Lyotard's *Driftworks*, she writes:

> across our engagement with different meanings, the images
> provoke a crisis of the intimate – the chimera of a stable identity

gives way to our manifold selves... Across disparate approaches to writing, fragments of ourselves are provoked and set adrift... the memory of meeting a photographer, and an attempted 'historical' narrative may all float, side by side, as partial evocations of a related past.

<div align="right">(Fisher 1987, pp. 99–129)</div>

Concluding that the historian–researcher must acknowledge "the dispersion of many selves", Fisher's text applies this attitude in practice, assuming different subject positions and expressive speech genres as the story departs from an historical narrative and becomes a hybrid, multi-perspectival and polyvocal text.

Let us Now Praise Famous Men (1941) also incorporates shifting authorial subject positions and speech genres. The author, James Agee, negotiates factual reportage as a journalist, observations as an ethnographer and evocative reflections upon his intrusion into his subjects' lives. Written nearly 50 years apart, these books illustrate the tensions and negotiations that arise as an author intersperses first-person testimony, second-person implication, third-person exposition and subjective voice within a single text.

These precedents provide us with conceptual frameworks and working strategies for reconciling the multi-perspectival subject positions and voices of the exegesis. Dislodging the primacy of the 'objective' academic monologue and recognising the writer's 'situated knowledges' acknowledges the partiality of authorship. Approaching the text as an 'assemblage' sets up the structural potential for assuming multiple subject positions. Envisaging the text as a heteroglossia enables us to accommodate the tensions that arise between differently situated voices and to avoid shying away from the clashes between centripetal and centrifugal discourses that this might provoke, instead incorporating them as a driving force of narrative and argument. Embracing a range of expressive forms provides a model for assuming multiple postures within the text. And understanding "the dispersion of many selves", each positioned in a different relation with the research, helps us to understand that we can shift between academic objectivity and the invested position of the reflective practitioner, as we orchestrate the interplay of expressive forms and voices. The question that arises

then is not whether we can legitimately integrate multiple perspectives, subject positions and expressive forms into the exegesis, but rather how we might move beyond polyvocal expression and the co-presentation of subject positions towards a polythesis – an exegesis that guides the reader through a coherent narrative form, enriched in resonance through the directed interplay of voices.

The Archives

Much experimentation has occurred as practitioner–researchers have developed strategies for writing the Connective exegesis over the past decade. Examples from the archives of the Creative Industries Faculty at Queensland University of Technology and the School of Art and Design at Auckland University of Technology (AUT) illustrate many ways in which HDR candidates have composed a multi-perspectival text, reconciled divergent subject positions of the practitioner–researcher, and integrated speech genres and expressive forms in practice. Here I will draw upon these archives because both universities have actively supported experimentation with the form of the exegesis, and their archives offer rich and diverse examples.

Perhaps unsurprisingly, the examples contained within the archives vary in terms of complexity and effect. A small proportion (approximately 15 per cent) of the QUT submissions avoid the complexities of a Connective exegesis by either taking a Context approach, with its objective, analytical posture and voice, or a first-person, reflexive Commentary approach. Others develop a dual orientation by pragmatically shifting, chapter-by-chapter, between Context and Commentary approaches. This is made easier, because some sections of the Connective exegesis (situating concepts, precedents of practice and discussion of the methodology, for example) naturally lend themselves to the Context model; while others (the impetus for the research and the researcher's creative practice sections, for example) lend themselves to a Commentary model. However, writing chapters as discrete, differently oriented entities in this way produces a split thesis. It is an awkward form that places an onus on the reader to reorient themselves as each new chapter heading signals a strict demarcation between objective academic posture and first-person

reflexive stance. Moreover, it places the onus on the reader to deduce the relationships between sections, as well as the connections between the practice and the field.

The majority of Connective exegeses in the archives do integrate perspectives within sections, however. The introduction and conclusion tend to intertwine subject positions, speech genres and first-person and third-person voices. And the 'researcher's creative practice' section naturally lends itself to integration of a dual orientation: with the methodological approach and overarching framework written in third person; and the rationale for the methodology and methods as well as the unfolding of the research process recalled in first person. The archives evidence a range of sophisticated and novel approaches. To provide a conceptual framework for considering them, I will align them with the models I have mapped out in the previous section.

An Assemblage

Some practitioner–researchers have produced what might be described as an assemblage – a multi-linear text comprised of 'fragments' that employ various *Lexia* (speech forms), thematically arranged through *réseaux* (networks), which run through the exegesis. Often, the researcher orients the reader to this approach through a positional statement in the introduction including a rationale for the various expressive forms and an explanation of the strategy used to categorise and structure them.

For example, in his Introduction to *Last Man Hanging* (a master's exegesis from AUT), Robyn Wilson identifies and positions the expressive forms and voices that he interleaves throughout the exegesis:

> In discussing sources of evidence in this project I will group data into the following arenas and sub-headings: secondary research (print media and documentaries) and primary research (interviews and photographs)... the newspaper's voice (the articles), my written narration of events (the poetic voice) and my visual voice (story telling through images) are present in the story and exist for an isolated and fixed instant.
>
> (Wilson 2008, pp. 10, 31)

Wilson then employs a consistent logic in the writing. Research drawn from primary resources is relayed in a first-person voice (as image and text), as are experiences conducting interviews and taking photographs, and conclusions on the benefits of these sources to the research project. Discussions on secondary sources, as well as research methods, outcomes and findings, are written in an objective, third-person voice. These approaches produce a cacophony of voices that encircle the subject and continuously refract its meaning, but there is an underlying persistent logic to the presentation of these fragments.

In other instances of multi-perspectival texts, formal rhythms are created through visual and textual devices that communicate directional shifts in subject position. An example is a QUT Doctorate of Creative Industries project, *Graphic Design with a Soul*, by Sujinda Hwang (2005). Within an overarching narrative sit periodic interjections. Each is visually signalled through indentation and comprises a 'set' of paragraphs representing a range of perspectives – 'Contemporary Thinking'; 'Journal Entries'; 'Marketing Reflection'; and 'Design Reflection' – each written from an attendant orientation (context, commentary, reflective). These sets recur in a persistent structure, with each theme denoted by a colour-coded icon that sits alongside the heading. In this way, principles of information design (Hwang's field of study) are employed to help the reader to anticipate tightly patterned shifts in orientation, speech genres, subject positions and voices. Formatting (justification, italicisation or font changes) is similarly employed by several other candidates to denote changes in orientation and speech genres as the text weaves in and out of multifarious perspectives and speech genres (see, for example, the extract from Verban (2008) below).

The Locus of Expression

Many exegeses do not employ such structured patterns or formal devices but interweave a shift in posture and the locus of expression through a dialogic unfolding of narrative. An example paragraph from an AUT MA exegesis by Lucas Doolan, *The Sublime Ruin: Enigmatic Feminine* (2007), shows this shift in conversational posture between an objective description of the methodology and reflective description of its application *in practice*. It unfolds as follows (with my explanatory interjections):

> Heuristics applies intelligent questioning... in order to help find knowledge, patterns or a desired result [third-person objective position statement]. Within the research there have been many complex creative problems to be solved [third-person testimony]. The best way I saw of solving these was by comparing the mysterious, unknown or problematic with something familiar and understandable... [first-person reflection]. Extensive experiments and intuitive creative have facilitated an understanding and conceptual reframing of the sublime ruin... [third-person reconciliation]. I utilise a multiplication of layers to produce a void between lightness and dark [first-person concluding statement].
>
> (Doolan 2007, pp. 14, 28)

The PhD of filmmaker Welby Ings, *Talking Pictures* (2006), from AUT tightly integrates a range of perspectives and expressive forms. A prime example is a sentence in the creative methods section, which draws the thread of theory (the abject) through to a discussion on approaches to the practice in line with the researcher–practitioner's intentions. Ings writes:

> This use of beautiful imagery as a method for intensifying the abject became a consideration in boy as I looked for more effective methods for dealing with the sense of time dislocation which one experiences during a physical assault.
>
> (Ings 2006, p. 51)

In this single sentence we see the interspersion of all of the expressive forms identified by MacDougall. First-person testimony ("I") combines with exposition (the use of a method), while implication ("one experiences") draws the viewer into the frame. Authorial subjectivity arises at the intersection of these expressive forms, even while it sits at odds with the statement's apparent academic objectivity.

Besides the introduction, conclusion and methodology section, discussions on the researcher's creative practice ideally combine perspectives, subject positions and expressive forms as they follow a through-line that ties the situating concepts, precedents of practice and methodological discussions to the researcher's practice. I use the term ideally here because this is what is at stake in the Connective exegesis. It is the connection of the researcher's practice and its artefacts/outcomes to

the established field that enables claims to be made about the research project's position within an ongoing research trajectory. Academic objectivity (looking out at the field) and reflection (looking towards the practice) must coalesce if the researcher is effectively to articulate the contribution of the research project to its field.

David Sinfield's MA exegesis, *Under the Surface: Reflections on Workers' Narratives from Below the Minimum Wage* (2009), from AUT provides a useful example that draws together the threads of theory and practice. An opening paragraph (in the form of first-person testimony) first describes the intent and motivation of the creative practice, then a paragraph (written in the third person and assuming the posture of academic objectivity) recalls and pulls through the theoretical and contextual framework established in the earlier situating concepts section and aligns it with the purpose of the work; this is followed by a (first-person) reflection, which explains the impact of the theory on the creative outcomes. Drawing the discussion to a conclusion, Sinfield intertwines expressive forms, as he writes:

> It was in this work that I encountered the fact that signifiers of the working class may differ from one culture to another. For instance an image like the seaside deck chair might connote escapism and freedom in the context of working class Britain.
>
> (Sinfield 2009, p. 26)

This paragraph might be aligned with the voice of Schön's 'reflective practitioner', who navigates between theory (the signifiers and denotation of semiotics) and practice (the images and icons of the graphic designer), and instigates an iterative process that drives the research forward in pursuit of new conclusions (in this case, on the visual signs of the working class).

Like Ing's work, we also see a shift beyond the co-presentation of subjectivities and expressive forms, towards what McDougall refers to as a polythesis. First-person testimony ("I encountered") combines with the abstraction of exposition ("an image might"), while implication draws the viewer in through discussion of class ("they"). This is a directed narrative, which is enriched by its multi-perspectival subject positions and interplay of voices.

The Clash of Discourses

Some exegeses in the archive purposefully integrate perspectives and expressive forms into a dialogic clash of 'situated knowledges'. An example is the PhD exegesis of Ali Verban, *A Porous Field: Blurring the Boundaries of Perception* (2008), from QUT, which investigates immersion through digital, intermedia installations. An extract of the exegesis illustrates the juxtaposition of 'official' (art historical) and 'unofficial' (artist's subjective) discourses:

> in discussions on ['immersive art'], optical illusion, synthetic realism and symbolic representation are their primary foundation... the visual is privileged over other sense [for example] Char Davies' *Osmose* (1995)... has been described as provoking the bodily experience of diving into 'world-spaces' that are metaphorical representations of nature... Grau views this work as a 'natural interface', a term frequently used in current debates on VR. However when I encountered this work at the exhibition 'Transfigure'... my experience [steered] me away from pursuing VR technology...
>
> *[It] demanded that I wear a heavy head-mounted display with a motion-tracking device to monitor my movements and a pad strapped tightly around my chest to monitor, relay and respond to my breathing... these factors completely undermined my perception of entering into and becoming immersed in the work. I could not keep my mind from focusing on the impact of the technological apparatuses on my body and what I needed to do with them.*
>
> *Osmose* did not succeed in producing in me the qualities of immersion that I am particularly focused on and interested in.
>
> <div align="right">(Verban 2008, pp. 36–38)</div>

Interposing analytic texts and experiential encounters produces a clash between centripetal discourses (authoritative sources on 'established' art practice and approaches to immersion) and 'centrifugal' discourses (unofficial sources such as journalled experience). At stake in this clash is the contestation of meaning. It is not unusual for a thesis to refute the work of an established author by presenting evidence to the contrary. But here it takes a different form to a traditional thesis. Third-person *exposition* (engagement with the text) combines with first-person *testimony*

(engagement in experience), and first-person *subjectivity* arises at their intersection as Verban explains that this experience precipitated her decision to investigate ways to produce 'embodied' immersive works. Poetic first-person memories and reflections run through Verban's exegesis as a through-line that pulls the reader along a narrative thread of discovery as it exerts pressure on the established field.

Finally, I will consider an excerpt from the PhD exegesis of Patrick Tarrant, *Documentary Practice in Participatory Culture* (2008) from QUT. Spanning the fields of film and interaction design, Tarrant's practice-led research project required him to occupy multiple roles – each of which gave rise to different perspectives that are interwoven throughout the text. For example, in the following excerpt, we see the perpetual repositioning of the theorist and practitioner unfold:

> to return to Nichols' idea of there being three stories to a documentary, and my point about the increasing importance of a fourth – the subject's story – it need not be seen as a contradiction on my part to subordinate the subject's story to my own. Rather, it is simply my argument that the subject's story is of increasing importance to media producers and documentary filmmakers for a variety of reasons, and that my method for arguing it on screen is to create a productive dialogue between my practice and theirs. But the distinction should be clear – although we might collide at the site of a participatory media event, my subjects have their practices and I have mine.
>
> (Tarrant 2008, p. 21)

In this single paragraph we see the analyst and theorist interpreting and extending the text of an established researcher; the methodologist developing a process for production and reporting; the practitioner/documentary story-teller intent on producing an interactive filmic narrative; the facilitator providing a forum for the speaking subject of representation, the collaborator in dialogue with the documentary subjects; the participant in an event and reporter of it; and the practitioner who reflects on the distinction between his own practice and other types of documentary (and so implicitly argues for theoretical innovation in the field).

Assuming a variety of perspectives in this way necessitates the adoption of different voices and speech genres, as the paragraph oscillates between the objectivity of the theorist; the insistence of polemicist; the neutrality of the documentary film maker; the narrator of the story of the research; the subjectivity of the reflective practitioner negotiating a stance; and the participatory voice of a collaborator – who at once claims affinity with, as well as differentiation from, the subjects of the film ('I', 'we' and 'them'). We see shifts between third-person *analysis and exposition;* first-person *testimony, reflection and assertion;* and second-person *implication* – for the reader is drawn into the frame through the address "it need not be seen as a contradiction" or, in other words, "you: reader (should not see)". He and they; I and we; and the implicated you, run through the paragraph as personal, objective and possessive pronouns.

This text shifts confidently between the academic objectivity of the observer/analyst/historian/theorist; the subjective, invested position of the practitioner/producer/reflective practitioner; and the subjective voice that is evoked at their intersection. It instigates a clash between the centrifugal pressures of 'established' expositional documentary practices and the centrifugal pressures of a documentary practice that is participatory and multi-voiced. At the same time, it establishes that the author is the practitioner and the driver of the innovation at the heart of the thesis. This is a complex negotiation, which is made possible through the interplay of the author's multi-perspectival subject positions, expressive forms and voices.

Conclusion

Writing up practice-led and practice-based research not only requires an advanced understanding of disciplinary traditions, it compels the practitioner–researcher to develop an understanding of his or her own, invested position in the research. It requires the negotiation of a range of expressive forms and speech genres that this duality gives rise to. And it entails composing/directing this polyphony of voices into a structured narrative that prosecutes an argument for the relevance of the research and its advancement of the field. Examples drawn from two archives of examined exegeses illustrate how postgraduate candidates have negotiated these complexities of the Connective exegesis through

innovative approaches to assemblages, dialogic narratives and heteroglossia that contest established discourses and challenge disciplinary norms. Beyond the *polyvocality that arises through the* presentation *of multiple, differently situated voices, we have seen the potential of a Connective exegesis to produce a* polythesis: an enriched understanding that comes about through the interplay of differently situated voices.

Acknowledgments

The author thanks Jacque Prior and Kathryn Gough for their assistance with the archives, and QUT's Creative Industries Faculty for funding attendance at Practice, Knowledge, Vision: Doctoral Education in Design (Hong Kong Polytechnic University) and the Doctoral Writing in the Visual and Performing Arts symposium at the Sydney College of the Arts, where these ideas were first presented.

References

Agee, J., & Evans, W. (1941) *Let Us Now Praise Famous Men*. Boston, MA: Houghton Miflin.

Bakhtin, M. (1981) *The Dialogic Imagination: Four Essays*. (Trans. M. Holquist). Austin, TX: University of Texas Press.

Barrett, E., & Bolt, B. (2007) *Practice as Research: Approaches to Creative Arts Enquiry*. London: I.B.Tauris.

Barthes, R. (1974) *S/Z*. (Trans. R. Miller). New York: Hill and Wang.

Biggs, M., & Büchler, D. (2009) Supervision in an alternative paradigm. *TEXT: The Journal of Writers and Writing Courses*, Special Issue No. 6, 1–14.

Deleuze, G., & Guattari, F. (1988) *A Thousand Plateaus: Capitalism and Schizophrenia*. (Trans. B. Massumi). London: Athlone Press.

Doolan, L. (2007) *The Sublime Ruin: Enigmatic Feminine*. MA Thesis, Auckland University of Technology.

Fisher, A. (1987) *Let Us Now Praise Famous Women*. London: Pandora.

Foucault, M. (1980) Two lectures. In C . Gordon (ed.), *Power/knowledge: Selected Interviews and Other Writings, 1972–7* (pp. 77–108). New York: Pantheon Books.

Hamilton, J., & Jaaniste, L. (2010) A connective model for the practice-led research exegesis: an analysis of content and structure. *Journal of Writing in Creative Practice* 3(1), 31–44.

Haraway, D. (1991) Situated knowledges: the science question in feminism and the privilege of partial perspective. In *Simians, Cyborgs and Women: The Reinvention of Nature*. New York: Routledge.

Hwang, S. (2005) *Graphic Design with a Soul*. DCI Thesis, Queensland University of Technology.

Ings, W. (2006) *Talking Pictures: A Creative Utilization of Structural and Aesthetic Profiles from Narrative Music Videos and Television Commercials in a Non-spoken Film Text*. PhD Thesis, Auckland University of Technology.

Landow, G. (1992) *Hypertext: The Convergence of Contemporary Critical Theory and Technology*. Baltimore, MD: Johns Hopkins University Press.

Lyotard, J. (1984) *Driftworks*, R. McKeon (ed.). New York: Semiotext(e).

MacDougall, D. (1998) *Transcultural Cinema*, L. Taylor (ed.). Princeton, NJ: Princeton University Press.

Milech, B., & Schilo, A. (2004) Exit Jesus: relating the exegesis and the creative/production components of a research thesis. *TEXT: The Journal of Writers and Writing Courses*, Special Issue 3, 1–13.

Paltridge, B., Starfield, S., Ravelli, L., & Nicholson, S. (2014) Genre in the creative-practice doctoral thesis: diversity and unity. In G. Garzone & C. Ilie (eds), *Genres and Genre Theory in Transition: Specialized Communication across Contexts and Media* (pp. 89–105). Boca Raton, FA: BrownWalker Press.

Schön, D. (1983) *The Reflective Practitioner: How Professionals Think in Action*. New York: Basic Books.

Sinfield, D. (2009) *Under the Surface: Reflections on Workers' Narratives from Below the Minimum Wage*. MA Thesis: Auckland University of Technology.

Sullivan, G. (2005) *Art Practice as Research: Inquiry in the Visual Arts*. Thousand Oaks, CA: Sage.

Tarrant, P. (2008) *Documentary Practice in Participatory Culture*. PhD Thesis: Queensland University of Technology.

Verban, A. (2008) *A Porous Field: Blurring the Boundaries of Perception*. PhD Thesis: Queensland University of Technology.

Wilson, R. (2008) *Last Man Hanging: A Book of Pictures*. MA Thesis, Auckland University of Technology.

Notes

1 There is considerable debate around the naming convention of the field. The terms 'practice-led research' and 'practice-based research' are employed (in reference to different research modes, as well as interchangeably). The term 'exegesis' is perhaps the most prevalent term for written component but some universities use alternate terms, such as 'dissertation' and 'explication'.

2 Held by the Creative Industries Faculty at QUT.

DIVERSITY IN CREATIVE AND PERFORMING ARTS DOCTORAL WRITING: A WAY FORWARD

Louise Ravelli, Brian Paltridge, Sue Starfield

Introduction

From 2008 to 2010, we were engaged in a research project that focused on doctoral writing in the creative and performing arts in Australian universities, and it is that project which has brought us to this edited volume. As teachers and researchers of academic writing, and as linguists, we had been alerted to the challenges that these texts presented for students, with both their written and creative/performed components (we will use the term 'thesis' to represent the combined presentation of both components[1]) and we wanted to focus on the diversity of written forms that could be found in these theses. Our engagement in this field quickly expanded from a focus on the written component of the theses to an attempt to gain a more comprehensive understanding of the complexity of these types of text and their context; of how such diverse forms can all succeed as 'one' academic form; and of how the different components of these theses – the written and creative – may interact.

In particular, it is that kernel of 'unity in diversity' (Meurer 2002; Paltridge et al. 2014) which continues to fascinate. In this developing academic field (or set of fields), how is it that such wildly varying texts as those in our corpus (a collection of 36 doctoral texts, Paltridge et al. 2012) can be accepted as exemplars of 'the' doctoral thesis? In this chapter, we aim to cast light on this question by applying an additional framework, that of Legitimation Code Theory (LCT) (Maton 2010a, 2010b), as an over-arching means of understanding the choices at stake. The different tools of the study and the associated findings will be introduced, before relating this to LCT.

Background

The one overriding finding from our project is that there is no one way to construe a doctoral thesis (in the sense of both its creative and written components) in the creative and performing arts. That is, in those theses which involve both a 'creative' (performed, created) component and a 'written' component, the two components can be brought together in diverse ways. Clearly, the creative components – in addition to being specific to a particular discipline – are each unique and individual. At the same time, we found that the written components are also likely to be unique, with barely two theses in our corpus of 36 having anything approximating an identical structure or voice. There seems to be an implicit assumption – among institutions, scholars and students – that such a situation is necessarily negative. Surely we 'should' know how to write a doctoral thesis in these fields? After all, isn't it the case that in other, more established disciplines there are clear conventions for how to structure a thesis, what tone of voice to adopt, and how to explain the methodology and derive appropriate conclusions? And even where 'established' disciplines are undergoing change, as in the 'new humanities', other voices and structures are emerging as clear alternatives (Hodge 1998; Starfield & Ravelli 2006; Turner 2003).

In linguistics, theories of genre would suggest that while diversity is always found in any text-type, a common, shared purpose is likely to lead to fundamental stabilisation of that genre, even if it is only "stabilized for now" (Schryer 1993). The evident diversity in the texts we sampled suggests that the genre is yet to stabilise fully (but see Paltridge et al. 2014 for evidence of stabilising trends), and there are a number

of indicators of anxiety around this issue. Institutionally, the status of research outcomes in the creative and performing arts – at any level, not just the level of postgraduate research – is yet to be fully clarified. While acceptance is growing, as evidenced in Australia by increasing recognition of these research products at national funding levels (for example, in Australian Research Council (ARC) awards and in the Excellence for Research in Australia (ERA) quality framework), it cannot yet be taken for granted, and many questions remain regarding the status of creative works as research outcomes (see, for example, Trowler 2012; Muecke et al. 2013; and especially Part 1 of this volume). Institutional uncertainty around this kind of research can be seen in the immense variety of institutional requirements (about length of the written component, relative weighting of the two components, and so on) and examination practices around the creative and performing arts doctoral theses (Paltridge et al. 2011a; Starfield et al. 2012). Numerous anecdotal accounts exist of academics needing to justify their place in the academy and never feeling quite as if they 'belong', as expressed often elsewhere in this volume.

For students, anxiety around these doctoral texts is palpable. Their pathway as artist–researchers is not at all straightforward, with the majority likely to have extensive experience as practitioners, but not as writers (Hockey 2003; Starfield et al. 2012) when they begin their doctoral studies. There is often concern that students feel they don't know 'how' to write: how to develop a sophisticated academic voice, how to give clear signals of structure and so on. At the same time, the conventional voice of academia may not sit at all well with their project aims and its nature, and may be quite an unsuitable vehicle for the written expression of their research. There may be no models available to exemplify other possibilities, and students often feel that they are treading these paths for the first time. Of course, it is also the case that students in *any* academic discipline are likely to experience some kind of anxiety over their thesis, and for each student, it is always in some sense a 'new' path – few PhDs are simple or straightforward. But as noted, for most disciplines, the pathways are well trodden and diversions from them depart from well-defined beginnings, where the assumptions, influences and approaches of the discipline are well understood.

The diversity in doctoral theses in the creative and performing arts is evident across a number of parameters. As noted elsewhere (Paltridge et al. 2011a, 2011b; Elkins, this volume), the written component of these theses varies wildly in form. Overall length may vary from around 20,000 words to around 80,000 words; the length of chapters may vary from less than half a page to 35 pages. The naming and sequencing of chapters may closely approximate 'traditional' theses (that is, with an Introduction–Methods–Results–Discussion (IMRD) structure; see Paltridge et al. 2012) or may depart radically from it, with unique chapter headings that bear no resemblance to conventional forms (such as, 'Far from Solid', to give just one example). The visual presentation may be entirely conventional in layout and typography or again, wildly original, including one thesis being printed on a variety of special papers and bound in special boxes. Images may or may not be included: there may be few or many; they may be of the author's work or of others; they may relate to the examinable creative component or may be separate from it. The voice of the writer may be a highly traditional one (impersonal, formal) or it may be informal, or poetic, or a stream of consciousness, or all of these things at different points, as discussed by Hamilton (this volume). The written component may barely relate to the creative component, operating essentially in parallel, or it may bounce off the creative work, back-and-forward so to speak, or it may be so fully intertwined that the creative component *is* the written component, and vice versa.

Clearly, then, with such diversity, it is not surprising that the academy remains sceptical about these theses, nor that students are unsure of how to proceed. And yet, our research also established that there is indeed underlying unity across all these theses. Following Meurer (2002) and Hood (2010), we proposed (Paltridge et al. 2014; and see Hamilton, this volume; and see Hamilton, this volume) a set of 'core rhetorical functions' for the written component of doctoral theses in the creative and performing arts, viz Research Warrant (that is, the study must be motivated, in personal and/or artistic and/or theoretical terms); Research Capacity (that is, the research approach must be positioned, in relation to personal/artistic/theoretical frames); Research Evidence (that is, the current practice/theory is presented as evidence); and Research Effectiveness (that is, an argument that the current research is a contribution to theory/practice). These core functions may correspond more or less

one-to-one with the chapters of a conventionally structured thesis, or the components may be dispersed and intermingled across the chapters of the thesis. Nevertheless, the core functions are clearly present and effectively differentiate the written component of these theses from the generally dispreferred model of the 'exegesis', which can be understood as being primarily descriptive of the creative work. As with any other thesis, students must be able to demonstrate that their work is situated in relation to a tradition of practice and/or theory, and that their own work contributes to this tradition, in ways that are acceptable to that tradition. The challenge is that all this unity can be demonstrated in such diverse ways.

Genre theory discusses the counterbalancing of centripetal and centrifugal forces (Bakhtin 1981; Schryer 1993; Meurer 2002) on text types, forces which drive texts towards unity, and forces which drive them apart. Centripetal (that is, unifying) forces include local consistencies and influences. These may be 'local' in the sense of a particular discipline or sub-discipline, where ways of doing these theses might be becoming more conventionalised. Or they could be 'local' in the sense of an institution or set of institutions, where the influence of one or more scholars can be seen on the work produced there. The centrifugal forces (that is, dispersing) include the relative newness of the discipline, the uncertain status of research from these fields within the broader academy, and the diversity of institutional requirements and practices around these theses. But this does not fully account for the diversity discussed above, and through understanding the source of this diversity, a way may be found to facilitate greater acceptance of this kind of thesis at the institutional level, and (slightly) more straightforward, or at least more evident, pathways for students embarking on this journey.

Legitimation Code Theory

One explanation of the diversity found in these theses may be found in one dimension of Legitimation Code Theory (Maton 2010a, 2010b; see also Hood 2010), which seeks to provide a sociological account of the counterbalance between different kinds of knowledge (our objects and domains of study) and different kinds of knowers (the personas enabled to engage in knowledge practices). Drawing on the work of

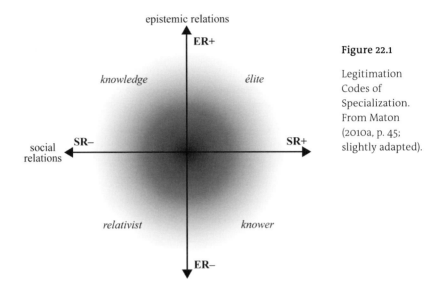

epistemic relations

ER+

knowledge

élite

SR−

social
relations

SR+

relativist

knower

ER−

Figure 22.1

Legitimation
Codes of
Specialization.
From Maton
(2010a, p. 45;
slightly adapted).

Bourdieu (1984, 1988) and Bernstein (1990, 1996, 1999), Maton (2010b, p. 161) emphasises that "fields comprise more than a formation of knowledge; they also comprise a formation of knower" and that "for every knowledge structure there is also a knower structure; that is, fields are knowledge–knower structures". What is important for us is how a combination of knowledge and knowers can define a 'legitimate gaze' (Maton 2010b, p. 155), whereby "knowledge claims and practices can [thus] be understood as languages of legitimation", or "strategic stances aimed at maximizing actors' positions within a relationally structured field of struggles" (Maton 2010a, p. 37). No stance is more strategic in academia than that of a doctoral thesis: it is the ultimate 'entry card', both to the discipline and to the institution. Institutions maintain strong surveillance practices over the doctoral thesis, most notably through the examination process, but also through procedures for allowing entry to the degree in the first place and allowing progress through the degree itself (such as annual progress reviews, confirmation of candidature and so on). Disciplines maintain legitimation through providing the examination expertise: ultimately, it is the discipline expert who decides whether the doctoral thesis warrants entry to the academic community or not, even if the institution maintains control over the process of the examination.

In terms of knowledge and knowers, LCT provides a Cartesian plane, reproduced in Figure 22.1, which explains four key 'specialization codes'. The first dimension of the plane is given by epistemic relations, that is, relations "between knowledge and its proclaimed object" (Maton 2010a, p. 44), varying from strong (ER+) to weak (ER-). The second dimension of the matrix is given by social relations, that is, relations "between knowledge and its subject, author or actor" (Maton 2010a, p. 44), also varying from strong (SR+) to weak (SR-). From the combination of the different strengths of relations along these two dimensions, four key codes arise: the knowledge code (ER+, SR-); the knower code (ER-, SR+); the relativist code (SR-, ER-), and the élite code (ER+, SR+). The two codes most relevant for our analysis are the *knowledge code* and the *knower code*. (The remaining two, *élite code* and *relativist code*, no doubt have their place as well, but for the purposes of this chapter we will focus on this oppositional dimension).

The knowledge code is characterised by stronger epistemic relations (Maton 2010a); that is, fields adopting this approach have specialised procedures and discrete objects of study. In other words, you are either studying physics, *or* chemistry, *or* biology. They emphasise "the difference between the field's constructed object of study and other objects, and between the knowledge its procedures are claimed to provide of this object and that provided by other intellectual fields" (Maton 2010a, p. 46). At the same time, there is "relatively little personal discretion in the choice of objects of study, procedures and criteria" (ibid.). Thus, "anyone can produce knowledge provided they comply with these defining extra-personal practices" (ibid.), and so the knowledge code is equally characterised by weaker social relations. In other words, so long as you know how to conduct an experiment according to established procedures, you can conduct it.

In contrast, the knower code's key claim for legitimacy is based "on a privileged *subject* of study, the 'knower'" (Maton 2010a, p. 46). There are weaker epistemic relations, whereby the "focus for truth claims may be hypothetically boundless, difficult to define, or encompass a host of disparate... objects of study" (ibid.) and where there is "personal discretion on the choice of topics, methods and criteria", with procedures that are "relatively tacit" (ibid., p. 47). So an emerging field such

as environmental humanities might adopt an historical, sociological or scientific approach, and different 'topics' may be at stake. At the same time, there are stronger social relations, as knowledge is "specialized to the privileged knower"; and knowledge claims "are legitimated by reference to the knower's subjective or inter-subjective attributes and personal experiences (which serve as the basis for professional identity within the field). The aim is to 'give voice to' this experiential knowledge, with 'truth' being defined by the 'voice'" (Maton 2010a, p. 47). That is, you have to legitimate your right to 'speak' in this context, and that legitimation may occur in various ways, for example, by referencing appropriate antecedents, or citing relevant personal experience.

In essence then, the knowledge code is most easily recognised by its strong delimitation of legitimate objects of and procedures for study – which anyone may access, provided they do so in the right way. The knower code is most easily recognised by its privileging of the author's insight, which is attained by largely intangible means, and which may be applied to a diverse or loosely defined object or set of objects.

Multiple Sources of Diversity

The understanding provided by these concepts from Legitimation Code Theory helps explain the first source of diversity for variation within the doctoral theses of the creative and performing arts. The knowledge codes and knower codes sit alongside each other as legitimate approaches to the field. Doctoral theses with conventional macro-structures (IMRD structures, as noted above) and predominantly conventional academic voices manifest the knowledge code: drawing on previously legitimated procedures and practices to validate their own approach. Those with less conventional structures and less conventional, including multiple, academic voices manifest the knower code, legitimating their work through an assertion of their right to do so, in relation to a potentially diverse set of foci. These two codes are not necessarily evenly distributed: based on our and other studies (Paltridge et al. 2012; Hamilton and Jaaniste 2010; Hodge 1998; Turner 2003), the knower code clearly predominates. At the same time, they are not black-and-white distinctions, but contrasting points among a matrix of possibilities (Maton 2010a, b). But nevertheless, the successfully examined doctoral theses

from our corpus demonstrate that both codes are equally legitimate, and this therefore accounts for at least some of the variation in the theses we have seen.

An additional source of variation can be found as part of the inherent nature of the knower code, following Maton's description thereof. Given that this is the approach which largely predominates in the creative and performing arts, it is important to examine this in more detail. Maton (2010a), in his work on LCT, provides a detailed analysis of a parallel field, that of cultural studies, particularly as it developed in post-war Britain. The comparison made here is not a claim that the creative and performing arts 'is' a cultural studies field (although cultural studies is of course a field that is drawn upon within creative and performing arts) but rather that there are a number of similarities between the two fields – as fields – which bear comparison. Thus, as an academic field or discipline, understanding of one helps illuminate our understanding of the other (see also Trowler et al. 2012).

The first parallel is in the marginal institutional and academic position held by cultural studies in the UK post-war, being taught initially in polytechnics and colleges, and being "associated with the teaching of socially and educationally marginalized groups" (Maton 2010a, p. 49). This mirrors the academic status of the creative and performing arts, where in Australia and the UK it was not brought into the mainstream of academia until the 1980s, as has been well established, and where artist–practitioners are still met with a good degree of scepticism from the academy. Another parallel is found in what Maton describes as the legitimating discourse of cultural studies, that is, one which regularly features "images of blurring, crossing and transgressing established borders or boundaries (intellectual, social, physical and so forth)" (2010a, p. 41). This is certainly what we found in many of the theses of our study: boundaries between academic and personal; between the formal and the informal; between disciplines; between modes of presentation: all these and more are regularly crossed or blurred.

Maton further notes that cultural studies is "committed to breaking down academic boundaries, such as between: established disciplines; 'official' educational knowledge and everyday experience; 'high' and

'low' culture; inside and outside higher education" (2010a, p. 41). It is characterised by "a critique of notions of the possibility of a neutral voice expressing objective scientific truth. Cultural studies has thus tended to valorise the subjective over the objective, and primary experience over the detached viewpoint" (Maton 2010a, p. 43). Here again the parallels with the creative and performing arts are evident: the boundaries are not so much 'high' and 'low' culture (though these may also apply), but 'art' and 'academia'; 'inside' and 'outside' the academic institution. The centrality of subjectivity and personal experience is equally evident. Cultural studies can be seen as 'giving voice' to the marginalised, as does the creative and performing arts. For cultural studies, it is in terms of social class, race, gender and sexuality (Maton 2010a, p. 42); for the creative and performing arts, it is in terms of recognising those who are not (already) members of the academy.

For our purposes, however, the most important parallels are in terms of the nature of the predominant specialisation code of legitimation in each field. As Maton describes it (2010a, p. 44), cultural studies is fundamentally a knower code, characterised by weaker *epistemic* relations (that is, relations to the objects of knowledge), producing "an espoused opposition to notions of disciplinarity, a relatively uncircumscribed object of study, open procedures of enquiry and teaching, and a commitment to problematising categories, boundaries and hierarchies between and within forms of knowledge and objects of study." Thus, epistemically, cultural studies – and, we argue, creative and performing arts – are inherently diverse and fluid, because of the nature of their specialisation code of legitimation. The object of study is not necessarily 'an artwork'; it may be a feeling about belonging, or a problem in the interpretation of theatrical performance, or how photography can enable learning. The overarching framework might be one drawn from history, from cultural studies, from art theory, or from any number of other pre-existing fields. The methodology may be clear and derived from one of those pre-existing fields, or may be entirely new and invented for the purposes of that thesis.

At the same time, as a knower code, cultural studies has *stronger* social relations, that is, in terms of 'knowers'. As Maton says, "Here, the emphasis is on 'giving voice to' the primary experience of specific knowers, where

legitimate knowledge or 'truth' is defined by and restricted to the specific 'voice' said to have unique and privileged insight by virtue of who the speaker is" (Maton 2010a, p. 44). In cultural studies, this unique voice derives from the social marginalisation of the speaker (through their class, gender, etc.); in the C&P Arts, when operating in terms of the knower code, it is the voice of the artist–practitioner which legitimates the right to speak. Thus, individual experience is validated, and an essential starting point, and thereby accounts for further diversity in theses and research, as each individual is unique. Even more so, "the potential categories of new knowers are hypothetically endless" (Maton 2010a, p. 54). To quote Maton at length:

> With this proliferation of knowers, where new knowledge is defined according to the criteria of articulating each knower's specialised voice, and truth is defined as whatever may be said by this voice, then it is not what has been said before that matters, it is who has said it. It is thus likely that, with each addition of a new adjective or hyphen, existing work within the field will be overhauled – old songs will be sung by new voices in their own distinctive register. Rather than building upon previous knowledge, there is a tendency for new knowers to declare new beginnings, re-definitions and even complete ruptures with the past – an anti-canonical, iconoclastic and parricidal stance generating recurrent schismatic episodes. The intellectual field then gives the appearance of undergoing permanent cultural revolution, of perennially being at year zero. However, although the names and faces featured regularly change, the underlying form of the recurrent radical 'breaks' characterizing the field is the same: they are empirical realizations of knower code legitimation.
>
> (Maton 2010a, p. 54)

According to Maton's analysis of cultural studies, the predominance of the knower code is not coincidental. Again, to quote at length:

> The discursive practices of cultural studies can thus be explained in terms of actors' strategies reflecting their institutional and social positions. In short, actors from dominated social positions (the working class, women, etc.) tend to occupy dominated institutional positions within higher education (colleges, polytechnics, etc.). By virtue of these positions of multiple domination, they

are inclined to adopt subversive 'position-takings' in an attempt to maximize their position: against dominant notions of disciplinary specialization, cultural studies celebrates non-disciplinarity; against traditional pedagogy is set a radical educational project; against positivism, subjective experience is privileged and so forth. Thus, given the perceived dominance of knowledge codes within higher education during the development of cultural studies, a knower code provided the oppositional means for actors occupying dominated positions to attempt to subvert the hierarchy of the field.

(Maton 2010a, p. 52)

The many parallels between cultural studies as an archetypal 'knower' code and the creative and performing arts as another (potential) example thereof are evident: in the creative and performing arts, the 'dominated social positions' referred to above can be seen in terms of participants in the field being artists and practitioners, positioned 'outside' the academy and largely excluded by the more established knowledge codes. The parallels between cultural studies and aspects of creative and performing arts as disciplines help explain why the knower code has come to predominate within the creative and performing arts, why the knower code is inherently multi-vocal, and why there is often the sense "of perennially being at year zero". At the same time, we need to remember that the knower code is *not* the only one that can be found within the creative and performing arts, and that the knowledge code can also be found (and no doubt, the élite and relativist codes also, though we cannot explore those here), thereby providing another source of diversity within the field. As Maton (2014, p. 77) notes: "dominant codes may not be transparent, universal or uncontested: not everyone may recognize and/or be able to realize what is required and there may be more than one code present, with struggles over which is dominant."

Moving Forward (Or Going Round Again)

An understanding of these concepts from LCT does not necessarily answer all the questions we might have about doctoral theses in the creative and performing arts, but it does cast a useful explanatory light on the potential reasons for some of the diversity that can be found therein and, by extension, in this (complex set of) field(s).

At the start of our research project in 2008, we noted (Paltridge et al. 2011a) the issues and debates around terminology in this field, whether research was characterised as practice-led, practice-based, research in practice or research as practice, and so on (see also Phillips et al. 2008; Candy 2006, as well as numerous chapters in this volume). These varying terms (and the varying definitions of each of them) stand as signals of different ways of legitimating the preferred approach to research. The point is not that each neatly aligns with a specific specialisation code, but rather that they point to a multiplicity of specialisation codes within the field. LCT enables us to explain that the diversity is not just random noise, or evidence of weak standards, but rather that diversity is a motivated source of variation within the field.

The presence of (at least) two co-existing specialisation codes within the field explains some of the variation in forms, structures, voices and presentation of these texts. The fact that one of the codes is itself inherently variable explains much of the rest. The impetus for the multi-vocalic nature of these theses (see again, Hamilton's chapter in this volume) derives from the nature of the knower code itself: multi-vocality is one of its inherent features, and an essential tool of legitimation. It enables the writer–practitioner to demonstrate that they can master, or have mastered, the voices of multiple approaches; that is, that they themselves can cross the boundaries which must necessarily remain fluid and permeable in the knower code, for example, between the institution of academia and their creative practice field.

As part of this multivocality, the knower code particularly valorises the role of subjectivity, as the research process is not just about 'what' knowledge is at stake, but about 'who' counts as a knower. The knower, and the knower's voice, must be asserted.

Legitimation Code Theory also provides a good explanation of the source for much of the anxiety surrounding questions of identity and the process of writing for these theses. There is a 'received myth' of how 'a' thesis 'should' be – 'received' from the more dominant and longer-established, primarily knowledge-code-based disciplines, with their clear structures and institutional voice. As it is in fact the knower code which is more predominant, it is little wonder that anxiety and

tensions ensue. The 'traditional' thesis has developed to suit a code that is largely not suited to the majority of explorations in the creative and performing arts such a code is univocal, defines a clear object of study, and unfolds according to largely well-established (albeit not unchangeable) processes. But in contrast, the knower code is inherently fluid, multi-vocal and subjective; the 'knower' must legitimate their research through means other than conventional methods: through the assertion of their interest in the field, of their experience, of the centrality of their problem – to themselves or to others – and so on. With the 'received myth' of how a thesis 'should' be weighing heavily on most students, it is no wonder that they struggle to assert their subjective and multiple voices, and no wonder that they worry whether their diverse and novel forms of presentation will be acceptable to the academy.

Importantly, as well as providing a source of understanding, LCT also points to ways to develop 'comfort' with this seemingly permanent state of discomfort, or with, as Maton put it above, a sense "of perennially being at year zero". He notes, following Bernstein, that knowledge codes are underpinned by strong hierarchical knowledge structures (characterised in Maton's model by stronger epistemic relations), such as might characterise the natural sciences, for example, whereby they develop through "*integration* and *subsumption* of knowledge" (Maton 2010b, p. 154; original emphasis). In contrast, knower codes are underpinned by horizontal knowledge structures (weaker epistemic relations) which "develop by adding another segment or approach horizontally" (ibid.). This may lead to a perceived weakness, whereby knowledge is not (to simplify somewhat) 'accumulated', but 'added to'. But Maton argues that the strength of knower codes lies precisely in their development of the 'knower': "the degree to which they integrate and subsume new knowers, their *sociality*, highlighting whether they develop through integration or accumulation of habituses" (Maton 2010b, p. 164). Thus knower codes have their own form of "progress and growth" (ibid.).

Literature around creative practice doctoral theses, elsewhere and throughout this volume, refers constantly to the importance of building sociality and developing habitus: through the accumulation of successful examples of doctoral theses; through the development of writing groups or circles; through supporting the role of the supervisor.

That is, given that the knower code has less obvious procedures and models to follow, other strategies are needed to develop the appropriate habitus in new students; this is why models of theses, writing groups, workshops and so on are particularly important. These are just some of the ways of developing sociality in this field and, put simply, the greater the sharing of experience – whether it be formally through fora such as conferences (or edited volumes!)[2] or informally, through student groups, for example – the greater will be the degree of comfort with the knower-code approach. But by the very nature of constant renewal inherent within knower codes, the development of sociality is itself a process which must be constantly renewed and sustained.

The implications for the field then are clear: that those in institutional positions, for example, on academic committees and boards, need to (continue to) argue for this diversity as a strength, not a sign of weakness, and demonstrate that there may well be diverse ways to claim legitimacy; further, that institutional processes and practices (for example, guidelines on the structures of these theses) should incorporate this diversity within them. Further implications are that the field should *not* seek one distinctive voice, as this would elide both knowledge and knowers; but that the apprentices (students) should be apprised of the multiple pathways, and guided either towards strong and predetermined methods (knowledge code), or to an understanding of and comfort with the inherent diversity of the knower code.

Legitimation Code Theory provides a useful framework for exploring academic practices. In our work, and as is evidenced throughout the chapters in this volume, we have found the PhD in the creative and performing arts to be fundamentally varied. It may potentially take on numerous organisational structures, multiple voices, multiple modes of presentation, and multiple relations between the creative and written components. With an understanding of Legitimation Code Theory, we should expect nothing less. Not only do distinctly different codes co-exist within the discipline – that is, (at least) the knowledge code and knower code – but one of these, the knower code, is characterised by fluidity, multivocality and subjectivity, and a constant process of renewal. This does not, in fact, return the field to year zero, but provides a way of moving forward through critique, repositioning, and a strong

development of sociality and habitus. The diversity is a resource, not a burden.

References

Bakhtin, M. (1981) *The Dialogic Imagination: Four Essays* (Trans. M. Holquist). Austin: University of Texas Press.

Bernstein, B. (1975) *Class, Codes and Control Vol. III: Towards a Theory of Educational Transmissions.* London: Routledge & Kegan Paul.

Bernstein, B. (1990) *Class, Codes and Control Vol. IV: The Structuring of Pedagogic Discourse.* London: Routledge.

Bernstein, B. (1996) *Pedagogy, Symbolic Control and Identity: Theory, Research, Critique.* London: Taylor & Francis.

Bernstein, B. (1999) Vertical and horizontal discourse: an essay. *British Journal of Sociology of Education* 20(2), 157–173.

Bourdieu, P. (1984) *Distinction: A Social Critique of the Judgment of Taste.* London: Routledge & Kegan Paul.

Bourdieu, P. (1988) *Homo Academicus.* Cambridge: Polity Press.

Candy, L. (2006) *Practice-based Research: A Guide.* Creativity and Cognition Studios, Sydney: University of Technology Sydney.

Fairskye, M. (1993) Frankly, I may be a genius, but don't call me Dale, I'll call you. *Ornithology and Art? A Bird's Eye View of Conceptual Rigour in Contemporary Art Practice.* Brisbane: Queensland Art Gallery.

Hockey, J. (2003) Practice-based research degree students in Art and Design: identity and adaptation. *Journal of Art and Design* 22(1), 82–91.

Hodge, B. (1998) Monstrous knowledge: doing PhDs in the 'new humanities'. In A. Lee & B. Green (eds), *Postgraduate Studies: Postgraduate Pedagogy* (pp. 113–128). Sydney: Centre for Language and Literacy, Faculty of Education, University of Technology.

Hood, S. (2010) *Appraising Research: Evaluation in Academic Writing.* Basingstoke: Palgrave Macmillan.

Maton, K. (2010a) Analysing knowledge claims and practices: languages of legitimation. In K. Maton & R. Moore (eds), *Social Realism, Knowledge and the Sociology of Education: Coalitions of the Mind* (pp. 35–59). London: Continuum.

Maton, K. (2010b) Canons and progress in the Arts and Humanities: knowers and gazes. In K. Maton & R. Moore (eds), *Social Realism, Knowledge and the Sociology of Education: Coalitions of the Mind* (pp. 154–178). London: Continuum.

Maton, K. (2014) *Knowledge and Knowers: Towards a Realist Sociology of Education.* London: Routledge.

Meurer, J.L. (2002) Genre as diversity and rhetorical mode as unity in language use. *Ilha do Desterro: A Journal of English Language, Literatures in English and Cultural Studies* 43(2), 61–81.

Muecke, S., Brannigan, E., & Scheer, E. (2013) *Towards the Experimental Humanities.* Australian Research Council Discovery Project, DP130104571.

Paltridge, B., Starfield, S., Ravelli, L., & Nicholson, S. (2011a) Doctoral writing in the visual and performing arts: issues and debates. *International Journal of Art and Design Education* 30(2), 88–101.

Paltridge, B., Starfield, S., Ravelli, L., & Nicholson, S. (2011b) Doctoral writing in the visual and performing arts: two ends of a continuum. *Studies in Higher Education* 37(8), 1–15.

Paltridge, B., Starfield, S., Ravelli, L., & Nicholson, S. (2014) Genre in the creative-practice doctoral thesis: diversity and unity. In G. Garzone & C. Ilie (eds), *Genres and Genre Theory in Transition: Specialized Communication across Contexts and Media.* (pp. 89–105). Boca Raton, FA: BrownWalker Press.

Paltridge, B., Starfield, S., Ravelli, L., & Tuckwell, K. (2012) Change and stability: examining the macrostructures of doctoral theses in the visual and performing arts. *Journal of English for Academic Purposes* 11(4), 1–13.

Phillips, M., Stock, C., Vincs, K., Hassall, N., & Dyson, J. (2008) *Draft Recommendations for Best Practice in Doctoral and Masters by Research Examination of Dance Studies in Australia.* Perth: West Australian Academic of Performing Arts at Edith Cowan University.

Schryer, C. (1993) Records as genre. *Written Communication* 10(2), 200–234.

Starfield, S., Paltridge, B., & Ravelli, L. (2012) Why do we have to write?: Practice-based theses in the visual and performing arts and the place of writing. In C. Berkenkotter, V.K. Bhatia & M. Gotti (eds), *Insights into Academic Genres* (pp. 169–190). Bern: Peter Lang.

Starfield, S., & Ravelli, L. (2006) The writing of this thesis was a process that I could not explore with the positivistic detachment of the classical sociologist. *Journal of English for Academic Purposes* 5(3), 222–243.

Trowler, P. (2012) Doing research: the case of Art and Design. In P. Trowler, M. Saunders & V. Bamber (eds), *Tribes and Territories in the 21st Century: Rethinking the Significance of Disciplines in Higher Education* (pp. 68–77). London and New York: Routledge.

Turner, J. (2003) Writing a PhD in the contemporary humanities. *Hong Kong Journal of Applied Linguistics* 8(2), 34–53.

Notes

1 The separation of the 'written' from the 'creative' component is for ease of reference only; as linguists, we more than agree that a 'written' work is itself fully creative.

2 Our research project led to a symposium, Doctoral Writing in the Visual and Performing Arts: Challenges and Diversities, Sydney College of the Arts, University of Sydney, 17 and 18 November 2011. Participants came from across Australia and represented a diverse range of creative-practice fields.

Acknowledgement

We would like to thank the Australian Research Council for the award of Discovery Project DP0880667, *Writing in the academy: the practice-based thesis as an evolving genre*, which enabled this research.

FROM ANOTHER PLACE:
NOTES ON CONTEXT

Iain Biggs

Introduction

This chapter is a set of linked speculative notes, a record of thinking in progress about the contexts of good doctoral writing concerned with creative praxis. It takes a provisional form because my thinking on this topic is still in process; because genuinely inventive practices are hard to distinguish from mere novelty (O'Neill 2012); and because we lack the terms necessary to articulate clearly the emerging understanding that concerns me here.

First Context – Exclusory Presuppositions

When Professor Ferdinand von Prondzynski, the Principal and Vice-Chancellor of the Robert Gordon University in Aberdeen, Scotland, acknowledges that universities, supposedly the prime generators of new knowledge, are among the most reactionary and conservative of our social institutions, we can be sure that our discipline-based

epistemology is in crisis.[1] That he links this crisis to the fact that the *realpolitik* of universities remains grounded in disciplinary hierarchies, which also dominate the doctoral process, is equally significant.[2]

Disciplinary thinking is structurally incapable of grasping the need for a praxis capable of engaging with and across the connectivities between the three ecologies: of the environment, human society and the constellations that make up the individual (Guattari 2000); a praxis upon which the future of all beings, human and otherwise, is now likely to depend. Students engaged in arts-led doctoral research are in a good position, given the right conditions, to understand and help address this situation. This is so because their study, properly understood, is located in a contested space between the institutional worlds of the arts and the university sector and, in consequence, can work productively with the tensions between these two worlds and broader social concerns.

My approach below, seen from an art-world perspective, might be associated with relational aesthetics. But relational aesthetics is just another way of ignoring the fundamental problem of the exclusivity of art in relation to human creativity as a whole. Thus Grant Kester begins *Conversation Pieces* (2004) with a series of exclusions. He informs us that only artists working through performative, process-based approaches to provide context, rather than content, will be deemed worthy of his attention. In doing so he recapitulates a given form of 'advanced', yet deeply academic, thinking. In short, relational aesthetics tells us more about the limitations of a dominant orthodoxy than about the conditions conducive to relationships that might productively embed creative work and understanding in new and radical forms of connectivity. Or, in the case of doctoral work, produce genuinely new knowledge.

Our socio-ecological circumstances now require forms of radical, extra-disciplinary thinking that break with the assumptions of exclusivity dominant in both the art and university worlds. Ironically, 'object makers' like my colleagues Christine Baeumler and Mary Modeen (working at the universities of Minnesota and Dundee respectively) are in fact far better able to enact that break than artists associated with relational aesthetics. Both work relationally in a broader ecosophical sense, providing communities with *both* content *and* context. Each works

through a performative, process-based approach (albeit not of the type of interest to Kester), and each is creatively engaged with a variety of communities of interest and practice and with the place-based communities of which they are active members.

'Advanced' art theory is still predicated on assumptions about the professional exclusivity of the artist 'as artist', regardless of the nature of her or his particular practice. Consequently, it cannot explore how such long-standing and active teacher–artist–researchers as Baeumler and Modeen provide, in different ways, both content and context for their students, colleagues, neighbourhoods and the commons more generally because, were it to do so, it would undermine its own raison d'*être*. So we lack the means to think through the rich and complex creative interrelationship between the performance of each of the roles that Baeumler and Modeen enact. Yet seen from the relational perspective of an ecosophical weave of inter-subjectivities, their work provides a creative dynamic that far exceeds, but is finally inseparable from, their work 'as artists'.

I want to think here about the potentially radical opportunities of the doctoral-level arts researcher–practitioner as these relate to questions about the construction, care and maintenance of active connectivities, ecosophically understood. This is an extra-disciplinary position I understand as a necessary constituent of good (in an ethical sense) doctoral writing in the creative arts. That is, of writing concerned with facilitating genuinely new and relevant forms of understanding, rather than merely reconfiguring elements of outmoded forms of disciplinary thinking and practice in marginally novel ways.

The art historian and theorist Marsha Meskimmon (2011) suggests that if we are to understand ourselves as subjects in a world that is being rapidly remade by globalism, we must reconfigure subjectivity in terms that go beyond the confines of a monolithic possessive individualism. What follows is predicated on that view and begins by presenting a simple proposition. This proposition sets out my understanding of the contexts in which the best doctoral writing in the creative arts takes place, moves to a specific example and concludes with a brief summary of my concerns.

A Proposition

Good doctoral writing in the creative arts as understood here requires the doctoral student to be located within a community of transverse action (CTA). Here action is understood in Hannah Arendt's sense of requiring both the capability to initiate – to begin something new, to undertake the unexpected – and plurality, the presence and acknowledgment of others that allows action to be a meaningful activity (Arendt 1958). That is to say it requires the student to become part of an intergenerational community able to engage strategically, both with regard to the overlapping institutional domains of art and the university and to vernacular concerns enacted outside those domains. This is the case because the real quality of such writing is now closely linked to an ability to carry through a highly sophisticated 'deception', one literally enacted by the doctoral candidate but ultimately dependent on a CTA as a whole. This deception is a sustained 'limit act' (Freire 1985); one that, through witnessing, reflecting, acting and reimagining, contests or problematises the normative orthodoxies of the fields of art and higher education (Lorenz & Watkins 2003).

Communities of Transverse Action

A CTA is a self-configuring community united by a commitment to *learning-as-becoming* in the service of action conducted on the basis of critical solicitude. It is focused around common sets of overlapping skills and concerns, oriented by action in Arendt's sense, and integrates and extends the concerns of communities of practice and of interest (Lave & Wenger 1991). Its members understand themselves as part of a collective endeavour made possible by a mycelial mesh of relationships between material environments, social relations, and the inter-subjectivities of human (and on occasion non-human) beings. In the context of doctoral education, such communities can be differentiated from the informal disciplinary and professional networks they somewhat resemble (and with which they inevitably overlap) by their balancing of critique with solicitude and hospitality; by their transverse function in relation to professional, disciplinary, institutional and other hierarchies; by their social engagement; and by their commitment to processes of learning-as-becoming that generate lasting relationships.

In the context of a CTA, the relationship between supervisor and student is based on an inclusive common engagement. It is initially that of mentor and mentee, but oriented by the understanding that, in time, the student will contribute to the community on equal terms with other members. The facilitation of a CTA has been my principle concern as Director of PLaCE (England) and as a co-convener of the Mapping Spectral Traces Network. Consequently, while I am fully aware of the difficulties such communities encounter both in coming into being and maintaining themselves over time, I also know them to be vital to ecosophically based education as a mode of action. Significantly, such communities reflect the understanding that the value of arts and humanities research is not captured by a production–consumption model, one that bears no relation to the ways in which innovation and creativity actually occur (Leach & Wilson 2010). The real value of such research lies in it being:

> carried by and in persons. As expertise, as confidence, as under-standing and orientation to issues, problems, concerns and opportunities, as tools and abilities. This is best captured... in the notion of responsiveness.
>
> (p. 7)

> This responsiveness is in turn understood as an aspect of citizen-ship that privileges those 'spaces and opportunities for discussion, argument, critique, reflection' in which, over time, collaboration itself becomes a basis for evaluation.
>
> (p. 3)

Understanding the reasons for this emphasis on enduring collaboration and citizenship – seen as both uniting and transcending professional, disciplinary and vernacular categories – is vital to good doctoral writing in the creative arts as understood here.

Such understanding ensures that, while a CTA may draw heavily on skills learned in the professional worlds of the arts and the university, it remains open to and engaged with the full spectrum of challenges posed by the more inclusive concerns it addresses. Additionally, its members cannot simply be categorised using orthodox conventions of identity (as 'an artist', 'a supervisor', 'a student', etc.), a point to which I will return. It

is neither possible nor desirable to capture these concerns in an explicit 'statement of intent' because they are by definition fluid, open and dynamically responsive to the mesh of connectivities of which they are a part. These concerns might, however, be identified as the educational imperatives requiring the unravelling of fixed disciplinary positions so as to develop modes of thinking able to work across the three levels of ecology, as identified in Felix Guattari's *The Three Ecologies* (2000).

Second Context – The Academy

The current *realpolitik* of the university sector renders precarious the position of (inevitably trans-disciplinary) arts doctorates in a culture in which doctoral work, seen from an institutional perspective, is still primarily a disciplinary gate-keeping exercise. While to a degree challenged by aspects of the growing convergence of business interests and academic research, notions of success and the institutionalised inertia of the academy will ensure that this *realpolitik* is sustained, at least in the immediate future. However, the vulnerability of the arts practice-led doctorate in this context is, ironically, also the basis of its potential value to those who wish to address a situation in which universities are increasingly mechanisms for perpetuating the values of the *status quo* at the expense of their duty to be socially responsive and responsible educational institutions.

Utility

Doctoral research conducted within a CTA will by definition stress the social utility of particular creative skills. In contrast to those who reject any form of utility in the name of art as an autonomous disciplinary value system (Leach 2011), arts-trained members of a CTA are concerned with employing their skills in processes that have an ecosophical utility. They explicitly reject those positions that have allowed the artist to stand in the popular mind as the quintessential embodiment of 'possessive individualism' (Leach 2011). They act as self-aware servicers, polemicists, critical observers, catalysts or animateurs, collaborators, enablers or facilitators; willingly entering into multi- and extra-disciplinary discourses, conversations and interventions in ways that have actual power and influence (Morgan 1989).

The best doctoral writing in arts-led research is thus reflexively aware of current tensions and mutations relating to the professional worlds with which it engages. This requires the openness and breadth of knowledge necessary to facilitate a tough-minded agnosticism towards the professional mystiques of both worlds and, more specifically, an extensive 'insider' knowledge inaccessible to a doctoral candidate unsupported by an informed and counter-normative collective such as a CTA.

Third Context – Indicative Intra-subjective Experience

I advance these views on the basis of a praxis that interweaves teaching, research and various forms of creative practice oriented by deep mapping (Biggs 2011); of having acted as a faculty director for research degrees; and over a fifteen-year period, of having supervised and examined doctoral students with a range of creative backgrounds.

While these doctoral students have for the most part worked as artists or artist–researchers, they would certainly reject any idea of having achieved a doctorate in 'studio art' (Elkins 2009) as both anachronistic and misleading. Most now work with innovative amalgams of academic research methods, trans-disciplinary approaches to theory, various forms of geographically or ethnographically inflected fieldwork, and a wide range of creative practices. They produce arts-led inter- or trans-disciplinary interventions that, in small but significant ways, reconfigure understandings identified with 'post-disciplinary' fields of engagement – for example, environmental studies, memory studies, landscape studies and identity studies. I understand their work as contributing to the formation of a relational and inclusive ecosophical connectivity through a hybridisation of arts skills, social concern and research, and in ways that are forming a new, as yet unnamed, creative praxis.

Doctoral Education beyond Possessive Individualism

My concern with the relationship between the quality of writing in doctoral work in the creative arts and its location within a CTA should not be taken as diminishing the importance of the individual. Rather it reminds us of the misleading application of the assumptions of possessive individualism to educational and cultural work.

James Leach (2011) reminds us that possessive individualism is the dominant secular belief system in our culture, one that requires us to take as given that individuality, creativity and originality are something exclusive to, and wholly owned by, a unique and monolithic self. This belief underpins our political assumptions and social organisation through presuppositions about the natural world and human society; presuppositions reflected in our taking for granted the emphasis placed on individuals to generate novelty or originality in contemporary art and new knowledge in academic research. My position here takes as an *a priori* that, as subjects, we are enmeshed in the world and are constituted in and through all our many and diverse forms of attachment, connectivity and relationship (Simpson 1989). It is important to note that this argument redefines the relational context and constitution of our individual becoming, but without in any sense denying validity to the individual within that meshwork.

As already indicated, Guattari provides a context in which to understand the necessity to enact, as individuals, both a greater unity and a greater differentiation regarding the self. An *interdependent* self – one that understands its own dependence on facilitating the wellbeing of the material, natural and social worlds – is characterised by a degree of multiplicity that reflects diversity. That is to say, one that is able to let go of notions of a monolithic centre with a distinct border between self and world, understands that it is decentralised and able to pursue aims other than those of the heroic ego (Watkins 1992). The importance of any CTA lies in no small part in its facilitating and sustaining alternative and interdependent understandings of self in a culture in which artistic and academic success are modelled on the increasingly pathological and ultimately self-destructive manifestations of just such a heroic ego.

Doctoral Education in a Time of 'Symbolic Arrest'

Michael Gibbons and colleagues remind us that it is often very difficult to produce recognisable knowledge outside socially dominant forms of disciplinary knowing (Gibbons et al. 1994). The dominant understanding of doctoral study is thus antipathetic to critically reflective doctoral arts projects. Consequently, doctoral students and their supervisors need a collaborative awareness of the difficulties and opportunities they face

so as to devise writing strategies that address this, often tacit, insti-
tutional antipathy. Such strategies must acknowledge that to work as
a professional artist or academic today is increasingly to be caught up
in an accelerating process of symbolic arrest, the result of progressive
substitution of managerial strategies for active facilitation of life prac-
tices. This creates a major difficulty for arts doctoral students and their
supervisors.

Critical Theory tells us that we are co-opted into a culture industry
in which the greater part of production is deliberately configured to
generate more or less empty phenomena that define themselves by
acting-out managerial imperatives. Such cultural phenomena are little
more than bland markers of their own location and function within the
economy of the art world, blank pages onto which critics, art historians,
theorists, curators, academic commentators and a growing diversity of
cultural facilitators, agents, administrators and managers can project
their own professional interests (Crowther 2009).

One response to this analysis (accurate in its own terms) has been to
encourage arts doctoral students to employ some variant of Critical
Theory in their work. However, it is increasingly difficult to defend this
option given the blatant and quite possibly hypocritical relationship
between the discourse of Critical Theory and the powerfully repres-
sive structures of academia and cultural institutions (Drucker 2005).
Moreover, much Critical Theory retains both the dominant – that is
exclusive – view of art and, additionally, sees even such art as it approves
as only able to affect everyday life in the most limited ways (Ray 2011).
This is not a productive basis on which to conduct genuinely innovative
arts-led doctoral study. Regardless of the pessimism of Critical Theory
concerning art's efficacy, it remains vital to good doctoral writing that
students understand that they can work productively and ethically with
and through the creative skills associated with art and deployed within
a doctoral context.

It is possible, for example, to retain the culturally reflexive critical
understanding necessary to doctoral study in the arts without reducing
art practice to an exercise in the politics of mourning (Ray 2011). What
is of primary significance here is the broader context of connectivities

in which creative skills are employed. This may be that of the specific CTA of which the student is a part or, for example, an exploration of such concerns as the possibilities latent in an ethically framed understanding of restorative enchantment (Bennett 2001).

Nonetheless, those undertaking or supporting doctoral-level writing need to take into account that, in reconfiguring what we understand by the production of new knowledge – namely by generating forms of reflection, witnessing, acting and reimagining that create or reanimate constructive forms of connectivity – creative practice-led research becomes both academically and artistically transgressive. Consequently, while it is vital that creative doctoral praxis is carried out in ways that ensure it is recognised as valid institutionally, we must in no sense internalise the terms and conditions of that institutional validation. It is in this context that I used the term 'deception' earlier.

Arguably the best doctoral work in the arts is a dynamic amalgam of ongoing imaginative speculation, material praxis, life experience, extended knowledge and analytical critique. Its ability to hold together opposing elements and positions, necessary to its meeting both creative and institutional requirements, is central to both the project's success as a doctorate and its capacity to challenge dominant norms. The necessity of working 'paradoxically' means that the best doctoral projects have both the capacity to subvert, in whole or in part, the terms of reference imposed upon them by the *status quo*, and the ability to defend successfully that subversion in academic terms. Good doctoral writing must, however, find the means to 'hide' its subversion of institutional norms in plain sight. This is best done by providing intellectual justification through written argument for its quality as creative and transgressive research that exceeds the limits of institutional frameworks of art and disciplinary thinking within which it is formally located.

This approach is predicated on Geraldine Finn's view (1996) that we always both exceed and fall short of the categories by which we are named and divided. Given this premise, and in order for creative practice-led doctoral work to be genuinely innovative in both its own and in institutional terms, it must be written in such a way as to 'speak' in at least two registers. It must signal understanding of, and a necessary

degree of conformity to, institutional doctoral conventions while, at one and the same time, constituting a *space between* reality and representation, life and language, experience and category that allows the candidate's work to move productively into genuinely new understandings. This places very substantive demands on the doctoral project that, in my view, can only be met if both candidate and the supervisory team are consciously located within the same CTA.

Three 'Voices' in the Doctoral Text

The Czech poet and chemist Miroslav Holub, while particularly well placed to reflect on the different working perspectives of poets and scientists, suggests (1990) that it is ultimately unhelpful to place too much emphasis on the exclusive concerns used in the self-definition of either professional group. As he points out, their members actually spend by far the greater part of their time working not 'as poets' or 'as scientists' but on tasks and in roles that require their own forms of creativity and reflection.

He argues that this more accurate account locates the actual professional work of 'poets' and 'scientists' in small, if sometimes pervasive, fields and that failure to acknowledge this results in our misconstruing social reality; a reality in which real power and influence lie primarily with systems of management and manipulation. These are systems that serve largely autonomous and increasingly feral elites that treat the remainder of the population in much the same way that an immunologist manipulates a microbial culture. Consequently, it is as important to focus on what might unite us – whether in a CTA or otherwise – than on disciplinary differences and exclusivities.

Holub's exposition prompts a better understanding of the animating tensions between two voices within doctoral writing: the 'poetic' – which takes as its starting point the inevitably inadequate nature of creative means – and the 'scientific' (in this context, methodological), which presumes its means to be, however temporarily, adequate. But, additionally and more particularly, doctoral students need to allow space for (or even actively to stress) a third, less disciplined and more vernacular voice. One able to evoke, in whatever way appropriate, those

constellations of particularities and contingencies that are central to engaged creative practice oriented by a CTA in that they reflect back to us our existential location as beings in process; beings always exceeding and falling short of categorical naming and division.

Teaching us to pay attention to and value this third voice is one of the important legacies bequeathed to doctoral writing by feminism. So, for example, Janet Wolff (1995) presents autobiography and memoir as a means of accessing particular cultural micro-histories and of allowing fragments and concrete particulars to serve as legitimate topics of social analysis. Such feminist approaches led in turn to the auto-ethnographic methods which, combined with action-led research, underpin an increasing volume of the best doctoral writing in the arts.

Writing the Third Voice in Practice

Dr Suze Adams recently received her doctorate for a project entitled *Location, Dislocation, Translocation: Navigating a Space between Place and Becoming through Practice-led Research* (2012). In this thesis, and in line with my observations above, she draws on the work of the feminist writer Peggy Phelan. With Adams' permission, I use extracts from her writing to suggest how a concern with a third voice, used in the context set out above, may be played out in practice. Grounded in what she refers to as a 'phenomenologically oriented walking-based practice', the approach she adopted in her writing is particularly relevant here because her fourth research objective is stated specifically as:

> To adopt a performative writing style in order to model an alternative approach to presenting practice-led research that challenges more orthodox academic practice and dissemination formats. Drawing on cross-disciplinary examples, to explore and assess the efficacy of such a strategy for textual documentation of a visual arts practice and to consider how a hybrid writing style can, in turn, be employed to underline *the context (the experiential landscape)* of this particular research study.
>
> (Adams 2012, pp. 7–8, my italics)

This in turn leads her to identify one of two overarching research concerns as being:

> To disseminate research in such a way that, as a contextual tool,
> the project serves to expand and extend the remit of research as
> practice by moving towards a new paradigm – a model that adopts
> a performative writing strategy to blur the boundaries between
> the corporeal and the conceptual, i.e. between lived and learned
> knowledges. I propose that such an example reflects the processual
> reality of practice-led research (in this instance in the visual arts)
> and, as such, offers strategies that can be adopted, adapted and
> further developed by practitioners across the disciplines.
>
> (Adams 2012, p. 8)

In her conclusion, she then characterises what she achieved in respect of the above claims, namely to have established:

> a precise style of dissemination deliberately co-constituting the
> topic of study which, as we have seen, situates the personal in the
> socio-cultural by building on memoir, cultural history and femi-
> nist critique in the context of place-based projects...

> In this respect I propose that my project provides a new model
> for practice in the field – a model that reflects the implications of
> practice-led research where, as we have seen, the value of the work
> lies as much in the experiential as in the theoretical and is, in this
> regard, disseminated via a productive dialogue performed between
> the creative processes of writing and arts practice.
>
> (Ibid., p. 244)

Adams' use of performative writing – in which the third voice (articu-lated through field notes) plays a pivotal part – blurs the boundaries between the corporeal and the conceptual, between vernacular social understandings and specialist disciplinary knowledge. As such, it brings together the creatively experiential and the critical so as to reflect the actuality of experience in the field. In this way, complex concepts are explored in practice and the poly-vocal 'writing up' of practical and theo-retical findings is able to progress and inform the inquiry significantly.

In Adams' project, the inter-relationship between specialist practice, vernacular concerns and theory, critically reconfigured in textual and visual forms, directly mirrors the processual nature of practice-led research. The aim is to leave no doubt in the reader's mind that critical thought, mundane attention to everyday phenomena, and connectivities

grounded in the corporeal are all integral to the research inquiry. The enacted exchange or conversation between a practice fully engaged with the life world and bodies of contemporary theory, together with the tensions and challenges this inter-play raises, effectively highlights the erasure of any formal boundary between poetic, methodological and vernacular concerns and, in doing so, models a new relationality.

Conclusion

It might be argued that what I have proposed above amounts to little more than a plea for attentive and responsible supervision, requiring a supervisory relationship based on a mutually proactive approach by student and supervisor, where both explicitly locate themselves within a shared, outward-looking and socially engaged arts-led research culture. If this chapter were to be read and genuinely taken to heart in those terms, it would achieve considerably more than any university regulations regarding supervision I know. More realistically, I hope that what I have written will encourage both current and prospective doctoral students to think carefully about what they undertake, where and with whom. A good doctoral project has the potential to be genuinely transformative for both student and supervisor, in the sense that both education and the best art is supposed to be but now very rarely is.

Obviously my real concern here is with something much more than doctoral education in the visual and performing arts. It is with the need to establish, facilitate and sustain the work of CTAs as central to cultural life, regardless of the particular disciplinary skills we are privileged to be able to employ. This is particularly important at a time when, in many parts of the world, a genuine university education is rapidly falling victim to the same processes that have led to increasing symbolic arrest in culture as a whole. And in each case, it is those who have access to the necessary educational and cultural capital who are best able to lead the way in establishing CTAs and, with them, the practical basis of a form of learning able to create a genuinely new and ecosophical engagement with the world.

Acknowledgement

I would like to thank Dr Suze Adams for permission to quote extensively from her doctoral text.

References

Adams, S. (2012) *Location, Dislocation, Translocation: Navigating a Space between Place and Becoming through Practice-led Research.* Unpublished doctoral thesis. University of the West of England.

Arendt, H. (1958) *The Human Condition.* Chicago, IL: University of Chicago Press.

Bennett, J. (2001) *The Enchantment of Modern Life: Attachments, Crossings and Ethics.* Princeton & Oxford: Princeton University Press.

Biggs, I. (2011) The spaces of 'deep mapping': a partial account. *Journal of Arts and Communities* 2(1), 5–25.

Crowther, P. (2009) Artistic creativity: illusions, realities, futures. In F. Halsall, J. Jansen & T. O'Connor (eds), *Rediscovering Aesthetics: Transdisciplinary Voices from Art History, Philosophy and Art Practice* (pp. 133–146). Stanford, CA: Stanford University Press.

Drucker, J. (2005) *Sweet Dreams: Contemporary Art and Complicity.* Chicago, IL: University of Chicago Press.

Elkins, J. (ed.) (2009) *Artists with PhDs: On the New Doctoral Degree in Studio Art.* Washington, DC: New Academia Publishing.

Finn, G. (1996) *Why Althusser Killed His Wife: Essays on Discourse and Violence.* Atlantic Highlands, NJ: Humanities Press International.

Freire, P. (1985) Reading the world and reading the word: an interview with Paulo Freire. *Language Arts* 62(1), 15–21.

Gibbons, M., Limoges, C., Nowotny, H., Schwartzman, S., Scott, P., & Trow, M. (1994) *The New Production of Knowledge: The Dynamics of Science and Research in Contemporary Societies.* London: Sage.

Guattari, F. (2000) *The Three Ecologies* (Trans. I. Pindar & P. Sutton). London and New York: Continuum.

Holub, M. (1990) Poetry and science. In D. Young (ed.), *The Dimension of the Present Moment and Other Essays.* London: Faber & Faber.

Kester, G. (2004) *Conversation Pieces: Community and Communication in Modern Art.* Berkeley and London: University of California Press.

Kwon, M. (2004) *One Place after Another: Site Specific Art and Locational Identity.* Cambridge, MA: The MIT Press.

Lave, J., & Wenger, E. (1991) *Situated Learning: Legitimate Peripheral Participation.* Cambridge: Cambridge University Press.

Leach, J. (2011) The self of the scientist, material for the artist: emergent distinctions in an interdisciplinary collaboration. *Social Analysis* 55(3), 143–163.

Leach, J., & Wilson, L. (2010) *Enabling Innovation: Creative Investments in Arts and Humanities Research*. Retrieved from: http://www.jamesleach.net/articles.html.

Lorenz, S., & Watkins, M. (2003) *Depth Psychology and Colonialism: Individuation, Seeing through, and Liberation*. Retrieved from: http://www.pacifica.edu/gems/creatingcommunityw/DepthPsychologyColonialism.pdf.

Meskimmon, M. (2011) *Contemporary Art and the Cosmpolitan Imagination*. London and New York: Routledge.

Morgan, S. (1989) Beyond the aesthetic adventurer: public art and education. *Circa Art Magazine* 45, 16–18.

O'Neill, P. (2012) To go beyond – the emergence of the durational commons. In S. Warren & J. Mosely (eds), *Beyond Utopia* (pp. 8–13). Berlin: Errant Bodies Press.

O'Neill, P., & Doherty, C. (eds) (2011) *Locating the Producers: Durational Approaches to Public Art*. Amsterdam: Valiz.

Ray, G. (2011) Mourning and cosmopolitics, with and beyond Beuys. In C.-M. Hayes & V. Walters (eds), *Beuysian Legacies in Ireland and Beyond: Art, Culture and Politics* (pp. 22–48). Berlin: LIT Verlag.

Ricoeur, P. (1991) *From Text to Action: Essays in Hermeneutics*. London: Athlone.

Simpson, E. (1989) The challenge of social change for psychology: globalization and Psychology's theory of the person. *American Pyschologist* 44(6): 914–921.

Watkins, M. (1992) From individualism to interdependence: changing paradigms in psychotherapy. *Psychological Perspectives* 27: 52–69.

Wolff, J. (1995) *Resident Alien: Feminist Cultural Criticism*. Cambridge: Polity Press.

Wolff, J. (2008) *The Aesthetics of Uncertainty*. New York: Columbia University Press.

Notes

1 http://universitydiary.wordpress.com/about/ (Accessed 10 November 2012)
2 von Prondzynski, F. (2010) *A post-disciplinary academy?* Retrieved 10 November 2012, from: http://universitydiary.wordpress.com/2010/10/14/a-post-disciplinary-academy/.

INDEX

Note: page numbers in bold type refer to Figures.